Linda Barrett Osborne and Paolo Battaglia
with a foreword by Martin Scorsese and introductions by Antonio Canovi and Mario B. Mignone

Explorers Emigrants Citizens

A VISUAL HISTORY OF THE ITALIAN AMERICAN EXPERIENCE FROM THE COLLECTIONS OF THE LIBRARY OF CONGRESS

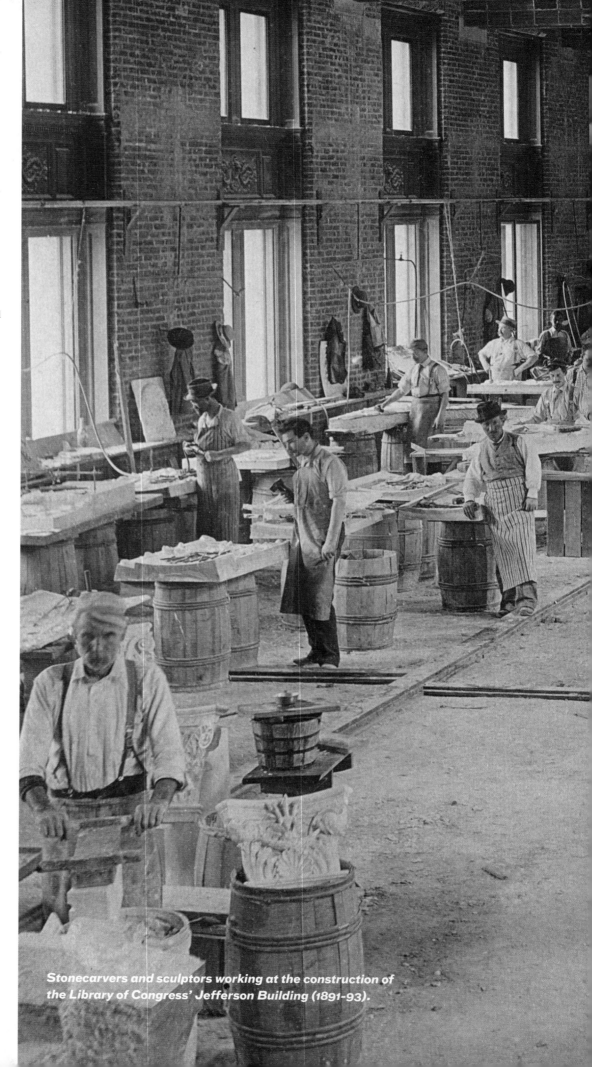

In memory of all the daring emigrants who left Italy with the hope of making a better life, their gift to the succeeding generations

For Catherine and Nick, who are half Italian, and Bob, who has the spirit

For Lalla and Vittorio, who always went along with my love for America and who would have been proud of this book

Copyright © 2013 by The Library of Congress and Anniversary Books.

Foreword copyright © 2013 Martin Scorsese

Introductions copyright © 2013 Antonio Canovi and Mario B. Mignone

Complete art credits appear on pp. 312-313

ISBN 978-88-96408-14-8

Printed in Italy

Authors
Linda Barrett Osborne and Paolo Battaglia

Design
Giulia Battaglia

Editorial contribution
Silvia Gibellini

For the Library of Congress:
Director of Publishing
Ralph Eubanks

Editor
Peter Devereaux

Anniversary Books
Via Emilia Ovest 695/a
41123 Modena (Italy)
www.anniversarybooks.it

Library of Congress Cataloging-in-Publication Data

Osborne, Linda Barrett / Battaglia, Paolo

Explorers emigrants citizens : a visual history of the Italian American experience from the collections of the Library of Congress / Linda Barrett Osborne, Paolo Battaglia ; with a foreword by Martin Scorsese and introductions by Antonio Canovi and Mario B. Mignone.

 pages cm.

Includes bibliographical references and index.

 ISBN 978-8896408148

1. Italian Americans--History--Pictorial works.
2. Italians--United States--History--Pictorial works. 3. Immigrants--United States--History--Pictorial works. 4. United States--Emigration and immigration--History--Pictorial works. 5. Library of Congress--Exhibitions I. Battaglia, Paolo. II. Library of Congress. III. Title.

E184.I8O75 2013

973'.0451--dc23

 2013026396

10 9 8 7 6 5 4 3 2 1

Stonecarvers and sculptors working at the construction of the Library of Congress' Jefferson Building (1891-93).

Explorers Emigrants Citizens

A Visual History of the Italian American Experience from the Collections of the Library of Congress

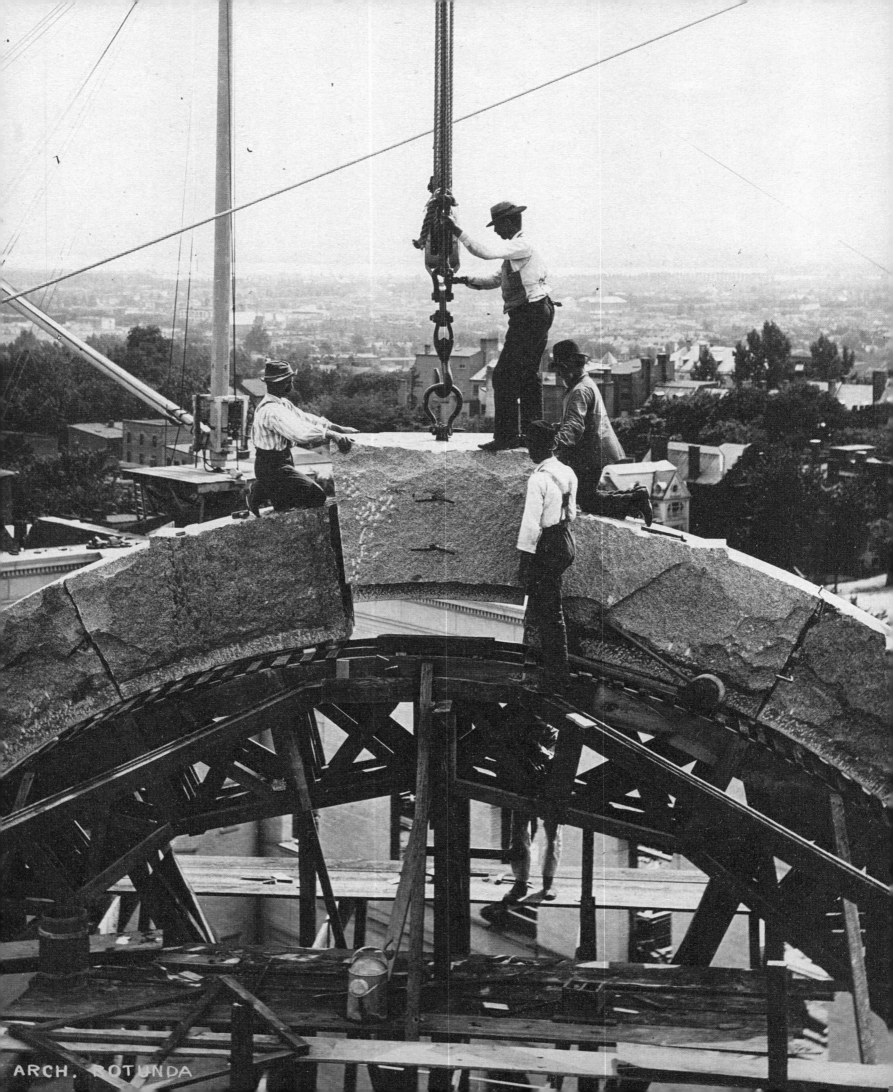

ARCH. ROTUNDA

Contents

Il Presidente della Repubblica Italiana

Le collettività di origine italiana, così come tutti gli italiani che oggi vivono stabilmente negli Stati Uniti, mantengono un vitale legame con la terra di origine. Lo hanno dimostrato in occasione delle numerose celebrazioni che hanno marcato negli Stati Uniti il 150° anniversario dell'Unità nazionale italiana.

Io stesso ne ho avuta diretta testimonianza in occasione della mia visita a New York, immediatamente successiva all'apertura delle celebrazioni, e ricevendo al Quirinale visitatori e delegazioni di Istituzioni americane, tra le quali la Library of Congress, e italo-americane.

Figure come Philip Mazzei, Giuseppe Mazzini e Giuseppe Garibaldi hanno alimentato reciproche influenze ideali e intellettuali tra le due sponde dell'Atlantico. In periodi storici successivi, l'epopea dell'emigrazione italiana negli Stati Uniti si è tradotta in un contributo decisivo all'edificazione della democrazia americana.

In questo spirito, desidero ringraziare la Library of Congress e i curatori di questo volume, e inviare il mio cordiale saluto a tutti i suoi lettori.

Dal Palazzo del Quirinale, 22 marzo 2013

Giorgio Napolitano

The American population of Italian descent, and the Italians living permanently on the American soil, are keeping alive their ties with the land of their ancestors. They clearly showed it during the many celebrations of the 150th anniversary of the Unification of Italy that have been held in the United States of America.

I received a clear demonstration of this fact right after the official celebrations had been opened, on the occasion of my visit to New York, and when I received the visit at the Quirinale Palace of a delegation of Italian American and American institutions, among which was the Library of Congress.

Personalities such as Philip Mazzei, Giuseppe Mazzini and Giuseppe Garibaldi fostered reciprocal intellectual and ideal influences between the two shores of the ocean. In the following decades, the epic of Italian emigration to the United States brought with it a fundamental contribution to the strengthening of American democracy.

With this in mind, I wish to thank the Library of Congress and the authors of this book, and to offer all its readers my cordial greetings.

From the Quirinale Palace, March 22, 2013

Giorgio Napolitano
President of Italy

Preface

James H. Billington,
Librarian of Congress

Unlike many of the libraries of Europe, which were designed for an elite, the architects for the Library of Congress's Thomas Jefferson Building, John L. Smithmeyer and Paul J. Pelz, were charged with rendering plans for a library for the masses. Smithmeyer felt that the Library of Congress should provide the people with "insight into the colossal array of knowledge which the human mind has accumulated and still gathers together, and into the enormous machinery required for access to and the utilization of every part of these intellectual riches."

All libraries provide an insight into the culture that brings them into being. So it is with the Library of Congress: its Thomas Jefferson Building found architectural inspiration in the Italian Renaissance. I'm sure the nod to Italian inspiration was not lost on the Italian-immigrant stone carvers who worked on the construction of the Library of Congress and whose faces grace the opening pages of this book.

Given the Library's history and its collections, as well as the role of Italian Americans in the construction of the Jefferson Building, it is fitting that the Library publish a book on the Italian American experience. The fact that you can explore the Italian American experience in our collections comes from an idea expressed by Thomas Jefferson that "there is, in fact, no subject to which a member of Congress may not have occasion to refer." In addition to an informed legislature, Jefferson believed in an educated American citizenry. "Enlighten the people generally," Jefferson also urged, "and tyranny and oppressions of body and mind will vanish like evil spirits at the dawn of day." The story of Italian American immigration in the collections of the Library of Congress, as seen in the pages of *Explorers, Emigrants, Citizens* represents the Library's attempt to fulfill Jefferson's desire that democracy be enhanced by the pursuit of knowledge.

While service to Congress is an important part of the mission of the Library of Congress, we remain a national library, made by the people and for the people, and open to the people. Books such as this one help make the Library's collections accessible to all Americans so that they can learn about important facets of our history. The Library of Congress has some 150 million items, largely housed in closed stacks in three buildings on Capitol Hill that contain many public reading rooms. As seen in these pages, the incredible, wide-ranging collections include books, maps, prints, newspapers, broadsides, diaries, letters, posters, musical scores, photographs, audio and video recordings, and documents. The Library serves first-time users and the most experienced researchers alike. All are welcome to use the collections of the Library of Congress, not just members of Congress, as the name might imply.

I hope that you, the reader, will seek and find in the pages of *Explorers, Emigrants, Citizens* stories of the Italian American experience that will inspire and inform you.

In addition, I would like to extend an invitation to you to visit the Library of Congress in person, or on the World Wide Web at *http://www.loc.gov*. Please come visit us. There is much in our collections that Americans and scholars from all over the world—in this case from Italy—will find of interest.

Foreword Martin Scorsese

My grandparents, who came to this country from Sicily at the turn of the century, were Italian. My parents, who were born over here, were ItalianAmerican. I was, and still am, AmericanItalian. And though I know that they will never forget their origins, my daughters are American.

In images and words, this wonderful book charts our transformation across generations—in my family, and so many other families—the hundreds of thousands of families that came to these shores and left their mark on this place we call America.

Sometimes, I find myself wanting to say "New York" but saying "America" instead. They're one and the same in my mind. The term "American experiment" more or less describes New York between the 1840s and the present day: a country, and a city, originally made of and by immigrants, endlessly rejuvenated and transformed by more immigrants coming in new waves from different places.

The transformation has never been peaceful or painless—how could it be? Apart from racial prejudice, there is also the isolation. When those first waves of immigrants arrived, they recreated the world that they knew. They made something called Little Italy, which had all the beauty and the warmth, and all the pain and the internal tensions, of the home they'd left behind.

When I was growing up, Little Italy was a world unto itself, located within a small corner of the Lower East Side of Manhattan—I'm sure the same could be said of Little Italies all over the country, from Boston to San Diego. It was right on the border of another self-contained world, Chinatown. The feasts, the rituals, the food, the markets, the values—it all came from Southern Italy. Before I was born, people who had come from the same village lived in one building, and intermarriage between different buildings was a very big deal. My mother's family was from Ciminna, my father's family was from Polizzi Generosa,

and they couldn't get married until it had been agreed upon in a meeting between the elders of the two familes.

For me and my friends, Houston Street was the borderline to the north. Beyond was the new world. There were a few ItalianAmericans who had become famous and left their mark on the culture. Still, it seemed daunting. And when I decided to leave our world behind, it was very painful. But I knew that I had to leave—I had no choice, there was no other way. "Human nature," wrote Nathaniel Hawthorne, "will not flourish, any more than a potato, if it be planted and replanted, for too long a series of generations, in the same worn-out soil." I hadn't read Hawthorne when I was young, but I felt what he expressed in those words. I knew that I wanted to make films. I knew that I wanted to show the world I came from in those films. I needed to see it from my own vantage point, at my own proper distance.

For me, Little Italy will always be home, just as Polizzi and Ciminna were home to my grandparents. Not the place itself, but the memory of it. For Hawthorne, Salem was home—not the Salem where he worked in the Custom House, but the Salem where his ancestors had settled, lived and died. "The spell survives, and just as powerfully as if the natal spot were an earthly paradise." And in my case, home is haunted by another distant home in Sicily. I'm sure that the same is true for most AmericanItalians.

This book brings back so much to me, about the way we lived and the values we shared, and about the texture of life, from the parochial schoolrooms to the religious processions to the grocery stands (like the one my grandparents ran). It also widens my perspective, and gives me a rich sense of ItalianAmerican life before my own time, and before my parents' time as well. Finally, it gives me a rich sense of historical transformation in general, and it does a beautiful job of commemorating a way of life that is now almost gone.

A few years ago, we made a little film after 9/11, which was shown as part of the Concert for New York City. We went down to Little Italy and visited some of the old places. We went to Albanese's, a butcher shop just up Elizabeth Street from the apartment where I grew up. Mary Albanese, who can be seen cutting meat in the opening of my first feature, was still there, in her nineties, working side by side with her son. Then we went to Di Palo's cheese shop down on Grand Street, where my mother did her shopping for years. Louis Di Palo, who now runs the shop with his family, told me that someone from out of town had come in one day and genuinely curious, asked him why he'd opened up an Italian store in the middle of a Chinese neighborhood. Of course, when his grandmother opened the "latteria" in 1925, it wasn't Chinatown yet—it was still Little Italy. But as the years went by, there were fewer and fewer Italian immigrants, and more and more people coming from all over China. Chinatown expanded, and Little Italy got smaller.

A decade later, Di Palo's moved just down the block, to a slightly larger space next door to a Vietnamese sandwich shop, and the business is thriving. But Mary has passed away and Albanese's is gone. Little Italy is now a historic district, a place for walking tours and visits to old-fashioned restaurants, a name for a neighborhood where all the apartment buildings have been cleaned up and converted into co-ops, but where fewer and fewer people of Italian origin actually live. Of course this is sad for those of us who grew up in that world gone by. But it's not a tragedy. It's New York, and it's America, both constantly transforming.

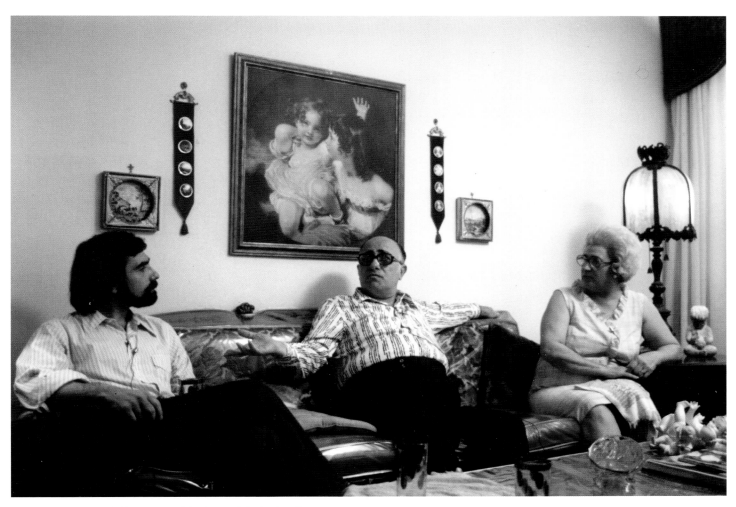

Martin Scorsese with his parents, Charles and Catherine Scorsese.

Introduction

Mario B. Mignone

Why would one publish this kind of book today? It has become so fashionable for our country's seemingly countless ethnic groups to celebrate and investigate the lives of the founding generations. Today, the desire to remember those who came first seems even more imperative, for the simple reason that identity-construction has to do with where we come from. This is a timely book because our nation has become more ethnic, perhaps even unmeltably so, and we have learned to appreciate and cherish diversity and find pride in how we mold in a texture to create a unique nation in the world.

Each ethnic group came to this country and contributed something unique to this extremely rich cultural heritage, helping to make our democracy a multicultural showcase. Like other ethnic groups, Italian Americans should and must talk about the contributions they have made to this nation. We must talk about the significant number of Italian Americans who have become leaders in every walk of life and to whom our young people can look as role models. And we have plenty to talk about. We can find important contributions by Italian Americans in every area of our national culture and in almost every town in the United States. They can be found in literature and the arts, in business and labor, in education and politics. They are part of the essential fiber of our social fabric. Often without our knowing it, their contributions are woven into our lives and have become the very blood of our existence. Italian Americans should make sure that those names figure in our country's history so that their children may gain and maintain a sense of pride in their ancestors' achievements. It is in this spirit that we applaud the Library of Congress for supporting the preparation and publication of this Italian American "story."

This story of the Italian presence in America, related through images and words, is unique because of the way it is presented. The images, through their visual power, tell the story by revealing the individual and choral drama and, for the most part, the triumph, both in its instantaneous psychological and social context and as part of a historic process. They narrate but also suggest a story which must be completed by the participation of the reader. They share a moment captured in the past, preserved and kept alive, and passed down through time. It is said that a picture is worth a thousand words. Imagine how many words may be worth a selected number of pictures organized to create an organic, historic and social context.

The images arranged in this book, selected by Italian author Paolo Battaglia from the vast assortment kept in the archive of the Library of Congress, do not merely represent precious memories preserved as in a family album; they represent the story of individuals, of families, of communities, of a people, of the Italians in America. With text written by Linda Barrett Osborne, they will offer the story from Columbus, Vespucci and the first explorers, followed by missionaries and adventurers who landed on the shore of the New Continent before the U.S. existed, until today when Italians not only are part of America's mainstream, but in many ways, they direct the stream. The Italian saga is revealed in its rich humanity, sometimes in its agony of defeat, but mostly in the thrill of victory. It is a book that will become a milestone in the historiography of the Italian American experience and will certainly provide a richer understanding of America in its historic evolution and in the diversity of its people.

I am very grateful to the Library of Congress, particularly Ralph Eubanks, former director of the Publishing Office, for having invited me to contribute to this volume and to add my perspective as an Italian emigrant and as an Italian American. For me, the participation in this volume is an act of relief, for it provides me with an opportunity to unload a pain that I endured for many years, especially in my youth while growing up in Italy, a pain caused by the way emigration and emigrants were regarded or, even worse, disregarded.

When I was a student in Italy in the 1950s, where I completed high school, I never read a page in our textbooks that recalled the sacrifice of emigrants. Not a page,

not a chapter, not a lesson was ever devoted to emigration, as if did not exist, as if Italy were ashamed of those Italians who had left the *patria* in search of *benessere* elsewhere. Yet, I and many of my classmates had been touched profoundly by emigration; many of us had relatives in many parts of the world and were eager to learn about their destiny. I had my maternal grandparents and uncles and aunts in America with whom we were corresponding—and eventually joined them—but their sacrifices were not recorded in any of our textbooks. I remember, as a child, getting up very early in the morning to say the last good-byes to the *paesani* and friends leaving for distant lands, many of them for Australia in those years. I remember the cries and the painful embraces of separation that we carried silently within us, entombed in our hearts for many years. I still remember how we, as children, would talk about the departure of our friends and wonder whether we were ever going to see them again; however, in the classroom there was never a composition to express our pain or to comment on our losses.

In the last couple of decades, Italy has made many attempts to recognize the magnitude of the phenomenon and what it meant for the nation. Conferences, publications, extraordinary legislative acts (dual citizenship and the right to vote and to be represented in the Italian Parliament), recognition by Italian authorities of Italians abroad who have achieved distinction, all have acknowledged our sacrifices and have healed our wounds. Most importantly, finally, Italy has acquired the courage to recognize the faceless millions of emigrants—who left silently as part of the "silent revolution," to create, through their labor, wealth in other countries and to generate some prosperity for the *patria* they had left—by making available for public viewing their historical importance. The creation of the National Museum of Italian Emigration (*Museo Nazionale dell'Emigrazione Italiana*), located at the base of the Victor Emmanuel Monu-

ment in Rome, was an extraordinary act, also symbolic, to remove the veil of silence that has accompanied Italian emigration. It is also very revealing that the entrance to the museum of emigration brings one to the Museum of Risorgimento. It is a museum with many pictures presented, with no theories or pompous rhetoric on emigration, but with simple descriptive narrative to allow the images to tell the story and history of emigration. We don't need theories on human sacrifices of such magnitude. A prominent part of the museum is devoted to emigrants at work. Certainly, it is the correct and proper way to represent the spirit of emigration and of the emigrant experiences. In the U.S., Italian emigrants poured the foundations, both literally and metaphorically, of their new nation: they built reservoirs, streetcar lines, subways, railroads, streets, sewage lines; they literally built new cities from the ground up. A portion of the skilled workers were still laborers as well to a certain degree. The skilled artisans, stone cutters, masons, tailors, carpenters, and horticulturists made a perfect marriage of craftmanship, experience, and hard work.

The museum is an official national act to recognize Italian emigration. As an emigrant, I am gratified: after all, it is a museum created to honor our parents, our grandparents and, in many cases, to honor us. We should appreciate the recognition that Italy has finally given to the work of emigrants in making their native country a respected economic world power. Equally gratifying is the decision of the Library of Congress to embrace the proposal coming from a small Italian publisher, Anniversary Books, and to present a visual history of the Italian American experience from the collections of the Library of Congress; it is another extraordinary recognition of the contributions of Italian emigrants: their strength, courage, and perseverance in seeking a new and better life for themselves and their descendants.

From Boccuzzi to Barrett

Linda Barrett Osborne

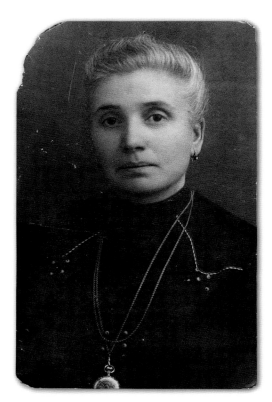

Boccuzzi, Valeri, Cerone, Marino—these are the names my great-grandparents brought with them from Italy when they came to New York some time in the 1880s or 1890s. I know little more than that about them. All my grandparents were born in the United States, as were my parents. As a fourth generation Italian American born in 1949, I was separated from my family history by decades of change and assimilation. My parents Americanized their name from Boccuzzi to Barrett to more easily fit into American society. In 1952 they moved from Brooklyn to Long Island, leaving the Italian American community behind them. Our neighbors were, among others, of Jewish, German, Scottish, and Irish heritage, a post-World War II suburban mix. I went to public, not parochial, schools where the languages you could learn, starting in seventh grade, were French and Spanish. I read the adventures of Nancy Drew and the Bobbsey Twins, and later books by Mark Twain, Nathaniel Hawthorne, and Willa Cather. I watched *Father Knows Best* and *Bonanza* on TV. To me, *Pinocchio* was a cartoon by Walt Disney. I went to a prestigious college and was the first in my extended family to earn a bachelor's degree. As I wrote the section introductions and captions for this book, I realized I was the embodiment of the third chapter, a fully assimilated American citizen.

And yet . . .

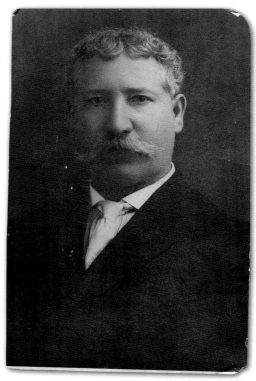

I never ate Sunday dinner with just my parents and sister, but with grandparents, aunts, cousins, friends from the "old neighborhood" who came out from the city—or we went there—to eat hours-long meals that started with antipasto, went on to pasta, roasts and vegetables, salad, fruit and cheese, and dessert. *Mangia* was the first word I learned in any language. A meal was a celebration. We ate artichokes and fennel, homemade manicotti and homemade pizza, foods my friends didn't eat, and we never used tomato sauce that hadn't cooked for hours on the stove—not been poured from a can. It is part of the stereotype that Italians enjoy eating, but it was a truth that nonetheless shaped me.

I grew up with strong family ties—not to the Mafia, of which we knew nothing and resented the way that crime was associated with being Italian American, but to my parents and sister, grandparents, nieces and nephews. My great-grandparents had been poor and lived in Italian ghettoes, still speaking their regional dialect and suffering discrimination. They were among the hundreds of thousands of Italian Americans who poured into the United States from 1880 through the early 1920s, frightening native-born Americans of An-

glo-Saxon descent, who considered them ignorant, dependent on public welfare, violent and too strange to assimilate. The U.S. Congress passed a quota law in 1924, limiting Italian immigration to fewer than 5,000 people per year. But my grandparents were also "native born Americans." They worked hard (my father's mother rolled cigars for fifty years, my mother's father ran a newsstand), saved enough to buy homes, saw their children finish high school and their grandchildren go to college. Yet even in the late 1960s I heard people talk about "dirty wops" and was told by classmates how lucky I was to be smart at school because Italians were not an intellectual people.

I have always been interested in my identity. My great-grandparents came from the north, south, and middle of Italy. Their children could only have met in America, where they were not bound by regional affiliations. I have straight, light brown hair and blue eyes, inherited from my blonde, blue-eyed grandfather, said to be from Milan. I can't count the number of times I've been told that I "don't look Italian," despite the fact that I am also known to "talk with my hands," passionate both in expressing feelings and discussing ideas. So where and who do I come from? I have no details about the lives of my forebears who came to the United States. But in writing this book, I am finding their stories in the stories of millions of nameless people who make up the history of Italians in America. I would like to speak to each of them, to hear about their dreams and difficulties, their fears and hopes; and to thank them for their strength, courage, and perseverance in seeking a new and better life for themselves and their descendants, their legacy to me.

La Mia Famiglia

My great-grandparents Josephine Napoletano Valeri and Nicholas Valeri (facing page, top and bottom) immigrated to the United States in the late 19th century. They were my mother's father's parents, said to be from Milan. This photo (below left) shows my parents, then Josephine Valeri and Jim Boccuzzi, on the day they were engaged in 1938. The photograph of my family in an "antique" car (below right) was taken at Coney Island in 1958. By then we were the Barretts: from left to right, my sister Carol, me, my mother and my father, Jo and Jim Barrett, who changed their last name before I was born.

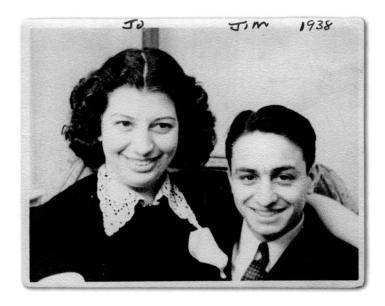

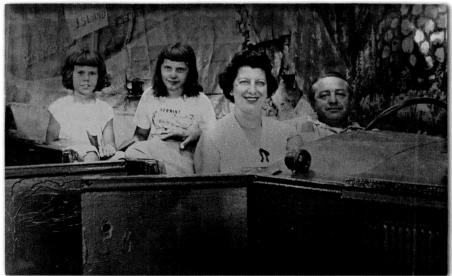

Birds of Passage

Paolo Battaglia

They live like animals, dozens in a room. Instead of sending their children to school, they exploit them. They live as recluses and only among themselves. They will never adapt to our culture and learn our language. Their beliefs are not religion but superstition.

These words are not an example of the racial complaints that some Italian politicians, journalists, and ordinary people address to "extras," as millions of immigrants reaching Italy from the poorest regions of the world have been brutally renamed.

Instead, they are the words Americans used to describe "dagos," my fellow countrymen who emigrated from Italy to the United States in the early 20th century, looking for a way to better their lives. Among the most deeply rooted American prejudices was the belief that these migrants were "birds of passage," who moved to the country to exploit its economic opportunities and who stayed only long enough to scrape together a little treasure to take home.

It is indeed true that temporary emigration was extremely widespread: an estimated 40 percent of Italians (almost 2 million people!) returned from the United States after either short or long working periods. One of them was Sisto Salvatori, my wife's paternal grandfather, who left Palagano, a small town in the mountains near Modena, in 1913. After traveling in steerage on the French ocean liner *Savoie*, he landed on Ellis Island, then joined a neighbor in Portland, Oregon, where he worked as a lumberjack. After ten years he returned to Italy and used his American savings to enlarge his family home and to open a tavern. As I retraced his story based on family memories and records from Ellis Island, it made me stop and think about how the choices, often accidental ones, of those who came before us affect our lives—in this case Sisto's decision to return and build his family in Italy.

The first time I visited the United States, I was still a child. I remember that in our hotel room in New York, my father showed me the city's monumental phone book, where the last name Battaglia filled several columns. During the research for this book, I came across my family name again: Aurelius Battaglia was among the writers of Walt Disney's *Pinocchio* who transformed one of the great classics of Italian literature into one of the great classics of American animation (the Italian author of the book, Carlo Collodi, had Pinocchio swallowed by a shark; but ask a child anywhere in the world who has seen the movie, and he will

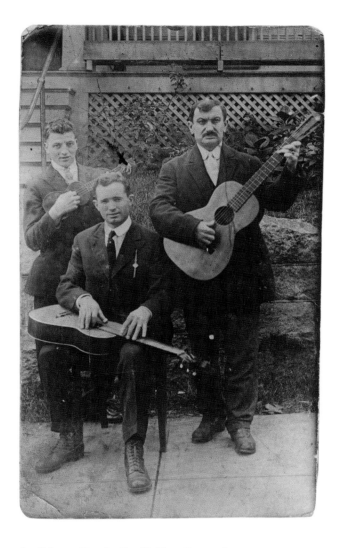

A slide-guitar in the Italian Apennines

Emigration leads to both large and small cross-cultural fertilizations. Sisto Salvatori (sitting, in the above picture), like many other emigrants, used music as a way to integrate himself into his new environment. When he returned to Italy, he brought with him a way of playing guitar never seen before in his small town in the Apennines.

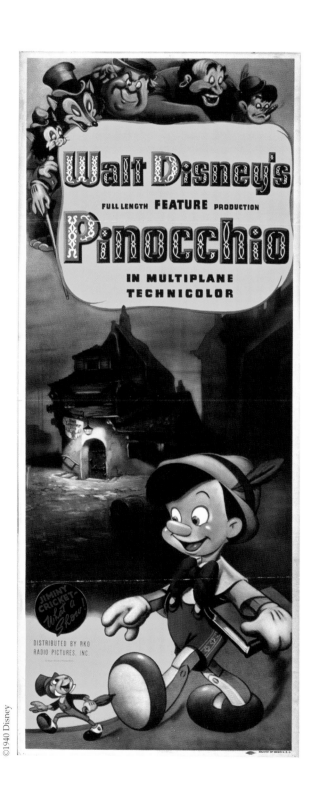

tell you Pinocchio was swallowed by a whale). I even discovered a document dated June 1916, in which a Paolo Battaglia, born in Ragusa (Sicily) on September 17, 1874—and of the *Southern Italian* (!) race—laboriously undersigned his request for U.S. citizenship.

Yet none of these Battaglias belong to my family. I was the first to establish a relationship with the United States, as a high school exchange student in Stockton, Missouri, then with repeated business and leisure trips. I can also be considered a bird of passage; and every time I go back, I leave with new impressions—and discover new contradictions—about America.

But before the journey of Sisto Salvatori became a part of the story of my family, I never bothered to learn more about the fate of other Italians, my fellow countrymen, who, by the beginning of the 20th century, were leaving by the millions for the United States. My generation in Italy is too far away from those Italians who got to know America as a land of opportunity through the exaggerations of emigration agents and the somewhat misleading letters of emigrants. We discovered it through rock music, film, and the great personalities of sports and pop culture. Our "sources" showed us highly stereotyped Italian Americans: noisy, colorful, and too often in a relationship with organized crime.

The long research carried out to make this book was, for me, a full-immersion life experience; as a result, I was freed from the stereotypes that, with a very snobby attitude, many Italians believe about our cousins across the Atlantic. I discovered the likes of Filippo Mazzei and Giacomo Beltrami, whose names are known in Italy only to a few insiders, but whose ideas and actions made significant contributions to early American history. (Mazzei was one of Thomas Jefferson's most valued advisers and Beltrami was the first explorer to reach the headwaters of the Mississippi.) I came to understand that for every Al Capone there are many Joe Petrosinos. It is easy to see this just by browsing the last names of the sad list of police officers and firefighters killed on 9/11.

The research also helped me to recognize how migrants affect not only their adopted country, but that of their origin. For example, we must fully acknowledge that the funds emigrants sent and brought home were instrumental in the revival of the Italian economy.

This book is intended to provoke reflection in Italy about our perception of immigrants. Here, for the first time in our history as a country, we have become a point of arrival, and not of departure, for migratory flows. Personally, developing the book also provided a context for my family history. But as the project went on, it eventually became more than that: a loving tribute to all those Italians who, either on a one-way or a round trip, brought a little bit of Italy to America.

Finding America

How the Book Was Made

Linda Barrett Osborne and Paolo Battaglia

*T*rovare l'America, literally translated, is "finding America." But in Italy, where our story starts—because every immigrant must be an emigrant first, tied to both countries—*trovare l'America* has a deeper meaning: "making one's fortune" and "accomplishing one's dreams." This is what Italians have done by crossing the Atlantic for more than five hundred years, from the day Columbus literally found America for Europe, through the years when many millions of emigrants—whether they stayed or returned—found their Americas.

As curators for this book, Paolo Battaglia and Linda Barrett Osborne found America at the Library of Congress in Washington, D.C. Most people think a library houses only a collection of books; but the Library of Congress also holds millions of photographs, maps, posters, letters and diaries, films, and sound recordings. It is truly the preserver of the American memory. There, we gathered more than five thousand items related to the rich history of the Italian American experience during more than twenty months of research. To unify the book, we decided to only include images from the Library itself, not from related institutions, whose collections often appear on the Library's website. However, its holdings are impressively broad for a single institution, including many time periods, media, and personalities that create a fairly thorough and accurate portrait. Where there are omissions, for example, complete coverage of Italian Americans in the western United States or of Italian Americans in the last thirty to forty years, we have filled in the blanks with the text.

We also made the decision to include both the good and the bad in this book. Many books on ethnic American groups concentrate on achievements and contributions. We do as well, but we also deal, for example, with negative stereotypes such as the Mafia; poverty and crime; labor unrest and anarchism; and political and cultural differences among Italian Americans, including those who supported and those who were against Benito Mussolini, whose influence reached the United States. There is no one type of Italian American, similar in education, work, character and beliefs. Our images from the Library of Congress show the range and diversity of Italian Americans themselves and of the lives they led in the United States.

It was also at the Library that Paolo and Linda discovered each other. Paolo was an Italian publisher and graphic designer who wanted to produce a book that presented immigration from both the Italian and the American perspectives. Linda was a senior writer-editor in the Library's Publishing Office (now retired), a fourth generation Italian American curious about her family's past and its origins in Italy. We realized that our experiences complemented each other and that we could bring different viewpoints to enrich the telling of this story. We also shared a fascination with the ways who we are and where we live have been influenced by the choices of our ancestors and the chance paths history takes. What decisions through generations put Paolo in Modena, speaking Italian, and Linda in Washington, D.C., speaking English? What connections across time and place gave us a common interest?

One belief we have in common is that immigration is a vital issue for both of our countries today. It is important that our governments shape political and social policy in a historical context and that individuals act towards each other motivated by the positive examples of history. Italy was once the source of mass immigration to America. Most Italian immigrants were extremely poor, often illiterate, unable to speak English, with customs and ways of living different from other Americans. Politicians, intellectuals, and ordinary people in the late 19th and early 20th centuries thought that they were too foreign—that they could never assimilate, learn American ways, or be fully American. Prejudice, fear, and misunderstanding stood in the way of their becoming citizens. Yet by the end of World War II, Italian immigrants had overcome prejudice, fear, and misunderstanding, through their loyalty, hard work, and service, to become accepted as Americans.

Now Italy has become a center of immigration for those from other countries who seek jobs and a better way of life for themselves and their families. These newcomers do not speak Italian. Their customs and traditions are foreign. It often seems, as it did with the Italian immigrants to the U.S., that they will never belong to their adopted country. In the United States too, immigrants arrive every day, mostly from Latin America and Asia. There are Americans who believe they will never learn our language, our way of life, or merge into the mainstream society. They call for restrictions to the number of immigrants. How, then, do we as countries and as individuals respond to immigration? We hope this book, which illuminates the experiences of Italians in America, will inform our contemporary debates. Italians came to America, persevered and prospered. Do we make it difficult, if not impossible, for people to come, do we deny them the rights of citizens, do we treat them with fear and contempt? Or do we welcome immigrants for their cultural diversity, their energy, their efforts to succeed; and do we treat them, as fellow human beings, with respect and compassion, the way we wish our forebears had been treated, the way we would treat our compatriots and ourselves?

OPIDVM S Augustini ligneis ædibus construotum,
amænissimos habuit hortos, vtiq̃ solo fæcundissimo
a nobis vero cum inde soluerrenos increto igne in
cineres redactum. Præsidium hic erat 150 Hispanoru,
aliud�q̃, item eodem numero ad duodecim Septentrione
versus leucas in loco S Helenæ dicto - hæc enim præ-
sidia quemadmodum canes in præsepi non alio consilio disposita
erant nisi ad prohibendos Anglos et Gallos ne intervetam
regionem quæ prorsus inculta iacet, occuparent

EXPLORERS
from Columbus to the Great Emigration

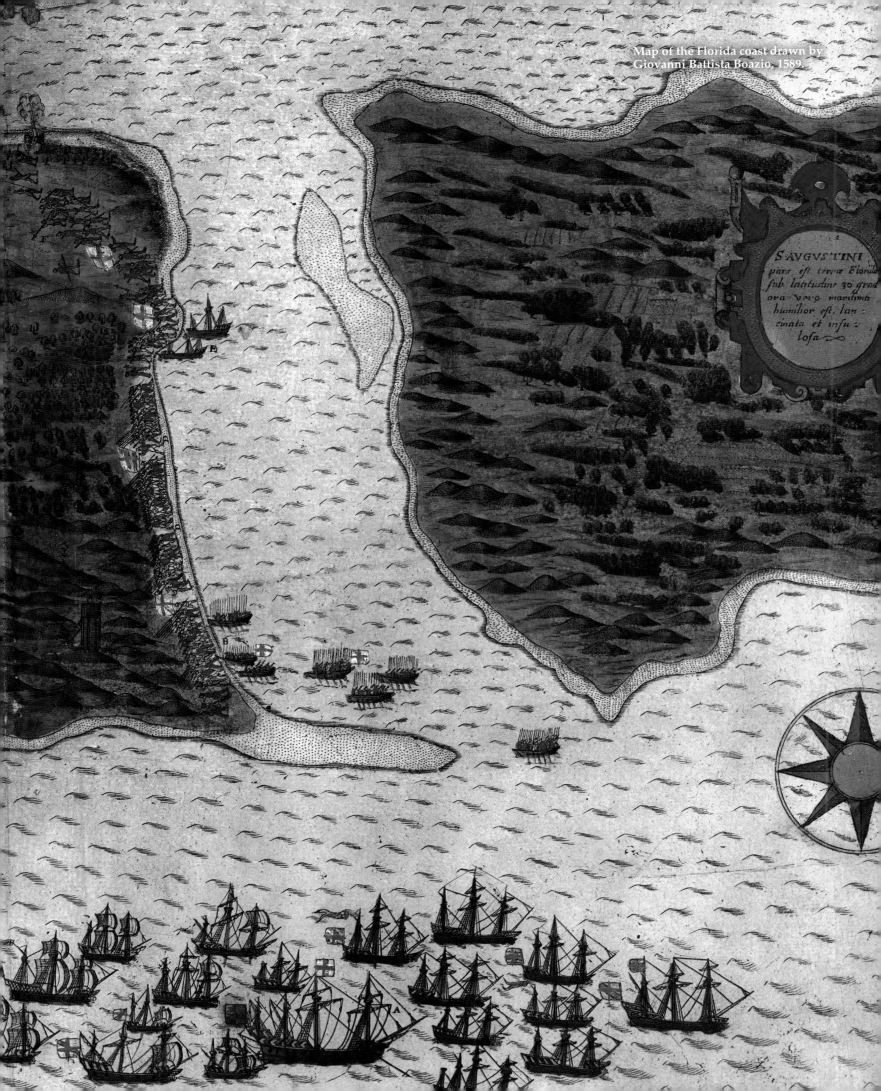

Map of the Florida coast drawn by Giovanni Battista Boazio, 1589.

The Idea of America

Antonio Canovi

Before being discovered, America was long sought, under a name that sounded legendary in 15th-century Europe: the East Indies.

Marco Polo wrote that the land of the Million (China) was a treasure trove of unparalleled richness, a continent so vast that it went much farther east than the Ancients had ever thought. However, the caravan trade had its drawbacks, for the uncertainty of the long distances to be covered and the risks associated with the political instability of the lands it crossed. The Genoese, before and better than others, had built their bridgeheads in Constantinople and in the ports of the Black Sea, but the increasing pressure of the Ottomans, who were creating an empire, gradually decreased the room available for free trade. Finding the shortest sea route to the "land of spices" thereby became the puzzle of many fortune seekers, beginning with those who, rooted in the center of the Mediterranean, had established their hegemony on the seas over the centuries: the Italians.

The Italian Maritime Republics—Amalfi, Pisa, Genoa and Venice—were extraordinary: geographically they constituted a hinge between the East and the West, historically they were a bridge between the Christian and the Arab world (just think of Sicily). Forced on to a thin strip of land, those cities, along with the secrets of offshore sailing, learned the arts of political and commercial diplomacy. Sailing and trading: these are the two elements of the "capitalism of the city" exported by the Italians, who lacked political unity, but not the consciousness that civilization could act as a unifying factor on a global level. Italy, with its hundreds of cities and thousands of *piazzas*, led a deep movement of humanistic regeneration destined to change the perception of the world.

America was born here, at the crossroads between the old and the new, far from the Pillars of Hercules that marked the boundary between the Mediterranean Sea—called *mare nostrum* (our sea) by the Romans—and the unknown. But to launch such a challenge in the first place, it was necessary to arm the first ship. The Florentine cosmographer Paolo dal Pozzo Toscanelli gave Columbus the key to open the vault of the Atlantic. Another explorer moved on to the Atlantic routes from Florence, the cradle of the Renaissance: Amerigo Vespucci who—in 1502, while exploring the coasts of what would later become Brazil—was struck by the understanding of being in a "new world." In 1507, Vespucci's first name provided the right inspiration to the German geographer Martin Waldseemüller: he called it "Country of Amerigo," or, in Latin, solemnly, "Terra America."

As for Columbus, he started mentioning a world "other" or "new" only in the account of his third voyage, but without having a real knowledge of it. This was a misunderstanding that became at times even exhilarating and that, according to the geographer Franco Farinelli, actually concealed a radical and paradigmatic shift. What made Columbus the first of the modern travelers was, in fact, his faith in the papers he was bringing with him, and through them he read and reallocated what his eyes were beginning to see. Following this concept, America is truly a New World: before being an adventurous exploration, it is the result of a two-folded cultural invention. First, against the Ptolemaic model, the land is thought of as a sphere, then it is looked at and "straightened" according to the mathematical rules of perspective. It becomes an unknown space to tame and then fiercely colonize.

By 1454—the year following the fall of Constantinople—the pope had granted Portugal full jurisdiction upon the shores of "Guinea" (Africa) and "further on, to all the regions leading to the Indies." The balance of power was then reestablished in favor of the unified crown of Spain, after it gained possession of the Canary Islands and the consequent release of four new papal bulls (*Bolla Aeterni Regis*, 1481). A new agreement was finally reached with the signing of the Treaty of Tordesillas, on June 7, 1494. According to it, the line dividing the two kingdoms was moved 370 leagues west of the Cape Verde Islands, so that all the discoveries to the east of that line, even if they had been

made under the Spanish flag, were entitled to Portugal (that according to the treaty would receive Brazil), and Spain was entitled to those to the west.

As long as Spain was the most powerful ruler in America—according to geographer Joachim Gustav Leithauser—it made the "new" World a part of the "old." Raids carried out by privateer ships were none other than the extreme transposition of the old continental conflicts to another stage, the newly discovered Atlantic routes. There is a symbolic date: 1522. This was the year in which a fleet of French privateer ships (one under the command of Giovanni da Verrazzano), intercepted near Cape St. Vincent (in Portugal) a portion of the extraordinary treasure put together by Hernan Cortez, snatching it from the king of Spain and taking it to France. It was the same year in which Ferdinand Magellan accomplished the circumnavigation of the seas, making clear to everyone that the world was round and that America indeed was a continent in its own right, with its own new nature. However, it took three centuries for America to win emancipation from Europe. Thus 1492 marked the first year of the modern era, a modernity generated in the womb of the maritime republic of Genoa and led by humanistic Italy, before being raped by the savage clangor of the *Conquistadores*.

Genoa—"this extraordinary city that devours the world," as it was defined by the historian Fernand Braudel—became an organic part of the Conquest through its alliance with the Spanish emperor Charles V in 1528. The slave trade and the transportation of gold secured to the Genoese the monopoly on credit (it was not a coincidence that Philip II borrowed the money to build the Escorial from the Spinolas, a Genoese family). According to the estimates made by historians, between 1530 and 1595, the ship owners of the city that still was the most important port of the Mediterranean pocketed something like 24 million ducats of gold and silver out of 80 million transported to Spain from the New World! Genoa was in its own way a privateer city: not by offering armed ships to the national monarchies, but by offering the model of a global state, the first known world-economy. Genoa in fact behaved as a financial empire, not by occupying territories but instead by founding trading posts. Its main instrument of intervention was the *Banco di San Giorgio*, whose role was to influence markets for its own benefit. It is not a coincidence that in this city they invented

IOUs. Its role was so strong that it was not affected by the political struggles of the city (which were quite aggressive, as in all Italian cities).

What was the relationship between the explorers, who are much like dreamers—the Polar star of Columbus, the Navigator, was the sentence *"buscar el Levante por el Poniente,"* which means "finding East by going West"—and the ravenous conquerors of every shining wealth? Some like to think that Italians invented globality, but refused to preside over it. If we examine Columbus's biography, we cannot forget that he was viceroy during the genocidal disaster of Hispaniola-Santo Domingo—with the annihilation in half a century of a Native population estimated at three hundred thousand people in 1492—but we also notice that his personal reluctance to lead a colony goes along with the inability to drive any modernization. Colombus is a man in the middle, always torn apart between the Middle Ages and the Renaissance, spending a lot of his time dealing with the Catholic monarchs about percentages, kickbacks, interest, and profits. And between 1499 and 1500, in "his" island, he is the first to restore the *encomienda*, a kind of contract inherited from the Middle Ages conferring on a master-settler (*encomendero*) his almost absolute rights over the servants-*Indios*.

Italy is a land between the seas, populated by knights, heroes, saints, and navigators. The figure of the explorer does not rhyme with that of the colonizer. Nevertheless, in history, among the Italians who emigrated to the five continents, there were millions who engaged in agriculture. But the farmer is one thing, the colonizer another, and although working the land might have fed the belly, it was not so for the imagination of Italy and of Italians. A few names nonetheless became legendary, although today they are commemorated more in America than in Italy. We only need to look at the way Columbus Day grew in history: from its early celebrations in the 18th century, to its popularization as an Italian American celebration (starting with Colorado in 1905), then as a federal holiday authorized during Franklin Delano Roosevelt's administration (1937).

The first of the great explorers of North America was Giovanni Caboto (today there is also a Cabot Day, celebrated in Toronto). Being a contemporary and a fellow citizen of Columbus (he was born around 1450), he sailed under the

banner of Venice to Cairo and even to Mecca, before landing in Bristol, England, in 1490 with the idea of exploring the unknown overseas lands for the "Christians." However, convincing Henry VII to finance the enterprise was no simple task. Finally, under the name of John Cabot, he was able to sail from Bristol aboard the sailing ship *Matthew* with his son Sebastiano (born in 1472). He needed eight weeks of sailing in the North Atlantic to spot the land (on June 24, 1497) near Cape Breton, Canada. Actually, Columbus did not set foot on the American continent until the following year, but in Nova Scotia there were no gemstones to loot, and the sea teeming with fish was not considered by the English monarchy a good enough reason to try again. John, a true explorer, investing his wealth in the endeavor, tried again the following spring with six ships, this time heading further south to Cape Hatteras. During the third trip, now seventy years old, Cabot disappeared into the frozen seas (presumably between Iceland and Greenland).

With England involved in dynastic and religious strife, Sebastian Cabot opted to work for the crown of Spain. In 1526 he discovered the Rio de la Plata in South America. Only in 1547, under a new king, was he declared a great navigator in England and it was revealed that a few decades earlier, he had traveled to an unknown ocean (it was the enormous surface that would be called Hudson Bay, named after its first explorer). The actual fact stands: in the history of American exploration and colonization, England—intimidated by the strength of the Spanish fleet and scared by the mutiny of a small group of British immigrants—came about one hundred years later than other European powers. In the meantime, the French had tried to reach the shores of the New World. In 1523, financed by Francis I, the Florentine Giovanni da Verrazzano reached Chesapeake Bay, then explored the coasts of New Jersey and Maine. His second voyage left from Madera, Spain, with fifty men and supplies for eight months, including weapons. A cyclone forced it along the southern coast, between Georgia and Virginia, then— going north with land in sight—it reached the future location of New York City (called Nieuw-Amsterdam at the time of its founding) and further north, to the territory where Vikings from Greenland and Iceland had landed five centuries before. France did put down roots in the south, paying, however, a high price for having challenged the Treaty of Tordesillas. In 1565 the Spaniards would conquer Florida and massacre its French settlers.

Despite the large brawl that arose with the finding of each new American treasure—with the main concern remaining its transportation to Europe as quickly as possible—the real potential of the new continent would long remain concealed to its alleged conquerors. The French scholar Marianne Mahn-Lot suggests a plausible answer to why when she states that the science of the men who "discovered America" came from the Bible and from the authors of pagan antiquity. All Genoese ships carried a sacred name. And the mystical identity of Columbus is well documented: with his voyages—together with the more prosaic purpose of reopening the Silk Road to the Western World—he dreamed of taking the Muslim world from behind and winning back the Holy City of Jerusalem for the Christian world. And it was not by chance that the economic mission was constantly paired with the "civilizing" mission, led by the vanguard of Jesuit and Franciscan missionaries. And here, among the "saints," the Italians were numerous. Father Marco da Nizza (a Piedmontese Savoyard), under the protection of Spain, crossed the Mexican border to evangelize New Mexico and Arizona. In the following century, Father Eusebio Francesco Chini took the same path. Known as Eusebio Kino, he was a missionary-cartographer, officially declared one of the founders of Arizona: in 1965 he earned a bust in the memorial chapel of the Capitol (the only Italian awarded with the honor). On the other hand, the exploration of California owes much to secular sailors such as Francesco Gemelli Carretti (he was sailing for France) and Alessandro Malaspina (born in 1754 in the castle of Mulazzo in Tuscany). We owe to Malaspina's obstinacy the longest scientific journey in the era of sailing ships, from 1789 to 1794. It was financed by Spain, but not well digested by the Inquisition, which put him under arrest later for having replaced the holy names of his two ships with *Descubierta* and *Atrevida*. Freed from prison under Emperor Napoleon, Malaspina—this time sailing under the French flag—opened the sea route to Alaska. Yet another Italian missionary, Aloysius Luigi Parodi, ended there by following the California Missions Trail.

California was the destination of the early arrival of a few Italians, coming either from the sea or from Mexico. At

the time of the unification of Italy, a generation in advance of the great migrations of the late 19th century, the number of settlers coming from Liguria and Piedmont was high enough to prompt Vittorio Emanuele II, just ascended to the throne of the Kingdom of Sardinia, to be the first to create a consulate, entrusting it to Lionello Cipriani. Originally from the island of Elba, in 1853 Cipriani had departed from St. Louis, with twenty-four men, twelve wagons, five hundred cows, one thousand sheep, hundreds of horses and mules, and stocks of seeds and plants. The aim was therefore to establish agricultural colonies, which might be more successful in California than in any European country. When the consulate was established, it is estimated that next to the Ligurian and Sicilian fishermen (owners of a flotilla of seven hundred boats) there were over six hundred gardeners, green grocers and farmers. The presence of the vineyard suggests the desire to recreate a landscape similar to the one left by Italian emigrants at the time of their departure.

Except for California, the presence of Italians in the process of building the western frontier is almost forgotten. In 1720, 250 emigrants departed from Liguria and Piedmont, with the destination of territories still under French rule (Louisiana and New France). Enrico de Tonti was another Italian serving the French (and hired to fight the Iroquois and the English who fomented them); it is not a coincidence that he entered the history books as Henri de Tonti. Born in 1649 in Gaeta, he explored the Midwest, and is considered among the founding fathers of Illinois, Arkansas, and Alabama. His brother Alfonso (Alphonse) was among the founders of Detroit.

In the French colonial army, King Louis XIV, in 1664, enlisted two squadrons of Piedmontese mountaineers possessing a deep military training: the *Régiment Carignan* and the Italian Regiment. Dismissed after two years of counter-insurgency (and many losses) many of them chose to stay in America, taking advantage of land grants in Quebec and Louisiana. Many of their names were given a French spelling, making it a little harder to recognize their ancestry. Some prominent personalities in the exploration of the western frontier came from those families: among them John Grandenigo, Peter Sarpi, and Francesco Maria Reggio. Among the explorers, Paolo Andreani and Count Luigi Castiglioni, corresponding with George Washington, made the

first circumnavigation of Lake Superior in 1791. Francesco Vigo, who was born in Mondovì (Piedmont) in 1747, served with George Rogers Clark in the American Revolution. This is not even to mention Filippo Mazzei from Livorno, who was a close friend of Benjamin Franklin and Thomas Jefferson. He was an agronomist, connected with the Georgofili Academy in Florence, who arrived in Virginia with a load of agricultural machines and technicians, seeds, olive trees and vines and became a neighbor of Jefferson's. The future president always praised Italy—he called Monticello his favorite mansion, built in a style created by the Italian architect Palladio—and was influenced by Mazzei.

The memory of the many traces that lead to Italians in America, before and during the *Risorgimento*, appears sporadic. Common sense tells us that Italians are at ease with the sea, and since in Italy there are many, their familiarity with mountains and hills cannot be denied. This was not true of the great plains of the West that fed the frontier spirit of America. That is why lives such as the one of Sister Blandina are recorded in the empyrean of individual uniqueness; born Rosa Maria Segale, she agreed to treat one of the members of Billy the Kid's gang, met Pat Garrett, and even met Geronimo.

In fact there is a tradition of exile that Italians practiced all over the world that fit very well with the principle of self-determination enshrined in the U.S. Constitution. Just consider the personality of Giuseppe Garibaldi, remembered in Italian popular memory as the "hero of two worlds." In 1861, at the time of the secession of the slave states of the South, the U.S. consul in Antwerp, James Quiggle, offered him an eminent role in the Union army. The Italian general, at the time deeply involved in the process of Italian unification, chose not to go, but his epistolary correspondence with Lincoln, whom he praised as the Great Emancipator, shows a deep sympathy toward the cause of the abolition of slavery. Even in the absence of their commander, many of his followers—called *garibaldini*—showed their willingness to fight for the cause, giving rise to the Italian Legion and to the regiment called the Garibaldi Guard, in active duty from June 6, 1861.

Garibaldi, however, during the course of his wanderings as an exile, had already landed once on the coasts of the United States, on July 30, 1850 (in Staten Island). He ar-

rived without his sea captain's license, suspended for political reasons, but was hoping to return to his youth when he was a merchant seaman, an occupation that could finally give him economic self-sufficiency (he was then forty-three years old). He arrived in New York from Cuba, leaning on a migration chain of Italian exiles, among whom there were Felice Foresti (professor of Italian at Columbia College), Giuseppe Avezzana (who had fought by his side in the Roman Republic) and Quirico Filopanti. Many people asked him to lead new revolutions, but he accepted a job as a laborer in the candle factory owned by the Florentine Antonio Meucci (he too belonging to the same geography of exile). Idleness did not suit Garibaldi, who started to sail out of the U.S. (without having formal command) and took a few boats to the Caribbean; he went with a Genoese friend, a merchant, to Nicaragua and then to Peru (where he visited Bolivar's partner, Manuelita Saenz). His biographers tell us how after each landing he met with the community of the Ligurians, always happy to meet him. This detail is very significant: Italians, not only Genoese, had moved across the seas and lands for centuries, and in 1850 the subjects of the Kingdom of Sardinia in the United States were about eight thousand.

Garibaldi left the United States for good on January 16, 1854, as the unofficial commander of the American ship *Commonwealth*, and arrived in London (on February 11) where Mazzini was waiting for him to resume their revolutionary activities.

After the unification of Italy, the process of migration to North America started very slowly. In 1880, there were just 44,230 Italian-born residents in the U.S. New types of immigrants started to appear beside merchants, exiles and refugees, acting as "temporary" teachers (they created the early Italian schools based in Boston and New York). They were peddlers, *figurinai* (people creating and selling small statues) from Lucca, musicians and craftsmen, bearers of the highest tradition of Italian arts and crafts (stonecutters, marble-cutters, plasterers, manufacturers of puppets, wood carvers, etc.). Costantino Brumidi became the first to use the technique of fresco painting in the U.S. Many of the most important sculptors of the Capitol are in fact Italians, like Carlo Franzoni, Luigi Persico, Antonio Capellano, and Enrico Causici (he also sculpted the statue for the Washington Monument in Baltimore). All these artists, according to the historian of migration Maddalena Tirabassi, exerted an important role in "shaping" America before the great mass migrations transformed it from a rural country to the largest urban and industrial democracy.

Italy's Contribution to the Age of Discovery

Mario B. Mignone

The Italian presence on the American continent did not happen by chance or accident; it was the result of political and economic designs, of personal adventurous desires, and of collective cultural aspirations for discovery. Not only had Italians been the leading explorers of the new millennium, but they had been opening routes on water and land that changed the world and, to a great extent, broadened Europe's geographical perspectives. Giovanni da Pian del Carpine, Marco Polo, Odoric of Pordenone, and Niccolò de' Conti explored land routes from the Mideast to Mongolia and China in order to enrich broader economic, political, and religious contacts with the Orient. They are among the most famous of the many brilliant Italian explorers that laid the ground for the discovery of the New World. Setting out in very small, slow ships on a voracious, uncharted ocean, their endeavors seem to straddle the line between bravery and madness. There are certainly many others that history does not record since they never made it back, which makes the deeds of these men all the greater. However, it must be remembered that their discoveries also led to the eventual conquest of lands by Europeans with all the ensuing consequences.

Today we tend to say that we live in a small world; however, as we know well, it was not always that way. In no small part due to the Italian sense of adventure and search for new trade, men on ships set sail heading out over the far horizon. That great time period for Europe, known as the Age of Discovery, would never have reached the heights it did without Italian master mariners. The fall of Constantinople to the Ottoman Empire in 1453 marked the end of the Byzantine Empire and the beginning of the end of the control by Italians of the Mediterranean. The Italian Renaissance rulers were forced to find new trade routes out of the Mediterranean, the stage of commerce on which they had dominated and on which they had amassed their personal and city wealth. Their success had been the envy of the royal families of the kingdoms on the Atlantic which had been looking for ways to find a share of trade; history had changed the commercial landscape and the Italians, the most skilled seamen of Europe, began to work in large numbers for the Spanish, Portuguese, English, and French monarchs to find an alternate, all-water route to the Orient. Their skills were unquestioned and for sale to the highest bidder while their maps of newly discovered lands were coveted by kings and *conquistadors* alike.

At the time ships from Venice and Genoa were still carrying most of Europe's Mediterranean trade with the Orient, the Florentine mathematician and geographer Paolo dal Pozzo Toscanelli was a leading proponent of the notion that the Orient lay conveniently westward, across the Atlantic Ocean from Europe. Christopher Columbus (1451-1506), the premier explorer to seek new routes, put those notions into practice. In the context of emerging Western imperialism and economic competition between European kingdoms seeking wealth through the establishment of trade routes and colonies, Columbus's speculative proposal to reach the East Indies by sailing westward eventually received the support of the Spanish crown. Those monarchs saw in it a promise, however remote, of gaining the upper hand over rival powers in the contest for the lucrative spice trade with Asia. During his first voyage in 1492, instead of reaching Japan as he had intended, Columbus landed in the Bahamas Archipelago, at a locale he named San Salvador. Over the course of three more voyages, Columbus visited the Greater and Lesser Antilles, as well as the Caribbean coast of Venezuela and Central America, claiming them for the Spanish Empire. Although Columbus was not the first European explorer to reach the Americas (having been preceded by the Norse expedition led by Leif Ericson in the 11th century), his voyages led to the first lasting European contact with the Americas. They inaugurated a period of European exploration, conquest, and colonization that lasted for several centuries. His voyages, therefore, had an enormous impact on the historical development of the modern Western world.

The mere mention of the voyages of Columbus elicits a wide range of opinions: to some he is a hero, to oth-

ers he is a heartless villain. In 1992, the 500th anniversary of his voyage, some scholars and many cultural activists re-evaluated his efforts, presenting a more negative image than that presented one hundred years before. His stature had been brought to new heights during the celebrations of the 400th anniversary held all over the American continent and Europe. Indeed, until three or four decades ago, the landing of Columbus on the shores of the American continent was as an occasion to celebrate the most famous watershed in history, an event identified in school books across the world as marking the beginning of the Modern Age. Columbus's landing was thought of as the beginning of a new world order, economically and culturally, as well as politically. He was portrayed as the first modern man and his landing, with his human and cultural profile, was closely tied to his age.

Columbus was seen as the modern Ulysses, the mythical Greek hero who embarked on his own dream of discovery, for which he died in Dante's Hell. I wonder if Columbus ever pronounced the *"orazion picciola"* to his sailors, which Ulysses pronounced to his companion in Dante's *Divine Comedy*. Certainly his voyage was inspired by the same spirit:

Considerate la vostra semenza:	Consider your origin:
fatti non foste a viver come bruti,	You were not made to live like brutes,
ma per seguir virtute e canoscenza	But to follow virtue and knowledge

<div align="right">(Inferno, Canto XXVI)</div>

For centuries, Columbus and his venture represented a period, the late 15th century, which was possibly unique in the history of humanity. It was a period when the clear vision of politicians, the creative entrepreneurship of merchants, the common man's desire to know and discover, and a taste for formal perfection all came together to form the spirit of humanism and Renaissance. Most of us grew up believing that Columbus was the Renaissance man *par excellence*, who affirmed the value of human independence and dignity, along with his aspiration to be the sole, authentic maker of his own destiny: the universal man who had the courage to press beyond the confines of the known world, while projecting himself beyond the limitations of separate national individualities. In the West, or better yet, in Western Civilization, Columbus was presented as the hero who sparked a unique and extraordinary period of economic and social expansion, of growth and progress, of new and

exciting discoveries in the fields of science and technology. Europeans felt very comfortable with these views.

In the U.S., Columbus was respected and venerated. Several cities across the nation are named Columbus or Columbia and many statues of him dot the American landscape. The first monument to Columbus was erected on the occasion of the 300th anniversary in 1792, in Baltimore, Maryland, when there was a serious movement to rename the United States of America "Columbia." That goal was not achieved, but the capital district became the District of Columbia. From big states like British Columbia in Canada, to countries like Colombia in South America, to dozens of cities and counties in the U.S., the Americas saw the need to memorialize Christopher Columbus.

In 1892, Benjamin Harrison urged all Americans to celebrate and observe the 400th anniversary of Columbus' initial landing; in 1937, Franklin Delano Roosevelt, after pressure from the Knights of Columbus, a powerful lay Catholic organization, declared Columbus Day, October 12th, as a federal holiday; and finally, in 1971, Richard Nixon officially made Columbus Day a national holiday to be observed on the second Monday of October every year.

For most Italian Americans, Columbus was and is more than an Italian navigator and explorer whose landing in the New World profoundly affected the culture of the two continents. Columbus was and is their hero because he gave them legitimacy on the American soil from the beginning of the new era. If you know the Italian American experience you might find a good explanation, if not a justification, of their attachment to their hero. For the majority of Italians, the American experience had not been pleasant, to say the least: it was marked by the highest number of deaths in the work place, especially in coal mines; and it was tinted by harsh discrimination that for many years made them feel as if they did not belong there and that the country was not also theirs. Columbus, the father of America, was their father too and, therefore, they could claim some legitimacy to the country, even more than the Anglos who later colonized America. They first discovered and then they built America, in a literal and in a metaphorical sense. Columbus and Columbus Day, a national holiday in the United States, is celebrated with pride also because it is evidence for Italians of their legitimate claim to this country from its beginning and

a recognition of their contribution to "making America." In the process, many endured sacrifices and pain in different forms and shapes, including the children of Columbus.

Columbus, the hero who proved that the ocean was crossable by man, by each of us when we are moved by hope and faith that the other shore can give us the material or spiritual reward of making the effort of crossing worthwhile, inspired more men, frightened and challenged by that same profound darkness, to cross and re-cross the ocean. He opened the ocean to many more Italian explorers who charted new waters and new lands. Even though no other nation or land can claim to have had so many explorers or contributed as much to the enlargement of the world of man by bringing together so many cultures, no new land was occupied or colonized by Italians, and Italian is not spoken in any of its regions. Nonetheless, poetic justice wanted the continent to bear the name of an Italian and Italian names denote many areas of the continent.

Another notable explorer was certainly Giovanni Caboto, better known in history as John Cabot. Known for his maritime skills, Caboto was hired in 1497 to sail for England in the hope of reaching China. Caboto actually discovered—as far as England was concerned—a *new found land*, which is still named to reflect Caboto's discovery: Newfoundland. With his voyage he established an English claim to North America.

Following Caboto, the Florentine Amerigo Vespucci (1454-1512) explored Brazil and the northeastern coast of South America during two voyages for Spain and Portugal between 1499 and 1502. He confirmed Columbus's late suspicion that the unknown region across the Atlantic was not the Orient and was the first to call these lands *Mundus Novus* (the New World). Vespucci's publications, giving illuminating descriptions of his travels, moved the German cartographer Martin Waldseemüller to name *Mundus Novus* "America" after him (1507). Although historians dispute the exact number of voyages he made to the New World and what role he played, no one disputed Amerigo Vespucci's consciousness of having found new lands nor his skills as an expert sailor: he was named chief navigator for the Kingdom of Spain. He was a well-known cartographer in his time and at his school for navigation in Seville he had Ferdinand Magellan, among others, as a student.

News of the explorations by these three Italians encouraged other explorers to cross the Atlantic and aroused stronger interest in other European nations on the North Atlantic to support exploration. As did the other famous Italian explorers, Giovanni da Verrazzano sailed for one of the major European powers of the time, the king of France. During his voyage to the coast of North America, he searched for the elusive passage to China. Although he is not as famous as Henry Hudson, he was the first European to visit New York Harbor. His explorations included Rhode Island's Narragansett Bay and parts of Cape Cod. In 1524 he charted the coastline from South Carolina to Nova Scotia. Verrazzano established a French claim to both Americas overlapping those of Spain, Portugal, and England. Although today he is mostly forgotten, there are a few testaments to his voyages. Visitors to the New York City area can travel along the Verrazano-Narrows suspension bridge—one of the longest in the world.

Italians also accompanied other great explorers on their expeditions. Antonio Pigafetta traveled with the Portuguese explorer Ferdinand Magellan on his 1519 expedition and became its chief chronicler. Others helped to clarify the complexity of the New World by exploring the continental interior and provided accurate geographical descriptions. Some of these observers were missionaries whose reports and maps increased geographical knowledge. The first Catholic bishop in the New World, Alessandro Geraldini, arrived as bishop of Santo Domingo in 1516. His published travel experiences were widely read in Europe and created a great appreciation and interest in the New World.

In the American Southwest, Fathers Marco da Nizza and Eusebio Kino (Chini) stimulated the first interest in New Spain's most remote possessions. Franciscan friar Marco da Nizza (1495-1558) in 1539 took symbolic possessions of the entire region of modern Arizona for the Spanish crown. His description of the golden walls of "the seven cities of Cibola," although inaccurate, led Coronado to explore the American heartland. Jesuit Father Eusebio Kino (1645-1711), whose variety of interests resembled those of Thomas Jefferson, was a major cartographer and mission builder. He explored much of Sonora and Arizona and concluded that California was not an island as shown on earlier maps.

Other Italians contributed to strengthening economic and political ties between Europe and America. In 1678 En-

rico de Tonti (1649-1704) accompanied the famous French explorer René-Robert de La Salle into the American Midwest. They were the first Europeans to navigate the Mississippi from the Illinois River to its delta (1682).

As some Italians charted the Atlantic shores, others charted the Pacific coastline. Alessandro Malaspina led a royal Spanish scientific expedition to California and the Pacific coast and launched the most comprehensive scientific survey of the plants and animals of the most remote regions of America. He prepared detailed hydrographic charts of the southern Atlantic and Pacific coasts. He spent three years (1789-1792) studying the coastal lands from Brazil south to Cape Horn and from Chile north to Russian America.

Italian contributions to the understanding and appreciation of the New World were profound and wide and lasted well into the development of the new nation. Early in the 19th century Italian explorers were busy describing the geography of the still untamed Mississippi Valley. These included Giacomo Costantino Beltrami, who discovered the sources of the Mississippi, and Count Francesco Arese Lucini. Further west, a number of Jesuit missionaries, among them Fathers Gregorio Mengarini, Anthony Ravalli, and Joseph Cataldo (founder of Gonzaga University) helped to open up the American Northwest. These religious men were early advocates of the rights of American Indians, compiling grammars and dictionaries of native languages. After Father Joseph Cataldo mastered twenty Indian languages, he served as peacemaker in their disputes. In the process, these missionaries of religion and culture brought education to the most remote areas. The original college of San Francisco, now the University of San Francisco, like the University of Santa Clara, was founded by Italian Jesuits.

When fighting ensued for the creation of the new nation, Italians volunteered: Colonel William Taliaferro, Lieutenant James Bracco, extraordinary warrior Francesco Vigo, and others contributed in exceptional ways. In 1778 Vigo joined Colonel George Rogers Clark in an effort to drive the British out of the Northwest Territory. Vigo gave his entire personal fortune of $8,616 to help supply Clark's soldiers. In the following decades many Italian men and women responded to different calls.

Italians certainly contributed to the American struggle for independence. A signer of the Declaration of Independence, William Paca served as the first Italian American governor from 1782 to 1785. He was born in Abingdon, Harford County, Maryland, from ancestors who came from Italy via England in the middle of the 17th century. The practice of using England as a way station en route to the American colonies was common to many Italians at that time. Filippo Mazzei, who had lived in both Turkey and England, bought a farm near Thomas Jefferson's Monticello and engaged in debates both philosophical and agricultural with his famous neighbor. Together with Jefferson he published a series of articles in support of the colonial cause which contained many words and ideas later found in the Declaration of Independence. When Jefferson finished writing the Declaration of Independence, he had a copy reserved for Mazzei.

And Italians made an impact throughout American history fighting and dying on the battlefields of the nation's wars, and many became heroes. More than forty Italian Americans have received the Congressional Medal of Honor since its establishment during the Civil War as the military's highest award for combat valor. When the Civil War broke out, Italian Americans joined both the Union and Confederate armies. In the North an Italian Legion was formed, which later merged into the multi-ethnic Garibaldi Guard. Private Orlando E. Caruana of the 51st Infantry, who risked his life under heavy fire to rescue the color sergeant and the company colors during a battle at Newburn, North Carolina, in March of 1862 was the first Italian-born recipient of the Medal of Honor. The most famous recipient of the medal was Colonel Luigi Palma Di Cesnola of the 4th New York Cavalry. Cesnola had fought for the State of Piedmont Army in the Crimean War and joined the Union army in 1861. Noteworthy during the Civil War was the possible participation of Giuseppe Garibaldi in the Union army. This famous Italian general, who played a determining role in the unification and birth of the Italian nation, agreed to serve the Union cause on the condition that Lincoln assure him that the war was not a political conflict, but a true struggle against slavery; and, secondly, that Lincoln would appoint him commander-in-chief of all Union forces.

The Indian Wars, which lasted over thirty years, found Italian Americans engaged in fierce combat on the Great Plains. Corporal George Ferrari, originally from New York City, was awarded the Medal of Honor for gallantry in action against Apache hostiles at Red Creek, Arizona, in 1869, while

attached to the 8th United States Cavalry. And bravery was displayed in the American war against Spain in 1898. Italian Americans joined the thousands of citizens who volunteered for military service, and a New York Private, Frank O. Fournia of the 21st Infantry, garnered the sole Medal of Honor.

As the new nation grew, so did the Italian presence in shaping it. Only a few hundred Italians entered the U.S. each year in the early period. They were welcomed and lured to come, both because of Italy's strong creative image and because of the special skills Italians had. Italy was the land of Dante, Titian, Raphael, Michelangelo, Leonardo, Bernini, Galileo; and present day Italians could transplant in the new nation the beauty of their country. Accordingly, Italians from the northeast brought with them their mosaic and stucco work skills, those from central Italy their marble and stone-cutting techniques, and the rest of Italy supplied specialized carpenters, joiners, wood-workers, plasterers, and painters.

Many other Italians who embodied faith, creativity, and imagination offered an early contribution to the development of American life and institutions. These included educators, sculptors, agriculturists, opera singers, and musicians. Adelina Patti won America's heart with her rich soprano voice; her debut in *Lucia* (1859) at age sixteen was reported to be the greatest event in the history of New York's Academy of Music. Lorenzo Da Ponte, after writing librettos for Mozart and acting as court poet at the Austrian Emperor Joseph II's court, lived in England for a few years. He came to the U.S. in 1805: twenty years later Columbia College (today University) appointed him its first professor of Italian. He turned *impresario* and brought Italian singers and musicians to perform in New York, which led him to create America's first opera house, the New York Opera Company. Though, like Mozart, Da Ponte lies in an unmarked grave, his legacy endures in the words that flow and soar with the music of Mozart and continue to touch people year after year.

Other Italians enriched and participated in the cultural life of the new country and helped mold its rich resources into imposing buildings and enduring art. Costantino Brumidi, dubbed the Michelangelo of the U.S. Capitol, was the artist that best manifested European art in America. After showing his talent for fresco painting at an early age, and painting in several Roman palaces and at the Vatican, Brumidi immigrated to the U.S. (1852) where he undertook several important works. His chief achievement was in Washington, D.C., in the rotunda of the Capitol, where his "Apotheosis of George Washington" in the dome and the Frieze of American History revealed him as one of the greatest artists of all times. Many of the paintings in the House of Representatives chamber, committee rooms, the President's Room, the Senate Reception Room, and throughout the corridor of the Capitol bear his name. His murals combine classical and allegorical subjects with portraits and scenes from American history and tributes to American values and inventions. Italian Americans have, as they did for Columbus, made him their hero, and for good reason. Whenever I visit the Capitol, I also feel a sense of pride in admiring the extraordinary fresco executed by this exceptional Italian artist. I find it fulfilling that Italian Americans have remembered Brumidi by naming organizations after him, as well as societies of every type, and engaging in a letter-writing campaign to the Stamp Advisory Committee to create a Costantino Brumidi Forever commemorative stamp in 2015.

The contributions Italians made to geographical exploration from the 1400s to the 1800s are immense and unquestionable. Our view of the world we inhabit, especially the Americas, is molded by their discoveries and their creativity. Our American culture—art, architecture, music, literature, religion, philosophy, and culinary art—has been given a strong Italian texture. Until the end of the 19th century, Italians universally enjoyed a reputation for extraordinary creativity and imagination. Wealthy Americans on their "Grand Tour" of the old continent considered Italy the high point of their travel. Cultured Americans praised the harmony of its *palazzi*, the beauty and grace of its music, the timelessness of its art. Although no part of this continent officially speaks Italian or was colonized by Italians, its *Italianità* is in the name of the continent, in the Italian names abudantly given to many cities, towns, squares, streets, and institutions. *Italianità* lies in physical strength and artistic beauty that are at the foundation of our nation.

Explorers for Hire

Italians Exploring for Foreign Kings

From the moment the first Italian made contact with America—when Christopher Columbus discovered the New World for Europe— the history and politics of Italy were in play. Columbus, a son of Genoa, did not sail for his country. Italy was not a nation. But Italians were expert seamen, merchants, navigators, mapmakers, and overland and Mediterranean explorers and the royalty of Spain, England and France was willing to invest in their knowledge. Educated Europeans of the time believed, not that the earth was flat, but that the distance to Asia and its riches were too far to safely reach. Columbus realized—and persuaded Queen Isabella and King Ferdinand of Spain—that the distance was shorter and the trip feasible.

Columbus left the Canary Islands in 1492 and landed in what is now the Bahamas. The rest is history. Perhaps that history would have been the same if a Spaniard or Englishman had made the discovery, but the fact is, it was an Italian. And the other fact that affected the Italian role in America for nearly four hundred years was that the cities and kingdoms of the Italian peninsula, often ruled by outsiders, did not unite until 1861.

Columbus was not the only influential Italian explorer in the 15th and 16th centuries. His reputation was eclipsed by another Italian emigre, Amerigo Vespucci, who made two, possibly three voyages to South America, the last in 1501-1502. Vespucci recognized that he had indeed come to a *Mundus Novus*—a New World. An articulate native of Florence, his letters and pamphlets were widely read in Europe. In 1507, a German, Martin Waldseemüller, made a map that named the new continent "Amerige or America" after the "discoverer Americus, a man of wisdom." Vespucci once wrote "I hope to become famous for centuries." Because he recognized the significance of the new lands—and because he wrote about it—his name lives on.

Before America had its name, Giovanni Caboto changed his—to John Cabot—and sailed for Henry VII of England in 1497. He landed in what the king later called "the new founde lande," now part of Canada. Cabot was the first of his generation to see, and lay claim to,

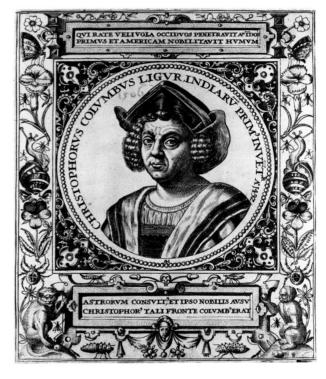

Italian Explorers

This portrait of Christopher Columbus engraved by Johann Theodor de Bry appeared in *Americae pars Quinta*, published in Frankfurt, Germany, in 1595. Columbus sailed with three small ships that first sighted land in the Americas on October 12, 1492.

Amerigo Vespucci, whose letters and pamphlets about his ventures in the New World were widely circulated in Europe, temporarily eclipsed Columbus's fame. He is shown (facing page, top), in a painting by Costantino Brumidi on the ceiling of the U.S. Capitol in Washington, D.C.—the District of Columbia—rather than the more widely used America, which was adapted from Amerigo's name.

The engraving of Sebastian Cabot (facing page, bottom) is based on a painting attributed to Hans Holbein the Younger, who, like Cabot, worked for the king of England. Sebastian also sailed for Spain, establishing the first Spanish settlements in what became Uruguay and Argentina.

the northern part of the New World for England. He was lost with his ships on his second voyage in 1498; he died thinking he had reached Japan. John's son, Sebastiano Caboto (Sebastian Cabot) first voyaged with his father and made several trips to the Americas for two English kings and for Spain. In 1526, he explored the Rio de la Plata, hunting for what he thought would be a passage to China.

Also searching for a sea route to Asia, Giovanni da Verrazzano sailed for King Francis I of France in 1524. He reached the coast of what is now North Carolina, then sailed north to New York Bay, the first European to do so. "My intention . . . was to reach Cathay . . . but I did not expect to find such an obstacle of new land as I have found," he wrote in a report now called the *Cellere Codex*. Instead, he discovered "a very agreeable place between two small but prominent hills; between them a very wide river. . . . We went up this river for about half a league, where we saw that it formed a beautiful lake [New York Harbor]. . . . Suddenly . . . a violent unfavorable wind blew in from the sea, and we were forced to [leave] the land with much regret on account of its favorable conditions. . . . We think it is not without some properties of value." Verrazzano reached Cape Cod and sailed as far as Newfoundland.

Columbus, Vespucci, Cabot, and Verrazzano are the names history remembers, but other Italians took part in the Age of Discovery: ordinary seamen who crossed the ocean, map makers, navigators, and merchants and bankers who outfitted ships and financed voyages. They embodied the spirit of the Renaissance. Lorenzo de Medici, who exemplified the power of the Italian city states but also their inability to unite, died in 1492, the same year Columbus found *his* America. Leonardo da Vinci (1452-1519), inventor extraordinaire lived at the same time as Columbus and painter and sculptor Michelangelo (1475-1564) would have known of his discoveries. The artists, writers, and scientists of the Renaissance brought the past to life and transformed it with new perspectives. The explorers absorbed this present knowledge and opened the way to the future, to a wider world. The countries that embraced and exploited this new world—those the Italians worked for—were Spain, Portugal, England, and France. While Italian courage and ingenuity were key to the story of America's beginnings, it would be four hundred years before large numbers of Italians left their imprint on the land their forefathers discovered and explored.

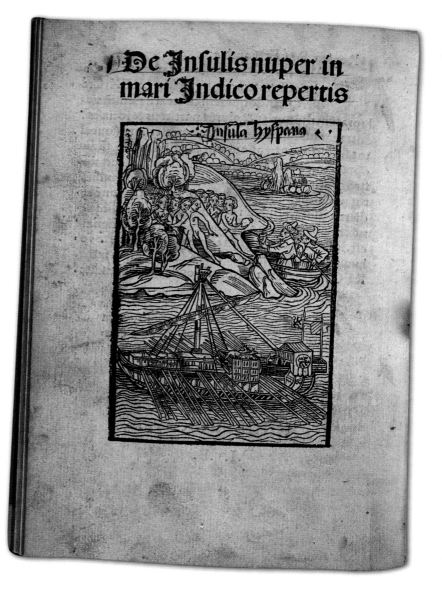

The First Accounts

Christopher Columbus himself wrote a letter to the Spanish court when he returned from his first voyage, published as *Epistola de insulis nuper inventis* in 1493. In it, he tells his royal patrons that "I will bring them all the money they need . . . and spices and cotton . . . and wood aloe." Seventeen editions of the letter *De Insulis in mari Indico nuper inventis* were published between 1493 and 1497. In 1494 one edition was published in Basel (bottom right and facing page, left), with five woodcuts supposedly portraying the trips, but actually imaginary drawings based on the Mediterranean environment.

Angelo Trevisan, a secretary to the Venetian ambassador to Spain, wrote yet another account of Columbus's first voyages (1501-1503) (above, left and right). He knew Columbus personally, whom he described as "a tall man of distinguished bearing . . . with great intelligence and a long face."

In 1520, astronomer Peter Bienewitz (Petrus Apianus) printed a "Delineation of the entire world" with maps (facing page, top) based on the theories of Ptolemy and the accounts of Columbus's and Amerigo Vespucci's travels. Vespucci's work was published throughout Europe, including the influential *Mundus Novus* (1503), several private letters to Florentine merchants and humanists, and *De Ora Antarctica per regem Portugallie inventa* (facing page, bottom right) in 1505. Contemporary Spanish historian Bartolome de Las Casas believed that in *Mundus Novus*, Vespucci's "discovery ... of the mainland [of the Americas] usurp[ed] the glory that belonged to the Admiral [Columbus]." He believed it should be called "not America . . . but Columbia from Colon or Columbo who discovered it."

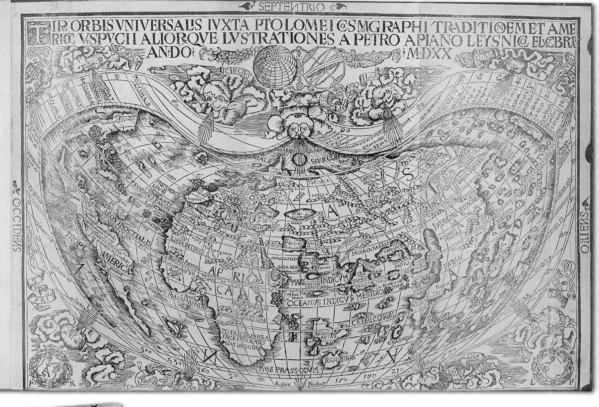

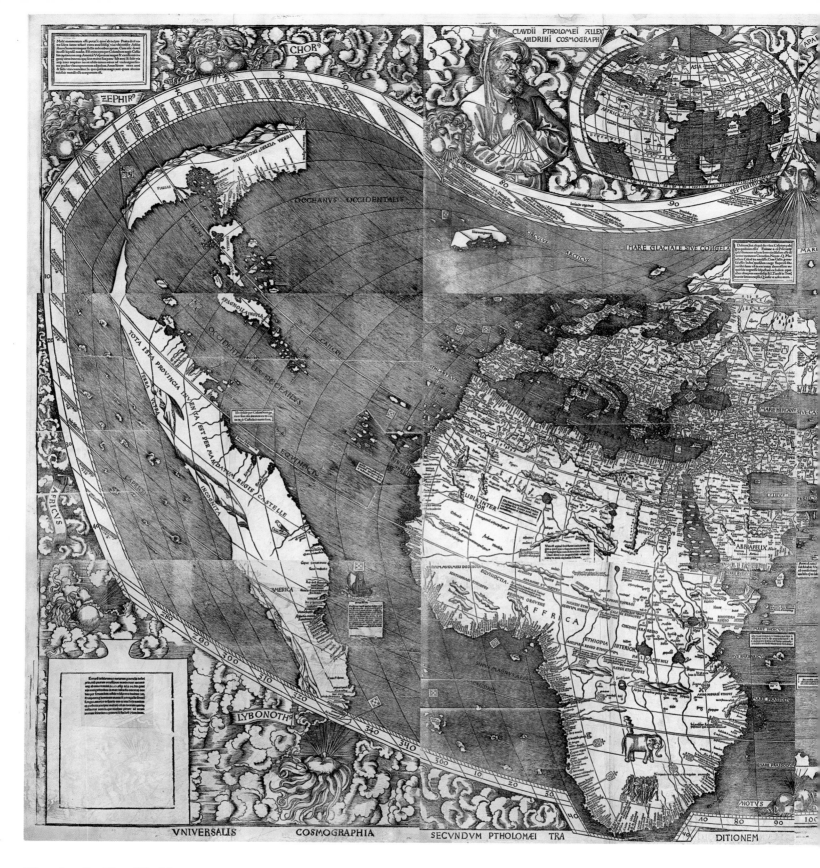

Mapping the New World

The first to name the continents discovered by Columbus "America,"—though he did credit Columbus for discovering the Caribbean—Martin Waldseemül-ler created a world map featuring a portrait of Amerigo Vespucci (top, right of center). This map, completed in 1507 in France, was one of the first of the efforts to document the new geographic knowledge explorers were accumulating in the late 15th and early 16th centuries. Waldseemüller's map was also the first to show North and South America in their own hemisphere, surrounded by two oceans—separate from both Europe and Asia, as Vespucci had surmised. The original edition consisted of one thousand copies, each printed on twelve sheets made from original woodcuts; only one copy remains, held at the Library of Congress. Titled *Universalis cosmographia secundum Ptholomaei traditionem et Americi Vespucii aliorumque lustrationes* (The Universal Cosmography according to the tradition of Ptolemy and the Discovery of Amerigo Vespucci and others), it acknowledges both the conceptual

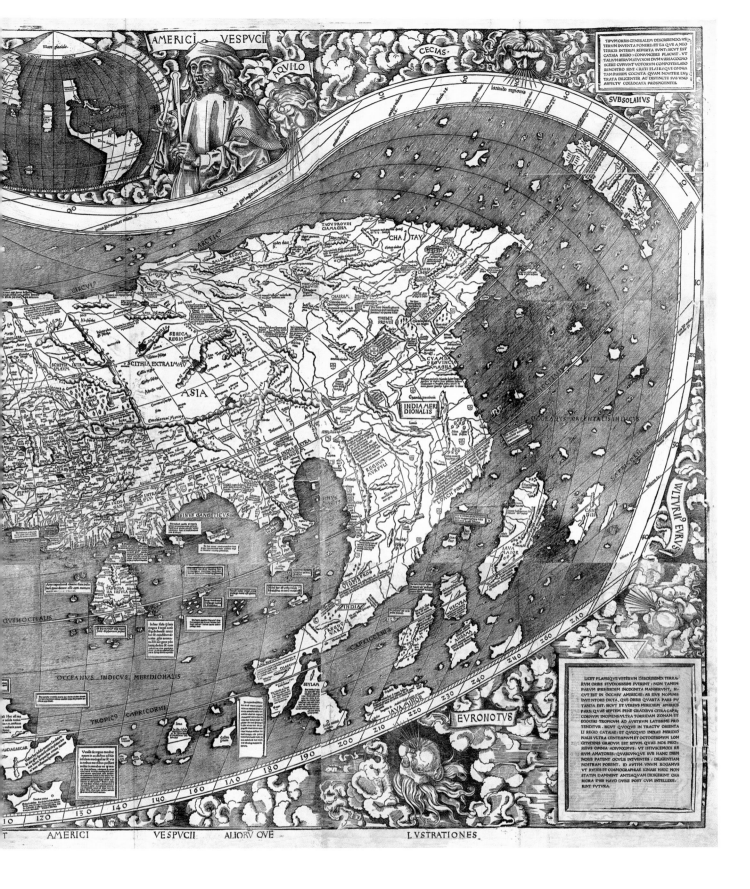

foundation Ptolemy established as a geographer and the discoveries of the New World. Other maps quickly followed. Gerardus Merca-tor, arguably Europe's best known map maker, produced a map in 1511 labeled "AME" across the northern part of the New World and "RICA" across the south.

Sixteenth century maps portraying the Americas became more detailed over time; although, as Waldseemüller's map indicates, Central and South America were better delineated than North America, which was more fully explored at a later period than its sister continent. The prominence of Italian explorers and merchants diminished as the century progressed, especially after Spain passed protectionist laws in 1538 to prevent foreigners from trading with the Indies.

Meeting the People

One map that did show the peninsula of Florida and part of the north Atlantic coastline (below) was one of nine charts (and a world map) in the Portolan atlas created by Battista Agnese of Genoa in 1543-44. It also shows Central America and the American Southwest before drifting into the vast Pacific Ocean.

In addition to charting the Americas, Italians gave vivid accounts of the native peoples they came across. When Columbus first landed in the Caribbean (facing page, above), he wrote of meeting a group of "naked people." "Because I knew that they were people who would rather convert to our Holy Faith [Catholicism] by love than by force, I gave them some colored caps and glass beads . . . and other baubles of which they showed great pleasure. . . . Later they came to swim to the boats . . . and brought us parrots and balls of cotton thread, spears and many other things. They do not carry weapons, nor [do] they know of them."

On the other hand, Amerigo Vespucci (facing page, below) encountered "400 men and many women, and all naked. They had nice bodies and looked [like] warlike men, because they were armed with their weapons, which are bows, arrows and spears. . . . Just as we were about to land with boats to a bow-shot distance, they all jumped in the water throwing arrows and preventing us to land. And all had paintings on their bodies in different colors and feathered quill[s] . . . and [we] were forced to use our artillery, and as they heard the thunder and saw some of theirs fall dead, all backed to the land. And it was resolved, because these people wanted our enmity, that we tried everything to become friends; and in case they did not want our friendship, we treated them as enemies and those who we could seize, they be our slaves."

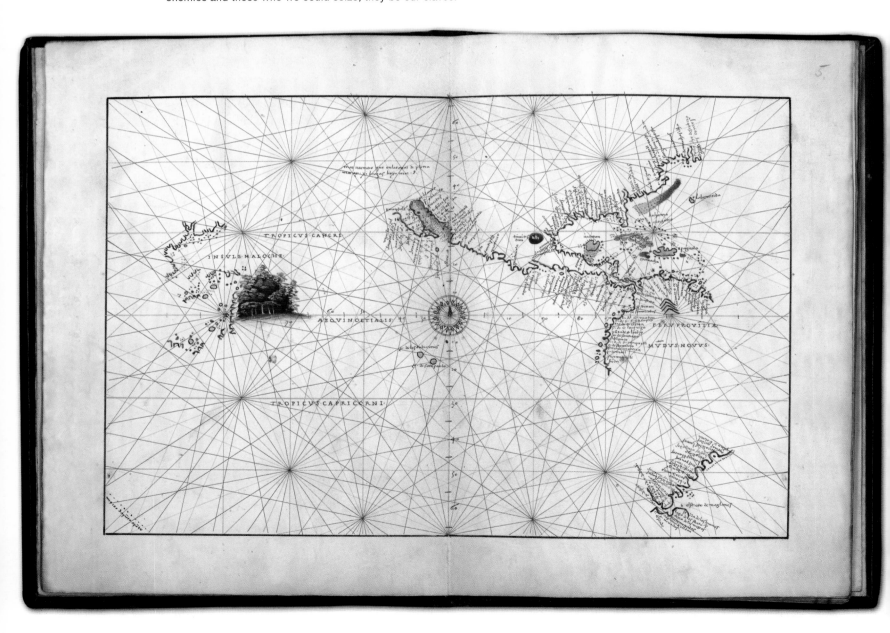

THE LANDING OF COLUMBUS
1492.

Giovanni da Verrazzano considered the first American Indians he encountered to be friendly and gentle. In New York harbor, "the people were almost the same . . . dressed in birds' feathers of various colors, and they came toward us joyfully, uttering loud cries of wonderment, and showing us the safest place to beach the boat."

In what became Rhode Island he found "these [native] people are the most beautiful and have the most civil customs that we have found . . . their manner is sweet and gentle, very like the manner of the ancients. . . . Their women are just as shapely and beautiful; very gracious, of attractive manner and pleasant appearance. . . . They do not value gold because of its color; they think it the most worthless of all, and rate blue and red above all other colors." On his third voyage, in the Caribbean, however, Verrazzano was killed by Native Americans. From these contradictory accounts, embellished by other encounters of Europeans and American Indians, rose two conflicting images. One was an idealized view of a pure, simple people living close to nature, without the encumbrances of fear, greed, jealousy, or inequality found in "civilization." The other was of savage beasts ready to kill people of other tribes and certainly foreigners, justifying takeover of their land, exploitation of resources, and enslavement. For humanists, native peoples represented a golden age; for European kings, adventurers, and investors, a source of gold. Neither view acknowledged their common humanity and the value of the age-old cultures the Europeans "discovered" in the New World.

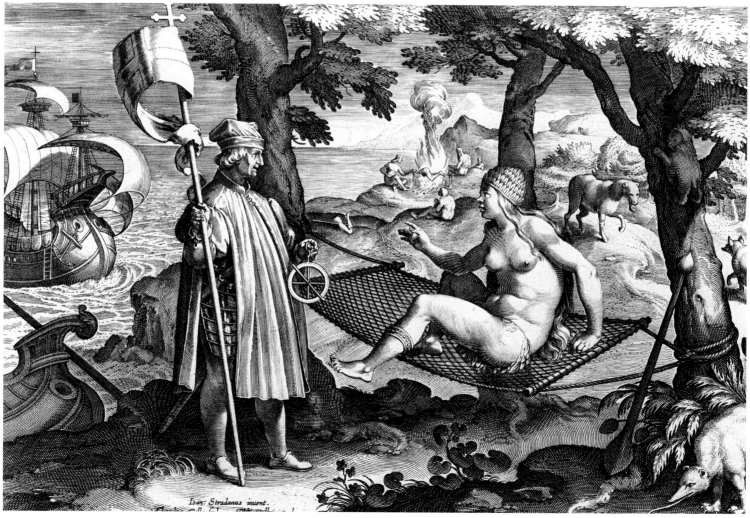

Ioan: Stradanus inuent.

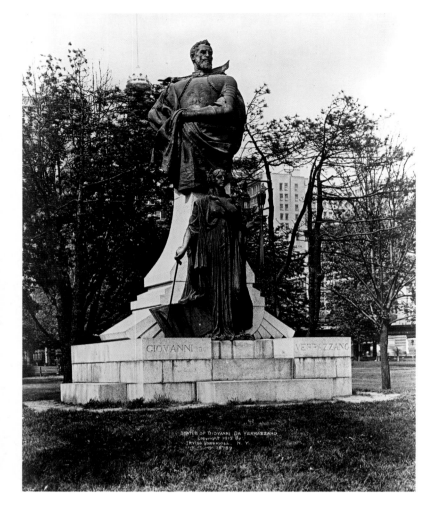

The Heritage of Discovery

The United States and other Latin American countries continue to celebrate Christopher Columbus's discovery of the Americas. As early as 1792, New York City celebrated the 300th anniversary of his landing. One hundred years later, Italian sculptor Gaetano Russo designed a statue of Columbus for the city, to commemorate the 400th anniversary. In 1905, New York completed work on Columbus Circle (above right and facing page, above), which surrounds the monument that is centrally located at the intersection of Eighth Avenue, Broadway, West 59th Street, and Central Park West.

Colorado was the first state to celebrate Columbus Day as a holiday in 1905. This commemorative book (right) was published in 1910 in Denver.

Parades also became a common way to remember the anniversary. This one (facing page, below) shows marchers in Washington, D.C., observing the anniversary in 1912 in front of Union Station.

Columbus Day (October 12) became a federal holiday in 1937; since 1971 it is observed on the second Monday in October. San Francisco claims the oldest continuous Columbus Day Parade (since 1868), while New York City claims the largest and most widely known. Italian Americans, who as immigrants experienced widespread discrimination in the United States, supported the drive for the holiday and embraced it as a tribute to their heritage.

The Italian American newspaper, *Il Progresso*, raised the funds to build statues of both Columbus and of Giovanni da Verrazzano (above left). Ettore Ximenes sculpted the explorer's monument, dedicated in 1909, located in Battery Park. Below Verrazzano, a female figure represents "Discovery." Fittingly for the man who discovered New York Harbor, the Verrazano-Narrows Bridge, opened in 1964, spans the New York City boroughs of Brooklyn and Staten Island.

Travelers and Pioneers

Breaking New Ground, Making New Connections

While the five explorers were opening up the Americas, Italy was beset by war. Charles VIII of France was the first to invade, in 1494. Thirty-six years of violence followed, with French, German, Spanish, Swiss, and Austrian troops and mercenaries (including Italian soldiers for hire) devastating the peninsula. Amidst the chaos and fighting to defend their own territories, only a small number of Italians crossed the Atlantic. Those in southern Italy, ruled by the Bourbons, were, in fact, forbidden to leave. Since there was no united Italian nation to claim territory in the New World or to start colonies, the Italians who did venture to the Americas came as individuals.

Some Italians still managed to find adventure as soldiers and sailors who worked for other countries. An estimated one third of Ferdinand Magellan's crew was Italian, sailing with him for Spain in 1519-1522, becoming the first people to circumnavigate the globe. A handful of Italian settlers in what is now the United States were artisans—the tradition of seeking Italians as architects, artists and craftsmen continues today. The British invited Venetian glassblowers to live in Jamestown, Virginia, as early as 1621! They made glass beads to trade with the American Indians. In the early 1700s, a group of northern Italians settled in Georgia to start a silk-making industry. And Maryland, that rare Catholic refuge in the Protestant British colonies, offered "to grant lands unto any persons of French, Dutch or Italian descent upon the same terms . . . as those of British or Irish descent."

The adventures and achievements of individual Italians span a period of 350 years after Columbus came to America. They coincide with the time, well into the 19th century, when the continental United States was being explored and settled by people from many countries. The Italians followed several paths. One was holy: Italians were among the missionaries who brought Christianity to the Native Americans. At the same time, the missions, churches and schools they founded cemented the European possession of land in North America.

Father Eusebio Francesco Chini (known as Eusebio Kino) was a noted Jesuit scholar, natural scientist, and cosmographer when he arrived in the American Southwest in 1681. He is said to have covered

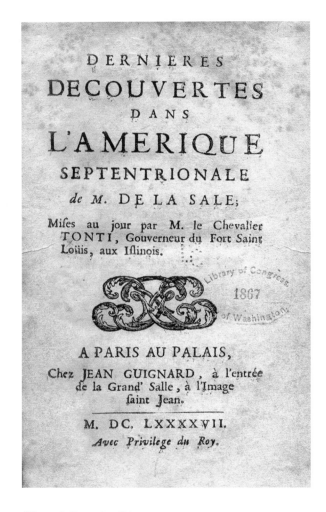

DERNIERES
DECOUVERTES
DANS
L'AMERIQUE
SEPTENTRIONALE
de M. DE LA SALE;

Mises au jour par M. le Chevalier TONTI, Gouverneur du Fort Saint Loüis, aux Iſlinois.

A PARIS AU PALAIS,

Chez JEAN GUIGNARD, à l'entrée de la Grand' Salle, à l'Image ſaint Jean.

M. DC. LXXXXVII.
Avec Privilege du Roy.

Chronicling the Discovery

One way to be remembered by history is to write it. Henri de Tonti's book (above), composed in 1697, documented the challenges—freezing weather, near starvation, American Indian attacks, alligators—of his explorations of the territory called Louisiana. C. Beltrami chronicled (facing page, above) his exploration of the Mississippi's beginnings as he traveled with Native American guides "backwards" from the mouth of the Ohio River through a vast wilderness. His journey ended at a small lake he called Julia; the streams pouring from it were the sources of the Mississippi. Charlie Siringo (pictured, facing page, below) subtitled his first book *Fifteen Years on the Hurricane Deck of a Spanish Pony* to emphasize the daring and endurance it took to be a cowboy. For ten years he drove longhorn cattle from Texas to Kansas, then wrote one of the first accurate, real-life accounts of cowboy life.

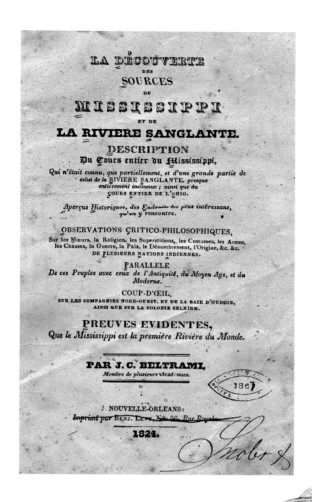

A TEXAS COW-BOY.
CHAS. A. SIRINGO.

130,000 square kilometers on horseback, mapping territory from the Colorado River to the Gulf of Mexico. Father Anthony Ravalli, born in Ferrara, arrived in the Pacific Northwest in 1845. He not only designed and built churches in Idaho and Montana, but because he was also trained as a doctor, he traveled hundreds of miles to treat the American Indians he befriended.

Other Italians continued to come as explorers, a role that often overlapped with that of religious missionaries, as friars and priests traveled, mapped, and claimed vast territories for Europe. In 1539, for example, Fra Marco da Nizza of Savoy claimed Arizona and New Mexico for Spain by setting a cross on a hill of stones. Two other Italian-born adventurers stand out in these centuries. Enrico de Tonti (known as Henri de Tonti) traveled with the French explorer Robert de La Salle down the Mississippi River. Tonti was the first of his party to reach the Gulf of Mexico, hence the first European to find the mouth of the Mississippi River. In the document granting the French possession of "Louisiana" (the territory surrounding the river, at that time, half of the United States), Tonti's name is just below LaSalle's. Nearly 150 years later, when the great river belonged to the United States, Giacomo Costantino Beltrami (J.C. Beltrami) discovered its sources.

Kino, Ravalli, de Tonti, and Beltrami were born in Italy, but as the centuries progressed the first "Italian *Americans*"—those of Italian extraction born in the United States—left their mark on the country's history. Lawrence Taliaferro was a major in the U.S. army who helped his friend Beltrami find American Indian guides for his travels. Beltrami urged Taliaferro to "replace the G in your name [Tagliaferro] and come with me to Italy, the home of your ancestors." And one of the best known cowboys—that icon of the American West— was born Charles Angelo Siringo to an Italian father in Texas. "Charlie" Siringo, who herded cattle and fought outlaws, was later a Pinkerton detective who wrote several books about his experiences, which spread his name throughout the United States in the late 19th century.

Indien vêtus de l'Amerique Septentrionale.

RELATIONS
DE LA
LOUISIANE,
ET DU
FLEUVE
MISSISSIPI.

Où l'on voit l'état de ce grand Païs &
les avantages qu'il peut produire &c.

A AMSTERDAM,
Chez JEAN FREDERIC BERNARD,
M. D CC. XX.

1720

Along the Mississippi River

Although separated by nearly two centuries, both Henri de Tonti and Costantino Beltrami emigrated from Italy for political reasons. The Tonti family was forced to leave Italy for France in 1648 after they took part in a failed Neapolitan revolt against Spanish rule. Beltrami fled Italy in 1821 when his liberal political views clashed with the clergy and conservative Italian governments. Both found fame in the United States.

De Tonti, a captain in the French navy, was wounded in battle and his right hand amputated. Yet he joined French explorer Robert de La Salle to traverse the St. Lawrence River and the Great Lakes before traveling down the Mississippi. As the frontispiece of the book (above) indicates, he lived among American Indians (the Illinois tribe) as well as fought them (the Iroquois and Seneca), gaining respect as "the iron-handed man" (a metal hook replaced his hand). He founded the first European settlement in Arkansas in 1686; in 1898, Pietro Bandini and a group of Italian farmers settled in Arkansas, naming their community Tontitown in his honor. De Tonti vividly described the hardships he endured. Near Lake Michigan he and his party "were stopped by the wind for a week, which forced us to consume the few provisions we had gathered together. We had nothing else to eat." After his great discovery, he made several trips up and down the Mississippi and settled 20,000 Illinois Indians near the French-owned Fort St. Louis who proclaimed their loyalty to France.

Costantino Beltrami (right, in pioneer dress), who had been a military and civil official under several different authorities in Italy, "possessed a restless spirit, desirous of adventure," wrote Gabriele Rosa in his 1861 biography of the explorer. After finding the sources of the Mississippi, Beltrami traveled through Mexico, then returned to Europe, where he supported liberal causes and "aspired for the elevation . . . of Italy." Yet he had fulfilled his dream. According to the American-born Lawrence Taliaferro, "his greatest anxiety was . . . to explore the wildest portions of the continent, North and West,—to see as many of the noble North American Indians as possible." The state of Minnesota named a county after Beltrami in the mid-19th century.

THE AUTHOR.
In his Dress when among the Indians.

See Vol 2. Page 448 & 481.

Southwestern Missions

Among his significant accomplishments, Jesuit Father Eusebio Kino was the first European to recognize Baja California as a peninsula (not an island, as the Spanish believed), as shown in this 1639 map (below). However, politics again intervened when Jesuits were banned by the Catholic Church from establishing missions in Baja. The Church favored settlement by Franciscans, believed to be less sympathetic to Native American rights. Kino did found Missions San Xavier del Bec (bottom) and San Cayetano del Tumacacori in Arizona, where he lived among the Pima Indians, teaching farming methods and cattle breeding and speaking out against the use of Indian slave labor in silver mines. The mission was rebuilt as San Jose de Tumacacori in the 18th century (left).

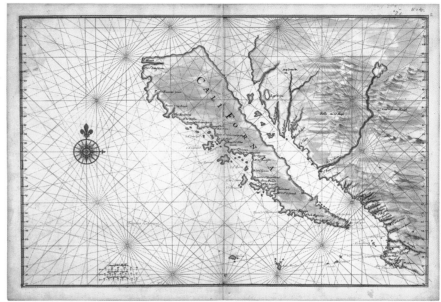

Carlo Gentile, Traveler and Photographer

One of the earliest photographers to take pictures of the American Southwest was Italian: Carlo Gentile, born in 1835 in Naples. Caught up in the California Gold Rush mania, he set up a photography studio in San Francisco in 1860. Some six thousand Italians lived in the city in the 1850s, many, like Gentile, successful businessmen. But in 1862, he was off to Canadian British Columbia, another gold mining center. He ran a portrait studio—among his subjects were Native Americans—and ventured into the rugged countryside, where he took "photographic views of interior towns, bridges, canyons, lake and mountain scenery," wrote a local newspaper. "These views . . . are well taken and exceedingly interesting, conveying . . . a very graphic illustration of the magnificent scenery of the country, as well as of the progress of civilization."

Gentile returned to the United States, traveling throughout California and Arizona. His story reads like the amazing plot of a dime novel. In 1871, he paid $30.00 to three Pima Indians to free an Apache boy taken by them in a raid. He called his adopted son Carlos Montezuma, who traveled with him for ten years and became a doctor and Indian rights activist. In Chicago they joined up with Ned Buntline, a Wild West show promoter who featured Buffalo Bill (William Cody) and "Dove Eye," an "Indian maiden" played by Italian ballerina Giuseppina Morlacchi. Gentile photographed them all and presented copies to "every lady visiting the Matinees." The back of one of Gentile's stereocards is shown (right).

Gentile's camera continued to click. His legacy documents the evolution of Native Americans, from the striking portrait of Mary Mookum (Maria Antonia), "a Pima with genuine Aztec features" (facing page, top center) to the "chief of the Yavapai Apaches" in a U.S. Army uniform (facing page, center). These photographs are among forty-one Gentile published in an album held by the Library of Congress, an incomparable ethnographic record. He went on to pioneer printing techniques and to operate acclaimed photographic studios in New York and Chicago.

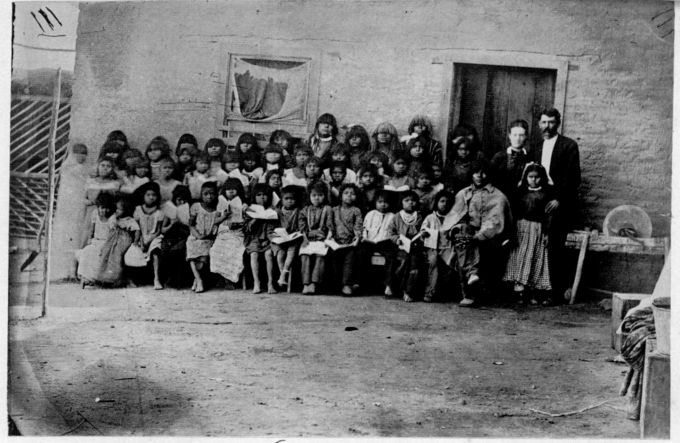

No 111. First Indian School in Arizona at the Pima Reservation. A group of about 50 boys & girls

44

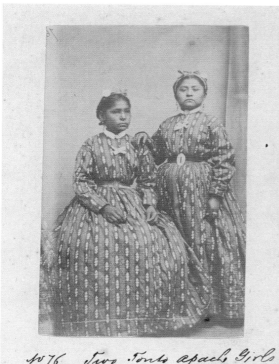

No 76　Two Tonto Apache Girls
civilized & christians good girls

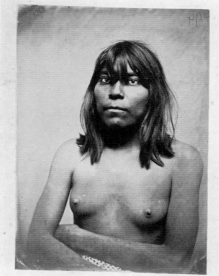

No 94　Mauly Mookum or Marri
Antonia. a Pima wal genuine
aztec features — an iscentric Girl —

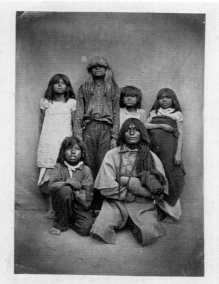

No 118. Group of Pimos taken at the
Reservation

Series of Photographic
views and Portraits of Arizona
and Arizona Indian Tribes
photographed by charles Gentile

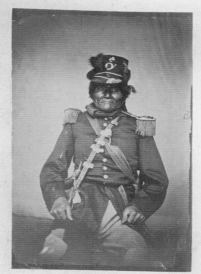

No 53　Chief of the Yarapai Apaches at
Date Creek. Ahosely Kamah.

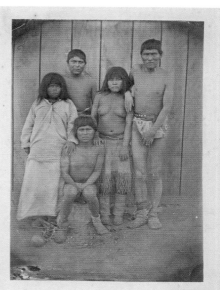

No 57　Group of Apache Tontos & Yarapai
Prisoners of United States at Camp
Verdi　Three men & 2 women.

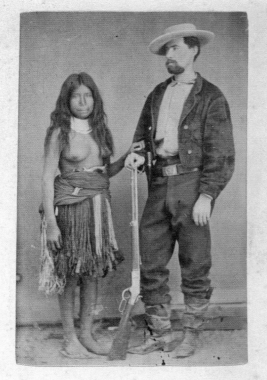

No 142.　Romantic Couple
on the Dalles of the colorado River.

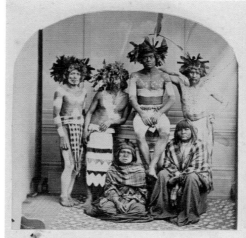

No 210　Group of Californians
very interesting.

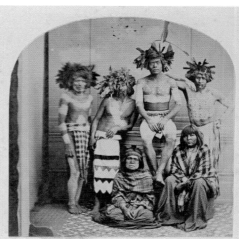

No 210　Same

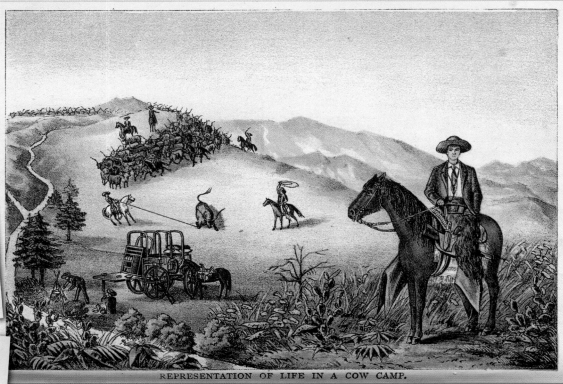

REPRESENTATION OF LIFE IN A COW CAMP.

In the Wild West

Sister Blandina Segale was born Rosa Maria Segale near Genoa, and was four years old when she came to Ohio. Charlie Siringo was born Angelo Siringo to an Italian father and Irish mother in Texas. Both became famous in the 19th century for writing about their adventures in the American West.

Siringo's books on cowboy life (left, top and center) sold nearly a million copies. Beginning in 1886, he had a second, twenty-one-year career as a detective for the famous Pinkerton Agency. Siringo worked the West from Alaska to Mexico City. He was one of the first undercover agents—posing as a gunman, he infiltrated Butch Cassidy's infamous Wild Bunch gang. At age sixty-one he joined the New Mexico Rangers to capture cattle rustlers, his last dangerous occupation.

As a young nun, Segale was sent to Trinidad, Colorado, to teach. It "was a rough place when she entered it," wrote the *Cincinnati Post*, "gentle it was when she departed. Rude men reverenced her walking among them as she did, unafraid." Segale (autobiography shown, bottom left) charmed the original Billy the Kid (not the famous one) when she nursed his fellow outlaw; he later declined to rob a stagecoach she was traveling on out of respect. She went on to found a hospital and school in New Mexico (below right) and a center to help Italian immigrants in Ohio.

As Old Albuquerque looked in 1881 when Sisters opened school. Church, Sister's residence, saloon and residences, eighteen room house used for emergency cases of need, flag staff, used for soldiers' dress parade and exercise.

Explorers, Emigrants, Citizens

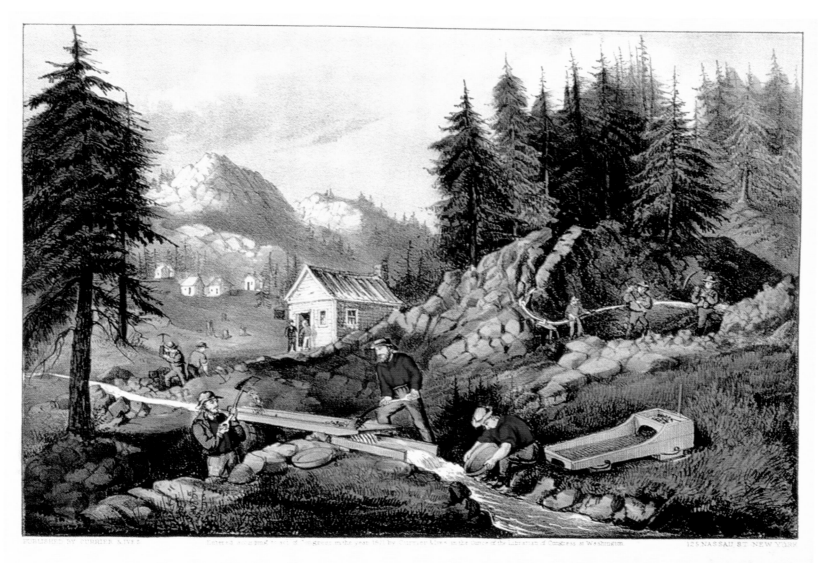

GOLD MINING IN CALIFORNIA.

Gold Rush

Italians and Italian Americans joined the hordes of hopefuls who headed to California for the gold rush of 1849. They came from Genoa and Tuscany, Romagna, Venice, Lombardy, and Piedmont; more than six hundred were in San Francisco alone, according to the New York newspaper *L'Eco d'Italia*. Others lived roughly in the mountains and gold fields (above). Some fifty years later, Felice Pedroni set off another gold rush in Alaska. Pedroni, born in the Duchy of Modena, came to New York in 1881, changing his name to Felix Pedro. As a prospector, he was indefatigable. In 1902, nearly out of supplies, Pedro found gold in the Tanana Hills; he was instrumental in founding the nearby city of Fairbanks. This photograph (right) shows one of the icy trails between the city and the mines. The rush to Fairbanks did not take off until 1904, but the mines there proved richer than those in other Alaskan territories. On July 22, 2002, a Felix Pedro Day was celebrated on the 100th anniversary of his discovery.

In the Land of the Free

The American Revolution rested as much on political philosophy as it did on arms. It was based on certain ideals expressed in the Declaration of Independence written by Thomas Jefferson: "that all men are created equal; that they are endowed . . . with certain inalienable rights . . . that among these are life, liberty, and the pursuit of happiness." These words echoed those of Jefferson's friend, Italian-born Filippo Mazzei, a thinker and owner of an experimental farm next to Jefferson's land in Virginia. A supporter of the rising tide towards American independence from England, Mazzei had written several articles on the validity of revolution in the _Virginia Gazette_. "All men are by nature equally free and independent," he stated in one translated by Jefferson. " . . . Each equality is necessary in order to create a free government. All men must be equal to each other in natural law."

Records show that about fifty Italian men served as enlisted soldiers in the American army. Among them, Francesco Vigo, born in 1747 in Mondovì, came to the Americas as a soldier in the Spanish army and stayed as a fur trader in Vincennes, Indiana. A friend of the American Revolutionary War general George Rogers Clark, Vigo was captured by the British and later gave Clark valuable information that allowed him to retake Vincennes. He also gave Clark his entire fortune—some $8,500—to buy weapons and supplies for the Americans.

Between 1783—when the United States became a nation—and 1861—when Italy did—only about twelve thousand Italians immigrated to the U.S. Many of these were politically motivated, inspired by the American Revolution and the subsequent founding of a democratic republic. These Italians sought unity and liberty for their homeland, but were exiled by conservative governments, such as their Hapsburg and Bourbon rulers, for their revolutionary efforts. Eleuterio Felice Foresti, who had been imprisoned in Austria, came to New York in 1836 and taught at Columbia University and the University of the City of New York. Fellow revolutionaries Gaetano de Castillia and Piero Maroncelli settled in New England. Most of the political exiles lived in New York and other eastern cities, but, especially after the California Gold Rush in 1849, many were drawn to San Francisco. The most famous was Giuseppe Garibaldi, a leader in the battles for Italy's liberation and unification (known as the _Risorgimento_), who lived in New York in 1850-1851. The Italian political cause was popular with the American press and public, who generally supported Italy's Second War of Independence (1859) and the conquest of Sicily in 1860.

Garibaldi's Men-at-arms

In 1849, Garibaldi led a Republican army to victory against the French outside of Rome. French reinforcements turned the tide, and the revolutionary forces retreated. On the run from French, Spanish, Austrian, and Neapolitan armies, Garibaldi stayed in San Marino and Tangier before embarking for New York. There he worked for another Italian, Antonio Meucci, in Meucci's candle factory on Staten Island. They lived at Rosebank, now listed on the U.S. National Registry of Historic Places as the Garibaldi Memorial. This photo (left) shows several veterans of the Italian wars. The white-bearded man in the foreground is Meucci, who had his own part to play in history. He patented a "telephonic device" in 1871, five years before Alexander Graham Bell, but did not receive recognition for the invention in America.

PORTRAITS & AUTOGRAPHS OF THE SIGNERS OF THE DECLARATION OF INDEPENDENCE.

The Revolutionary War

Italians who sought a unified, republican government for Italy were interested in the transformation in America from thirteen English colonies to an independent United States. A big step was the signing of the Declaration of Independence in 1776. The signers (pictured above in a lithograph created in 1876) included William Paca, thought to be of Italian ancestry. His great-grandfather Robert purportedly left Italy for England when he became a Protestant, then immigrated to America in the 1660s. Paca represented Maryland and later served as its governor. Another signer, Benjamin Franklin, was much admired in Europe. An inscription in *Le Lettere americane* (1781) by Italian political economist Giovanni Rinaldo, grants Franklin credit as "the first to give us the most grandiose and adequate idea of your great continent, in which You take pride in having [been] born." On the American side, Richard Talliaferro was a captain in the American army; and a Cosimo Medici sent a report (left) on the North Carolina 3rd Continental Light Dragoons to commander-in-chief George Washington himself on May 10, 1778, still preserved in the collection of Washington's papers.

Thomas Jefferson and Filippo Mazzei

Thomas Jefferson and Fillippo Mazzei shared two loves in common: Italian food and American freedom. Mazzei started an experimental farm in Virginia in 1773 to grow Italian vines, olives, and seeds. Jefferson, who had a French cook skilled in Italian recipes, served his guests exotic fare like pasta. His 1787 drawing of a machine to make macaroni (below), complete with recipe, even shows a sectional detail where the strands of dough extruded. Jefferson helped Mazzei with a series of articles the Italian published in the *Virginia Gazette* under the pseudonym "Furioso." Jefferson translated from Italian to English or edited the ones written in English. Mazzei served the Americans during the Revolution as an agent of Virginia, seeking money for weapons in Europe. After Mazzei left the United States for good, the men continued to correspond, as seen in this letter written by Jefferson to Mazzei (left).

Mazzei later wrote, "wherever I go I shall always work for the well-being and progress of the country of my adoption."

Philip Mazzei Esq.

recommended to the care of his Excellency, Thomas Jefferson Esq. American Minister at Paris

Maccaroni.

The best maccaroni in Italy is made with a particular sort of flour called Semola, in Naples: but in almost every shop a different sort of flour is commonly used; for, provided the flour be of a good quality, & not ground extremely fine, it will always do very well. a paste is made with flour, water & less yeast than is used for making bread. this paste is then put, by little at a time, viz. about 5. or 6.℔ each time into a round iron box ABC. the under part of which is perforated with holes, through which the paste, when pressed by the screw DEF, comes out, and forms the Maccaroni g.g.g. which, when sufficiently long, are cut & spread to dry. the screw is turned by a lever inserted into the hole K. of which there are 4. or 6. it is evident that on turning the screw one way, the cylindrical part F which fits the iron box or mortar perfectly well, must press upon the paste and must force it out of the holes. LIM. is a strong wooden frame, properly fastened to the wall, floor & ceiling of the room.

N.O. is a figure on a larger scale, of some of the holes in the iron plate, where all the black is solid, and the rest open. the real plate has a great many holes, and is screwed to the box or mortar: or rather there is a set of plates which may be changed at will, with holes of different shapes & sizes for the different sorts of Maccaroni.

Garibaldi and his Followers

This very early—and very scarce—daguerreotype of Giuseppe Garibaldi (right), taken by the eminent photography studio of Mathew Brady before 1860, was probably shot when Garibaldi lived in the United States in the early 1850s. Dashing and charismatic, Garibaldi felt that in the U.S., "I was perfectly free, I could work if I liked: and of course I preferred useful work to any other occupation, but I could go hunting a few times, and often went hunting with . . . friends from Staten Island and New York who often favored us with their visits." His home with inventor Antonio Meucci was a magnet for Italian political refugees, including members of the Italian Legion of Montevideo and Paolo Bovi Campeggi of Bologna. Since Bovi knew how to slice meat—and Garibaldi disliked idleness—they started a salami factory in Meucci's basement. When Meucci started a candle making factory, Garibaldi applauded, "we can employ many poor exiles and we can not fail, because the light is needed everywhere." On Sundays, crowds came to Staten Island to listen to Garibaldi's stories of adventure and to play *bocce*. Garibaldi's later triumphs in Italy made him famous internationally. When the U.S. Civil War began, the Union government offered him a major general's commission in the U.S. Army. Garibaldi refused because the U.S. was not yet ready to abolish slavery (and he only wanted to be commander-in-chief). The Italian colony in New York celebrated Garibaldi's association with Italian Americans and his fame in America with a statue placed in Washington Square Park (shown below in an 1888 print).

The Inventor of the Telephone?

Alexander Graham Bell or Antonio Meucci are the candidates. Italians believe Meucci was the man; Americans put their money on Bell. Meucci settled in the United States in 1850. He had already invented a kind of acoustic telephone and what he called a "telegrafo parlante," a machine that imperfectly transmitted the human voice. While Meucci employed and supported other Italian exiles, he worked to perfect an instrument that would allow his invalid wife to communicate with him from a different part of their home. He claimed to have fashioned an electromagnetic telephone in 1857. But Meucci went bankrupt, lost his home, and could not find a financial backer. Nevertheless, in 1870 he created his "telettrofono," which could transmit a voice over a mile of copper wire; his wife sold it for the money they needed to live. Finally, Meucci filed for a patent in 1871—but he did not use the term "electromagnetic transmission" in his claim.

It was Bell who made the electromagnetic aspect of his device clear when he received a patent in 1876. The American press applauded Bell's invention and the Bell Telephone Company was founded. Meucci sued—evidence went missing, bribery was suspected, Meucci could not produce absolute proof. When Bell finally offered him a generous financial settlement, however, Meucci refused. He wanted recognition for his achievement; the achievement, as he insisted, of an Italian. The fight between Meucci and Bell unfolded at a time when poor Italians were coming to the United States in greater numbers and beginning to alarm the dominant British- and German-heritage population. Not only did he lack the resources of a corporate giant, Meucci was on the wrong side of a debate about who should be allowed to immigrate to the U.S., one that continued into the 20th century.

Cultural Elites

Colonial Aristocracy and Classical Artists in a Modern Country

Italy was the ultimate shrine of culture and beauty in the pilgrimage that American artists, art lovers, and wealthy tourists made to 19th century Europe. Before the great migration of Italians to the United States in the late 1800s, Italian artists, actors, singers, and musicians were welcomed here. These elite cultural ambassadors—along with the country's political refugees—were the face of Italy for most Americans, from "aristocrats" like Thomas Jefferson, to the ordinary theater goer in New York or San Francisco.

The Italian language became part of the curriculum at Benjamin Franklin's Philadelphia College (now the University of Pennsylvania) in 1753. In the 1770s, Carlo Bellini, a friend of Filippo Mazzei, began teaching at the College of William and Mary in Virginia. Lorenzo Da Ponte—the librettist for Mozart's *Don Giovanni, Le nozze di Figaro,* and *Cosi fan tutte*—arrived in New York in 1805. He became the first professor of Italian literature at Columbia College (now Columbia University), prompting other Ivy League colleges to add the language to their curricula. Naturally, Da Ponte also introduced opera to the city.

Italian art and architecture influenced American style, particularly in Washington, D.C. The buildings constructed there in the first decades of the republic are known as Federal architecture. Giuseppe Ceracchi, Carlo and Giuseppe Franzoni, and Giovanni Andrei were among the first sculptors to come from Italy. Ceracchi's portrait busts of the country's founders set the style for 19th century American sculpture. Costantino Brumidi—another political refugee as so many of the artists were—filled the U.S. Capitol building's interior with monumental paintings, earning the nickname "Michelangelo of the United States."

The U.S. encouraged Italian artisans to immigrate to America to construct both public and private buildings. This country was becoming an economic powerhouse, but it still looked to Europe for its artistic sensibilities. Italian companies sold to the American decorative market; Giannetti & Figli of Lucca, for example, specialized in creating huge bald eagles. And Italian opera singers, such as Adelina Patti, were hugely in vogue as the young nation fed its appetite for culture and sought to develop a culture of its own.

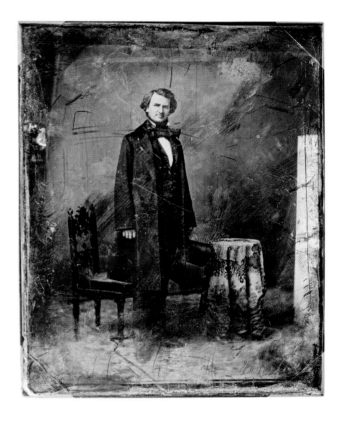

First Families of Virginia

The most ubiquitous Italian surname that survives from 17th century America is Taliaferro. The first Tagliaferros (the original name was spelled with a "g") came to Virginia from London, where one of them had performed for Queen Elizabeth I as a musician. Thomas Jefferson sketched the Tagliaferro coat of arms (upper left) on a visit to Italy for a friend with a wife from the American branch of the family.

The Mathew Brady Studio took the portrait of Taliaferro Preston Shaffner (above), some time between 1844 and 1860. Virginia-born, he was an inventor known for early work on the telegraph. Other well-known Taliaferros include Lawrence, a colonel in the Revolutionary War; Benjamin, a member of the U.S. House or Representatives; James, a U.S. senator; Mabel, an actress; Samuel Taliaferro Rayburn, one of the most influential Speakers of the House; and Dr. William Taliaferro Close, actress Glenn Close's father. Booker Taliaferro Washington, an African American educator, orator, and political leader, also shares the name.

Taliaferro County, Georgia

This large cabin (right) stands in Taliaferro County, Georgia, which was incorporated in 1825 and named for Revolutionary War leader Benjamin Taliaferro. Pioneering female photographer Frances Benjamin Johnston snapped the shot.

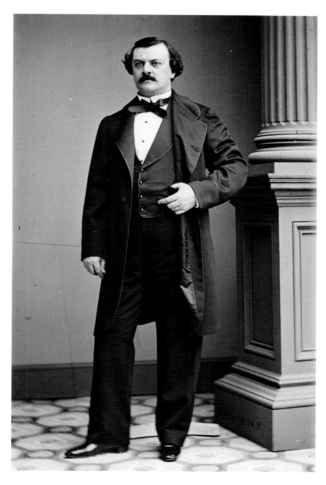

Portraits of Celebrities

Mathew Brady was *the* fashionable American photographer of the mid-19th century. Actors, singers, and artists stand out among the Italian names of his subjects. Pasquale Brignoli (left) was an opera star born in Naples, who immigrated to the United States in 1855 and successfully toured the country with his own opera company. Miss L. Boschetti (right), though not famous, struck an elegant pose for the Brady Studio.

Mozart's Librettist and the First Opera Houses

Lorenzo Da Ponte had a life as colorful—and operatic—as any opera. He was born Emanuele Conegliano into a Jewish family, which converted to Catholicism. Da Ponte was ordained a priest in 1773; he also kept a mistress. He stood trial for living openly with a concubine and was banished for fifteen years. Da Ponte became the librettist of the Italian Theater in Vienna, writing twenty-eight librettos. His goal in *The Marriage of Figaro*, he stated, was "to paint faithfully and in full color the diverse passions that are aroused, and . . . to offer a new type of spectacle." He moved on to London, then to the United States, where he opened a grocery store in Pennsylvania. Da Ponte finally settled in New York, teaching at Columbia and running a bookstore. In 1828 he became an American citizen. Da Ponte wrote this 1832 letter (right) to Fortunato Stella, an Italian bookseller, ordering books to sell in the United States. The following year, he started the New York Opera Company, the first U.S. opera house and forerunner of the Metropolitan Opera. In debt, Da Ponte had to sell the building, but New Yorkers had developed a taste for the art. The Astor Opera House opened in 1847, presenting Giuseppe Verdi's *Ernani*. Two years later (as shown below), a riot engulfed the building, its curious cause a disagreement between fans of American actor Edwin Forrest and English actor Charles Macready about who was the better performer.

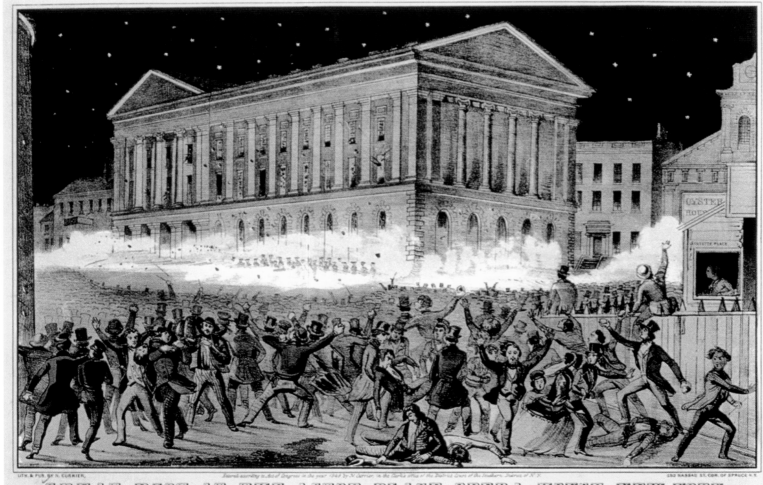

GREAT RIOT AT THE ASTOR PLACE OPERA HOUSE, NEW YORK.

ON THURSDAY EVENING MAY 10TH 1849.

Stage Divas

The diva of her day, soprano Adelina Patti (bottom, photographed by Mathew Brady) sang for President Abraham Lincoln and earned a phenomenal $5,000 a performance—once, after a bidding war, she was paid $25,000 to sing. Charles Harris wrote "The Last Farewell" (sheet music cover below, left) in her honor. Adelaide Ristori (shown in a Brady portrait, right) was a renowned tragic actress. Beginning in 1866 she made four tours in the United States. In 1888 she published *Studies and Memoirs*, an insightful look into the psychology of the tragic characters, like Lady Macbeth, she portrayed.

The New Nation in Marble

Italians brought a sense of beauty to public art. Sculptor Giuseppe Ceracchi (top left) came twice to the U.S., hopeful of building a monument to George Washington. He asked for financial support in a document (middle left) that explained he was "influenced by admiration for the revolution lately accomplished . . . and by a desire of distinguishing himself as the instrument of erecting a Monument so worthy of a great event." Fund raising failed and the elaborate piece was never built, but Ceracchi won a reputation by sculpting portrait busts of notables including Benjamin Franklin, Thomas Jefferson, and George Washington in a Roman toga. These reside in major American museums today. Antonio Capellano wrote the letter to James Madison (bottom left) requesting an appointment with Madison to sit for a portrait. Capellano fashioned a relief sculpture of Pocahontas in the U.S. Capitol, but he is most noted for his work in Baltimore, including statuary on the Battle Monument (1815-1825, below), one of the oldest existing monumental sculptures in the United States.

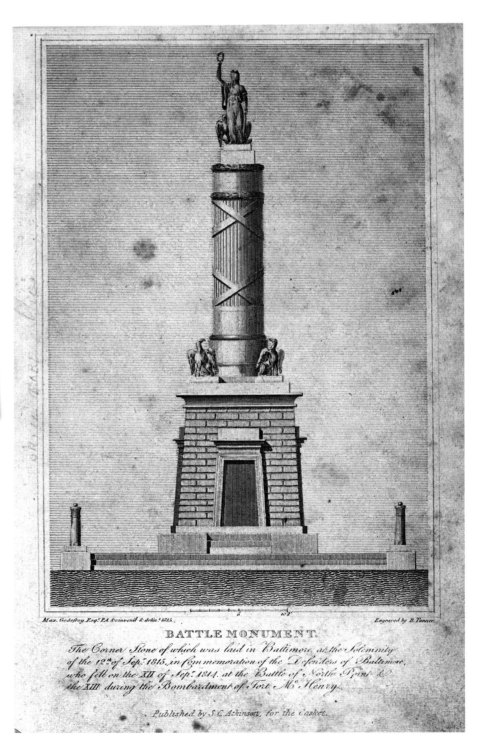

GIUSSEPE CERACCHI.
SCULPTOR.
Nat. 1760.— Ob. 1801.

From the original painting in the Trumbull Collection Yale School of Art.

Albert Rosenthal

Copy of Subscription Paper

NATIONAL MONUMENT.

BATTLE MONUMENT.

The Corner Stone of which was laid in Baltimore at the Solemnity of the 12th of Sep.t 1815, in commemoration of the Defenders of Baltimore, who fell on the XII of Sep.t 1814. at the Battle of North Point & the XIII during the Bombardment of Fort McHenry.

Published by S. C. Atkinson, for the Casket.

Michelangelo of Washington

Born in Rome to an Italian mother and a Greek father, Costan-tino Brumidi (portrait by Mathew Brady, right) left Italy after his support of the failed Roman Republic (1849). He became an American citizen in 1852. Brumidi applied to work on the U.S. Capitol in 1855, painting a fresco on the spot to secure the job. He brought a sensibility steeped in Renaissance art to his paintings, clothing many of his figures in classical dress. He wanted America's political and technical achievements to seem timeless and to convey the nation's power and wealth. He painted the frescoes, notably in the "Brumidi Corridors" in the Senate wing, directly onto the walls. His painting on the Capitol's dome (below) is an allegorical masterpiece. The center shows George Washington in heaven—he wears his American army uniform above a billowing drapery—flanked by figures representing Fame and War. The outer circle rep-resents freedom, inventiveness, maritime power, industry, the mechanical arts, and agriculture.

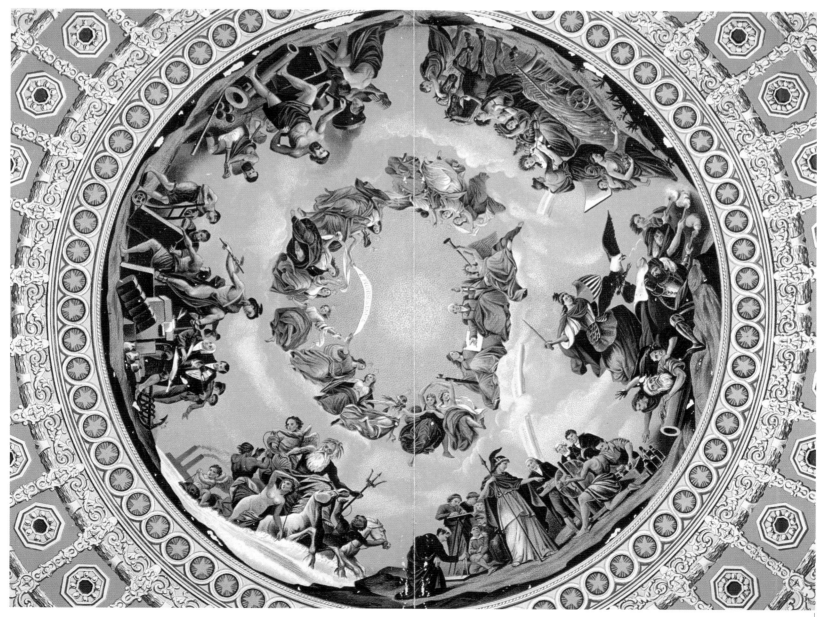

Artists of the Capitol

Filippo Mazzei recommended two sculptors to carry out Benjamin Latrobe's design for the new Capitol. Brothers-in-law Giuseppe Franzoni and Giovanni Andrei arrived from Carrara, renowned for its marble, in 1806. Franzoni's work included the figure of Liberty for the Senate chamber and a frieze representing Justice. The eagle in the frieze was modeled after the preserved head and neck of a real American bald eagle, an early instance of combining American symbolism with classical style. Andrei sculpted much of the architectural ornament, including mantels in the Senate chamber.

Statuary Hall (above), located in the old Hall of the House of Representatives, included work by Italians Enrico Causici and Giuseppe Valaperta. British forces burned down the Capitol during the War of 1812. Andrei's sketch of the destroyed House remains an important historical document. The photo (left) shows the east front of the much more elaborate rebuilt Capitol in 1858, with a view of Luigi Persico's sculptures "Discovery of America" and "War."

Lincoln from the Bronx

The majestic statue of Abraham Lincoln (left) in the Lincoln Memorial in Washington, D.C., was actually carved in the Bronx by the leading stone carvers of their day: Giuseppe Piccirilli and his six sons, Ferruccio, Attilio, Furio, Masaniello, Orazio, and Getulio, who immigrated to the United States in 1888 after Giuseppe had fought in the war for Italy's unification. Early 20th century sculptors, like Daniel Chester French who designed Lincoln, sent plaster models to the Piccirilli workshop. There, the brothers would transform them into the massive works of public art on view in American cities. In addition to Lincoln, the Piccirillis carved thirty figures for the Brooklyn Museum, the arch at Washington Square in Manhattan, the Tomb of the Unknown Soldier in Arlington National Cemetery, the Dupont Circle Fountain in Washington, D.C., and the famous lions outside the New York Public Library.

Furio and Attilio were sculptors in their own right. Attilio stands beside the memorial (below) that he designed to commemorate the loss of the Battleship Maine during the Spanish American War. It was placed at Columbus Circle at the entrance to Central Park in 1913. Furio crafted sculptural groups for the San Francisco Panama-Pacific Exposition. Their art grew out of their Italian heritage, but the Piccirillis considered themselves Americans. "Once I went back to my native city," said Attilio in 1938. "What did I find? I was a foreigner in Italy. I could speak the language but I couldn't think Italian. . . . I first *knew* that I was a real American when I brought my mother's body back from Italy. . . . We buried her here and I made a statue of motherhood for her . . . It is when you bury one you love in a country's soil that you realize that you belong to that soil forever."

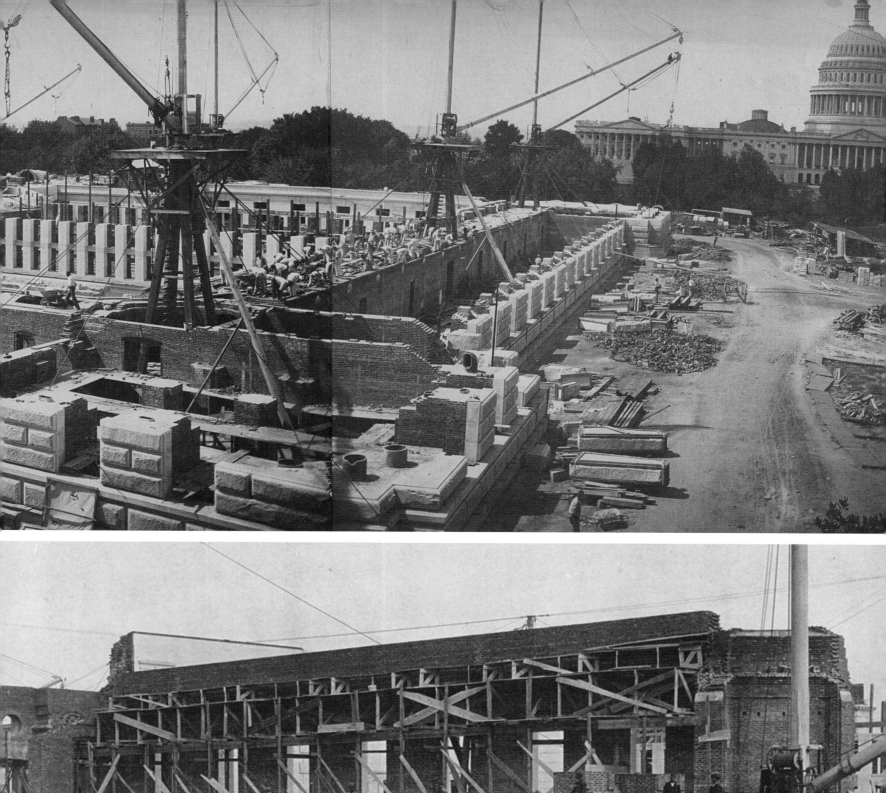
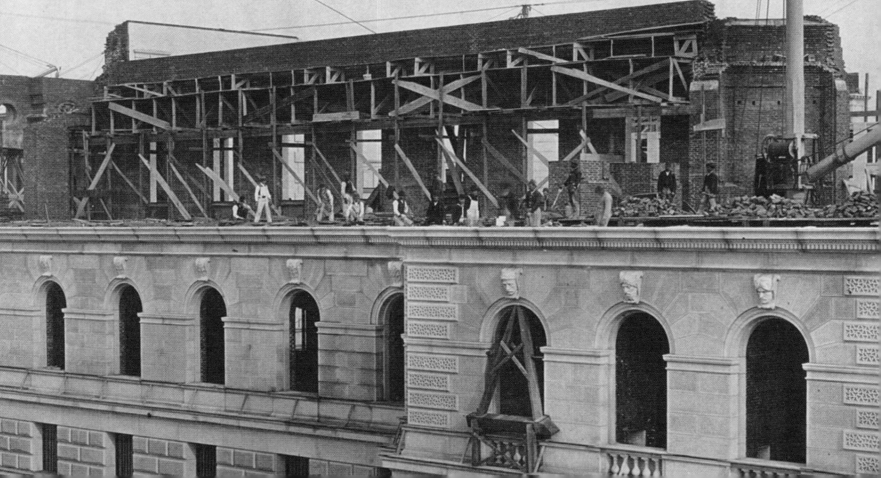

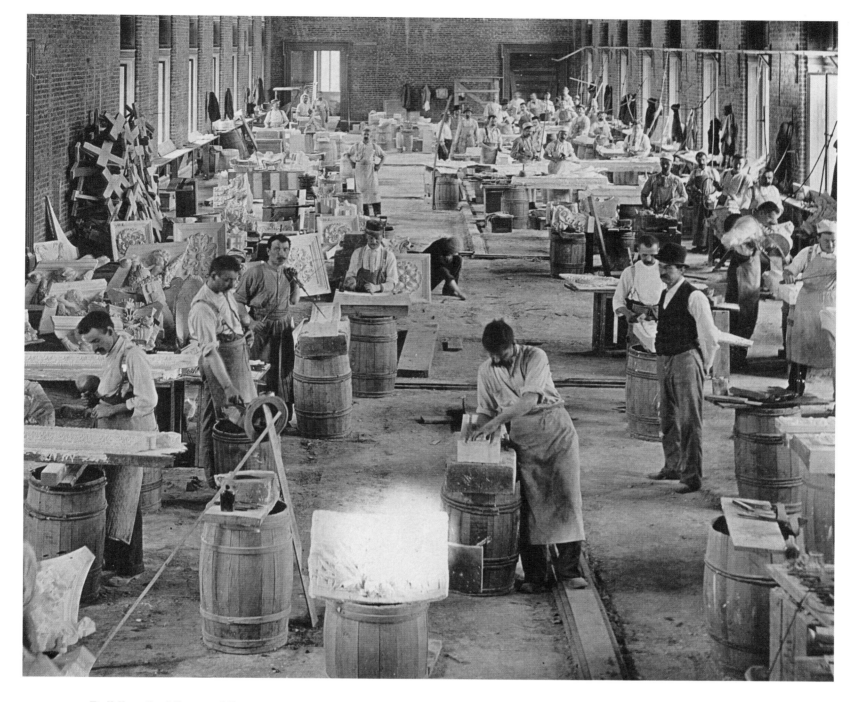

Building the Library of Congress

The Library of Congress was conceived to be as grand as the national libraries of Europe. "The National Library. . . should be more a museum of literature, science, and art, than strictly taken as a collection of books," Ainsworth Rand Spofford, then Librarian of Congress, believed. Since the founding of the United States, the Library had been housed in the Capitol. Spofford called for a separate structure. The foundation was laid in 1889 and the new building (now called the Thomas Jefferson building) opened in 1897.

Heavily influenced by Italian Renaissance architecture, the Library's many designers were nonetheless all American-born, but the artisans and craftsmen who actually fashioned the building included Italian marble carvers (above) and builders. The work of these men (also shown on the Library's exterior, facing page) was documented in three albums and numerous negatives and prints now in the Library's collections. The photos were taken by the studio of Levin Corbin Handy, a nephew of Mathew Brady's who continued Brady's work photographing historic events.

After an 1899 visit, Ugo Ojetti, a prominent Italian journalist, wrote of the new Library in *America vittoriosa*: "When, on the hill of the Capitol . . . for the first time you face the Congressional Library, you get the most radiant proof not only of the strength and the ambition of this new people, but also of its intellectual potential. . . . All their panting thirst for knowledge, for everything that was thought or dreamed of in the world—to completely dominate the past and the future since the present is quite certain in their hands—is clearly manifested here, in all its frenetic and almost childish exaggeration and in all the beauty of noble, proud, indomitable desire."

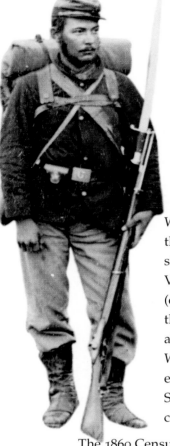

Fighting on Both Sides

Like Italy, North vs. South

Within four weeks of each other in 1861, Italy and the United States experienced two of the most significant events in their histories. On March 17, Vittorio Emanuele II became king of a united Italy (except for Rome and Venice) after the defeat of the Bourbon-governed South by Giuseppe Garibaldi's forces. On April 12, the United States Civil War began, pitting the North (Union) against eleven seceded southern states (the Confederate States of America), which threatened to divide the country forever.

The 1860 Census showed that some 11,000 Americans were Italian-born when war broke out. Combined with first generation Italian Americans, the number was still small compared to other immigrant groups like the German or Irish. Yet Italians and their descendants were just as enthusiastic about embracing the cause—either of the North or the South—as other immigrants. Many believed in the ideals Garibaldi had fought for, unity and liberty, and joined the Union forces (although the Union had no initial plans to end slavery). A smaller number, living in the South, fought with the Confederate States.

An estimated 5,000 to 10,000 Italians served in Civil War armed forces. Soon after the North declared war on the South, the Italian American newspaper *L'Eco d'Italia* called for the formation of an Italian Legion. At the same time the Garibaldi Guard was organizing, drawing veterans of the Italian wars who had fought with Garibaldi, as well as French, Spanish, Hungarian, Polish and Swiss troops. The Italian Legion soon merged with the guard. Officially, it was the 39th New York Infantry, but was better known by its popular name. Among its leaders were Alexander Repetti, a Garibaldi veteran, and Louis Tinelli, who owned a silk factory in New Jersey, both commissioned as lieutenant colonels.

Italians joined Confederate regiments as well, especially in Louisiana, where a number of Italians already lived. The Italian Brigade out of New Orleans included 341 soldiers with Italian surnames. One of these men was Raffaele Agnello, a Sicilian living in Orleans Parish who joined the Italian Guards Battalion. Soldiers who had fought for the southern Kingdom of Two Sicilies until it yielded to Garibaldi also

Colorful Troops

Italian volunteers served in Confederate regiments, but their first uniforms were more colorful than that of the New Orleans militia officer (above) drawn by the Civil War's most prominent artist, Alfred Waud. Like Italians in the North's Garibaldi Guard, they wore uniforms modeled after the famous Italian light infantry (the *Bersaglieri* of Sardinia). In the South, Italian soldiers wore the red shirts made famous by Garibaldi. In the North they wore Union blue coats over red undershirts and blue pants piped in red. Their cocked hats sported feathers in the Italian national colors of red, white, and green. This print (facing page, top) shows the Garibaldi Guard parading before President Abraham Lincoln and Union General Winfield Scott, carrying the "Dio e Popolo" Italian flag, as well as the U.S. Stars and Stripes.

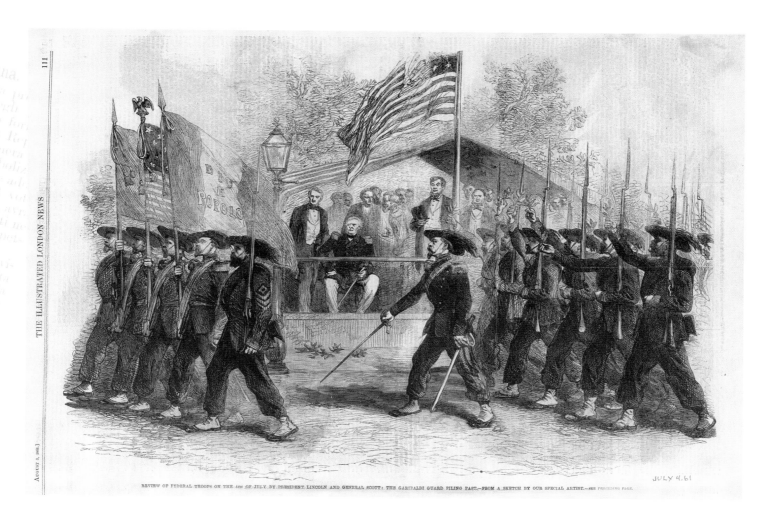

REVIEW OF FEDERAL TROOPS ON THE 4TH OF JULY BY PRESIDENT LINCOLN AND GENERAL SCOTT: THE GARIBALDI GUARD FILING PAST.—FROM A SKETCH BY OUR SPECIAL ARTIST.—SEE PRECEDING PAGE.

signed up to fight for the South. In both the United States and Italy at this time, cultural, educational, economic, and societal differences separated North and South. (These differences continued to be a factor in the 20th century.) In each country the North was more prosperous, urban and industrial, while the South was primarily agricultural and made up of large plantations or estates. In both Italy's and America's civil wars, the North turned out to be the winner.

Several Italians became noted officers. In the South, Joseph Santini recruited Italians in New Orleans. They formed their own Garibaldi Legion, led by Captain Santini. Decimus et Ultimus Barziza (the "tenth and last" child of an impoverished Venetian nobleman) was a captain in General John Bell Hood's Texas Brigade. He led a company at the Battle of Gettysburg, where, he wrote, "the trees were literally barked and thousands of bullets flew to atoms against the hard rocks." Taken as a prisoner of war, he escaped and returned to battle.

The Union's Italian leaders included Francesco (Francis) Spinola, appointed brigadier general by President Abraham Lincoln to lead four regiments he recruited in New York, known as the "Spinola Empire Brigade." Eduardo (Edward) Ferrero, born in Spain to Italian parents,

rose to the rank of major general. Enrico Fardella, a Sicilian nobleman and one of the few high ranking southern Italian volunteers who fought for the North, became a brigadier general, commanding the 85th and 101st New York State Infantry. Luigi Palma di Cesnola, who had served in the First Italian War of Independence and the Crimean War, commanded the 4th New York Cavalry.

The overall number of Italians fighting in the Civil War was not large, especially in the South. As the toll of war mounted, the South's Garibaldi Legion merged with a Spanish militia and became known as the European Brigade. The soldiers of the Union's Garibaldi Guard, despite casualties, did fight as a unit through the last campaign at Appomattox, Virginia, where the war ended in April 1865. Some Italian Civil War veterans, like Fardella, returned to Italy. Others, like Louis Tinelli and Cesnola made the United States their permanent home. The Union had been preserved, slavery was defeated, they had proved their loyalty, and their adopted country accepted their small number. But the fallout between Northern and Southern Italy after unification was underway and the first waves of thousands of Italian immigrants were about to reach American shores.

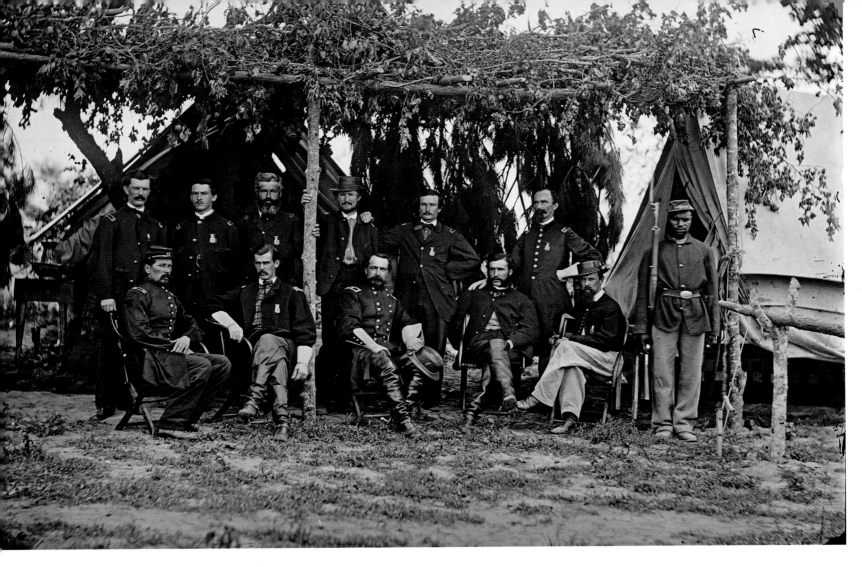

Italian Troops in the Union Army

This sharpshooter (left) was with the Garibaldi Guard (the 39th New York Regiment), but not all Italians and Italian Americans who joined the Union forces fought with the guard. In fact, many more served in other units, including the 51st New York Regiment and the 4th New York Cavalry.

Edward Ferrero, who immigrated to the United States as a small child and taught dancing to wealthy New York families, entered the war as a lieutenant colonel of the 11th New York Militia. He was assigned to lead several different brigades from 1861-1865. Cited for bravery at Antietam—one of the bloodiest Civil War battles—he was promoted to brigadier general. He eventually attained the rank of major general, and is shown (above), with his staff in Petersburg, Virginia, in 1864. During the siege of Petersburg, he commanded the Ninth Army Corps' "colored division." African American (then called colored) troops were segregated in the Union army and only led by white officers. Ferrero was one of the first to command black soldiers. In addition to Ferrero, more than one hundred Italians and Italian Americans were Union officers, including two naval commanders. It is difficult to estimate the exact number because Italians had already begun to anglicize their surnames or marry into non-Italian families.

Explorers, Emigrants, Citizens

The Garibaldi Guard

It is difficult to overestimate the honor and heroism credited to Giuseppe Garibaldi by Americans after his military victories. Coming on the eve of the Civil War, his prestige seemed even greater than it had during his stay in New York. The *New York Herald* praised the men who joined the Garibaldi Guard as veterans of "the glorious fields and strifes on Italian soil." The guard officially became part of the U.S. Army on May 28, 1861. *Harper's Weekly*, one of the most popular and influential magazines of the era, featured the guard in a full page spread (right) on June 8. The top image shows the presentation of colors (national and regimental flags) to members of the guard. The bottom image shows them marching in "double-quick" step up Broadway. They carried the original flag Garibaldi himself had carried throughout his 1848-1849 battles in Italy.

The symbolism of Garibaldi's leadership and patriotism united these men, but as immigrants—many newly arrived—the war gave them the opportunity to more quickly become Americans and to be accepted in their new country. The "Garibaldi War Song," written in 1861, proclaims: "Ye come from many a far off clime./ And speak in many a tongue/ But Freedom's song will reach the heart/ In whatever language sung/ Then wake your voices, let them ring/ From mountain-side to sea,/ In one glad chorus—'GOD PROTECT/ OUR HOME AND LIBERTY.'" The Garibaldi Guard fought in nearly every major Civil War battle in the eastern U.S., including Harper's Ferry, Gettysburg, the Wilderness, Spotsylvania Courthouse, Cold Harbor, the siege of Petersburg, Virginia, and Appomattox. The regiment lost 278 men during the course of the war.

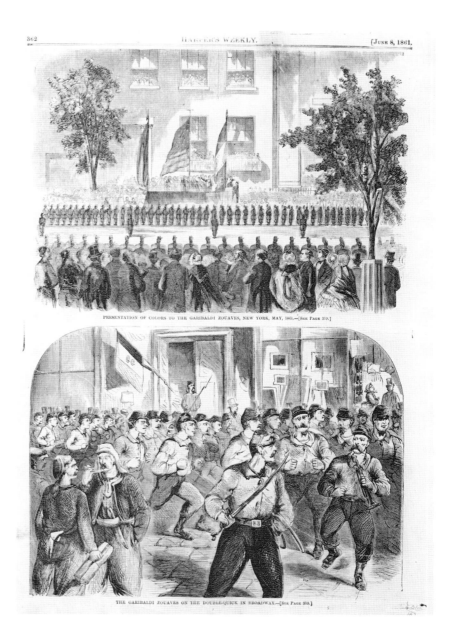

PRESENTATION OF COLORS TO THE GARIBALDI ZOUAVES, NEW YORK, MAY, 1861.—[SEE PAGE 359.]

THE GARIBALDI ZOUAVES ON THE DOUBLE-QUICK IN BROADWAY.—[SEE PAGE 359.]

25375 - 1

Lincoln and Garibaldi

In 1861, President Abraham Lincoln considered Giuseppe Garibaldi's offer to serve as a leader of the Union forces, but Garibaldi turned down the American terms specified by Secretary of State William Seward, that he be commissioned only as a major general. "He said that the only way in which he could render service . . . to the cause of the United States, was as Commander-in-chief," American diplomat H.S. Sanford responded to Seward, "and with the additional contingent power . . . of declaring the abolition of slavery."

When the Civil War began, Abraham Lincoln had not attempted to end slavery in the United States. Eleven slave-owning states had seceded, but four slave states had stayed in the Union, and he did not want to lose these states to the South. But after two years of war, Lincoln issued the Emancipation Proclamation on January 1, 1863, freeing the slaves in the Confederate States. Garibaldi and his sons, Menotti, and Ricciotti, praised Lincoln in this letter to him (left), dated August 6, 1863. "If our voice can still reach you among the clash of arms, oh Lincoln, please let us, as free sons of Columbus, send you a greeting and admiring word," they wrote. ". . . You will be remembered for eternity as the Emancipator, a word more enviable than any human honor. Dignity, charity and love was restored to a whole race of men, enslaved by selfishness of other men, and the price for it was paid by noble American blood."

L. Di Cesnola

Luigi Palma di Cesnola: General and Adventurer

Luigi Palma di Cesnola (left), the son of an Italian nobleman, fought in the First Italian War of Independence and in the Crimean War. He arrived penniless in New York in 1860, and gave Italian and French lessons. But his fortune changed when he opened a military academy on Broadway. The sign outside read "War School of Italian Army Captain Count Luigi Palma di Cesnola." He trained more than seven hundred students in the basics of warfare. Many of them became officers in the Union army, including Cesnola himself, who started as a lieutenant colonel with the 11th New York Cavalry Regiment.

Cesnola had a strong personality, fearless but impetuous. His men loved him, but he exasperated authority. Once his superior officer arrested him during battle for not following orders; he leaped into the fight anyway, without a sword. The officer was so impressed, he rescinded the arrest order. Soon after Cesnola was taken prisoner by the Confederates and placed in Libby Prison (below right) in Richmond, Virginia. He could have been released in a prisoner exchange, but the Confederates held him longer because they were so irritated by his constant complaining. Cesnola wrote about his experiences in a small book (bottom left). There was no doubting his bravery, however; he received the Congressional Medal of Honor in 1897 for his action at Aldie, Virginia.

After the war, Cesnola was appointed U.S. consul to Cyprus. He became the island's foremost archaeologist. "With [the] creativity of an artist . . . the doctrine of an archaeologist, the fierceness of a soldier, the persistence of a mountaineer, he attended the study, the interpretation of texts, the comparisons, the explorations, the digging, and the classifications," wrote Italian Giuseppe Giacosa in *Impressioni d'America* in 1908. He also became the first director of New York's Metropolitan Museum of Art, which bought his Cyprus collections. *Harper's* wrote, "The importance of [his] discoveries ... can hardly be overestimated."

TEN MONTHS IN LIBBY PRISON.

BY LOUIS PALMA DI CESNOLA,

LATE COLONEL 4TH N. Y. CAVALRY.

Colonel Cesnola is a Sardinian of noble family, and was educated in the best military schools of Europe, having been placed in that at Paris when only nine years of age. His father was at that time Secretary of War under the Sardinian government. The son came to this country just before the breaking out of the rebellion, and hostilities quickly elicited his enthusiastic interest in the cause of the Union. Having had experience in the Crimean war, as a member of the staff of the Sardinian General-in-chief, he was well qualified for the duties of the field. In September, 1862, he took command of the 4th N. Y. cavalry, whose superior discipline and many brave achievements have gained for it an enviable fame. At the battle of Aldie, June, 1863, he was commended for his gallant conduct by General Kilpatrick, early in the action, but afterwards, while far in the advance, he was surrounded by superior numbers, and taken prisoner. He spent ten months in Libby prison. After his exchange he returned to his regiment, and led the brigade to which it belonged in many severe engagements previous to its mustering out, in September last.

Soon after entering Libby, the rebel officer in charge, offered Colonel Cesnola, with some other *foreigners*, better quarters than their fellow officers had, which proposal was indignantly rejected. "We are U. S. officers," they said.

I entered the service of the United States in October, 1861, and was captured in Virginia the 17th of June, 1863, at the cavalry engagement of Aldie. I was marched, mostly on foot, more than one hundred miles to Staunton, and thence by railroad conveyed to the rebel capital and confined in the Libby prison. I arrived in Richmond the 25th of June, at about four o'clock in the afternoon, and remained immured in that tobacco factory until the 24th of March, 1864, when I was specially exchanged for Colonel Brown of the 59th Georgia, (———) regiment.

SEARCHING FOR VALUABLES.

At my arrival in Libby I was called into the office of the commanding officer of that military prison, Captain (now Major) Thos. P. Turner, and by him, my name, rank, regiment, etc., was registered in his book; the walls of Turner's office were covered with captured U. S. colors, regimental battle-flags, and cavalry guidons. From that office I was ordered into a spacious dark hall, in a corner of which, a rebel seargeant searched me through from head to foot, in the roughest manner possible. He took away from me every little trinket I had, my penknife, eyeglasses, meerschaum-pipe, matches, and a bunch of small keys; and was angry because he could not find any greenbacks on my person. He ordered me to take off my boots for inspection; I answered him that I always had a servant to perform that service for me. He insisted, but I refused until he took them off himself, and searched them very minutely. He asked me what I had done with my money, and if I had any watch. I told him that a chivalric Southron had stolen my watch and money during the march from Middleburg to Staunton. He began to abuse me, using very profane language and denying my veracity. I told him that perhaps the gentleman intended only to borrow those articles from me. Captain Fisher, a signal officer of the Army of the Potomac, was punished and kept walk-

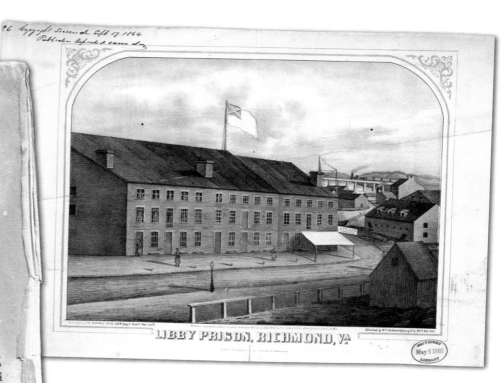

LIBBY PRISON, RICHMOND, VA.

CYPRUS:

ITS ANCIENT CITIES, TOMBS, AND TEMPLES.

A NARRATIVE OF RESEARCHES AND EXCAVATIONS DURING TEN YEARS' RESIDENCE IN THAT ISLAND.

BY

GENERAL LOUIS PALMA DI CESNOLA,

MEM. OF THE ROYAL ACADEMY OF SCIENCES, TURIN; HON. MEM. OF THE ROYAL SOCIETY OF LITERATURE, LONDON, ETC.

Explorers, Emigrants, Citizens

Harper's Ferry

Harper's Ferry

The Battle of Harper's Ferry took place from September 12-15, 1862, in the state of Maryland. But in its way, it was an extension of the fight for Italian unification (the period known as the *Risorgimento*)—the northern regiments included the Garibaldi Guard, with veterans of the victorious northern kingdom of Sardinia; while the South sent in the 10th Louisiana Regiment, composed of former soldiers of the Kingdom of Two Sicilies, which had recently suffered defeat at the hands of Garibaldi's forces. The famous Confederate general Stonewall Jackson led the southern troops against the Union, which tried to defend their strategic position on Maryland Heights. Alfred Waud's drawing (left) shows soldiers camped beside ruins destroyed by Jackson's fierce artillery barrage. The South decisively won against union commander Dixon Miles, taking more than 12,000 Union prisoners; some of these were from the Garibaldi Guard. For the Italian soldiers in the 10th Louisiana, the victory was a kind of revenge for their defeat in Southern Italy. The red-shirted *Garibaldini* captured—those who weren't killed—were forced to spend time in prison. The Union soldiers also earned the nickname "Cowards of Harper's Ferry," for their weak defense.

NOTES AND OBSERVATIONS —on— Army Surgery,

BY

Dr. F. FORMENTO Jr.,

SURGEON IN THE FRANCO-SARDINIAN ARMY DURING THE ITALIAN CAMPAIGN OF 1859; LATE CHIEF SURGEON OF THE LOUISIANA HOSPITAL OF RICHMOND, etc.

Hospitals and Prisons

Dr. Felix Formento Jr., born in Louisiana to Italian parents, served as a surgeon for the Sardinian army during the wars for independence. In 1860 he returned to the U.S., becoming chief surgeon of the Louisiana Hospital of Richmond, writing about his experience (right center, and below left). The Confederate hospital near Richmond (below right) shows how medical facilities were often improvised from cabins and tents. Doctors did not understand about modern hygiene and medicine was often scarce. Prisons like Libby were even more crowded, unhygienic, and lacking in necessities.

BIBLIOGRAFIA.

Notes and Observations on Army Surgery.—PEL DR. F. FORMENTO, Jr., ETC. NUOVA ORLEANS, 1863.

L'autore dell' opuscolo qui sopra annunciato era già favorevolmente conosciuto pei buoni e rilevanti servigi da lui prestati come chirurgo negli eserciti franco-italiani nell'ultima guerra di Italia, in modo speciale sui campi di Magenta e Solferino.

Appena questo egregio giovane seppe vicina una guerra fra Italia, Francia ed Austria, lasciò la sua numerosa clientela in Nuova Orleans, ove risiedeva, ed accorse ai patrii lari. Ciò fa vedere quanto nel suo cuore sia fervente l'amore di patria, del grande, del bene, e dell'umanità.

Il padre del Dr. Formento praticò eziandio con grande successo la medicina in detta città, ed ora trovasi ritirato a Vercelli. Quell'illustre Italiano lasciò nella metropoli della Luigiana un

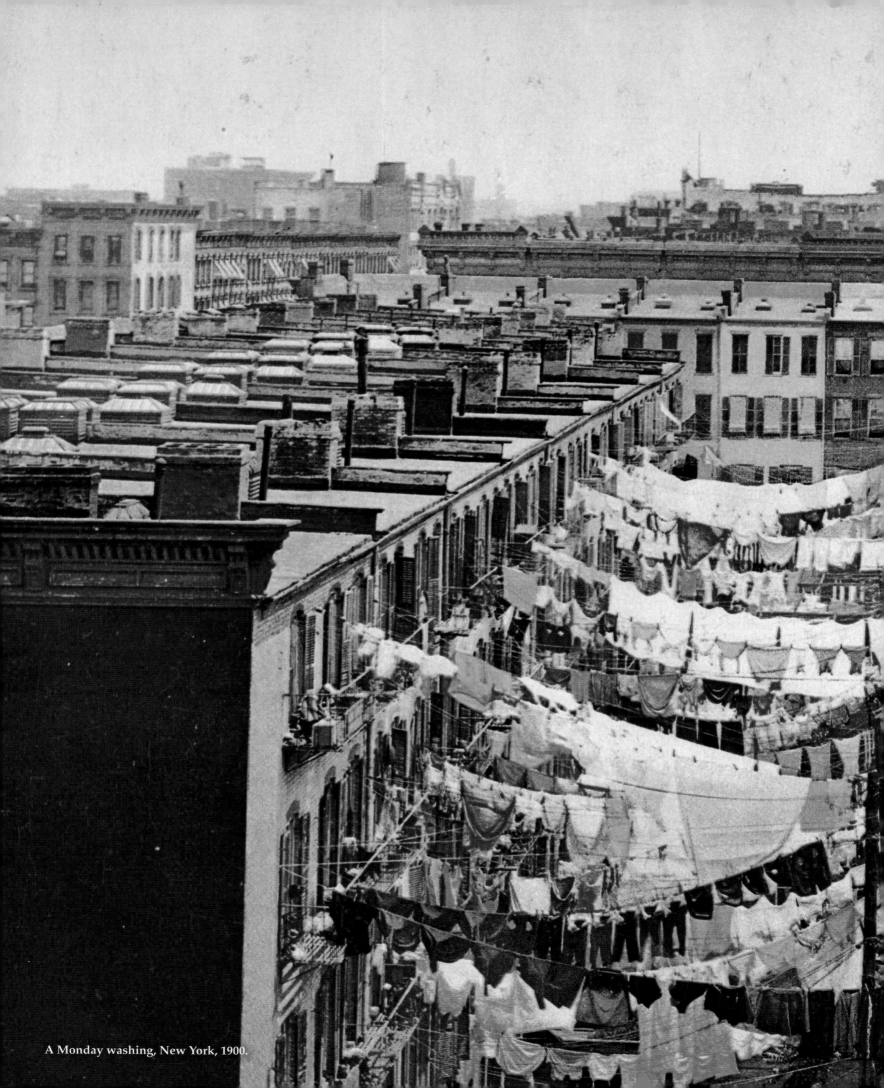

A Monday washing, New York, 1900.

EMIGRANTS
Seeking the Land of Opportunities

The New Discovery of America, Traveling Steerage

Antonio Canovi

Cristofiru Culumbu, chi facisti?
La megghiu gioventù tu rruvinasti.

[Christopher Columbus, what did you do?
You ruined our best youth.]
Calabrian emigration song

This is a song describing America as a painful experience of alienation from Italy, starting with the trip on the *vapore* (the steamship) across an ocean that appeared ever larger and unrecognizable from the point of view of people leaving behind the relatively small Mediterranean Sea.

The next discontinuity was experienced in the landscape awaiting them: such a "great" continent confused all certainties of the "small" world that the immigrant was carrying in his suitcase. In individual experiences, transition between the old and the new would lead to ambivalent results. The "promised land" became, for many, a "bitter" America, beginning with the Atlantic crossing, for the vast majority in steerage, which belonged almost exclusively to poor emigrants. Italian novelist Edmondo De Amicis in his book, *On the Ocean*—which upon its release in 1889 sold ten editions in two weeks!—wrote an admirable sociological analysis of what it meant to board a vessel built for the transportation of emigrants:

> And it was not only a large village . . . , but a small state. In the third class, there were the people, the bourgeoisie in the second, the aristocracy in the first, the captain and officers represented the Government, the Commissioner the judge.

The proportion between classes, at least on *Nordamerica*, the ship boarded by the writer, illustrated the importance of the "social question" exaggerated in this case: fifty passengers in first class, twenty in second (he noticed with a hint of bitterness that among them many were old priests), 1,600 in steerage! In addition there were two hundred crewmen. Room for each traveler was not equivalent, as the reading of the logbooks suggests (in Genoa there is an extraordinary collection of logbooks). "Poor people," De Amicis observed with intense emotion, "fit in and fill every interstice like water."

Of course, one must remember that navigation during the 19th century introduced many innovations. The first steamship, an American invention, went from New York to Albany in 1807, but one had to wait until 1843 for the first propeller driven iron ship, the *Great Britain*. And the application of steam to different machines—to work the land, to travel—would also affect the great agricultural crisis that brought European agriculture to its knees between 1873 and 1896, with internal cycles of recovery and relapse. How could people compete, in fact, with the mechanical harvesters and threshers tested by Cyrus McCormick in the vast plains of the Midwest? He too—the story has to be at least outlined—was an emigrant: he arrived in Chicago in 1847, after years spent in a vain attempt to make his way with his inventions in England where agricultural labor at a low cost abounded. Once he filed the first patent, he went from hays to grains, then to the harvester: a machine that marked a point of no return in the revolution of agriculture, giving the United States a headstart of a century over Europe.

While seeds and vegetables went to European ports, a current in the opposite direction was starting to mount. The technological revolution of the steamboat brought with it a social upheaval—mass migration—in which we are still immersed. Before mass migration the so-called *redemptioner system* was very common; it was a form of "indentured servitude" under which the merchant or captain of the ship, in exchange for transportation from Europe, acquired the exclusive right to the services of the emigrants for a period of three to ten years. This system was used before the introduction of slavery from Africa and was common especially among German emigrants until its collapse in 1817, when legal emigrants, with official permission to travel abroad, reached their new maximum.

In the 19th century, America became a much more reachable and affordable destination. Both political refugees and migrants looked at it with mutual sympathy; England and the United States were the two countries in which right of asylum and immigration closely intertwined. The first arriving in large numbers to the American shores were British, Germans, and Scandinavians, along with the Irish, who were oppressed politically and decimated by famine in 1845. This event forced the departure of one fifth of the population, many of whom were in very poor health: it has been calculated that in 1846, out of 90,000 Irish emigrants, 15,000 died during the crossing, while between one third and one quarter of those who disembarked ended up in hospitals in the ports of arrival. The horror of too many crossings, marked by overcrowding and outbreaks of diseases, however, would not stop what Robert Foerster—by observing the migration habits of Italians—called "proletariat globetrotting."

Why does Italy stand as a paradigm of the great contemporary migrations? The first reason is connected to the fragile condition of the new economic and political status of the Italian kingdom; the second, equally influential, is connected to the feeling of contempt and harassment shown by Italian ruling classes against a population maintained in its vast majority in the condition of illiteracy. The Italian consul in Le Havre (France) called them "the plague of our colonies": the human procession advancing near the harbor, composed of poor wanderers, musicians, acrobats, accordion players, conductors of performing beasts, charlatans, youth, children, etc. According to economist Leone Carpi, in 1870, of every 105 people leaving, some eighty-five came from the countryside. And a Neapolitan physician, during the investigation conducted on emigrant children in 1867, would draft this grim statistic: out of every one hundred children (of both sexes) leaving the country, only twenty would return, thirty would settle in different regions of the world, and fifty would succumb to disease, deprivation and ill-treatment. It is not a coincidence that *Cuore*, a very popular children's book written by Edmondo De Amicis in 1886, contained two tales dedicated to the wars of the *Risorgimento* ("The Little Vidette of Lombardy" and "The Sardinian Drummer-Boy"), and three relating to children emigrating: the Ligurian brave boy who sets out in search of his mother in Argentina; the young Sicilian who escapes a shipwreck and gives way in the lifeboat to an Italian girl he just met; and the small proud Paduan patriot sold by his parents to a charlatan.

People going to the Americas—as the scholar of migration Emilio Franzina puts it—were not Italian, they were *paesani* (villagers) by the millions. To avoid inspection of travel documents, quite a few left from foreign ports; often, especially in the early years, they boarded ships run by non-Italian companies. The only Italian ocean line, created in 1881 by the merger of Florio and Rubattino, was the Navigazione Generale Italia. In the same period, Italian ports were crowded with British companies (Prince Line, Dominion Line, Cunard Line, Anchor Line, White Star Line) and German companies (Hamburg America Line, Lloyd Bremen). In 1912-13, at the pinnacle of Italian migration, half of the emigrants were traveling on non-Italian ocean liners. Prices for the tickets sometimes were exorbitant, not to mention the many openly fraudulent episodes against the emigrants. However in general, according to German scholar Klaus J. Bade, a vertical drop of prices along with more efficient means of navigation, lowered the prices to the point that, according to his calculations, after 1880 a ticket to the Americas would cost less than a railroad trip from northern Italy to the north of Germany.

Complex dynamics affected the price of the trip, related to the expectations of migrants and those of governments. The massive departure of Venetian peasants emigrating to Brazil—about 250,000 between 1891 and 1897—was certainly related to the agrarian crisis, but it was boosted by an extensive direct grant (to be used to cover travel costs) issued by the Brazilian federal state of Sao Paulo. After news started to come back from that country speaking of the real condition of servitude which Italian immigrants were suffering in the plantations (they had been called to replace the slaves freed by decree), the Italian government attempted to put a stop to departures. This effort did not meet with the expected success, for the simple reason that there was no credible alternative being offered to the emigrants. Beyond the humanitarian reasons given, the real dispute concerned the power exercised by governments on emigrants.

The Italian government, in particular, could never decide if emigration was desirable or rather a phenomenon that

had to be opposed with disdain, portrayed as dangerous to public order. Who would continue to cultivate the fields if every day laborer emigrated? Ministerial measures, issued first by the Ministry of Agriculture (circular Lanza, 1873), then by the Ministry of the Interior, tried to slow down emigration, but they tackled the problem inconsistently and never solved the eternal dilemma. In 1887, for example, Prime Minister Francesco Crispi came up with a decree that would prevent the release of passports to emigrants with a free passage—a measure that lasted for just two days, demonstrating the lack of power of the Italian government in the international geopolitical context. He tried again some time later (December 30, 1888), following the same path of vacuous patriotism and substantial disregard for the fate of the emigrants. It was not until 1901 that a culturally coherent law was issued, with the creation of the *Commissariato all'emigrazione* (Committee for emigration) and the transfer of the authority over emigrants to the Ministry of Foreign Affairs. Ostracism against manual workers, however, remained as a constant in the policy of the Italian government. The real emigrants found themselves undergoing their migratory journeys, suffering both from a sense of distrust of their own government and from the lack of a national strategy on emigration.

In this context, it is easy to understand the stigma against agents of navigation companies, rebuked by an otherwise moderate religious personality like bishop Giovanni Battista Scalabrini, founder of the most important religious order committed to the assistance of emigrants, known as *Scalabriniani*. In his book *L'emigrazione italiana in America: osservazioni* (1887) he dealt with the evolution of Italian emigration. Emigrants were starting to show a massive preference for America. Scalabrini's point of view showed an unprecedented agreement on migration issues between the Church and the government (remember that Rome had been conquered from the Vatican at gunpoint by the Italian army in 1870). The political design was to encourage a process of "economic colonization," with the assistance of clerical orders (he created the *Società dei missionari per gli emigrati italiani in America*, the Missionary Society for Italian immigrants in America) and in strong opposition to the legalization of a mediating role for agents of navigation companies. However, microhistory research shows that agents acting as "middlemen" did not always seem to be malevolent towards emigrants. One example is that of Ruggiero Manzieri, who acted as a "sub-agent" for emigration in the rural village of Santa Vittoria di Gualtieri (near Reggio Emilia) in the 1880s, and became in turn an emigrant to Argentina. There he was registered by the Italian political police as belonging to the anarchist movement.

Historical documents show that mass emigration, at least in its early days, became one of the instruments in the hands of the workers to influence job recruitment in their favor. It is worth noting that, in the early 1880s, in the countryside near Mantua and then along the entire Po River, a chant had begun to rumble: *La Boje, la boje, e de boto la va de fora!* (It boils, it boils, and all of the sudden it goes out!). What was boiling was the rage of poor laborers of the Po Valley. By studying social dynamics—as Marco Fincardi, a historian specialized in social issues, documented well—we realize that wage claims and migration to other labor markets belonged to the same political strategy. The words of political songs help to convey the idea of what was at stake: *Su bravi, o signorini/gettate gli ombrellini,/gettate i vostri guanti,/ lavoratevi i campi:/noi andiamo in America* (Come on gentlemen / throw away your parasols, / throw away your gloves / go work your fields / we are leaving for America). The same goes for *Lamento di italiani prima di partire per lo stato felicissimo di Francia* (Complaint of Italians before leaving for the delightful country of France), a pamphlet printed in the valley town of Gonzaga in 1882. In it, author Cesare Rossi wrote: *E voi altri affittuari/che fin'or approfittando/di noi poveri somari/cui sfruttaste imbrogliando;/quando privi di noi sarete/la zampogna suonerete* ("To you, landowners / who until today took advantage / of us poor donkeys / whom you exploited and cheated / when you will be without us / you'll play your bagpipes.") The last sentence is probably referring to the Italian saying "con le pive nel sacco" which means being left with nothing.

The Po Valley region, in the northern part of the country, was undergoing a deep transformation in land management. Between 1887-1888, laborers started to feel a strong need for new perspectives. This is when women started to leave; they left with their men, and their children to join the men who had already emigrated, or even—a few began to do it—alone. The great emigration started earlier and came

more heavily from the more advanced areas of Northern Italy responding to the inherent logic of globalization processes: for example, the railway network was more structured in the North, and trains, along with goods, moved men.

Even when going far away to America, Italians attempted to preserve their peculiar way to emigrate. Until they started going to the United States in large numbers, many had practiced a "back-and-forth" migration, according to the seasons; or their migration plan took into consideration the trip back. It has been calculated that half of the migrants left in the spring, worked abroad during the autumn and went back to Italy in the winter, just like swallows. But if migration cycles were closely modeled upon those of seasonal crops in Argentina and in South America, things were less linear in the United States. It should be remembered that the U.S. was a late choice for emigrants, especially for those from the regions of Southern Italy. In 1880, when the Po Valley was the primary source of emigration, no more than 5 percent of Italian immigrants followed the route to New York or Philadelphia; one generation later, with the Apennines of Calabria and Lucania and with Sicily hit by the migration fever, these destinations absorbed up to 43 percent of departures.

The reasons for this change can be found on both sides of the migratory journey. It has been observed that Italians, especially when coming from the South, maintained an extreme flexibility both in the choice of destination and in the sector of employment, when compared to other contemporary European flows. While South America had the best conditions for a more rapid assimilation of immigrants from Southern Europe, the United States had far more extensive labor markets, with a wider range of jobs available for unskilled laborers and with comparatively high wage levels. Emigrants could compensate for the cost of the trip (one that did not enjoy the financial support of the government, but on the other hand was faster). There is yet another fundamental aspect of the system to be remembered: the internal transformation of the United States during the years of Reconstruction following the Civil War, from a rural country to a country with large industrial cities. The large majority of agricultural workers from Southern Italy intended to leave behind their condition as poor farmers, and they did it by investing in new American cities—even if they had to start from the lowest professional steps (low-skilled jobs in industry and services) and had to live in very poor housing. By adapting to unbelievable working and living conditions, the *paesani* were able to reach the horizon of the New World.

Who were the millions of Italians denied the right to full citizenship in the new Italy, unified under the banner of the Savoy monarchy? Unfortunately, we have many police reports and very little national literature to answer this question. This absence can be explained—according to the Marxist philosopher Antonio Gramsci—by the substantial disregard shown by the Italian ruling classes towards the working classes. During his long and deadly imprisonment imposed by Benito Mussolini, Gramsci wrote that the fact that the Italian literary world did not find a way to deal with emigration abroad "should be less surprising than the fact that scholars did not deal with it before people left the country . . . that they did not deal with the tears and blood that mass emigration represented, first in Italy then abroad."

In other words, despite the *Risorgimento*, the Italian government maintained a despotic attitude, treating workers as slaves rather than as citizens. The economist Albert O. Hirschmans explicitly suggests the idea that Italian mass emigration was a silent social protest: seeing that their right to vote was denied, "they voted with their feet." As we noticed, the alternative between emigration and commitment to Italian unions and political organizations was not so clear-cut in reality, while there is no doubt of the lack of recognition immigrants suffered with regards to history (and geopolitics). Only in recent years, the historical significance of that huge, momentous movement of men and women has been acknowledged. By looking at the numbers, it is clear that emigration represented a fundamental safety outlet for Europe, unable to provide a political response, even if only in terms of food, to a tremendous growth in population. The "old" continent went from a population of 180 million in 1800 to about 266 in 1850, to 328 million in 1882, to 428 million in 1910: an increase of 248 million people equalling a 140 percent increase! And let us not forget that at the same time about 60 million people (fifty to fifty-five in net figures) became "exiles" by emigrating overseas.

It then becomes important to understand to what extent emigration was a way to extend, as long as possible,

the social relations that had been crystallized since the Restoration (after 1815). Also, for those who decided to leave, was emigration a real change of social status? These questions deeply influenced the biographies of poor peasants and artisans willing to flock to America, after being denied any expectation of continuity in their traditional community work. Scholars of migratory systems point out that proletarian masses in motion were not open-minded global players. Then and now, large migrations are forged in the heat of tensions between the constraints dictated by social context and the room left for individual choices. On one side there is the macroeconomic perspective called *push and pull*, where for every departure, no return is expected; on the other there is a more complex consideration of the consequences of the migratory journey in terms of construction of a transnational space. The latter is the perspective that, beyond rhetoric, is expressed in the heartfelt words written in 1909 by Pasquale Villari about Calabria:

> In the South, where devotion to one's hometown seemed so tenacious as to make it impossible for a true migration to start, these constraints were suddenly broken, and in recent years it began a sort of collective emigration, which has almost no other example in history. Entire villages were emptied, and their population, with the parish priest leading the way, crossed the Atlantic Ocean to go to the United States.

Villari, a scholar deeply interested in understanding the social and historical truth about the South of Italy, felt that the country was facing a pivotal landslide that left him baffled. Not only young farmers, but whole families, and even the notables were leaving their homeland. It was the procession of the exodus, and it was not relegated to "poor" Calabria: a generation before, in the countryside north of Modena, with the open dissent of authorities, there had been a similar collective departure (to Brazil that time).

What made emigration to the United States different was the prevalence of informal migration chains, with no institutional stakeholders involved, even though there have been a few attempts to establish Italian colonies. Sicilian enclaves, built along the navigation route Palermo to New Orleans, are well documented along the Mississippi, with many Italians ending up in the sugar cane plantations of Louisiana and Arkansas (Sunnyside). The scholar Ilaria Brancoli Busdraghi described the settlement of stonecutters coming from the marble quarries of Carrara to Barre, Vermont. Other destinations derived from available jobs along the railway lines, in small towns in the Northeast and Midwest, and close to the mining regions: Dilworth on the border between Minnesota and North Dakota, Old Forge in Pennsylvania, Hurley in Wisconsin, Cle Elum in Washington State, Boise in Idaho, and Pueblo in Colorado. In California, New Asti (founded by Andrea Sbarboro), New Lodi, and Cloviso (with the contribution of immigrants from Canton Ticino, through the Italian Swiss Agricultural Colony of Pietro Cesare Rossi) brought the Italian wine culture.

Although Italian settlements might be found deep in the heart of America, numbers speak for themselves. Italians are almost absent, today as yesterday, in vast regions of the South (except Florida and Louisiana) and in the West (except Nevada and Colorado), as their focus remained in large cities of the East, in Illinois and California. There is a definite historic conjunction that must be taken into account. After the American Civil War, when the race to the western frontier restarted, mostly English, Irish, Germans and Scandinavians were landing in the major ports of the East. The Homestead Act (1862) was a tool designed to attract new immigrants, coming with their plows to colonize an "empty" space extending beyond the Appalachians on to the Rocky Mountains and the Pacific Ocean. (Actually it was populated by millions of Native Americans and by huge herds of buffalo, both slaughtered in the process of building the frontier.) Each family would get a free allocation of eighty hectares, only by committing to plough it. The great race to the West lasted the time of a generation. A symbolic date was May 19, 1869, when the two railway lines coming from the East (Union Pacific Railroad) and West (Central Pacific) met at Promontory Point, Utah. In 1890, after the massacre of American Indians at Wounded Knee and the creation of the states of Wyoming and Idaho (the previous year, South Dakota, North Dakota, Montana, and Washington had been admitted in the Union) the "frontier" was officially closed. Meanwhile, the United States had purchased Alaska from Russia (1867), getting rid of any rivals on the American soil. After only a few years the war with

Spain broke out (1898), followed closely by the American expansion in the Pacific area (the Territory of Hawaii was incorporated in 1898).

Once the geopolitical boundaries of America had been drawn, the spirit of the "frontier" turned inward. At an incredible pace, it transformed the country from a "rural republic" to an "urban nation," polarized around major metropolitan cities and industrial areas. Starting from the 1880s, living in the United States generally meant experiencing life in the city. In 1830, one out of every fifteen Americans lived in towns of eight thousand or more inhabitants. The ratio became one to six in 1860 (when no American city was yet over one million citizens) and one to less than three in 1890 (when New York jumped to 1.5 million inhabitants, and Chicago and Philadelphia to one million each). The phase change in mass migration, going from old to new immigration, took place between 1882— with the peak of arrivals from Anglo-Saxon and Northern Europe—and 1896, when the majority came from Eastern Europe (Russia, Austria-Hungary) and the Mediterranean (with Italy leading). In the new context, the sociological type of the uprooted became prominent: the immigrant who—lacking the space and the opportunity to spread in the fields of the West—stopped in eastern coastal cities, therefore being uprooted from his European background made up of small villages and countryside.

After 1900, Italians became the emblems of the new immigration. First, because of their number: between 1881-1890 they accounted for 5 percent of the arrivals in the U.S., up to 26 percent in 1911 and in 1915. At the beginning there was a substantial balance of immigrants coming from the North, Center and South of Italy, while in the years of maximum intensity, four out of five left from the five southern regions that once formed the Bourbon Kingdom: Calabria, Campania, Abruzzo, Molise, and Sicily. Regions with a lower migration rate at the time, such as Lazio, Puglia, Basilicata, and Umbria, also showed a clear preference for U.S. destinations.

Ira A. Glazier, along with many other scholars of the migration phenomenon, pointed out that "they were the children of a pre-modern and traditional social order in an advanced stage of disintegration." Their roots were mostly rural, with a significant portion of artisans; in the vast majority they were illiterate; these facts only partially explained the distrust that was reserved for them by the urbanized American society. Rudolph J. Vecoli stressed the fact that they emigrated in groups of villagers, relatives and neighbors, usually under the guidance of someone who had already made the journey. This kind of choral travel to unknown lands, and of tight-knit settlements after the landing, was not a peculiarity of Italians. However, it is interesting to recall how the "migratory chain" became an interpretative category after observing Italian immigrants in Australia (John and Leatrice MacDonald, 1964).

The diplomat Luigi Villari, in 1912, wrote of immigrants of Italian origin in New York: "In some neighborhoods there are exclusively people from a given region; in one we do not find but Sicilians, in another only people from Calabria, in the third from Abruzzo; in this street we have the colony of Sciacca, in that one the colony of San Giovanni in Fiore, in the other one the colony of Cosenza."

Geo-historical references show the persistence over time of some migratory chains. Samuel Baily created the interpretive category of "village projected to the outside." Following this interpretation, the social and historical importance of Little Italy, not as mere folklore, can be assessed. Why were Italians, more than Russians or Poles, able to activate so much passion and so much discussion around their community settlements? The first reason, as widely documented by historians of Italian American issues, was due to the documentary genre used to represent the lives of immigrants: photography. The photographs taken by Jacob Riis, reissued at the end of the 1880s in the book *How the Other Half Lives - Life in the Tenements*, contributed to the rise to fame (but Italian Americans would probably say the "curse") of Mulberry Street in New York's Little Italy. The location in the heart of Manhattan of this Italian "colony" was clearly an important example of this new urban type. In 1891—as reported by Donna R. Gabaccia—one of the editors of Rand McNally's guides, Ernest Ingersoll, urged tourists to go there for the "exotic" emotions of a place that was hard to believe was not in Naples. The largest Italian colony in New York was actually located further north, in Harlem, more precisely Italian Harlem (in the 1930 census it housed 89,000 Italians, with throngs of children). With

the crowded religious rituals—the miracle of San Gennaro on Mulberry Street, the procession of the Blessed Virgin of Mount Carmel, known as the Madonna of 115th Street in East Harlem—acting as testimonials, Americans approached Little Italy with a mixture of curiosity and fear (at least initially) towards ethnic difference. Around this peculiarity, American society built the modern urban stereotype of ethnic neighborhoods. Before Little Italy, in fact, Chinatown had become a frightening and mysterious place in popular wisdom, and alongside this there were also Germantown, Jewtown, and other ethnic enclaves.

Little Italy generated the largest emotional involvement on the part of American society, also thanks to the persistence of street life in Italian neighborhoods. Serious documentary photographers like Lewis Hine created reportages of huge ethnographic importance. Some people, however, started to enjoy slumming with a camera under their arms. Italian American author Amy Bernardy wrote about "the explorer who, armed with curiosity, intelligence and maybe a Kodak" might wish to visit Boston's Little Italy. This is not simple urban tourism; it was, instead, a first draft of the "sociology of truth." The "sympathetic" state of living conditions of Italians, who were at once exotic but not totally alien to Euro-American culture in New York, became an integral part of American social reform. Little Italy's exclusive ambiguity ensured its survival in the visual landscape of the American city: it was a place at the same time distinct and approachable. From the European point of view, a similar ambiguity characterized the image of the American metropolis in the 20th century with the co-existence of two hyperboles both essential when describing the new urban life: on one side the luminous skyscraper, on the other the sordid ghetto.

Albeit reduced to a simulacrum, Little Italy is still the community place par excellence, with thresholds of access that are beyond those of modern car-oriented suburbs. However, ethno-cultural otherness, in a deeply democratic society, generates controversial effects: on the one hand, people experiencing this otherness are bearers of "authenticity," on the other they are not willing to accept "the moral mimicry that assimilates everything and everyone," as Amy Bernardy put it in 1911, when illustrating

for the Italian public the original recipe that held together the "new" America. Colorful Little Italy fed a distinct image, at the same time paternalistic and authoritarian, of the Italian American. The family-criminal stereotype found its constant nourishment in the plot connecting kinship ties and regional origin. If we analyze Mario Puzo's *The Godfather* or Emmy Award-winning TV show *The Sopranos*, we see that the Mafia actually plays a cultural role that is entirely American, where the old ways (not only those of Italian immigration, but more profoundly those peculiar to American society and lifestyle) clash against the new ways, driven by social mobility.

Little Italy, with its multiple and controversial faces, proved to be much more than just "typical" and to be important, not so much as a preserver of ethnic roots, but as an intergenerational laboratory. Amy Bernardy became aware of this after seeing the first generation of migrants side by side with a large second generation of children and young people:

> And finally we have, in the colony [in Little Italy], a special language spoken also by the well educated, it is even printed and if you want you can read it, daily: Italian in appearance, of American etymology, of use so common now and with an intrusiveness so broad that it drags everyone, the prominents, the consul, the priest, the banker, everyone should understand it and use it more than once to make himself understood. It is composed of remodeled English words pronounced with an Italian accent and of Italian words phonetically similar to other English words, which in losing their original meaning, become part of a linguistic heritage that is constantly renewed and enriched: it is the language of the *'iesse'* [yes]. Since it is exactly the *'Sì'* [Yes in Italian], the first word deleted from the colonial vocabulary of every immigrant arriving in *'Cialiston'* [Charleston] to go to *'sciabolare in Ricciomondo'* [work with the shovel in Richmond], or to download *'u dorte int'u diccio sulle tracche di Portolante'* [the dirt in the ditch from the truck in Portland]. *'Iesse'* and *'oraitte'* [Yes and all right] are the cornerstones of Italian-American

glossary that with unconscious allegorical wisdom transforms the dangerous whiskey in 'vischio' [mistletoe], and in Elevated sees a sound akin to the native olive grove [uliveto in Italian]. . . . Around schools you would see the small and very small trying to solve in their own way the problems of assimilation and Italianity beating and thrashing the 'airsich' [Irish] 'li giuda' [Jews] and the 'germanesi' [Germans] who treat them like 'dagos', and use the most native American slang to prove that Italy is not afraid of anyone. Moreover, if you ask them what they prefer, be it America or Italy, the most educated will regret Italy with a sigh, the street urchins will scream as one man: America.

According to the authoritative opinion offered in 1921 by William I. Thomas—one of the masters of American sociology, who grew up in the fruitful Chicago school of sociological study—when compared with other immigrant groups, "Italians showed perhaps the dearest wish to remain in separate communities." They settle "according to the villages and even the streets of origin, and those who were neighbors in Italy try to become it here, too." Ethno-social maps help define the difference between different Italian colonies when they have to face the host society. The cartography of the Italian settlements in New York shows, for example, proximity on a regional scale for groups of Northern Italy (Piedmont, Emilia Romagna, Lombardy and Veneto). The scheme is the same for some regions of central and Southern Italy, but it is already complicated by the input of important urban polarities (Genoa, Naples), and finally crashes into a multiplicity of references when it comes to Sicilian communities (Palermo, Messina, Sciacca, Girgenti, Cinisi). By observing closely the latter, Thomas drew some crucial conclusions to consider. The first is that people do exactly what they did in Cinisi, to the point that this group is more interested in Cinisi politics than in American politics. In this community there are no political parties, rather, young veterans (who therefore became Americans) sell their votes in exchange for favors (monetary value of the exchange: five dollars a vote). The group—according to his lapidary judgment—is not interested in citizenship.

The sociologist's opinion claimed neutrality, but at some point—when Thomas moved from New York to the Sicilian communities in Chicago—Altavilla Milicia, Bagheria, Vicari, Ciminna, Termini Imerese, Monreale, Palermo—the point of view of an American citizen takes over that of the scholar: "Schools where Italian is taught are deserted. Italian families even falsify the age of the children to be sent out in factories rather than at school, making a show of greed more sordid than that of Shylock. There is not one girl who knows how to type in both languages and our businessmen must give the jobs to young Jewish or even American girls, for lack of Italian girls."

On the other hand Thomas admits—but is it the scholar or the American White Anglo-Saxon Protestant speaking?—that "Italians preserve longer than many other communities the peculiarities of the organization of the primary group." At the end, he goes back to family and kinship, in this case, as a community of affection and not as a group practicing social control. Then Thomas's observations on "Italian community" follow the thread of a touchy subject, the Black Hand. He recites a long list of misdeeds, but even here he introduces some dynamic elements. First, the courageous figure of Lieutenant Joseph "Joe" Petrosino, who tragically was killed in 1909 in Palermo, after arresting a great number of Mafia affiliates. Then he lists some local communities able to stand together and protect Italians from coping alone with "their" criminals. In 1905, the city council of Scranton, Pennsylvania, offering big rewards to those who would break the wall of silence; in 1907, the Italians led protests in Paterson, New Jersey, after a bomb killed Italian American judge Roberto Cortese.

Thomas makes an extensive use of microsociological documentation in order to weave a precise script: his goal is to understand the dynamics of the process of assimilation, observing them in the crucible of dense ethnocultural syncretisms taking the name of melting pot. The conflict between "natives and foreigners" is the gist of this theory and does not concern "the quality of the population" (which, on the contrary, is the characteristic on which any kind of racism concentrates). Since the conflict depends on "urban social disorganization," it becomes extremely important to operate in the field of social engineering to modify and rebuild social cohesion. When the scholar notes that "until 1914 the

Sicilian community in Chicago was a complete stranger to the world around it," he shows that the social relationship had already started to change. We are told that even the most refractory among migrant micro-communities capitulate when facing macro-processes of social change (in this case the end of isolationism and the U.S. entering World War I). That kind of change does not come by decree, but —as sociologist Robert E. Park wrote—"through participation of the immigrant in the life of the community in which he lives." The existence of immigrant organizations, with their claims, is an element of value orientation and of self-training connecting the different generations of migrants. Ultimately, Thomas insists, these "organizations are giving to their members degrees in American life. . . . And this is the only fully democratic process, because we cannot have a political democracy unless we have a social democracy."

From the methodological point of view, the latter concept led, inter alia, to life history: a subjective tale, when seen in a process of ethno-social fragmentation, that helps to find a way to recompose the frame of a common narrative, a frame in which women are finally included. Between 1880 and 1930, 1,176,945 Italian women arrived in the United States (one third of the total), joined by 475,056 more in the following thirty years, with the highest percentage, equal to 40 percent of the total, in the period between the two world wars—these last came under the U.S. Quota Act of 1924, with its highly discriminatory approach towards migration from the Mediterranean. These numbers are striking. How did women influence the processes of assimilation? Unfortunately, we know very little of the stories—the labors, expectations, results—of those migrant women. However, if one wants to understand the conservation of migratory chains, it becomes inescapable to study their contributions. Then, as now, women acted as family and neighborhood mediators and were in charge of the hospitality and care of their fellow countrymen in boarding houses. It is not a coincidence that, in 1909, the *Commissariato Generale dell'Emigrazione* entrusted to Amy Bernardy an investigation into the living conditions of women and children of Italian origin. While many came to join a family member, there were women coming by themselves, especially after 1900. When analyzing the gender, the extent of transformations related to the migration processes can be fully understood. Amy Bernardy observed the behavior of three generations of Italian women: "Grandmothers are the Vestal Virgins, granddaughters the iconoclasts of native costume." This observation is all the more significant when compared with the very stereotypical literature dealing with Little Italy. Yes, community rites survived, but America came to the surface, with the possibility of influencing choices in individual costumes.

Franco Ramella, a fine scholar of micro-history, better than others expressed the methodological necessity to analyze the immigrant experience more than through the eyes of migration processes. In commenting on a series of letters addressed by the Piedmontese peasant Giovan Battista Vanzetti to his father Bartolomeo during his stay in California between 1881 and 1883, Ramella noted that, "even with the best intentions, the accent is always on the sordid side of emigration . . . individuals are cast onto an opaque background and at the same time they are shown at the mercy of dark impersonal forces, devoid of choices and with no skills." Giovan Battista Vanzetti's letters show a different background: Battistin (his nickname) left out of individual choice, not because of poverty; he left with a neighbor, on a route (Le Havre-California) already followed by other emigrants coming from his hometown, Villafalletto. It was a migratory journey that contemplated the return. Letters show that Battistin was still engaged in the management of the family, primarily through remittances, then with the exchange of information and opinions related to the work in the fields with his distant father. Therefore, the emigrant traveled a long way to California, without actually ever leaving his family. Ramella suggests that remoteness nourished with money and memories strengthened the social cohesion of the family. From this point of view, the lesson that Battistin brought back to his family was not that of the discovery of urban life (from which he stayed away, despite going to San Francisco for a short period as a laborer), but instead that of a countryside so rich that it could be envisioned as the country of plenty.

He met with Italians in California. They were many and they were moving around, from the countryside to the city, and from California to Italy. This is how Italians earned the reputation, at all latitudes, of migratory birds, of birds of passage. (The statistics show that between 1899 and 1925,

forty-six out of one hundred Italian emigrants returned home, the highest percentage among migratory groups.) The peculiarity of Italian emigration to the United States must be found in the tension between circular mobility (which helped to maintain a balance in the family and in the peasant communities of origin) and definitive mobility that disrupted the native social bond, establishing new bonds in the host society. The son of Giovan Battista, Bartolomeo, started as a baker in his hometown, then went to Turin as a laborer in a factory, and in 1908 (after the untimely death of his mother) immigrated to the United States. But his expectations were different. He wrote in a letter to his father on December 15, 1914:

> You ask me if I love America so much because I am not speaking of returning? This is it. Given my character, my way of thinking, my love for freedom, the physical strength which does not make me dread any hardness or effort, I appreci-ate this country. On the other hand, the longing for my family, all of you, friends, the hometown sky, often make me frown and clamp my heart, but knowing that my ideas make me so different from you, my Father, and from the public opinion of my country, holds back my desire to return.

Bartolomeo felt that American freedom was incomparable, according to the yardstick of Italian society. However, in the black wind of the Red Scare, the great fear of "reds" or Communists that followed the Bolshevik revolution in Russia, there were those who would remind him of his dual guilt of being Italian and anarchist. The electric chair imposed on Nicola Sacco and Bartolomeo Vanzetti, on August 23, 1927, may well be read as a tragic misunderstanding of the dream shared by many other migrants, Italians or not, of a new chosen citizenship, loved and defended until the loss of life.

Going to LaMerica

<div style="text-align:right">Mario B. Mignone</div>

In September 1960, when I boarded an Alitalia DC-10 bound for New York, I did not know that I was part of the last wave of Italian emigration; I did know, however, that my voyage was very different from those of millions of Italian emigrants who had preceded me. It was certainly different from that of my grandfather, Carmine Biagio Iannace, who had emigrated to America in 1907: I was leaving on a plane, getting to New York in eighteen hours, traveling with my entire family, and joining my grandparents and several uncles, aunts, and cousins who had prepared a warm welcome. No, my uprooting was nothing compared to that of my grandfather and the millions of other emigrants who departed with him.

The Italian emigration of the end of the 19th and beginning of the 20th centuries was a Diaspora; it was an exodus of biblical proportions. The first wave occurred between the unification of Italy in 1861 and 1900. At the time of unification, Italy's population was approximately 24 million. Over 7 million people emigrated during those forty years, 66 percent from the northern regions and 33 percent from the South. More than half went to other European countries, while the rest went overseas to North and South America.

The second period of mass migration occurred between 1900 and 1914. During this time, over 9 million Italians, mostly from the rural South, sailed for America. In 1913 alone, 872,598 people left Italy. From 1861 to 1914, 16 million, mostly male immigrants, left Italy. In 1907, the peak year of emigration to the U.S. during this period, of the some 1,285,000 immigrants entering the country, about 200,000 came from Italy. In the first decade of the century, American immigration officials classified as Italians 23.26 percent of all those arriving, and 77 percent of them as agricultural workers.

Although World War I put a stop to Italian emigration, the flow began again almost immediately when the hostilities ended. In 1920, about 614,000 Italians left the country, with half immigrating to the U.S.. During the first five years of Fascism, 1.5 million people left Italy, approximately 300,000 per year; 300,000 left as late as 1930. Many were older family members joining their established spouses, sons, and daughters in the new country. In 1927 there were approximately 9,200,000 Italian emigrants living overseas—almost 20 percent of the population.

The third wave of Italian emigration included my family and many of my friends. Much better educated than the previous two generations, we were still emigrating for economic reasons. From 1861 to 1985, 29,036,000 Italians emigrated; 10,275,000 returned to Italy, 18,761,000 remained abroad. The Italians abroad have created a population of 60-70 million who claim Italian origin. These huge numbers of people on the move, significant for the size, are only part of this story: it is also relevant to know how emigration profoundly changed individuals, families, communities and nations.

Emigration should and deserves to be studied from many perspectives using different analytical approaches: psychological, historical, economic, sociological, cultural, etc. Each approach reveals different facets of the phenomenon. I am an emigrant who can be the subject and object of that experience. I am also someone who, before emigrating, was the grandson, nephew, and cousin of emigrants living in America. I grew up hearing painful family stories about my grandfather, who had immigrated to America by himself at age seventeen and had spent many years separated from his family—a wife and young children. I also heard stories, just as painful, about my grandmother and my mother and her siblings, who spent a good part of their lives without the presence of their father and husband. We rarely pay attention to how emigration affected, even psychologically, those who stayed behind: to the thousands of mothers and fathers whose young sons had left, in many cases for good; to the thousands of young wives whose husbands left them waiting, sometimes forgetting them completely and creating the "white widows;" to the thousands of sons and daughters growing up dreaming of the whereabouts of their fathers. All this pain and sorrow rarely receives attention by the emigration scholars. This book, too, focuses attention on those who left.

In telling the story of those who left, we must ask ourselves the five "Ws" we were taught in high school—why, who, what, when, and where—to comprehend the significance of the phenomenon and appreciate the individual and collective acts of heroism of those millions. They included Carmine Biagio Iannace, my grandfather, who by deciding to leave had to face, from the very beginning, a sometimes insurmountable number of obstacles.

Italian emigration as a mass phenomenon happened after the birth of the Italian nation (1861), the American Civil War and the Industrial Revolution, the invention of the steamship, and the spread of the phylloxera epidemic that destroyed most of the vineyards for wine grapes throughout the Italian peninsula. All these factors constituted forces of expulsion and forces of attraction. At the base of the forces of expulsion were the terrible economic conditions of the young Italian nation. After the unification, many Italians had grown disillusioned with their young nation because the social and economic conditions, especially in the South, had deteriorated. The dream of a better life in a nation where the Italians finally had gained control of their destiny had evaporated and the prospects for a better future seemed vanished forever. The agricultural system remained primitive and not competitive—land was being worked mostly by hand as was done during the previous thousand years, disease affected crops, and increased competition came from American food products—all affected the economy. At the same time, employment opportunities were poor and a large sector of the population was either unemployed or underemployed. For many, emigration was the only hope for freedom from the chain of poverty and for the realization of a better future. But not everyone who suffers poverty, oppression, or discrimination emigrates or leaves a country. In order to emigrate, besides having a dream and a burning desire to realize such a dream, one must also possess courage, guts, and a sense of adventure, an innate "Ulyssesism." Many millions of courageous and strong Italians had those qualities and left the country. Through the "silent revolution," Italy, by releasing "the social pressure valve," lost some of its most productive children. America, in turn, welcomed them to plan and build the strong nation that it would become.

For many courageous men, the myth of the "American dream" trumpeting around became irresistible. For millions of Italians, especially from the depressed and hopeless South, and for those who were willing to sustain hard work, America, a dream land, was also attractive for the idea that if one works hard and meets his responsibilities, one can get ahead, no matter where one comes from, what one looks like, or whom one loves. In those days there was no end to the rumors about America and everybody had an opinion. Certainly those who had already returned with gifts, stories, and often money enough to buy a *villa* or a good piece of land were having an impact on those suffering from poverty and pushed them toward a whirlwind of mass emigration. And then there were those who helped to inflate the mythology for self-interests, mainly business. The promise of America both bedazzled and bewildered those who followed it.

Emigration was certainly propelled by the invention of the steamship, which shortened the voyage across the ocean—in 1906 it took twelve days for my grandfather to reach New York from Naples—and made it possible for thousands to leave in systematic ways. But the steamship companies emerged as a new business to "transport" passengers. Agents acting on behalf of steamship companies or foreign employers were eager to enlist laborers and certainly contributed to the mythology of the American dream through an iconographic campaign of wealth and abundance. American mythology was certainly inflated by the small-town "political class" who had a vested interest in emigration because it was quickly becoming an important unofficial source of income. By the 1880s, the southern middle class, especially, was busy enrolling poor laborers, hiring ships, and making money on those whom it had been exploiting the most. Sometimes it even managed to export its social dominance across the Atlantic, to reappear as "bossism."

After overcoming the many obstacles to departure, the transatlantic voyage was a big challenge. The crossing required not only a strong spirit, but also a strong stomach. The middle passage, the trip across the Atlantic, usually was in third-class, or "steerage," so-called because the quarters were below deck next to the steering mechanism and engines. Steerage fare was usually between fifteen and twenty-five dollars. If an immigrant could afford it, it was certainly worth traveling second-class instead of steerage. Not only would second class passengers avoid the crowded, smelly, windowless confines of life in steerage, they would, in addition, be admitted into the U.S. without rigorous inspection.

When those millions arrived at the shores of the new continent, the mythology that had lured them to emigrate and had helped them to endure the rapture of departure and the hardships of the transatlantic voyage faced the first test at Ellis Island. It was the first match of the American dream with American reality. For many, it was not a pleasant encounter, especially for the fear and anxiety about the health check that was in many respects humiliating. The biggest problems were tuberculosis and the eye disease, trachoma; in addition new arrivals had to assemble a puzzle to show that they were mentally fit. For 2 percent of the emigrants the process was tragic because they were sent back home for medical reasons.

During the verbal and mental fitness tests the immigrants were questioned about job status, amount of money in hand, final destination, waiting relatives, criminal records, and other such matters, and were checked against the ship's manifest. It was common at that point for complicated names to be changed to simpler ones. Few immigrants complained about changes in their names, so anxious were they to pass through Ellis Island without incident. Immigrants had to be especially careful when answering questions about their job status. If they said they had a job waiting for them they could be considered contracted labor, and sent back to Italy; and if they said they had no job prospects they could be rejected as being potential public burdens. They carefully rehearsed answers such as, "I have good job prospects," or "my cousin will help me find a job."

The length of the projected stay abroad frequently influenced the choice of occupation, because the immigrant could decide either to leave Italy permanently, taking his family with him, or to emigrate alone and work intensely to maximize his savings and then return home. This typical feature of migration, especially common in those who traveled to South America, reminiscent of the seasonal trips of migratory birds across the hemispheres, was whimsically referred to as "The Little Swallow." This kind of emigration, based on temporary mobility, characterized the initial life of Italian immigrants in the host countries in a way that was different from the other immigrant groups who made a clear break from their countries when they left.

At the time this habit of repatriation was unique in American history and was seen with suspicion. The creation of stereotypes and the consequent discrimination that gradually started to coalesce was also due, I believe, to the lack of ability of some historians, sociologists, and politicians to relate not simply to masses, but to masses of people on the move. If we read the representation of these masses on the move offered by the masses themselves through their own life-writing, we might better understand the motivation for those modes of life. Nobody better than they could express the weight they bore for their migrations, their departures and arrivals, their fortunes along the way, the jobs they worked at, their celebrations and sufferings, their thoughts and dreams. I know some of it through the astonishing stories in my grandfather's autobiography, *La scoperta dell'America*, or in works by well-known writers of that experience: Bernardino Ciambelli's *I misteri di Mulberry Street* (1893, The Mysteries of Mulberry Street), Pascal D'Angelo's *Son of Italy* (1924), and *Soul of an Immigrant* (1924) by Constantine M. Pannunzio. The pictures in this volume corroborate vividly much of what I had learned through my grandfather's oral stories and his autobiography. His story and many others are personal stories of immigration, and in essential ways are similar to the millions of untold stories of those who came to America during the Italian exodus.

Many immigrants who had left their families behind dreamed of going back to the old village one day to buy a piece of land that would give them the dream of independence. Quite a few did go back, sometimes twenty or more years later, when the children they had last seen as infants were adults. Many of them, like my grandfather, went back and forth for many years and finally decided to bring the rest of the family to the U.S. when the children had become adults. Most, however, changed their minds about returning and had their wives and children join them in America. Family and kinship ties provided chains of migration that contributed greatly to the demographic growth of Italian immigration to the U.S. and to the structural development of Italian communities in American cities. Although the bulk of these immigrants were originally from rural areas, in the U.S. they tended to cluster in cities and suburbs, forming "Little Italies." Little Italies emerged as a natural consequence of the kind of emigration Italians followed: those men coming here for work gravitated upon their arrival, for existential necessity, where there were relatives or *paesani* who would provide initial shelter and assist them in finding a "job." This basic type of anchorage where immigrants would find mutual assistance created a process of

urban construction through an aggregation of individuals, families with cousins, aunts, and uncles, with a network of *paesani*, *compare* and *comare*, a map of kinship and social relations. As can be expected, most of these enclaves emerged where heavy industries, big construction, canal work, or major railroad or seaport connections required immigrant labor. Smaller Italian enclaves emerged in small factory towns, mining villages, and rural America. These Italian American neighborhoods have many variations based on such elements as size, concentrations, and immigrant generation, from tiny California fishing villages to the huge concentration of Italians in New York City's East Harlem, South Philly in Philadelphia, North End in Boston, the New Westside in Chicago, the port area in Baltimore, "Dago Hill" in St. Louis, North Beach in San Francisco and New Orleans. The development of the enclaves varied as each city drew a different type of immigrant from Italy. This resulted in a wide range of dominant occupational structures and degrees to the extent and intensity of the Italian ambience.

Due to a combination of factors—especially low wages and the need to save money to help the family left beyond—the Little Italies emerged in the most degraded parts of cities, overcrowded slums filled with ramshackle houses and fire-trap buildings: slum tenements, streets full of fruit and vegetable stands, children playing in less than salubrious conditions. The Lower East Side of New York City at the beginning of the 20th century held almost 300,000 people per square mile. One block of tenements on Mulberry Bend might house 1,200 or more immigrants, perhaps ten to a room if the occupants were all male workers or all members of one family.

The Little Italy communities were characterized by an insularity caused by inner needs and outer forces. While the fear of the outside, hostile world promoted a protective, clannish attitude, on the other hand, the outer world kept the Italian communities circumscribed from spilling over to "contaminate" larger urban areas. For most immigrants the challenges of so many hurdles—a new language to learn, new customs to use, new mores to understand, and most of all a new land and new nation—were difficult but not insurmountable. As the population grew and the length of tenure in the U.S. increased, so did the presence of the family and the number of communal associations that helped create a fuller community life: mutual-aid societies, fraternal orga-

nizations, Catholic churches, *paese* clubs, Italian-speaking local unions, and other related entities, sodalities, parochial schools, sport teams, and credit unions. These community centers in turn attracted businesses, ethnic newspapers, and restaurants, and produced a wide range of ethnic density and material culture.

The family, especially for the emigrants from Southern Italy who for necessity had historically relied on the family to survive in a hostile environment, played a key role in the social and economic evolution of Italian emigrants in America. The traditional function of the family as a place where people go for consolation, help, advice, provisions, loans, allies and accomplices, remained unchanged in America. The family continued as a warm and supportive sanctuary of individual life and group experience that provided the final and dependable refuge against everything that was external and threatening to its members. From the family flowed the courage that fortified them against the discrimination they had to face. In short, the family continued to act as the pillar and the gauge to measure everything in the world in which they lived.

In this first stage of economic evolution the unity of family was a necessity; children were economic contributors to the budget and family livelihood. Many Italian immigrants, especially women, took work home from clothing factories. To earn enough to get by, all family members, from the very old to the very young, had to work. The activity called "piece work"—because the workers were paid by the pieces they produced—involved the entire family, including children. The tedious task was usually turned into a group project that kept the family together at home.

The family structure and its role in the life of Italian emigrants created stereotypes in the popular culture that sometimes have been reinforced by the writings of scholars, who often did not fully understand the complexity of their reality. The "familism" label attached to the Italian family—to indicate a patriarchal family strongly focused on the life and success of the nuclear family to the detriment of the common good—did not represent the historic base that molded that behavior. The insularity of the Italian family toward the rest of society was not for selfishness or disregard for the outer world. No one can argue the necessity of strong family cohesion in the first generation. Family members often made huge sacrifices to overcome barriers of

immigrant status and contributed to upward mobility for the next generation.

Nonetheless, the "familism" of the Italian emigrants in Little Italies did not work to the detriment of the common good because there emerged a network of mutual aid societies and other organizations that were created with the exact intention of helping others. One of the oldest and strongest fraternal organizations that is still very much active today, the Order Sons of Italy in America (OSIA) stated in its constitution of 1907 that its principal goal was "to give voluntary aid and protection to its members, and establish the relationship of fraternal brotherhood among them; and to voluntarily further the practices of Christian charity, benevolence and aid towards all who are in need and deserving of assistance." The *Società Italiana di Mutua Beneficenza* in San Francisco, the Italian Welfare League in New York, the *Società di Mutuo Soccorso* in Chicago, the Society for the Protection of Italian Immigrants, the St. Raphael's Society and many others, very often bearing the name of the village from which some emigrants left, had as their objective to assist the needy. The public social life of the neighborhood was rich with musical bands, fraternal lodges, street-corner political clubs, and the *paesani* societies. Next to the "dark side" of the family and the neighborhood clannish solidarity, we should not miss the high sense of altruism and civic engagement.

However, it was on the "job" that the real test of Italian emigrants was verified; it was on the job that the American myth could potentially find its translation into reality. In no other terms, Italian emigration must be profoundly tied to work, that is, labor, which is the application of human energy to produce wealth. Italian emigrants left home in search of work and were lured abroad to work. It was their ability to work and work hard that made them a valuable commodity. For the most part they affirmed their identity and their worth on the job. It was work that defined their personal and national identity; it was their work that changed their social status and that of their families; it was their work that created prosperity for their host countries and for the homeland they had left. In essence, our emigrants worked to live, but they also lived to work.

Indeed, their rite of passage from the old to the new life revealed itself mostly in the challenges of the way they faced work. Many of them had to go from a folk-based agricultural economy to the modern industrial milieu, from a sedentary life based on the seasons of nature to a life based on the move of the factory or construction sites, frequently working into the night. They worked in mines, lumberyards, quarries, tunnels, and railroads. They constituted a strong presence as masons, stonecutters, barbers, and shoemakers. In particular, more than half of all the masons in the U.S. were Italians; they took pick-and-shovel jobs and filled the ranks of sanitation departments. The impact of the Italian immigrants was also huge in agriculture. In rural life and activities Italians integrated far more rapidly than in industrialized urban areas.

This book gives a vivid representation of Italian immigrants at work, of nameless millions who immigrated to this country and whose names do not appear in the history books, but to whom we owe a great debt of gratitude for their exemplary lives. I am speaking specifically of our parents and grandparents, and for some, our great-grandparents. They came to this country often with little but the shirts on their backs. They demonstrated the same type of persistence and pluck that our country has always demanded of its newcomers. They worked hard and followed a severe work ethic. Their grim working conditions and bottom-dog existence are well known: fourteen-cents-an-hour wages, one dollar and twenty-five cents a day, no union, long working days, dangerous working conditions, frequent mishaps, no safety net or social security. Work made them equal and different at the same time, creatures and creators. And they went on to play a key role in building America, for they are those who dug the ditches, toiled in the mines, laid the rails, and carried the bricks and mortar. They quietly mingled their sweat and blood in the material foundation of America

Many of the emigrants lost their lives because of dangerous work and unregulated working conditions. Mining claimed the highest number of lives and Italians were regularly among those who had the highest number of victims. The history of Italian emigration is not made up only of enduring sacrifices, but also of wounds and too many deaths as well. Of the 259 miners who died underground in 1909 at Cherry, Illinois, seventy-three were Italians. In 1907, in a mine collapse that occurred in the Monongah Coal Mine (West Virginia), where there were at least 362 victims, 171 were Italians, and some were children—children were often favored as mine workers because their small size allowed them to work in the cramped mine shafts more comfortably

than grown men. In 1911, in a fire at the Triangle Shirtwaist Company, one of the worst industrial tragedies in U.S. history, of the 149 workers who died, thirty-nine were Italian young women, some as young as twelve years old.

Italians, as other immigrant groups, could not be too choosy about the selection of work, how easy or dangerous it could be. They could not rebel from living under harsh conditions in a society that very often despised them. The fear of returning home as a failure was one of the worst nightmares of an emigrant, therefore, the predisposition to endure any hardship and, at times even humiliation, was engraved in the soul of most of them. For this reason they accepted hard and difficult jobs and often endured discrimination. Their lives, sustained by tenacity at any cost and guided by parsimony to save money to send back home, created a behavior and a way of life that contrasted with the American life.

While opinion molders from the ranks of the cultural and social elite demeaned Italian immigrants as threats to the purity of American culture, leaders of the nascent labor movement also viewed them with suspicion for being unorganizable threats to the American wage standard. The experiences of some American trade unionists, at least at the beginning of the big emigration, when many Italians were transient emigrants, had taught them that emigrants from "backward" countries were most often used by employers to depress wages, break strikes, and smash labor organizations. Thus, some American unionists viewed the rising tide of Italian immigrants with great suspicion as they worked with restrictionist legislators to curtail immigration drastically or, at the very least, to outlaw certain employment practices, such as "contract labor." The leadership of the American Federation of Labor also seemed to feel that Italian immigrants were instinctively resistant to unionization. All of this created a negative perception of Italians in the labor force.

As the presence of Italian immigrants became more stable through the years, the reverse effect also created a negative perception of Italians, this time in a wider stratus of American society because of the visibility of their actions and positions in American labor organizations. As they increasingly began to join unions and many started to take active roles within labor organizations, Italian immigrants began to be noticed in different ways. The workers joined many strikes, and some Italian American workers even

built their own unions in some industries prior to 1910. The most dramatic strikes and significant unionization drives in which Italians participated took place in those industries where they were most heavily represented: mining, textiles, and the needle trades. In the Lawrence mill workers strike of 1911, which profoundly affected the future of the textile industry and had national attention, Italians played a prominent role both in numbers and leadership. Angelo Rocco, Joseph Ettor and Arturo Giovannitti acquired notoriety in the strike. Despite their attempts to maintain a nonviolent posture, a full-scale riot broke out after a confrontation between police and demonstrators on January 29, 1912; one policemen and one of the strikers (Anna LoPizzo) were killed in the melee. Ettor and Giovannitti were jailed. This incident was one of many to attract the general attention of many Americans who increasingly viewed Italians with suspicion.

Italian immigrant workers increased their leadership and prominence in the labor unions. In the 1920s, Luigi Antonini, one of the prominent and effective union leaders in the garment industry, paved the way for many more. The cultural values of those Italian Americans who built labor organizations in the coal-fields of Colorado, the textile mills of New England, and the sweatshops of New York City's garment districts stressed the primary nature of familial relationships, the loyalty to friends and community, and the efficacy of voluntary associations intended to sustain the stability of the family circle. These values strengthened Italian workers in their struggles to organize. But there was also the motivation created by the conditions Italian workers faced in their everyday work lives and the discrimination and exploitation they faced in all other areas of American life as well. Therefore, activism in organized unions and community politics became a matter of survival. The political values articulated by the founding generation of Italian American union activists were influenced as strongly by theories of class struggle as by the older tradition of southern Italian peasant culture. Consequently, their politics were as "radical" in terms of American society of their era as they were "traditional." The post-World War I Red Scare, the nativism and conservatism of the 1920s, did not take well to the activism of many Italians.

Some Italian activists took strong positions in reference to the American economic system and became prominent leaders in the mass public manifestation of protest. How-

ever, as they emerged as a powerful organized force, they were accused of sedition. Carlo Tresca, Bartolomeo Vanzetti, and Nicola Sacco were some of those leaders who attracted not just national, but international attention. Sacco and Vanzetti in many ways became international heroes for the way in which they had to pay for their beliefs and for their political activism. Although the arguments brought against them were mostly disproven in court, the fact that they were known radicals (and that their trial took place during the height of the Red Scare) prejudiced the judge and jury against them. Before sentencing, Vanzetti told the jury: "Not only am I innocent of these two crimes, not only in all my life I have never stole, never killed, never spilled blood, but I have struggled all my life . . . to eliminate crime from the earth . . . I am suffering because I am a radical and indeed I am a radical; I have suffered because I was an Italian and indeed I am an Italian . . . I am so convinced to be right that you could execute me two times, and if I could be reborn two other times, I would live again to do what I have done already." They were unjustly convicted in Massachusetts of a 1920 armed robbery and murder and sentenced to an execution which took place in 1927. On August 23, 1977, Massachusetts Governor Michael Dukakis issued a proclamation that Sacco and Vanzetti had not received a fair trial. He stated: "The atmosphere of their trial and appeals was permeated by prejudice against foreigners and hostility toward unorthodox political views . . . and the conduct of many officials involved in the case sheds serious doubts on their willingness and ability to conduct the prosecution and trial fairly." Unfortunately, American history is stained by too many unjustified fatal punishments, with Italians enduring a high toll. After African Americans, Italians suffered the highest number of lynchings.

Looking at how the first generation of immigrants lived, according to what expectations, under what conditions, and with what values, made established Americans suspicious. It is not surprising that the Dillingham Commission, formed by Congress in 1907, labeled the Italians as "new immigrants," that is, different from those who had been coming before their arrival. Not only were they mostly male, unskilled, illiterate, and transient, but they were also too frugal and sent too much of their earnings back home. Supposedly, southern Italian immigration was the first great migration of people who went back to their native land from the United States in large numbers, and when they decided to stay, many of them gradually became labor activists. The widely accepted, though severely flawed, "scientific" results of the Dillingham Commission not only led to restrictions on immigration, but also labeled Italian enclaves as pathogenic environments.

The Emergency Quota Act of 1921 was vetoed by President Woodrow Wilson as he was leaving office, but it was signed by incoming President Warren G. Harding. The quota law was meant to discriminate against southern and eastern Europeans. And it did. Italian immigrants were restricted to an annual limit of just over 42,000. In 1924 President Calvin Coolidge signed the Johnson Act into law, which lowered the immigration quotas even further. The quota system was finally abolished in 1965.

The anti-immigrant American sentiments recurring through the years have hit different groups at different times, especially in the period of their most intense flow into this country. They reflect the American ambivalence toward immigration, which oscillated between welcoming newcomers in order to develop the country and harboring suspicions, but among the strongest have been those that originated in the conflict of Anglo-Saxons and Italians.

Not all Italian Americans suffered the same degree of harshness and persistence of discrimination. Those who settled in the western part of the United States, such as California, experienced a milder form of bigotry, perhaps because they were from the North of Italy, but most likely because their limited numbers did not constitute suspicious, densely populated enclaves that could be perceived as a threat. It was far different, however, for the bulk of the Italian immigrants who settled in large cities in the eastern part of the country. In these settings Italians were subjected to some of the most vicious campaigns ever directed against any immigrant group. During a congressional hearing they were described as a non-white people and in some work situations were given wages substantially lower than other whites. Negative images of Italians were based on several perceptions, such as ignorance, indolence, conspicuous illiteracy, ragged dress, inherent criminal mentality, and emotional, religious superstition. Very often newspapers made Italians an easy target for prejudice; some denounced situations whereby Americans could no longer safely walk city streets that had become overrun by indolent intruders from Italy, annoying everyone with the omnipresent hand organ and monkey.

The extreme ethnic prejudice that Italian emigrants faced was the result of their "otherness," their different ways of life and certain types of behavior that made them be perceived as "different." This prejudice established their subordinate status in American society and shaped the expression of Italian ethnicity for succeeding generations.

There is a direct relationship between the all-consuming round of heavy labor that characterized their day-to-day lives and the way they, as immigrants, were perceived by the outside world, especially the American elite. One of the more insidious forms of prejudice directed at Italian immigrants was the use of labels, actually defamatory epithets—"wop," "dago," and "guinea"—which stigmatized them as despised foreign intruders. At the core was the view that Italians were not only different from, but also inferior to, the Anglo-Saxon race stock of the American majority. This racial stereotype was especially signified by the epithet "guinea" and was underlined in the characterizations of Italians as "dark" and "swarthy" in complexion. Racial inferiority, moreover, determined degraded cultural patterns such as ignorance and poverty. It should be noted that immigrants from Northern Italy were somewhat exempted from this scenario as "Teutonic Italians" compatible in race and culture. This view was in line with the prejudice of northern Italians towards southerners at the time of unification, a belief that had been reinforced by the views of some anthropological positivists such as Cesare Lombroso and Enrico Ferri. Lombroso divided, for instance, northern Italians and southern Italians into two different "races," and claimed that southern Italians were more crime-prone and lazy because they were unlucky enough to have less Aryan blood than their northern countrymen. It should also be noted that when Italians arrived in America, they were identified as "Italians" or "Southern Italians," a division that placed the southern Italians at an inferior level.

However, what makes Italian American history different from other immigrant sagas is the permanent nature of the criminal label bestowed on them, and the crushing effect it has had on their development in America. Even though Italian immigrants and their children have contributed no more, nor less to crime in America than any other people, the general perception remains that Italians are especially prone to criminal activities. Propagating this stereotype was the blanket view that Italians in America were, if not innately criminal, certainly a Mafia-ridden people. Feeding this label in the popular mind as well as in academic circles was the association of Italian Americans with organized crime to such an extent that the two became one in the eyes of many Americans. What is true in this myth? The data show that in almost all criminal categories Italians committed fewer crimes, proportionately, than other groups. However, they emerged as greater offenders, proportionately, in violent crimes, the type of crime that received and naturally deserved more public attention. Especially in the first period of arrival, when the world in which they lived was most hostile to them, many Italians carried knives and guns, and some of them did not hesitate to use them to settle a dispute. For a time, then, their proclivity to violence stood out in American history.

As the inclination to resort to violent crime declined after World War I because Italian immigrants were gaining a stronger rooting on American soil, the introduction of Prohibition created a fertile ground for those Italians struggling for jobs or searching for ways to enter into business in order to satisfy consumer needs. Italians started making and selling wine and assorted homemade brews for neighborhood consumption. These business activities became commonplace in a nation where the general population was willing to circumvent certain laws in order to satisfy its desires. Unlike the criminal who forces victims to give in to his demands, organized crime figures found willing participants eager to avail themselves of the illegal service. The leading organization of organized crime, the Mafia, followed the same concept of community service, and besides selling bottled liquor, offered gambling and prostitution. The Mafia became large-scale criminal entrepreneurs, owning and operating gambling halls and brothels. The Irish, the forerunners of modern urban gangs, had part of the control of these "businesses" and the Italian Mafia became their competitors.

After Prohibition, organized crime attracted the interest of some of the lawless Italian Americans. Consequently, there arose a Mafia myth which identified a ruthless secret society with the expression of Italian ethnicity. The interest of the mass media in mobsters, especially Italian American mobsters, not only sustained but actually increased the illusions that the Mafia myth can be extrapolated to all Italian Americans.

The fact that many Italians became part of police departments in urban centers and distinguished themselves as staunch fighters of crime—seeking every kind of criminal, including members of the Mafia—did not help much to change the ingrained conviction of many Americans that the tendency to criminality was congenital to the Italian character. Not even the death of New York City detective Joseph Petrosino helped to lessen some of the Mafia mystique or remove it from the shoulders of Italian Americans. Even though his assassination in the pursuit of criminal *mafiosi* in Sicily in 1909 earned him recognition from U.S. President Theodore Roosevelt, the mass media and general perception remained unchanged.

Although ethnic labels and stereotypes are affected by changes in status and power relations, popular stereotypes of Italian Americans lagged behind socioeconomic changes. The stereotypes of a degenerate proletariat molded on the first immigrant generation should have been irreconcilable with the record of Italian American cultural adaptation and socioeconomic achievements. Italian Americans gradually became more affluent and part of the cultural mainstream, but the old stereotypes persisted. Television and film images especially continued to portray Italian Americans with the former behaviors and working-class lifestyles.

Unfortunately, even the way Italians professed their strong, sometimes passionate faith made them vulnerable to prejudice and discrimination. There is no question that one of the most relevant definers of ethnic identity is the practice of religion, but in the case of Italians it is more so also for historic reasons—after all the Catholic Church has its roots and base in Italy and has molded the life and consciousness of Italians for centuries. However, Italians, especially southern Italians, have tailored Catholic beliefs to their own individual needs for hundreds of years. For southern Italians especially, living in an agrarian economic structure and culture where the state was absent and people lived on and from the land, at the mercy of mother nature, religious belief in the supernatural forces that controlled drought, floods, hail storms, and any natural cataclysm was a natural option. Guided by the Church, people lived with hope in a world pervaded by danger and uncertainties. Religion offered belief in the efficacy of magic and devotion to saints and Madonnas, along with a basic indifference to and distrust of government. When people needed help for their crops, or a

miraculous cure for themselves or members of their family, or protection from dangers both seen and unseen, they appealed to their favorite Madonna or saint.

The Italians who emigrated brought with them the strong and realistic sense of religion which they professed with fervor and an irrepressible expressiveness. In America too, their faith was guided by an innate urge to externalize and materialize spiritual impulses in art, architecture, and elaborate ceremonies, which clashed mightily with the religious practices of both Protestants and other Catholics. Moreover, there is a rich tradition of piety centered in the privacy of the home. Pictures of saints and crucifixes decorated homes; votive candles flickered before homemade shrines to saints, the Virgin Mary and Christ (well portrayed in a very interesting and revealing movie, *Household Saints*, 1993, by Nancy Savoca). Saints and Madonnas were (and to a certain extent still are) worshipped in a variety of ways through many social contexts, both inside and outside the walls of churches, in streets and squares. The rhythms of family life followed the liturgical calendar, with appropriate foods prepared and prayers said for the feast days of important saints. The private religious life was complemented by the public *festas*.

Until recently, especially among southern Italians, the veneration of saints and Madonnas was imbued with a high dose of paganism. Sacred images were often seen with such superstitious symbols as *il corno* (the twisted horn), worn to ward off *il malocchio* (the evil eye) while rituals were performed to ward off evil spirits.

In essence, Italian American Catholicism was both pragmatic and this-worldly and lacked any "surrender" to transcendence; it was a Catholicism that was mediated through vehicles which were personal, concrete, immediate, and situational. Thus, it is not surprising that Italian Catholicism clashed with the religious practice of other Catholics, especially the Irish, who controlled the hierarchy of the Catholic Church in America. The external and exuberant religious practices of the immigrants were discordant with the reserved and private Anglo- and Irish-American practices. As a result, the Irish-American Catholics viewed as "flamboyant paganization of true Christianity" the public *festas* (feast days), processions, and pageants in honor of various saints and Madonnas. They did not have the cultural predisposition to accept that the "civil" part of the *feste* was mere

amusement, an occasion to show collective love and gratitude to a saint or Madonna; food, music, and companionship were supposed to be seen as a public expression of joy and thankfulness to the "protector."

Nonetheless, the Italian immigrants added their own unique contributions of warmth and spiritual fervor. Most importantly, they contributed money, labor and creative skills in consolidating the presence of the Catholic Church in America. Thousands of churches, Catholic schools, hospitals, and mutual aid societies were built with the labor and contributions of Italian immigrants. Italian priests, friars, missionaries, and nuns came to America in large numbers to assist and to guide. A special religious order, the Scalabrinians, was specifically created (1887) with the aim of caring for the spiritual and social welfare of immigrants.

The Church played an extremely important role as a unifying link between the old and new world through the continuation of various religious celebrations. The presence of priests who spoke the immigrants' language helped to solidify the Italian community and cement old traditions. Names of ethnic parishes bearing the names of patron saints of the *paesi* of origin were important cultural bridges between the world the immigrants had left behind and the new world that their children were participating in building.

By the early 1920s Italians were coming of age as Americans. While the older generation played *tressette* and *bocce*, the new generation—those born in America—took up football and baseball, and became involved in a host of sport and social activities that started a gradual process of integration. Even though the outside pressures to assimilate were strong, the Italian home milieu remained almost impenetrable. Italians continued to celebrate their *feste* as a normative part of life because they embodied, as no other moment could, the coming together of family and of a community. Celebratory moments were usually only open to cultural insiders and often consisted of singing, dancing, and feasting. The events reflected the participatory rites of actual celebrations of life, but they were also life-sustaining events transplanted to the new land to nourish lives with the same flavors and spirit as they were lived in the old country; they were a vital link-age with the old country while the immigrants moved on in the process of integration. The pictures that make up our visual story represent immigrants' collective identity in joyous scenes of family and community celebrations, very often religious events that clearly illustrate some aspects of harmonious community life.

In all this, food was the cementing ingredient. Italian American food has a long history in the homes, markets, and restaurants of the United States. Not only "we are what we eat," but for many immigrants, the hunger and food shortages associated with *la miseria* (literally, "misery") were a primary motivation for emigration, and thus the food customs which the immigrants and their descendants brought to and developed in the U.S. were not only a means for maintaining ethnic identity and culture, but also a marker of success. Given that these food customs emerged as the United States' first notable "ethnic cuisine," they have long functioned as a primary representation of that ethnicity to American society at large—a context, then, in which Italian-American identity and culture were expressed, encountered, negotiated, and re-formed over time.

And enjoyment of the new land also came with afternoons at the beach, weekends in the country, and evenings at the local theaters and clubs where the immigrants enjoyed Italian singers and stage actors in performances in Sicilian or Neapolitan dialect, which connected them to their regional cultural milieu. Farfariello, the stage name of Eduardo Migliaccio, was one of the many well-loved stage delights that lightened the burden of heavy weeks of work for the immigrants. Very often the daily struggle of families in humorous contexts were the subjects of the comedies and sketches represented.

Not even the Great Depression in the 1930s could stifle the pursuit of the American dream for the sons and daughters of Italian immigrants. While the children were becoming strong fibers of the American social fabric, the proud immigrant parents who had been working in factories and construction sites, or as artisans, craftsmen, shopkeepers, and public servants, gradually became the owners of cars, houses, and businesses.

The Tide

Mass migration from the late 19th Century

The culmination of *Risorgimento*—the union of North and South (followed in 1870 by the addition of Rome) changed more than just Italy; it changed the United States. Living conditions in the South—the area known as the *Mezzogiorno*—actually grew worse. An 1863 parliamentary report urged the national government in Turin (later moved to Florence) to "extend education and see to a fairer distribution of land [in the South]. Roads must be built, marshes reclaimed, public works begun, and the forests looked after." But this did not happen. The poorest peasants were taxed on basic necessities like mules, salt, and the grinding of grain. Absentee landlords lived in beautiful palaces, while the peasants scratched a living out of land they rarely owned. The population suffered from malaria, hunger, and unemployment. The Italian Army was forced to suppress several small rebellions and widespread banditry in the South after 1861.

At the same time, the U.S., having endured a civil war, was thriving. Propaganda from steamship companies, *padrones* ("bosses"—intermediates, often exploitative of the immigrants, between American employers and Italian workers), and reports from Italians who had lived in America painted a picture of opportunity. What did an impoverished Italian have to lose by emigrating? In fact, a great deal—family, friends, culture, and tradition—but they would also find jobs. Many planned to earn enough money, then return to Italy. Italians, more than any other immigrant group to the U.S., were "birds of passage," who would cross the ocean when they needed work, then come back home, often several times over the years.

The United States had a long tradition of immigration, welcoming foreigners to fill the vast spaces of its country. But the immigrant groups before 1870 were overwhelmingly from Britain, Germany, and Scandinavia. The "new" groups that came in the last decades of the 19th century were Italians, Jews, and Eastern Europeans. Many people grouped all Italians as southern Italians, but in fact, until 1900, the majority of Italian immigrants came from the North. The magazine *Giornale popolare di viaggi* wrote in 1871 that "the number of Italians, born in Italy and children of Italian parents, living in the United States . . . ascends to 55,000 except California. . . . Dividing the Italian emigration to the United States according to the different regions of the Kingdom, one can determine the following classification in descending order of importance: Ligurians, Sicilians, from Lombardy and Romagne, Piedmontese, Tuscans, Neapolitans." After 1900, however, the tide turned, with the majority coming from the South.

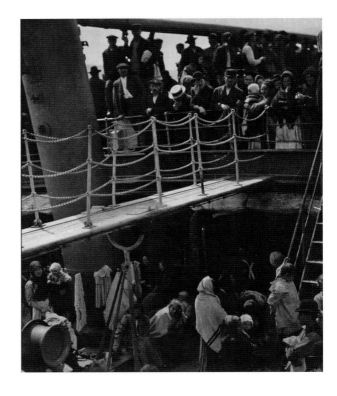

From Thousands to Millions

In 1850 the United States took its first census that included those born outside this country. It recorded 3,645 people born in Italy. In the decade of the 1880s, three hundred thousand Italians immigrated to the U.S., three times more than *all* Italians who had come previously. The figure doubled in the 1890s to six hundred thousand immigrants. From 1900-1910 the number had jumped to two million. These figures represent immigrating Italians, not those who had already settled here. In 1920, Italian-born residents accounted for 117 of every 1,000 immigrants born in any foreign country. The image (facing page, bottom) from *The Literary Digest* of May 7, 1921, graphically demonstrates how large the proportion of Italians (more than 1.6 million) had become, only exceeded by Germans. Interestingly, it illustrated an article on limiting immigration by groups such as Italians. The 1907 photo (above) by famous photographer Alfred Stieglitz shows that most of these immigrants came in steerage—the cheapest and most crowded and unhealthy class of steamship travel.

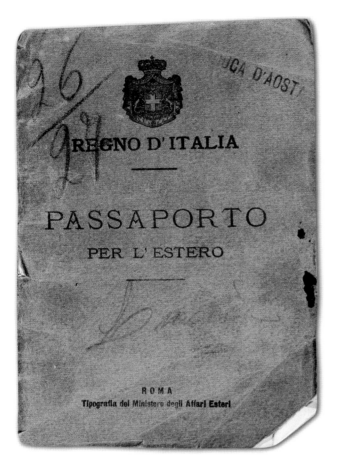

Travel Documents

The Italian passport (above), a necessity of 20th century travel, belonged to Lucia Forgnone and her son Giuseppe Boggio, aged ten months, issued in 1909.

Whether northern or southern, Italian men came first, and they came to work. City laborers, construction workers, or road builders, lumberjacks, and others on the move, they usually lived in primitive conditions, saving money to send home or to bring their families over. "The Italian woman who is in the U.S. represents only one third or one fourth of our emigration," wrote journalist Amy Bernardy in 1911, "and when she comes, she is mostly a mother or bride or daughter or sister who follows her transplanted family and works in the house as if she were still at home, and she becomes a laborer in the factory to make money for the day." "Chain migration"—where one family member follows another, or a neighbor or friend comes, then brings a brother, who brings his family, and so on—was an important aspect of Italian immigration in particular. And when they reached the United States, whole villages and communities replicated themselves, living in the same neighborhoods, speaking their own dialect, going to the same clubs and entertainments, celebrating their local saint in *festas*, marrying their sons and daughters to each other.

Before 1900, relatively few rules existed for leaving Italy. In 1901, a law giving emigrants some protection passed. It eliminated agents—men similar to *padrones*, who were intermediaries between emigrants and steamship companies, often deceiving the emigrant about costs and conditions. Steamship companies had to meet basic requirements before they could be licensed by the government. Because American laws had changed, potential immigrants had to be examined at the American consulate prior to emigrating, to make sure they had no contagious diseases and their papers were in order. This meant that fewer would be turned away when they reached the United States.

And what did they find when they did arrive, those immigrants who could not speak English, often were illiterate in Italian, had no money, and few or none to welcome them here? Not the streets paved with gold that they believed in or were promised; but distrust and prejudice from the majority of Americans, miserable living conditions, and hard work.

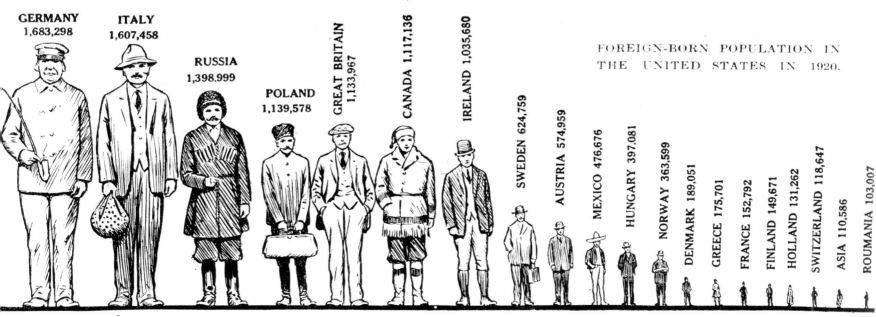

GERMANY 1,683,298 · ITALY 1,607,458 · RUSSIA 1,398,999 · POLAND 1,139,578 · GREAT BRITAIN 1,133,967 · CANADA 1,117,136 · IRELAND 1,035,680 · SWEDEN 624,759 · AUSTRIA 574,959 · MEXICO 476,676 · HUNGARY 397,081 · NORWAY 363,599 · DENMARK 189,051 · GREECE 175,701 · FRANCE 152,792 · FINLAND 149,671 · HOLLAND 131,262 · SWITZERLAND 118,647 · ASIA 110,586 · ROUMANIA 103,007

FOREIGN-BORN POPULATION IN THE UNITED STATES IN 1920.

VERSO L'IGNOTO

Tristezza e Speranza

"You leave your old mother, wife, children, in short, all that you cherish the most to go to the United States . . . to earn a living," wrote an emigrant in the book *Da Biella a San Francisco di California* in 1882. "Yet we leave, it is true, with a tight heart, who would not? But we do it, thinking that with the money earned there . . . we and our family can live with some ease. . . . Believe me, it is better to live ten years . . . working, and see happiness in our family, than to live one hundred years, in misery."

Most Italians like this immigrant left home with the mixed feelings described in this page (top left) from the New York magazine *Domenica Illustrata*: *"Verso l'ignoto—Tristezza e Speranza"* (To the Unknown—Sadness and Hope). "The day came when we had to go and everyone was in the square saying good-bye. I had my Francesco in my arms. I was kissing his lips and kissing his cheeks and kissing his eyes. Maybe I would never see him again! It wasn't fair! He was *my* baby!" described Rosa Cassettari, who left Italy in 1884.

Many felt that they did not have a choice. In the late 19th century, the poet and stonemason Bruno Pelaggi wrote: "Hunger with a shovel/ you take it and with the hoe/ those who can escape it/ [go]to Novajorca [New York]." Before 1901, emigrants were lured by agents of private companies who promised them riches. The companies were headquartered in port cities like Genoa and Naples. Town locals—who earned a commission—encouraged leaving. Letters from America were also persuasive. (In a frame from the movie *The Italian* (below), Beppo, the main character, sends money to his wife to come). Those letters that praised the U.S. as the promised land were read out loud, passed from hand to hand. Guides (bottom left) were published to help the emigrant through the complicated process. But nothing deterred the determined. "I heard a great noise coming from the [train] station," wrote Angelo Mosso in 1905 after visiting a Sicilian town. "I was told that they were migrants. . . . I saw a black flood of farmers with sacks on their shoulders, running toward the third class wagons with women and children following and shouting. . . . When the train pulled out, it was an agonizing cry, like a burst of tears coming from a crowd in a moment of great misfortune."

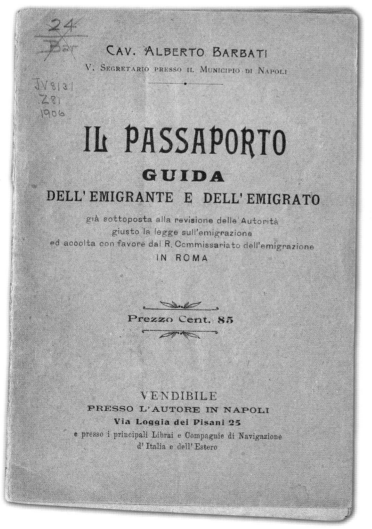

CAV. ALBERTO BARBATI
V. Segretario presso il Municipio di Napoli

JV8131
.Z81
1906

IL PASSAPORTO

GUIDA

DELL' EMIGRANTE E DELL' EMIGRATO

già sottoposta alla revisione delle Autorità
giusto la legge sull'emigrazione
ed accolta con favore dal R. Commissariato dell'emigrazione
IN ROMA

Prezzo Cent. 85

VENDIBILE
PRESSO L'AUTORE IN NAPOLI
Via Loggia dei Pisani 25
e presso i principali Librai e Compagnie di Navigazione
d'Italia e dell'Estero

The Crossing

Steamboat passage in steerage—the third and lowest class of travel—is almost universally acknowledged to have been miserable. "All us poor people had to go down through a hole to the bottom of the ship," remembered Rosa Cassettari, who sailed in 1884. "There was a big dark room . . . with rows of wooden shelves all around where we were going to sleep—the Italian, the German, the Polish, the Swede, the French—every kind. The girls and women and the men had to sleep all together in the same room. The men and girls had to sleep even in the same bed with only those little half-boards up between to keep us from rolling together. . . . When the dinner bell rang we were all standing in line holding the tin plates we had to buy . . . waiting for soup and bread." The photo (bottom left) shows preparations for a meal on the *Lahn* in 1903. Andre Castaigne drew the evocative portrait of five people sleeping on the *S.S. Umbria* in 1898 (top right). Perhaps the most tragic group are the refugees (bottom, right) from a 1908 earthquake and tsunami that claimed at least 100,000 lives in Messina and Reggio Calabria. By then, a ship's medical officer noted steerage's "unbreathable" atmosphere. "The stench . . . is such that the crew often refuses to come to wash the floor."

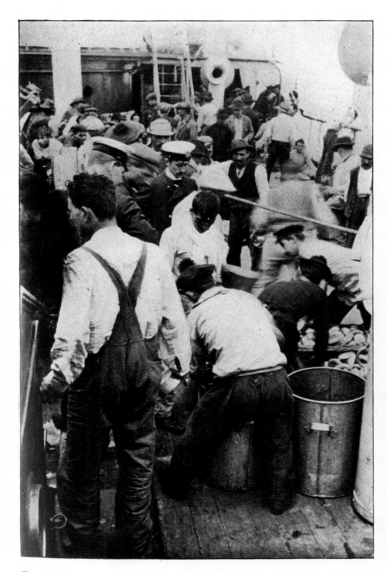

Preparing to Serve a Meal on the *Lahn* from the Food-tanks and Bread-baskets

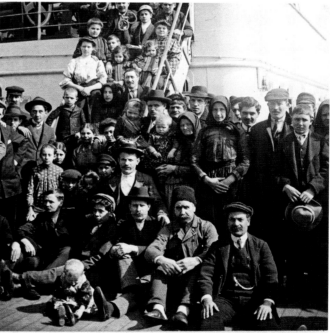

17325. Going to the Land of Opportunity, Homeless Italian Earthquake Refugees on their way to America.

New Twin Screw Steamship "EUROPA" of "La Veloce" Navigazione Italiana a Vapore. 'The Fast Italian Line.'
Length, 450 feet. Displacement 11,000 Tons. Speed about 17 miles

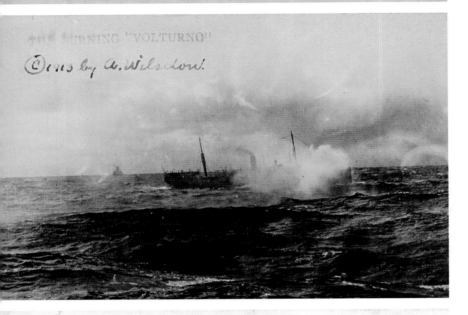

S. S. "CHRISTOPHER COLUMBUS." 324 COPYRIGHT, 1900, BY DETROIT PHOTOGRAPHIC CO.

"La Touraine" Cⁱᵉ Gⁱᵉ TRANSATLANTIQUE (FRENCH LINE)

Ocean Liners

In 1847, on the schooner *Bettuglia*, it took Andrea Gagliardo, a farmer who lived near Genoa, fifty-seven days to travel from Genoa to New York. A true "bird of passage," he crossed between Italy and the United States fourteen times. In 1861 he sailed—this time on a steamship—from Liverpool to New York in just seventeen days. The technical revolution in shipbuilding supported mass emigration—Italians could come to America in a matter of days rather than weeks.

Genoa was the favored embarkation port for Italians in the 19th century. Sixty-one percent of Italian emigrants left there between 1876 and 1901. Mirroring the increasing number of emigrants from Southern Italy, Naples quickly became the predominant port. Ships out of Naples carried 240,000 emigrants in 1907; it had more traffic than any other port, not only in Italy, but in Europe. The major passenger lines to the United States, in fact, were all European; none were American. But these lines had offices throughout the U.S. (advertisement, below right) where immigrants could prepay for tickets and send them on for their loved ones in Italy to use.

Some of the best known companies were Navigazione Generale Italiana, Lloyd Sabaudo, and Cosulich. The most famous boats (because so well-traveled) that carried passengers to America included the *Conte Rosso, Conte Verde, Dante Alighieri, Re d'Italia* and *Duca degli Abruzzi*. Four ocean liners are shown in postcards (left). But old and unsafe steamships were still used in the 20th century. The log book for the *City of Turin* in November 1905 states, "With over 600 people on board, there were 45 deaths of which 20 for typhoid fever, 10 for bronchopulmonary diseases, 7 for measles, 5 for flu, 3 for accidents on deck." And in 1907, a Neapolitan emigrant could write: "How can a steerage passenger remember that he is a human being when he must first pick the worms from his food . . . and eat in his stuffy, stinking bunk, or in the hot and fetid atmosphere of a compartment where 150 men sleep?"

Explorers, Emigrants, Citizens

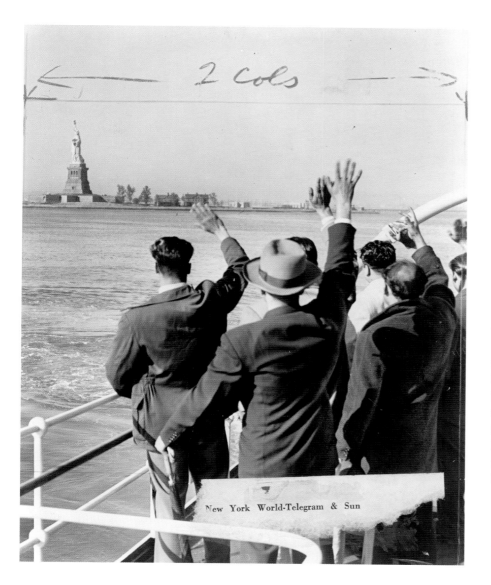

2 cols

New York World-Telegram & Sun

Lady Liberty

No matter how wretched the voyage—and how difficult life was afterwards in the United States—first spotting the Statue of Liberty (left) in New York harbor was a moment of joy and hope for most immigrants. "The night before we arrived, they told us if we wanted to see the statue we'd have to get up early in the morning," recalled Renata Nieri, who came to America in 1930, at age eleven. "We were up at four o'clock. We went up on deck, and everybody was up. And, oh, my God, when she came into sight I got gooseflesh, and to this day, I've been out there six or seven times. . . . I took some cousins of mine who came from Italy. We went to Ellis Island, and I still get gooseflesh. I love that lady. She's beautiful."

As symbolic of freedom as the Statue of Liberty is, it was not erected until 1886. When Rosa Cassettari came in 1884, what she saw was "the tall buildings crowding down to the water [that] looked like the cardboard scenery we had in our plays at the *istituto* [orphanage]"—still quite a site for an arrival from rural Italy.

Ellis Island (below), the other symbol of entry for hopeful immigrants, did not open until 1892. From 1855 to 1890, the official immigration center was Castle Island, in Battery Park at the tip of New York City. "The inside was a big, dark room full of dust," Cassettari described. "That room was already crowded with poor people from earlier boats sitting on benches and on railings and on the floor."

Ellis Island. New York City.

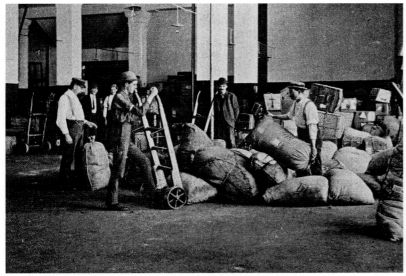
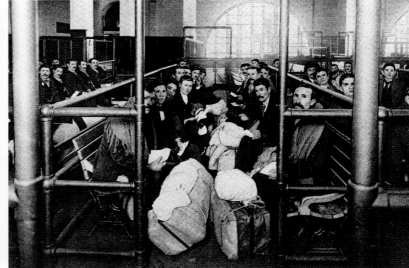
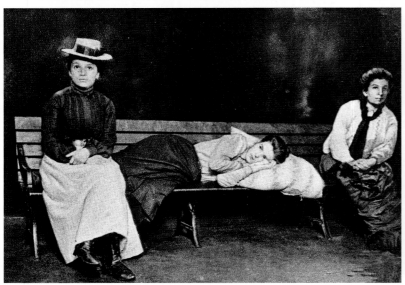
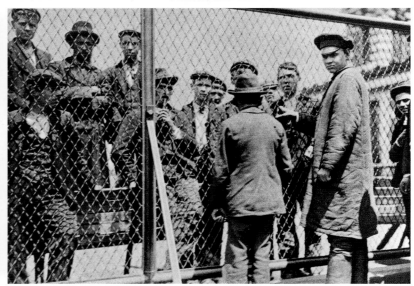

Going through Ellis Island

Nothing, not even the miserable ocean crossing, engendered more fear in emigrants than the possibility that they would be turned away at Ellis Island. Departing from their ships, they entered a network of rooms and buildings. The photos above (clockwise from top left) show a baggage room; a pen for holding thirty emigrants; a group of men about to be deported; and three women, also waiting for deportation. Women who traveled alone were usually sent back if there was no man to meet them.

The new arrivals were most afraid of the medical examination (bottom right). "[Many] were found to be suffering from trachoma [eye disease], and their exclusion was mandatory," said Fiorello LaGuardia, who had worked as an interpreter on Ellis Island in his youth. "It was harrowing to see families separated. . . . Sometimes, if it was a young child who suffered from trachoma, one of the parents had to return to the native country with the rejected member of the family. When they learned their fate, they were stunned. . . . They could see all right, and they had no homes to return to."

Although many came on prepaid tickets, they were advised to say they had paid for themselves; and also, that they had not made a prior agreement for work. American authorities sought to protect them from the *padrone* system—which secretly operated nonetheless—and to be sure they would not become "public charges"—impoverished residents who relied on government money to live.

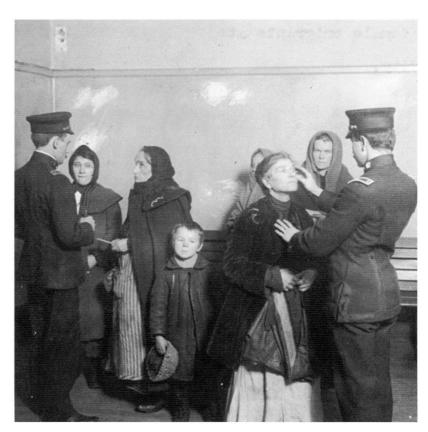

Explorers, Emigrants, Citizens

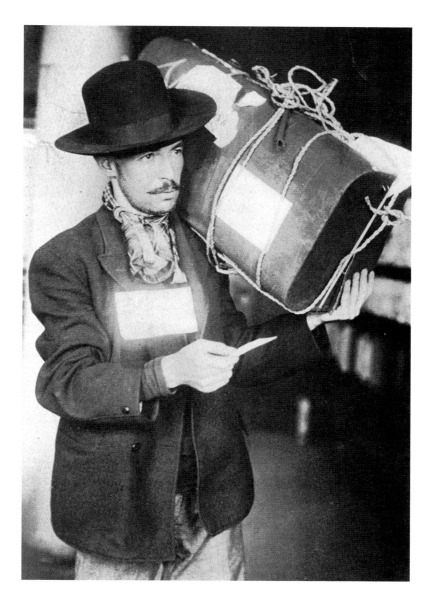

Imported Americans

In 1903 Broughton Brandenburg, an American author from a well-to-do family, did a remarkable thing. Disturbed by the growing outcry in the American press that immigration from "undesirable" countries like Italy should be limited, he realized that what he read was never "*from the point of view of the immigrant himself*." He and his wife, on assignment from *Leslie's Monthly*, literally lived the life of Italian immigrants for several months. Brandenburg wrote about what it was like in the book *Imported Americans*, published in 1904.

The Brandenburgs stayed in a New York tenement to learn Italian, traveled to Naples in steerage, and lived with the family of Antonio Squadrito in the Neapolitan mountain village of Gualtieri Sicaminò. They returned to New York—in steerage again—with their Italian family, and survived the hurdles of Ellis Island. The photo (left) shows Brandenburg "as He Looked when He Passed through Ellis Island as an Immigrant." *Imported Americans* demonstrates the strength of appearances in triggering prejudice: "Agents and janitors refused to show us apartments in the [Italian] garb we were in." Brandenburg is not without his own class biases—he finds Sicilians "a thoroughly desirable type . . . from the standpoint of good raw material for a great growing nation [the U.S.]". But he is a compassionate, observant writer with a mind more open than many of his American contemporaries.

Traveling in First Class

There was one sure way to avoid the snares of Ellis Island: travel to the United States in first or second class. Then American officials assumed one could support oneself. "The usual crowd awaited the first-cabin passengers. Some of the Italians bore extra coats to give to the shivering "greenhorns" [naive newcomers]," said Broughton Brandenburg. "What seemed to the eager [steerage] immigrants an unreasonably long time of waiting passed while the customs officers were looking after the first class passengers." One of these (right), identified as a Signor Moranzoni, casually stands on the deck of the *Giuseppe Verdi*, which sailed out of Genoa. Most Italians emigrated for survival, but some came to perform, others for business, and still others for leisure and pleasure. They could be assured of "a short week stay in a luxurious floating hotel," wrote librettist Giuseppe Giacosa in his book *Impressioni d'America* in 1908. "With good weather, life on board resembles that of the great cosmopolitan hotels in Nice and San Remo, except that there is more tempting and copious food, ready and punctual service, more diverse people, and daily news spreads faster." A little money could even buy extra comforts for third class passengers—better food, sleeping arrangements, and more fresh air.

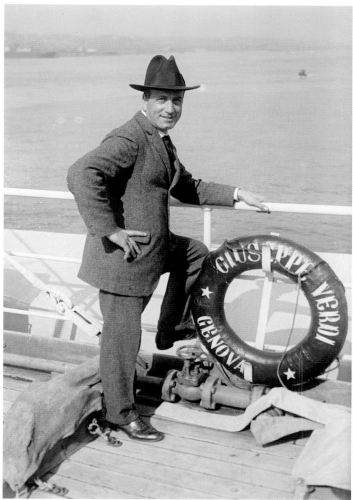

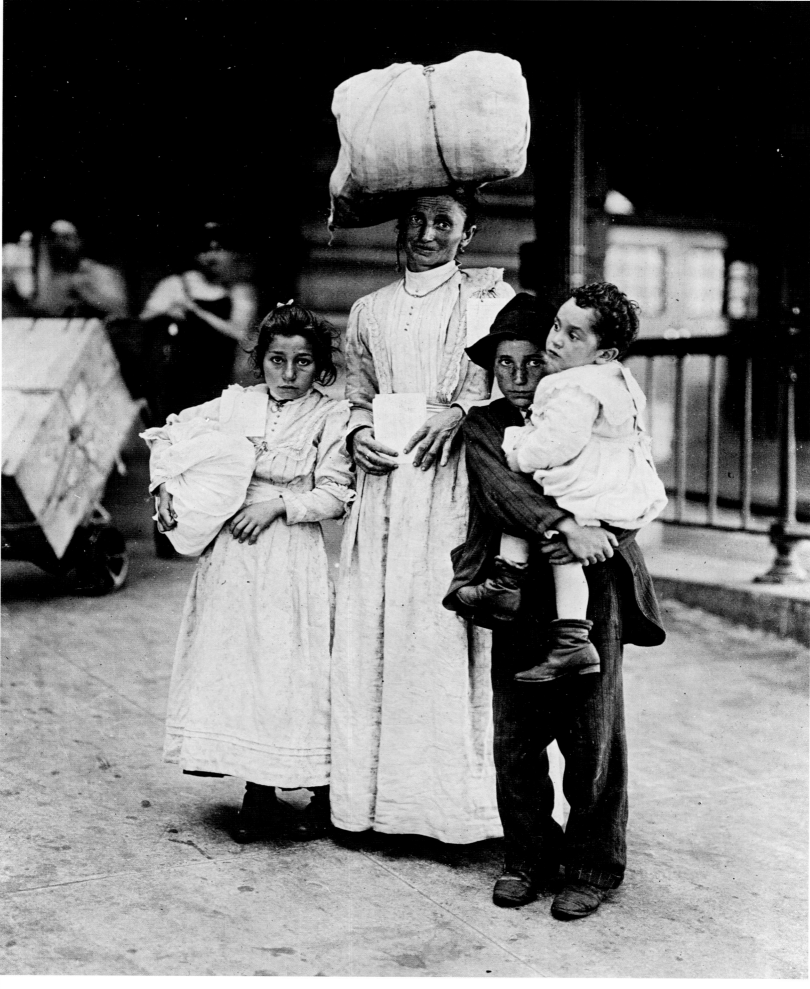

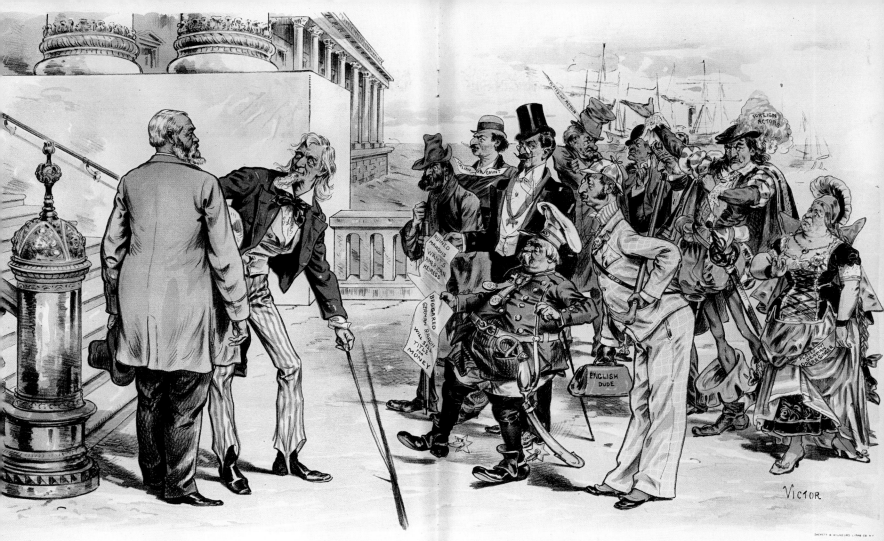

PRESIDENT HARRISON RECOMMENDS RESTRICTION OF IMMIGRATION.

Uncle Sam—"If we must draw the line, let us draw it at these Immigrants!"

"We should not cease to be hospitable to immigration, but we should cease to be careless as to the character of it. There are men of all races whose coming is necessarily a burden upon our public revenues, or a threat to social order. These should be identified and excluded."—Harrison's Inaugural Address.

The End of an Era

Immigrants like the Italian family (facing page), who arrived in 1910, were frightening to native-born Americans—including those whose families had come from Britain and northern Europe only decades before. A growing number of Americans felt that the United States was being taken over by impoverished, dangerous foreigners and that they would soon be in the minority. These cartoons (above and right) highlight the movement to restrict immigration.

Not only Italians, but Jews and Slavs alarmed American "nativists"—those born here who believed that only people of Anglo-Saxon heritage could become real Americans. They thought that the flood of southern and eastern European immigrants could never be assimilated into U.S. society and culture. These newcomers looked different, dressed and spoke differently, lived in crime and disease-ridden, filthy neighborhoods—never mind that the nativists did not want them in their own neighborhoods. Even elite and educated Americans began to equate race with ethnicity, as if race were a scientific fact. Southern Italians were not considered "white." A construction boss put it bluntly: "An Italian is a Dago."

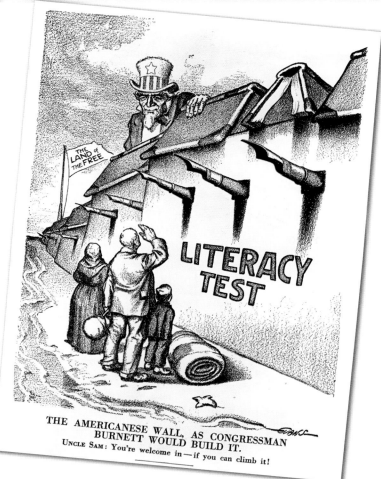

THE AMERICANESE WALL, AS CONGRESSMAN BURNETT WOULD BUILD IT.

Uncle Sam: You're welcome in—if you can climb it!

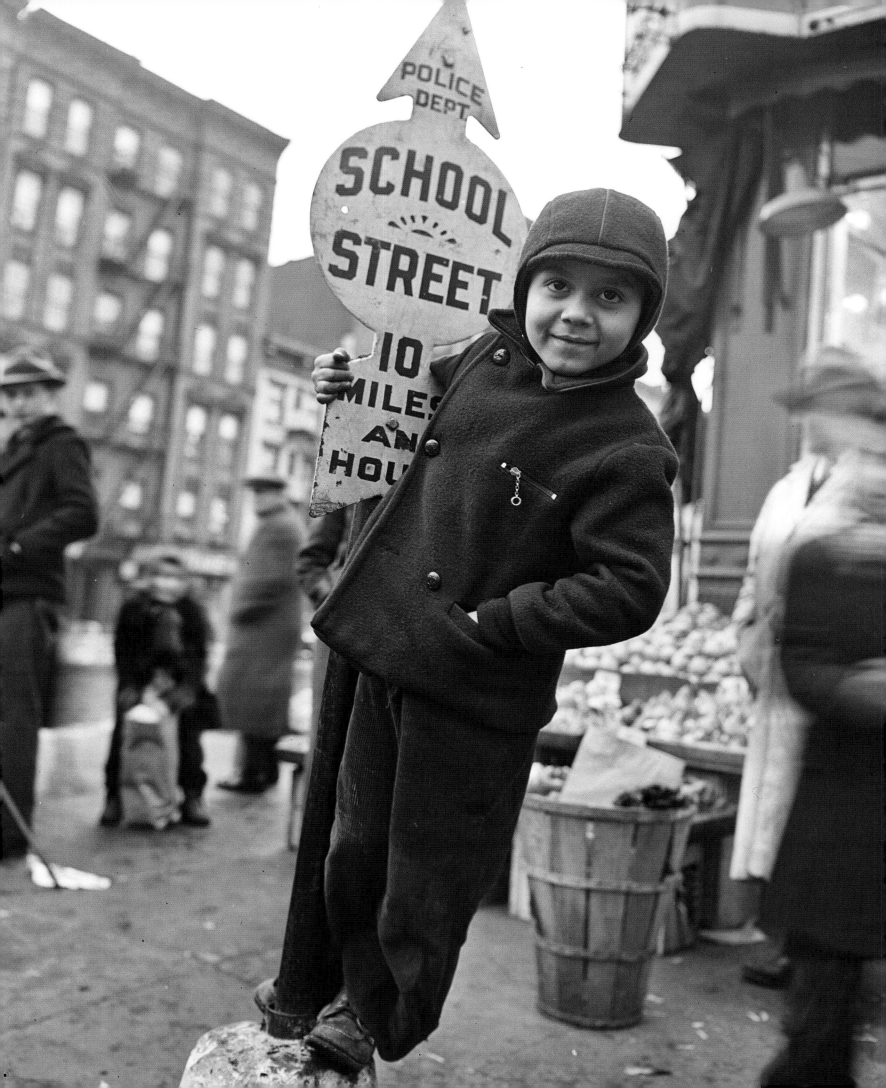

Living in the City

From Rural Italy to the Skyscrapers of America

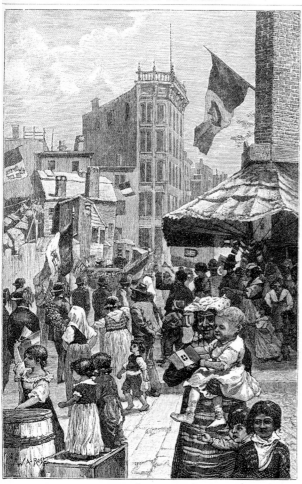

ITALIAN LIFE IN NEW YORK.

AN ITALIAN FÊTE DAY IN NEW YORK.

"New York, New York"

The crowded streets of Little Italy in the 19ᵗʰ century (above, from *Harper's*) and the 1943 photo of an Italian American boy at First Avenue and Tenth Street (facing page, by Marjory Collins) show the continued vibrancy of street life in New York City. Little Italy, in Lower Manhattan, and East Harlem on the Upper East Side were famous for being Italian. But New York had five boroughs, and by 1920, fewer than half of the city's Italian immigrants lived in Manhattan; more than a third lived in Brooklyn, a tenth in the Bronx, and 7 percent in Queens and Staten Island. All these neighborhoods had an ethnic feel as shops and businesses specialized in Italian products and allowed buyers to speak their own language.

The majority of Italian immigrants during the great migration landed in New York, and that is where most of them stayed. They lived in humble dwellings—boarding houses, tenements—generations of families crowded together. But they also showed the Italian propensity for being outdoors and gathering in public places. "Just like in Naples the sky [in New York] is webbed by frequent stretches of cloth running from one house and another," wrote Giuseppe Giacosa in 1908. "In the doorsteps, on the steps of the stairs, on stools made of wood or straw right in the middle of the street, the women show off their whole domestic life. Nursing, sewing, peeling wilted vegetables, the only seasoning of their soups, washing clothes in anointed tubs, grooming and tidying each other's hair."

It was probable that new arrivals would live in a city. (New Orleans and San Francisco drew some Italians, as did Chicago and Boston.) "The consequences of the poverty of immigrants and of their ignorance was their crowding in big cities," explained Alberto Pecorini, the director of an Italian American newspaper. "The [American] South is not completely unknown to our emigrants," pointed out Italian Ambassador Edmondo Mayor des Planches. "One wonders if there are reasons why our emigration does not go there. . . . According to the common opinion, the South would be ruined and poor, Italians there would be kept under servile conditions, abused or treated badly, and the labor contracts in the South would often be unclear and contain pitfalls. Moreover, our emigration lands on the northern shores. [They are] exhausted of resources and energy, afraid to delve further into a country where they ignore the language and do not know the conditions; [they] fall under the immediate temptation of the large cities, with Italian settlements existing in landing places close by."

But as Italian neighborhoods grew and more families were reunited in the early 20ᵗʰ century, the immigrants built a sense of community. "There was an Italian club on the street where I lived and they'd have a dance every weekend,"Albertina di Grazia, from New Jersey, remembered. "People would go there and some of them knew how to play music and they danced. At home in our living room, we had no furniture, just chairs. No rugs. But we had a Victrola and I always remember how we danced around on the bare floor. And we were always so friendly with our relatives . . . always being together." Even as they faced discrimination and hardship, Italians were learning to accommodate to their lives in America.

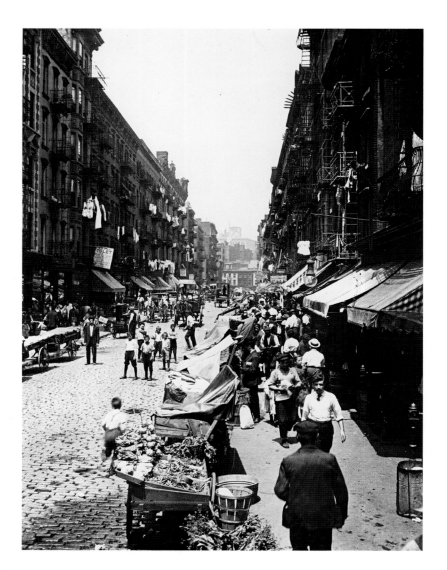

Little Italies

Recreating Home and Family

Street Life

This photo (facing page, bottom) was taken in Lower Manhattan's Little Italy on the feast day of a saint in 1908. Men sit on the sidewalk outside a shop selling tall candles for the *festa*. The largest candles are decorated with religious scenes. Arguably the best known Little Italy of all, the neighborhood was traditionally bounded by Kenmare and Spring Streets to the north and Canal Street to the south. Mulberry and Mott Streets ran down the center, and Hester, Grand, and Broome Streets ran parallel to Canal. The sidewalks were lined with shops and cafes, with tenements on the upper floors of the buildings (left).

"In Little Italy (the name of that part of the city where the Italians live) they are divided into groups," wrote Angelo Mosso in 1908, referring to the way that Italian immigrants replicated their life in Italy—not held together by a national identity, but by a loyalty to village, extended family and the chain of relationships that had brought them to the United States. "Sicilians, Calabrese, Pugliese, etc., they are all separate," Mosso continued. "People from neighboring villages are indifferent. The real ties are those of the family, then of friendship; they live firmly united in isolated groups, speak their own dialect and discuss the events of Italy on Mulberry and on adjacent streets [the area called Little Italy in Lower Manhattan], as if they were on the village square."

In the 1880s, after the first wave of immigration, Little Italies started popping up in American cities and towns. For non-Italian Americans looking at them from the outside, these neighborhoods seemed to be one, homogenous place housing one group of people. But inside, for the immigrants themselves, they were divided by regional and

family connections—even to the level of block by block, church by church, building by building. Displaced and disoriented Italians behaved like any other people; they sought comfort and familiarity. "This distrust [of outsiders], this gregarious spirit . . . the difficulties of language, and nostalgia, even if unconsciously, regretting his voluntary exile: all aspects conspire to create and maintain Italian immigrants in a range of activities limited to the group that is most closely related to his community of birth, family, traditions," observed Amy Bernardy in 1911. "What do we have in Little Italy if not a number of villages?"

Feeling part of a community, links in the same chain, could bring strength and pleasure. "We were a group all from our town that . . . came together," said Grace Calabrese, who emigrated in 1924. "This uncle of mine, my mother's brother, he brought his whole family over here too. We lived close, about four blocks away; and on a Sunday [we would] visit one another. One Sunday you spend two hours by me, have a cup of coffee, and

so on. You see, whoever we met over here, they group together. . . . And when they heard . . . say, 'Mrs. Baretta came from Italy and she's got a daughter. How about if we match her up with our son? You know, they're from the same town and we know one another.' And that's how it worked. . . . In fact, my mother . . . wouldn't *allow* me to marry anybody else from a different town. It's got to be from the same town."

But living inside Little Italies had serious disadvantages. It isolated Italian immigrants from other Americans—partly because most Americans, including other immigrant groups like the Irish and Germans, would not rent or sell to an Italian; partly because Italians were more comfortable and secure living with others from their hometown. They could avoid learning to speak English or adopt American customs, limiting their opportunities. Working the poorest paid jobs, they were crowded into the poorest slum neighborhoods. Malnutrition and tuberculosis affected children and adults. Even though they tried to recreate Italy, these mostly rural, agricultural people lived without one of the best health benefits of the countryside—fresh air.

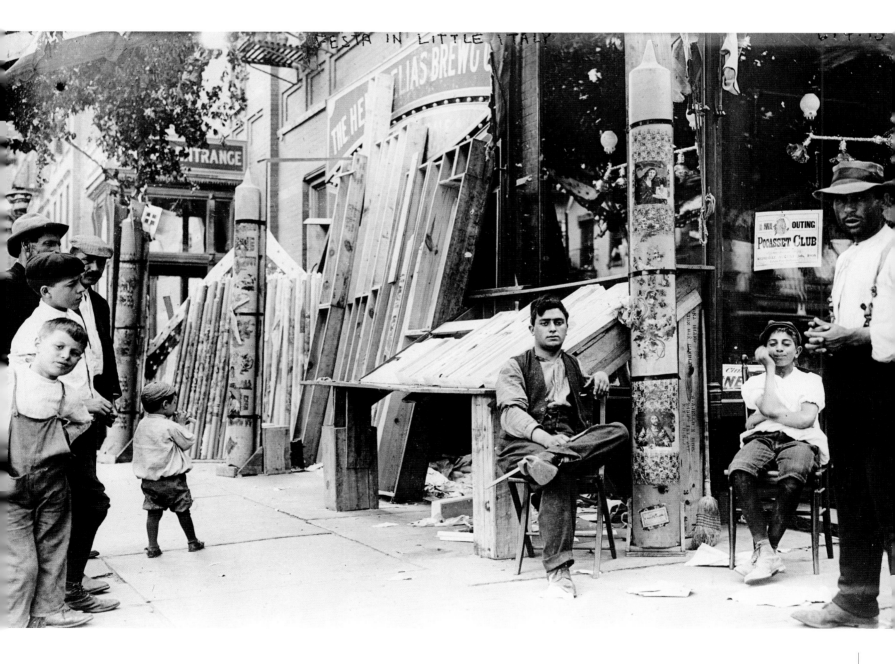

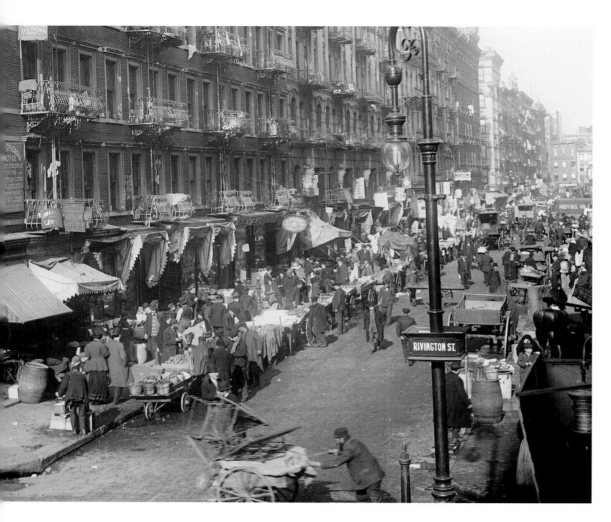

From North to South

The photo (left) of a "ghetto" neighborhood in New York's Lower East Side was taken between 1900 and 1915, at the height of mass immigration. The postcard (below) shows the Boston house once owned by the revered American patriot, Paul Revere—now next to an Italian shop selling jewelry. By 1875, Boston was the second largest port in the U.S. In the 1880s and 1890s, immigrants from Sicily, Abruzzo, and Naples began to take over the city's North End. By World War I, the population of the neghborhood was almost completely Italian. Many were fishermen, some of whom developed prosperous fishing fleets in Boston and smaller towns including Gloucester and Rockport. Others left to work in the Massachusetts textile mills—one in Lawrence would soon become famous for a labor strike. In 1911, Amy Bernardy wrote, "today [the North End] is no longer enough, the Italian groups invade the South End and suburban villages where the immigrant soon becomes a citizen and lives a little more hygienically."

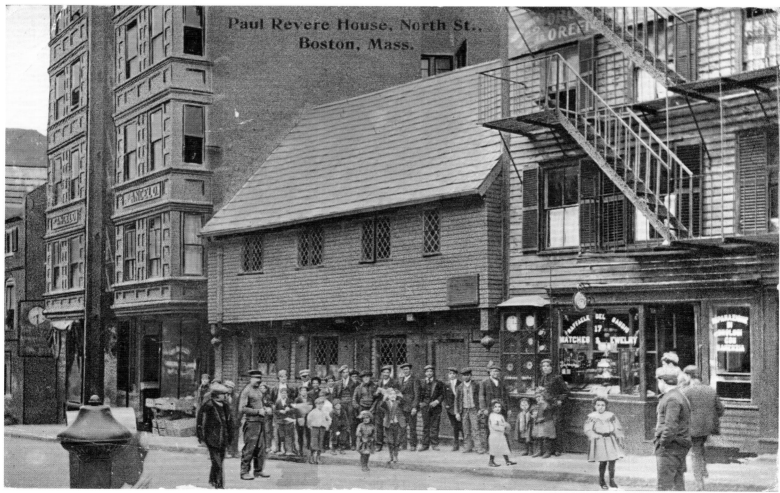

Explorers, Emigrants, Citizens

Italian immigrants also settled in Chicago, where the Jane Addams Houses (above) provided educational, cultural, and social programs for immigrants from all countries. "Settlement houses" like Addams Houses were organized by progressive middle and upper class women to respond to the poverty, disease, and crime they saw in the tenements. Here children play in the cool waters of the fountains outside the house. Italians began arriving in Chicago in the 1870s. As the city grew—by 1910 it was the second largest city in the U.S.—so did the Italian population. The majority were from Sicily, though tightknit groups of Calabrese, Piedmontese, and Genovese had their own enclaves.

Italians had come to New Orleans since the 1850s. They did not live in Little Italies, observed Amy Bernardy, "but you can hear Italian spoken in the market and in the restaurant, on the dock and on the street, a little everywhere." Italians could gather at the Italian headquarters on Madison Street (right). "The majority of the [Italian] colony belongs to the less educated and less affluent classes," wrote Edmondo Mayor des Planches in 1913, "but, not a few reached a comfortable life. . . . I am shown valuable real estate belonging to Italians. . . . A large hotel, a shoe manufacturer, and a great restaurant Italian doctors and lawyers, who are able to enter the most closed Creole [aristocratic New Orleans] society."

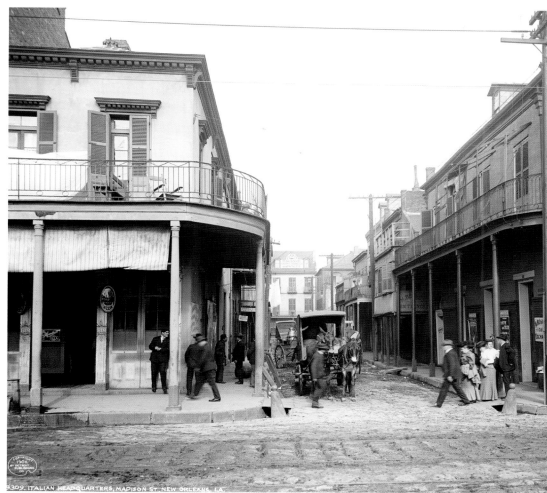

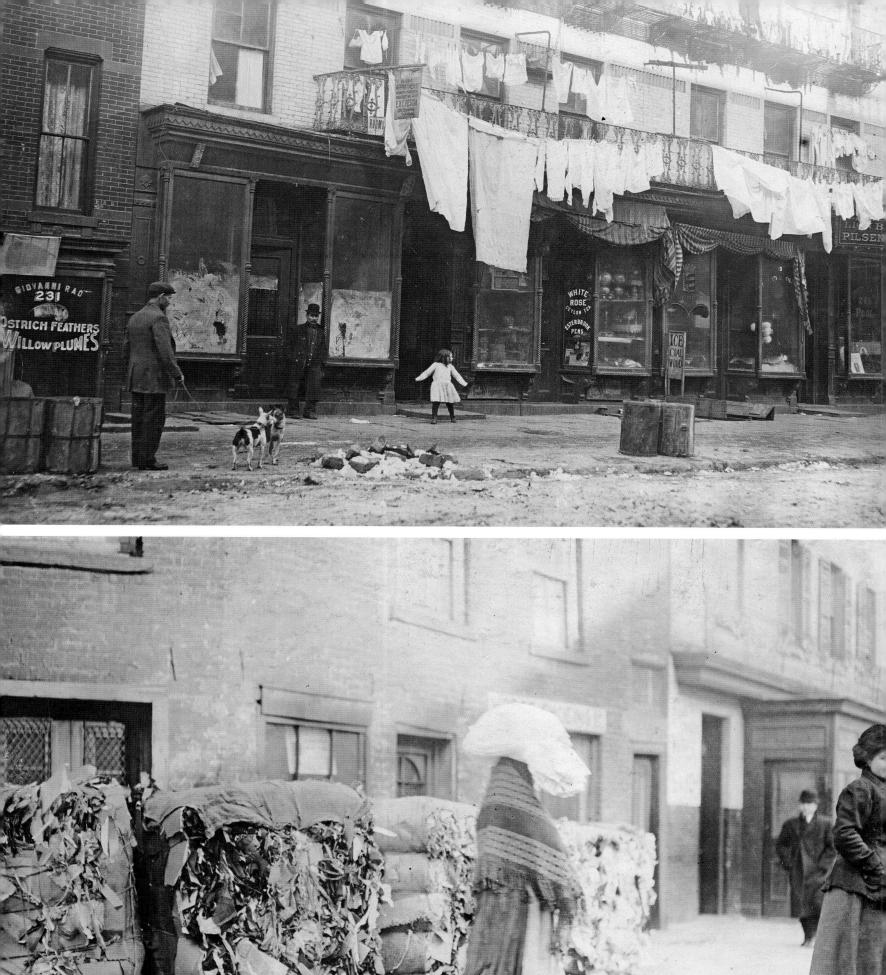

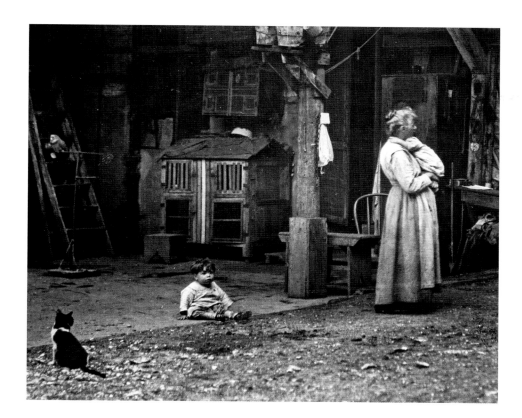

The slums

In 1908, one Italian writer pictured a "Little Calabria, across the ocean [where immigrants] return to their homes and after a very frugal meal, go to their poor beds, huddled against each other, for a little rest. Everyone can imagine how these tired and undernourished beings might easily develop the germs of diseases, especially tuberculosis." This verbal portrait of life in the slums is amply illustrated: East 107[th] Street in New York (facing page, top) where several families lived crowded together despite a sign promoting "Eleganti appart[a]menti" (elegant apartments); Lower East Side near the Brooklyn Bridge (facing page, bottom) in 1912; an Italian courtyard in New Orleans (left) in the 1920s; a yard in Jersey Street, photographed in 1888 when it was the worst New York City slum (bottom left). In the 1930s, when LaGuardia was mayor, a Tenement House Department (bottom right) still urged New Yorkers to keep their neighborhoods clean, and eradicate the images and the realities of slums.

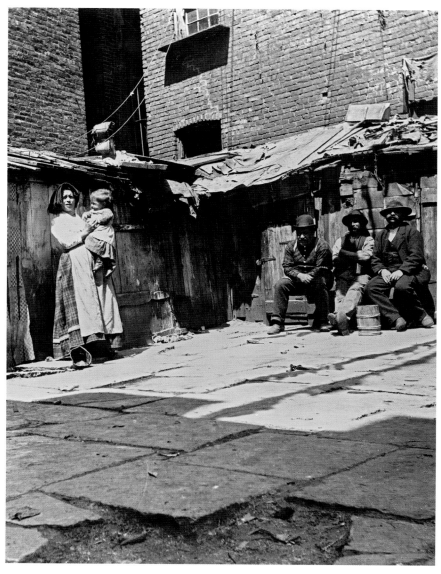

Help your neighborhood by keeping your premises clean

TENEMENT HOUSE DEPT.
OF THE CITY OF NEW YORK

F. H. LAGUARDIA
MAYOR

LANGDON W. POST
COMMISSIONER

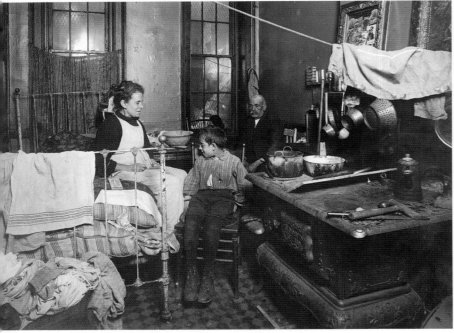

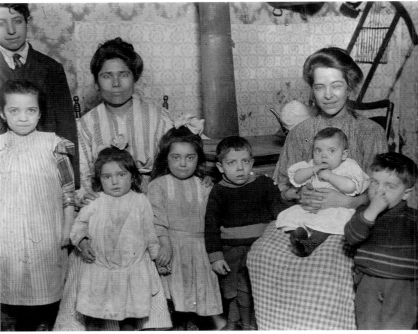

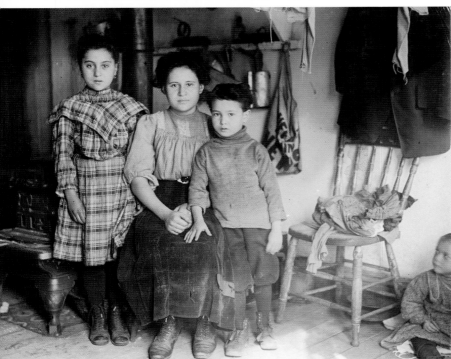

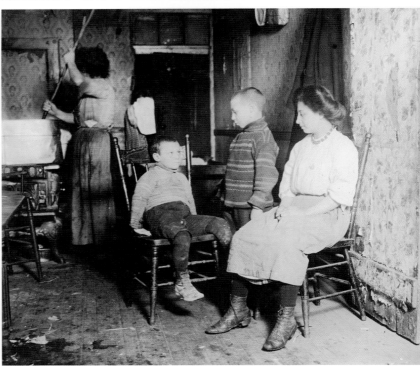

In the Tenement

"In one block of tenements which totaled 132 rooms, 1,324 Italian immigrants lived, mostly men, Sicilian laborers sleeping . . . more than ten people per room, for an entire block," journalist and social reformer Jacob Riis noted in the early 20th century. In tenements "the air is stifling, piles of clothes and rags lying on the floor, mixed with scrap, leftover food, the air and filthy living conditions make it fertile and fruitful for the germs of tuberculosis. . . . In every tenement we met at least two women suffering from tuberculosis." Riis's words come to life in the faces photographed by Lewis W. Hine, who documented living and working conditions, particularly for children. In 1913, Hine photographed Jimmie Chinquanana (top left), the ninth child of an immigrant family—six of his siblings had died. In 1910, he portrayed the homes of immigrants working in a canning factory in Buffalo, New York: Rosario Guarino and family (top right); Rose (age 13), Sarah (age 9) and Jo (age 6) Sarosa (bottom left), who were paid eight cents an hour for their work; and the Paresse children (bottom right). These children missed weeks of school to labor for the pathetic wages their families needed to get by.

Explorers, Emigrants, Citizens

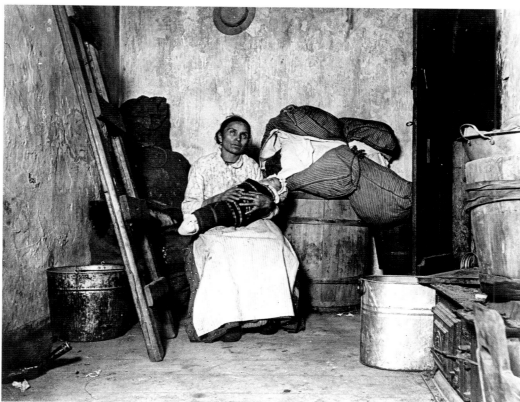

A FIVE POINTS LODGING CELLAR.

"Bordanti"

Married Italian immigrant women could only work at home; they often took in *bordanti*—boarders—to supplement income. Albertina di Grazia was five years old in 1913 when her father brought the family over to Scotch Plains, New Jersey. "Before long, my mother had twelve boarders, Italians who had come over without their families and were working to save money. They worked in the woods for a lumber concern . . . and whenever they had any spare time, they worked on the land." These boarders fared far better than the Italian mother and her baby in Jersey Street (top right), one of New York's worst slums, or those crowded into a lodging cellar at Five Points (bottom), another infamous slum, in 1872. "Sophy and the baby in the tenement," (top left) delicately drawn by F.C. Yohn in 1910, might have been a boarder or taken in *bordanti* herself.

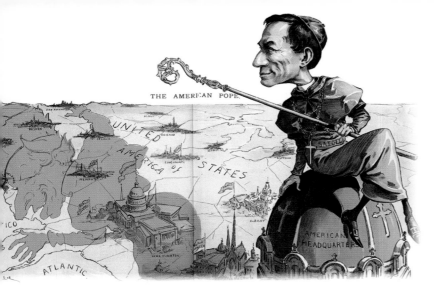

THE AMERICAN POPE.

Religion and Education

Catholic Churches and American Schools

European religion and politics—and the politics of religion—came to the United States with the immigrants. Italians were unique in their relationship to the Catholic Church because their country was home to the papacy, a powerful political entity in the 19th century. Many Italians who supported the *Risorgimento* were anti-Catholic (anti-clerical) because the Church opposed Italian unification. On September 20, 1870, the game was pretty much lost as *Risorgimento* troops took over Rome and secular Italy was finally unified under Vittorio Emanuele II of the House of Savoy.

Many Italian immigrants welcomed unification and celebrated September 20 every year as a patriotic anniversary. But supporters of the Catholic Church in the United States were unhappy. In November 1870 Joseph Alemany, Bishop of San Francisco, expressed the "general feeling of horror for the occupancy of the Papal State by the Italian Army and the oppression of freedom occurred to the Holy Father."

At the same time that Italians divided on the fate of the Church, nativists—those who believed that only people of Anglo-Saxon or Scandinavian ethnic background could be true Americans—were extremely anti-Catholic. They believed Americans should be Protestants—and some Catholics did convert so they could assimilate more easily into American society. Nativists also believed there was a papal plot to take over the United States. Enter the post-1870 Catholic Church, which began to realize that although it had lost power in Europe, it had millions of followers in North America. Rather than lose Catholics to Protestant propaganda, it could support them as a base of political power in the United States.

Most Italian Americans lived their lives without thinking about these larger issues. In Italy, it was problematic to support both the unified secular government and the Church. But for immigrants to the United States, pride in being Italian increased in the late 19th century, and to be Catholic was also a way to be Italian. Italian flags began to appear regularly in religious processions. The Church did not welcome this association of religion and the state because Italian unification was a defeat for the papacy. But the way Italian immigrants expressed their faith—in street festivals and saints day celebrations— was a deep part of their cultural heritage. They cared less about regu-

Catholicism in America

In 1893, Cardinal Francesco Satolli became the first apostolic delegate to the United States, based in Washington, D.C. Appointed by Pope Leo XIII as a religious, not a political, representative, Satolli was meant to pacify the ethnic feuding in the American Church. But in this print by Udo Keppler in 1894, (top left) he is considered "the American pope," casting a shadow in the shape of Leo XIII across the U.S. to indicate the menace of Catholic influence on such nativist traditions as public education. Beyond the realm of international politics, the Italian faithful attach dollar bills to the statue of San Rocco (above) during the saint's festival in Paterson, New Jersey.

larly attending mass on Sunday than venerating the Madonna. This put them at odds with the American Catholic Church, primarily composed of German and Irish Americans, who saw the Italians as superstitious and improperly disciplined.

Italian immigrants also felt differently about education than did other American Catholics, who often sent their children to parochial schools. Italians tended to use the public schools, which were free, but did nothing to support piety or ethnic culture. Perhaps this attitude was natural, considering that Italians expressed their faith through community activities rather than strict adherence to parish rules and regulations or to formal doctrines. But by sending their American-born children to public schools where English was the only language used and where they were exposed to American ways, the immigrant generation created conflict between their own values and beliefs and those of their sons and daughters.

"The child does not know much of Italy other than the broken dialect spoken in the family, the obscene words he hears on the streets," observed Edmondo Mayor des Planches, Italian ambassador to the United States from 1901-1910. "He never sees an Italian book at home because no one knows how to read, he knows nothing of Italy because his father can tell him nothing." He also described an immigrant family where "the daughters grew up in the independence of the American girls, attended American schools, have American friends and companions, offering one of the most characteristic examples of the speed with which the environment encircles and assimilates. . . . Should they fight to counteract the conquest that the adopted country is making?"

THE POPE'S NEW HOBBY.

"An Italian Paper—the *Examinatore*—recently declared, in a passage which has been widely copied, that the Roman Court expected soon to control the American Republic, and the writer added: 'The populous City of New York even now, in fact, is governed by the Roman Court, through the cunning of the Papal Hierarchy, and their universal subjection of religious interests to those which are politico-ecclesiastical.' "—*Tribune*, May 1.

Foreign Plots or Good Americans?

In this editorial cartoon (above), the "Pope's New Hobby," the pope seems to be riding—and taming—the American eagle. The Italian newspaper *L'Esaminatore* stated that the papacy expected to take control of the United States, adding that "the populous city of New York . . . is governed by the Roman Court, through the cunning of the papal Hierarchy." In the U.S., allegiance to the pope was seen by non-Catholics as a barrier to assimilation.

Immigrants were encouraged to attend classes in learning English and American citizenship, as these women are doing in New York (right), drawing them further away from their Italian roots and into American society.

ST. MARY'S DAY IN LITTLE ITALY. THE PROCESSION ON ITS WAY TO THE CHURCH.

Solemn Coronation

Statue of Our Lady of Mt. Carmel
NEW YORK, 1904

Cover and Contents Copyrighted, 1904, by Rev. Father John Dolan

PRICE 10 CENTS

Italian Popular Religion

"The hand carts full of sacred images of rosaries and candelabra, roam the streets of Italian neighborhoods," Amy Bernardy reported in 1911. "At the exit of Mass, rural Italy comes back to our memory and regrets. . . . Churches are no longer near the mountain or along the sea, but the crowd is still wearing the traditional costumes . . . and the shawls are still in the vivid colors of Italian villages, and the voices still resound of the Messina or Benevento." But more important than mass, the worship and celebration of a patron saint on his or her feast day reaffirmed the immigrant's Italian regional traditions and connected men and women to each other in their American communities. For the annual feast of "the Madonna of 115th Street"—the Madonna of Mount Carmel (left) of New York's East Harlem—"everybody had to clean their house that week, the week before, new curtains and everything," in preparation for the celebrations that began on July 16. The highlight was "the great Mount Carmel parade," according to scholar Robert Anthony Orsi, "with thousands of marchers, several bands, trailing incense and the haunting sounds of southern Italian religious chanting. [It] made its way up and down every block in the 'Italian Quarter' of Harlem." Participants carried giant devotional candles; fireworks exploded; street vendors sold food and religious objects. People waited patiently to enter the church, where, at the altar, they left devotional gifts of gratitude. Other Italians celebrated St Gabriel, St. Lucia, St. Sebastian, and San Gennaro's days, as well as St. Mary's Day (above) with a traditional parade to the church, which was also popular. This was the feast of the Assumption, celebrated on August 15, when Mary ascended to heaven.

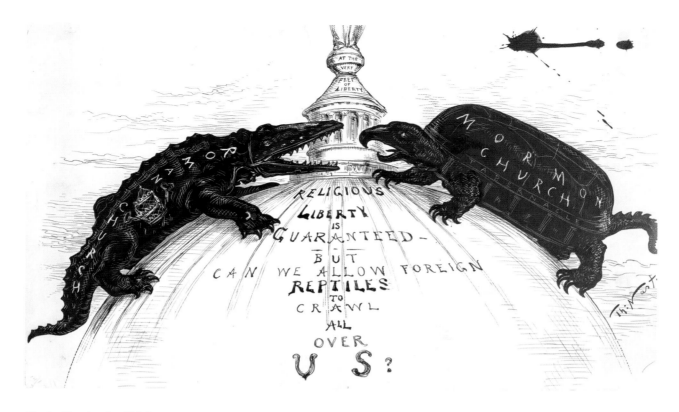

Catholics in the USA

The United States's foundation rested on religious liberties, but in this late 19ᵗʰ century Thomas Nast cartoon (above) nativists and even more moderate Protestants worried about the takeover of the country by Catholics. Alberto Pecorini wrote in 1910 that Europeans were "surprised when they see the magnificent cathedrals built by Catholics in a Protestant country . . . that there are in the United States fourteen archbishops, eighty bishops and eleven thousand priests with fourteen million followers." But "Europeans do not notice" this sign of American prejudice: "that the number of Catholic senators, congressmen, governors, diplomats is miserably small compared to the number of the faithful, who make up fifteen percent of the entire population."

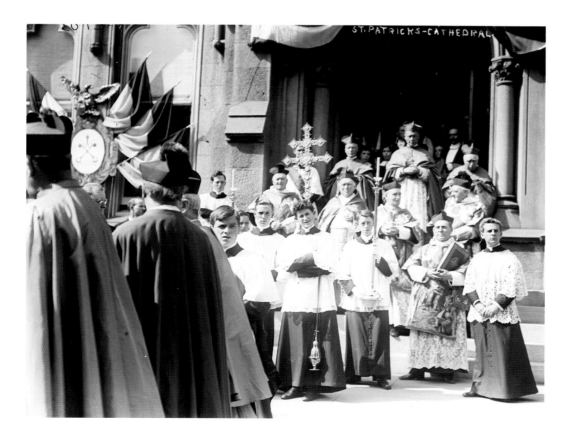

Irish and Italian Catholics

In 1888, Irish Catholic priest Bernard Lynch explained to his parishioners that the "dark-eyed, olive-tinted men and women" arriving from Southern Italy were not really Catholics. "The fact is the Catholic Church in America is to the mass of Italians almost like a new religion." Italians "fed on the luxuries of religion," like pilgrimages to shrines or special devotions, without understanding "the great truths which alone can make such aids to religion possible." Ethnic Irish clergy dominated the hierarchy of the American Catholic Church. New York's magnificent St. Patrick's Cathedral (left), shown here on the day it was consecrated in 1910 in the presence of Italian Cardinal Vannutelli, was a visible symbol of their influence. One ethnic French priest asserted that their attitude had lost the Church twenty million Catholic immigrants. Italians and other ethnic groups needed priests and parishes who understood them.

Costello, Photo. ALTAR OF ST PAUL OF THE CROSS NO 2 J. C. Heights, N. J

ENTERED ACCORDING TO ACT OF CONGRESS IN THE YEAR 1863 BY A, B, COSTELLO, IN THE OFFICE OF THE LIBRARIAN OF CONGRESS AT WASHINGTON.

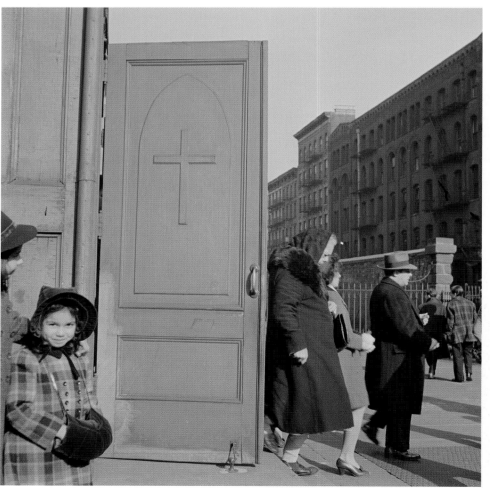

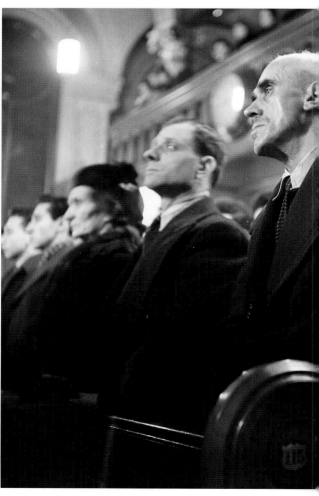

Italian Parishes

When Giovanni Battista Scalabrini, Bishop of Piacenza, was on a train platform in Milan, he observed the pitiable condition, as he saw it, among passengers on their way to the Americas. In 1887 he formed the Congregation of the Missionaries of St. Charles Borromeo—now known as the Scalabrinian Fathers and Brothers—to support the Catholic faith in Italian immigrant communities and to ensure the immigrants' welfare. (A Scalabrinian order of sisters was founded in 1895).

Also in 1887, the Vatican office *Propaganda Fide*—Propagation of the Faith—authorized the forming of "national" parishes in the United States. Instead of having authority over a neighborhood, these parishes had authority over specific immigrant groups who spoke a common language. The following year, St. Joachim in Manhattan became the first Catholic church founded for Italians in New York. The church of St. Paul of the Cross in West Hoboken, New Jersey (facing page, top, in a photo by Italian photographer Alfred B. Costello) was one of these early churches. By the 1940s, there were Italian parishes throughout New York, including St. Patrick's on Mulberry Street (facing page, bottom left) and Saint Dominick's (facing page, right and below), and across the U.S.

Italian parishes often felt discriminated against by non-Italian, usually Irish American, bishops. The first Italian American auxiliary bishop, Joseph Pernicone, was not appointed until 1954. The first Italian American cardinal—Joseph Bernardin—was appointed in 1982! Italians in Italy and the U.S. worried about the lack of Italian-speaking priests; in the early 20th century, a number of Italian clergy immigrated to the United States, but for lack of organization, they were not always placed in Italian parishes. Yet these parishes managed to build churches, schools, hospitals, and orphanages that reflected their needs in America and their dearly held traditions.

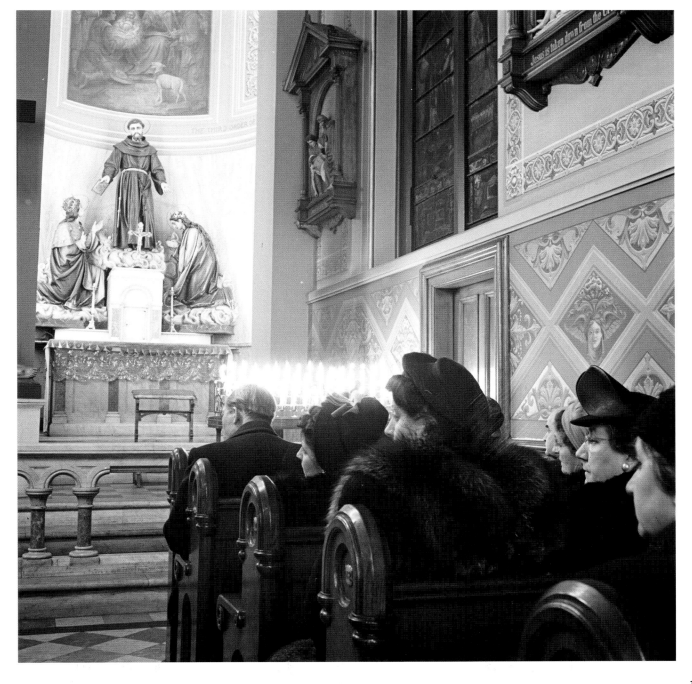

Saint Frances Cabrini

In 1888, Sister Frances Xavier Cabrini asked Pope Leo XIII if she could start a mission in China. "Not to the East, but to the West," he is reported to have told her. In 1889, he sent this cofounder of the Missionary Sisters of the Sacred Heart (and a friend of Bishop Scalabrini) to the United States to minister to the flood of impoverished Italian immigrants.

Cabrini herself was an Italian immigrant. She was born in Italy in 1850, in Sant'Angelo Lodigiano. When she began her work in New York, she could not speak English. But she persuaded the Irish American bishop to support her and took to the streets of Little Italies to see what help was needed. The first institution she founded was an orphanage in 1890. To commemorate the 400th anniversary of Columbus's discovery, she opened her first hospital—Columbus Hospital of New York—in 1892. She was later based in Chicago, and founded an astonishing number of medical facilities, schools, orphanages, nurseries and other institutions—sixty-seven—throughout the United States and Latin America.

Cabrini became an American citizen in 1909. She died in 1917 and her tireless energy and charitable accomplishments were soon recognized. She was the first American to become a saint, canonized in 1946, the same year this portrait (right) was painted.

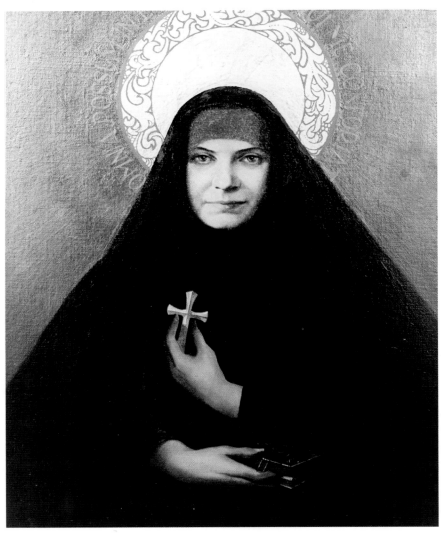

Italian Pupils

In a way, the teaching of Italians in America dates back at least to 1851, when Italian Jesuits John Nobili and Michael Accolti founded Santa Clara College (aerial photo facing page, top), the oldest institution of higher learning in California. The intent was to provide Catholics in the West with a Catholic education.

The desire to preserve the Italian language and heritage, as much as to teach Catholicism, fueled the founding of Italian and/or Catholic schools for Italian immigrants. Most Italians sent their children to public schools because they were free. Italian aid societies tried to counter this trend by founding Italian schools. *Giornale popolare di viaggi* reported in 1871 on "the Italian school . . . called the Five Points [in New York]. . . . More than 200 Italian children of both sexes gather there daily, and will receive free Anglo-Italian education which is more than enough to provide them with the means to earn a decent and honest life."

Italian pupils (right and below, taken between 1910 and 1915)—the first generations born in the United States to Italian immigrant parents—lived in two worlds, especially if they attended public school where only English was spoken. If their parents spoke English at all, it was often what Amy Bernardy called "a special language . . . remodeled English words pronounced with an Italian accent and of Italian words phonetically similar to other English words, which . . . [lose] their original meaning." Thus, as Adolfo Rossi noted in 1894, Brooklyn became "Broccolino," yard became "jarda," and shovels became "sciabole." In the meantime, the children were losing touch with their native tongue.

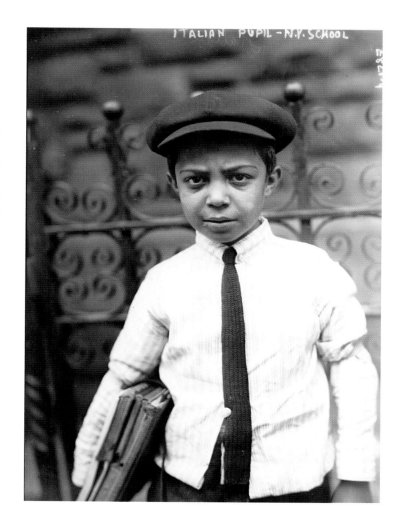

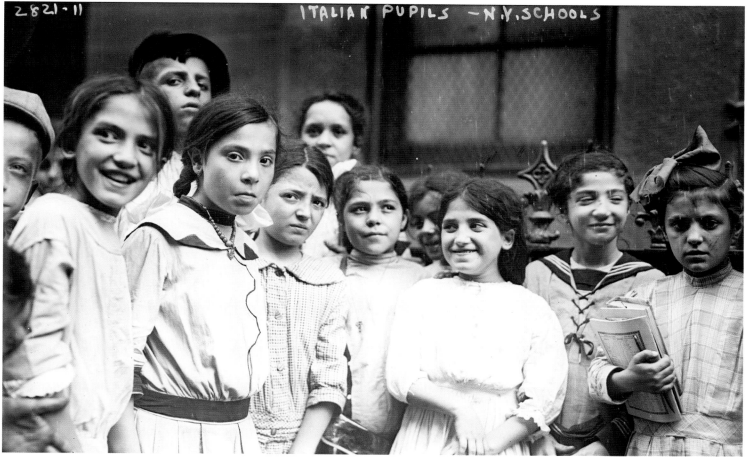

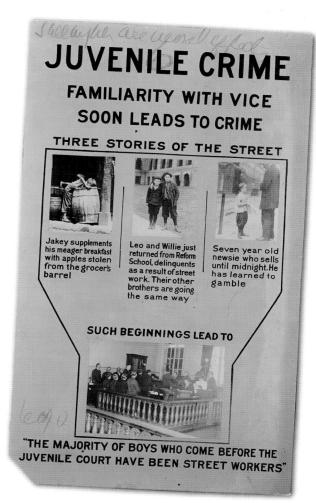

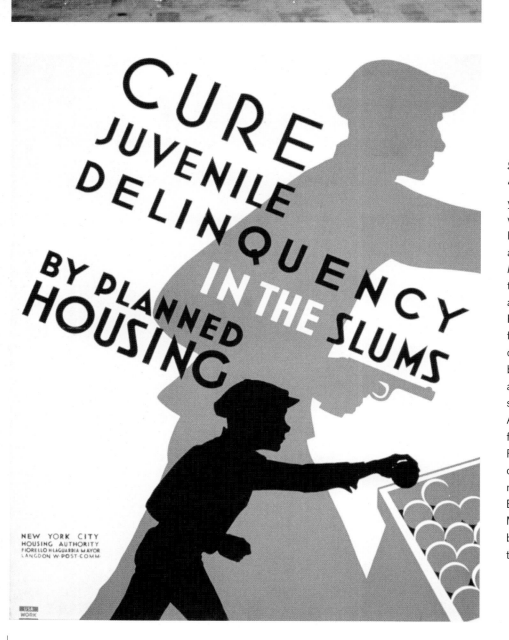

CURE JUVENILE DELINQUENCY IN THE SLUMS BY PLANNED HOUSING

NEW YORK CITY
HOUSING AUTHORITY
FIORELLO H LAGUARDIA MAYOR
LANGDON W POST COMM

Street Kids

"Do not send [from Italy], for a small gain [paid by a *padrone*], young children with . . . [no relatives], religion or morality, whose purpose is only to enrich [the *padrones*] . . . by selling human bodies, Italian bodies, who are called white slaves," an Italian emigrant warned Italian parents in *Da Biella a San Francisco* in 1882. With the great waves of immigration came the problem of impoverished, parentless children working for a pittance and virtually growing up on the street.

Poverty and discrimination caused even young people with families to join gangs, exposing them to a life of violence and crime. "You could do two things when we were kids," remembered a resident of Italian East Harlem. "You either became a thief and eventually go into the rackets or you could go to school." These Lewis Hine photos show first generation Italian American boys hanging out in Boston (top left, 1909), Springfield, Massachusetts (facing page, top, 1910) and Providence, Rhode Island (facing page, bottom, 1912). The posters (above, c. 1913 and bottom left, 1936) show that juvenile delinquency remained a problem, especially in big cities.

But mostly, Italian American children went to work. In the 1910s, Mary Cerone and Rose Marino each left school at fourteen to become apprenticed to trades—one to make cigars, the other to make candy. They worked at these trades their entire lives.

Explorers, Emigrants, Citizens

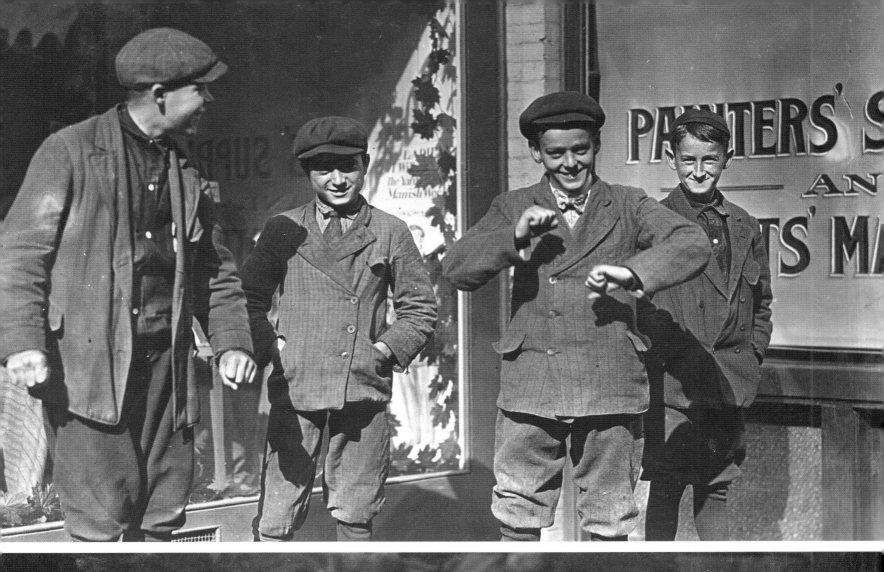
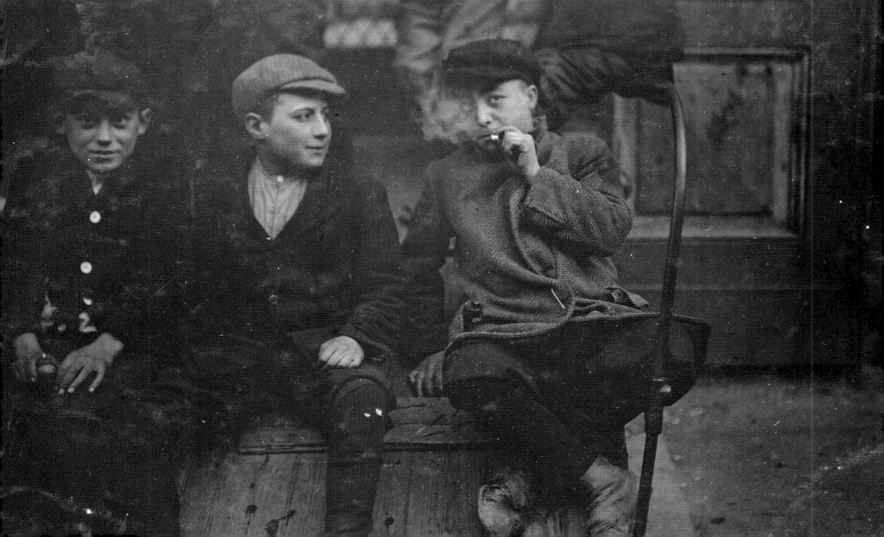

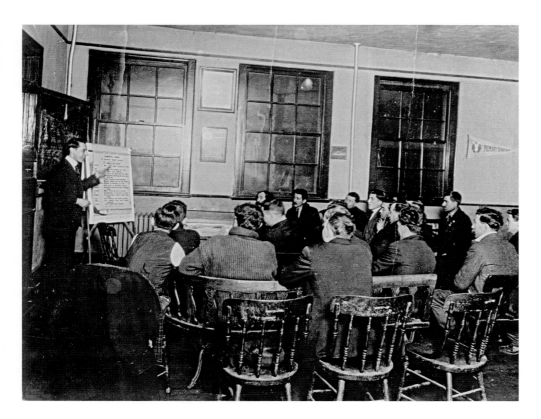

Adults Learning English

"The problem faced before all others for those who arrive in America is language," pointed out an Italian American newspaper during the peak waves of immigration. "If you cannot talk, you will be in conditions of great inferiority in comparison to other citizens. You will need to adapt to any kind of work, many profiteers will easily exploit you and you will suffer constant humiliations. English is needed to find a good and profitable job; for your relationship with the Americans; to buy the things that you need in a more convenient way; to enforce your rights as a worker and as a law-abiding citizen."

Free classes were open to those who sought to learn English. From the American side, they were a worthwhile investment to speed assimilation and to improve the ability of workers to do their jobs. The Ford Motor Company in Detroit offered classes to these immigrants (below, photo taken before 1932). They were sponsored by the U.S. Department of Labor, as were the classes at the Newark, New Jersey Y.M.C.A. (left). The immigrant students also learned about citizenship.

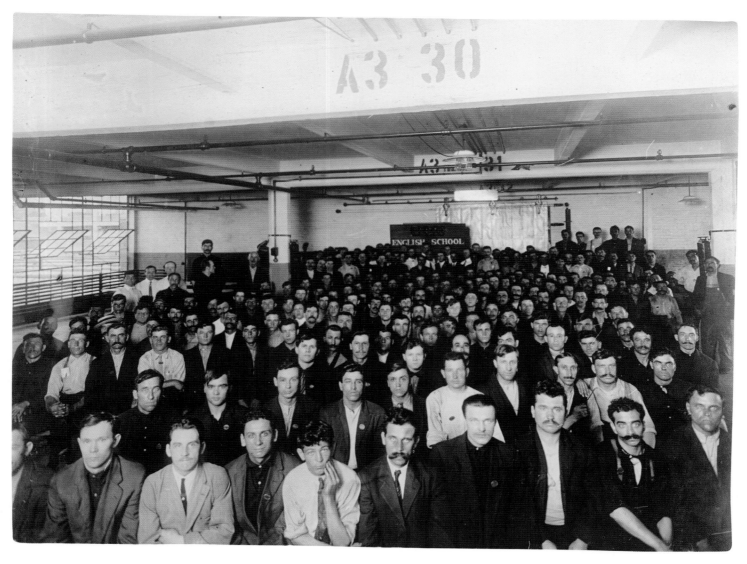

Explorers, Emigrants, Citizens

LA DOMENICA ILLUSTRATA

ITALIAN AMERICAN WEEKLY REVIEW

EDITED BY ROMEO RONCONI & STEFANO MIELE

Published and distributed under permit (No. 829) Authorized by the Act of Oct. 6, 1917, on file at the P. O. of New York—By order of the President.—A. S. Burleson, Postmaster General.

| Vol. I. | NEW YORK, 25 GIUGNO 1921 | No. 17 |

GRADUATION DAY

Copyright—Domenica Illustrata Publishing Co., Inc.

"Angelina Cirig...li...ano"

5c 5c

Learning to be American

The 1921 cover of *La Domenica Illustrata* (left) indicates the sense of achievement mixed with shame, when Italian American children graduated and the principal handing out the diploma could not pronounce the student's last name! At the Beecher Street School in Southington, Connecticut (bottom right) in 1942, half the student body was of Polish descent, half Italian. Yet they were celebrating May Day decked out in red, white, and blue. Assimilation was often a one-way street. As former Italian ambassador Edmondo Mayor des Planches pointed out in 1913 after he visited an Italian immigrant family, their six daughters "not only do not speak any language but English, but their inflections and voice sounds are typical of those who have English as their mother tongue." Adults like these at the Hudson Park Library in New York (bottom left) went to school to learn citizenship skills as well as language, but still retained memories of Italy. However, "in large cities, where there are many children of immigrants, in schools almost every class must display the national [American] flag and a special care is put in teaching hymns and patriotic songs," wrote Alberto Pecorini, who edited an Italian American newspaper, in 1910. "It saddens my heart to think that, going to schools with hundreds of Italian pupils, we saw those black and intelligent eyes sparkle to the sound of the American national anthem, we saw them proudly pointing to their new flag, but we never heard a child, even among the newly arrived, who could recognize the colors of the Italian flag."

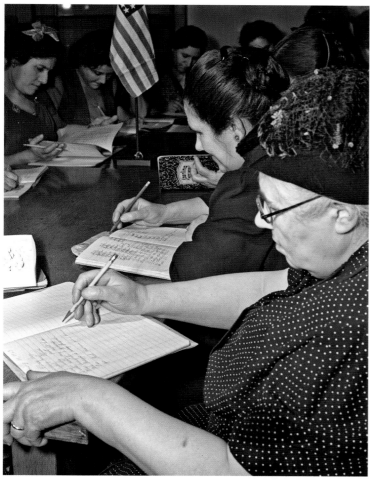

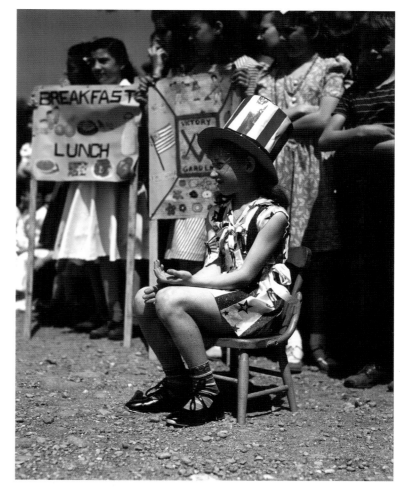

Italian Culture

News & Entertainment in America

Fiorello LaGuardia, one of New York's best beloved mayors, wrote in his autobiography that when he was growing up in Prescott, Arizona, in the 1890s, "I must have been about ten when a street organ-grinder with a monkey blew into town. He, and particularly the monkey, attracted a great deal of attention. I can still hear the cries of the kids: 'A dago with a monkey! Hey, Fiorello, you're a dago too. Where's your monkey?'"

The Italian organ grinder—stereotyped by many Americans as reflecting an unsophisticated, even base, foreign culture—was perhaps the best known entertainment during the early decades of mass immigration, offering immigrants nostalgic pleasure. But it was only one small part of the wealth of music, shows, film, newspapers and books available to Italians in the United States.

More than a thousand Italian-language weekly or monthly magazines were published, and from 1900 to 1930, some thirty newspapers also published for an Italian American audience. Orazio de Attellis founded the first newspaper printed partially in Italian—*El Correo Atlantico*—in 1835. Giovanni Casali in 1849 founded both *L'Europeo Americano*—failed after nine weeks—and *L'Eco D'Italia*, which lasted until 1896. After 1880, *Il Progresso Italo Americano* became New York's most important Italian newspaper, perhaps because its business-minded founder, Carlo Barsotti, had been a *padrone*, and was a banker and entrepreneur. Generoso Pope bought *Il Progresso* in 1928 and doubled its circulation to 200,000, making it the largest daily Italian-language newspaper in the United States.

Newspapers reported on real-world events, but Italian fiction writers also wanted to give a voice to immigrants who were set upon by discrimination and difficulty but also aspired to fulfill their dreams. These novels ranged from the thrillers by Bernardino Ciambelli, published in the 1880s and 1890s, such as *The Mysteries of Mulberry Street* and *The Trials of Emigration;* to *Gente Lontana (The Faraway People)* by Corrado Altavilla in 1938.

Italians had a more robust association with opera rather than theater, but most immigrants could not afford to attend live per-

El Correo

Marquis Orazio de Attellis Santangelo (above), born in Italy in 1774, was the first to publish an Italian language journal in the United States: *El Correo Atlantico*, which he founded while living in Mexico and continued to produce in New Orleans, where its contents were printed in Italian, Spanish, and French. Attellis, a political exile who had belonged to a secret society promoting revolution in Italy, supported Texas' independence from Mexico. He thought Texas should not become a part of the United States either, however, because he feared it would encourage the spread of slavery. Attellis became a U.S. citizen in 1828 and in 1844 published *The Texas Question, Reviewed by an Adopted Citizen.*

formances. They attended free band concerts (many sponsored by Italian organizations like the Sons of Italy) and some purchased gramophones. Tenor Enrico Caruso became famous to Italian immigrants, not through his stage appearances but his recordings. One of the most beloved performers was Eduardo Migliaccio, nicknamed Farfariello (Little Butterfly), a singer and satirist who came to New York in 1898. After losing a job making pants, he started singing at the Villa Vittorio Emanuele, a New York café. He was best known for *macchiette*—comic character sketches—his most famous being his impression of the *macchietta coloniale*, or Italian immigrant, with exaggerated gestures and language.

Theaters on New York's Bowery catered to Italian audiences by presenting melodramas, farce, and *commedia dell'arte*. These were usually in regional dialect and featured titles like *Nu Muorto che non è Morto (The Corpse That Wasn't a Corpse)* and *Pasca' si a 'nu Porcu (Pascal, You're a Pig)*. "The [Italian] theater is filled with . . . working men in their shirt sleeves . . . women with black hair parted over their oval faces, suckling their babies. . . . Boys in white coats with baskets of multi-colored pop and various forms of soda water, . . . and you see mother and children, young girls with their young men, grey haired grandmothers, tightly bound in thick black shawls in spite of the heat, sipping the red and pink and yellow pop through long straws," wrote novelist Carl Van Vechten in the 1920s. The audiences became completely involved in the plays, talking to each other and the actors, crying and booing, not holding back on emotion.

The least expensive entertainment was the *Opera dei Pupi,* or puppet show. Agrippino Manteo, who emigrated from Sicily to the United States in 1919, brought his family and fifty puppets with him. They advertised as "Papa Manteo's Life-Size Marionettes." Film eventually replaced puppet theater—or any theater, for that matter—as the most popular medium. Two Italian-made films burst upon the American scene, making film history. *Quo Vadis* (1912), directed by Enrico Guazzoni, was an epic of ancient Rome. *The Last Days of Pompeii* (1913) followed two entangled love triangles just before Mount Vesuvius erupted in 79 A.D. It was directed by Mario Caserini and Eleuterio Rodolfi. These movies embodied the idea of Italy for all Americans. But there were also films imported specifically for the Italian market by small distributing companies. The Giglio family opened Cinema Giglio in New York, which showed films they acted in themselves.

Italian American organizations were formed partly to keep Italian culture alive. They included small religious associations, chambers of commerce, and groups like the Unico National (1922) and the Italian Civic League (1932). The largest, *Figli d'Italia*—the Sons of Italy—was founded in 1905.

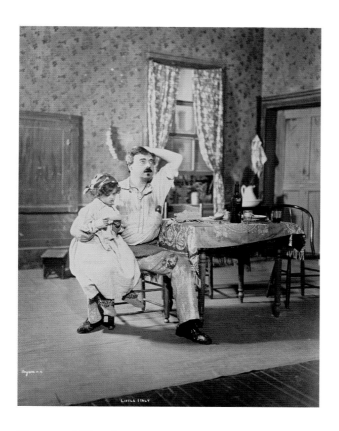

Tenement Theater

This scene from the play *Little Italy: A Tragedy in One Act*, shows an immigrant Italian and his daughter in their tenement home (above). The play was not written by an Italian, however, but by Horace B. Fry, who wanted to draw middle and upper class theater-goers' attention to "the short and simple annals of the poor," as he wrote in his introduction to the published version of the play. He called for the setting to be "a sordid living room . . . on the fourth floor of a tenement house of five floors." The actual set looked better than many tenements—there is even a window. But the play was a sincere effort to convey the humanity of the humblest human beings, no matter what their national origins or status.

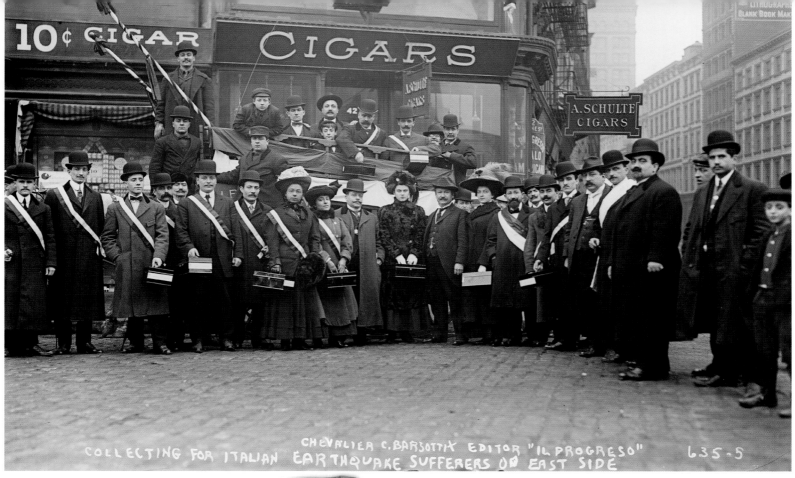

COLLECTING FOR ITALIAN EARTHQUAKE SUFFERERS ON EAST SIDE CHEVALIER C. BARSOTTI, EDITOR "IL PROGRESO" 635-5

Italian Newspapers and Magazines

Giovanni Francesco Secchi de Casali, a Protestant refugee from Italy, founded *L'Eco D'Italia* (facing page, bottom left) in 1849 to be "the reflection of everything that happens at home [in Italy]," but would also offer Italians in New York a newspaper in their own language about the United States. *L'Eco* made the same transition the immigrants were making, focusing increasing attention on living in the United States and the problems Italian Americans had to deal with.

Il Progresso Italo-Americano (facing page, bottom right), founded by Carlo Barsotti in 1879, surpassed it in popularity. "The newspaper is small: two full pages devoted to ads," wrote Adolfo Rossi, an editor at *Il Progresso*, in 1894. "That leaves the other two. The second is filled with Italian news and events taken from different Italian newspapers. On the first we translate the last transatlantic dispatches from English, we write a little editorial and summarize the American news." Barsotti appears in this photograph (facing page, top, not specifically identified), of New Yorkers collecting funds for the victims of a 1909 Italian earthquake.

La Domenica Illustrata (top left), published by the Italian American Publishing Company in New York, gave readers feature stories about Italian Americans in a magazine format. *Il Corriere Italiano* (bottom, left), published in Buffalo, New York, ran from 1898 through the 1950s. *Controcorrente* (bottom right), "an organ of agitation in the battle against Fascism," demonstrated Italian Americans' continued concern for politics in Italy.

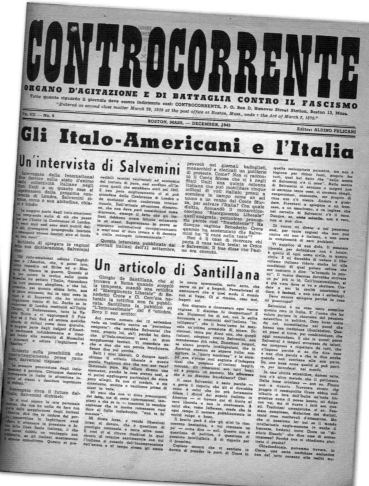

Italian Festas

"Their aromas of food, the sight of burly men swaying from side to side and lurching forward under the weight of enormous statues of exotic Madonnas and saints, . . . the bright arches of colored lights are essential memories of my childhood, as they are of many second-generation Italian Americans," remembered Richard Gambino about the Festa of San Gennaro, the largest *festa* in the United States, held in New York in September. But *festas* were more than just religious occasions. They were a chance for several generations to come together, a reminder of roots, a celebration of Italian culture. Vendors set up stands on the streets (right), men and women in their Sunday best strolled and greeted each other (below). In 2013, 371 Italian festivals were planned in thirty-nine states, not only in New York. They included the Italian Heritage Festival in Wheeling, West Virginia, and Milwaukee, Wisconsin's Festa Italiana.

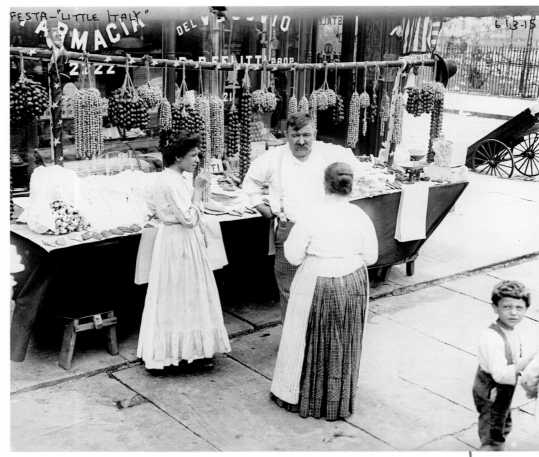

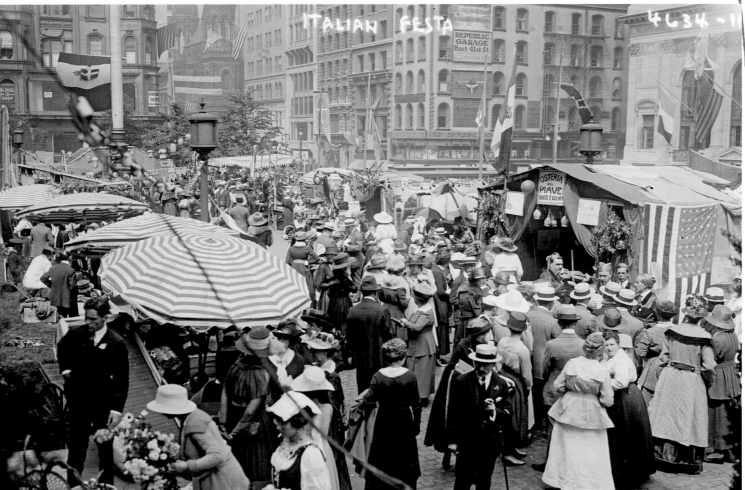

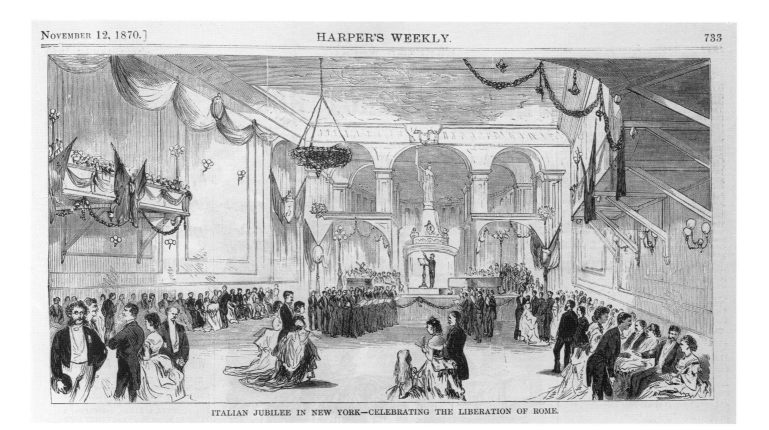

ITALIAN JUBILEE IN NEW YORK—CELEBRATING THE LIBERATION OF ROME.

Celebrating Italy

Many Italians in America applauded the liberation of Rome. The November 12, 1870, issue of *Harper's Weekly* shows a celebration in New York (above). "The hall was tastefully decorated with flags and flowers, and a colossal representation of free Italy towered over the platform where the speakers of the evening were assembled," reported *Harper's*. "The speeches were all in the same spirit of enthusiastic congratulation. . . . Among the attractions of the evening was the singing of a fine martial chorus, composed expressly for the occasion by Signor Barilli." Some forty years later, Italian Americans represented Italy as they proudly marched in ethnic dress in a Fourth of July parade in New York City (below).

cieta' Garibaldi.

orrenza dell'onoma-
useppe Garibaldi, la
he in New York ne
me, darà il suo ballo
nifica sala della Tam-
iamo che fu venduto
di biglietti.
i Presidenti Onorari
pure eletto il vecchio
ldi, Sig. John Ander-
lettera, che gli annun-
rispose col seguente

o :
Novelli,
Società G. Garibaldi.
ritown, 8 marzo 1881.
no appunto ritornato e
lettera del 28 febbraio,
za risposta per tal moti-
el mio nome può essere
vizio alla Società Legione
baldi nel modo che pro-
concedo volentieri.
re d'inchiudervi un pa-
o dollari che spero possa
che modo strumento nel
l successo della vostra fe-
a cui, per altro, con mio
to non posso partecipare
te.
ri auguri per la prosperità
Soc che felicemente
d'uomo così illustre, che
di salutare in persona fra

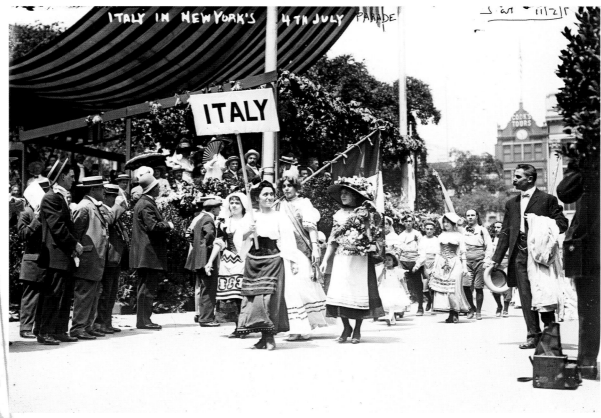

Hosting Italians

Italian Americans closely followed events in Italy, as the wealth of Italian language periodicals published in the United States attests. Italy was also an ally of the United States in World War I. The battleship *Conte di Cavour* (named after Camilo Benso, Count of Cavour, the first prime minister of a united Italy), built for the *Regia Marina* (the Royal Italian Navy), was an Italian flagship in the southern Adriatic Sea during the war. In 1919, it landed in Halifax, Canada, then stopped in several American ports. A *New York Times* article of August 25, headlined "*Conte di Cavour*, at Boston, Opens Week of Welcome," highlighted the ship's first U.S. stop. The photograph (above) shows a grand reception for officers and sailors of the *Conte di Cavour* on Boston Common on August 26. As the *Times* reported, the Italian ambassador to the U.S., Count Vincenzo Macchi Di Cellere, represented the Italian government at the weeklong festivities. In this photo (left), costumed children (the American dressed as Uncle Sam, the Italian as a traditional Royal Italian Army *Bersagliere* with his plumed hat) represent the U.S. and Italian governments, offering a handshake of amity and goodwill.

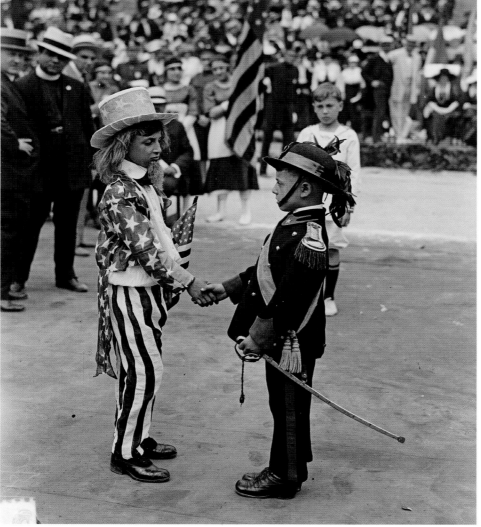

Explorers, Emigrants, Citizens

li Ufficiali e Marinari della Conte di Cavour ...mon Agosto 26, 1919.

Italy participated in the New York World's Fair of 1939-1940 (the second largest world's fair ever in the U.S.), with a pavilion (right) designed by Michele Busiri-Vici. Busciri-Vici came from a family of architects dating back to the 17th century. The pavilion featured a 200-foot-high waterfall and a monument to Guglielmo Marconi, the pioneering radio inventor. Busiri-Vici's design was thought to combine Roman grandeur with contemporary style. In 1939 he visited the fair, where he was declared an honorary citizen of New York.

The fair opened on April 30, 1939, when Benito Mussolini ruled Fascist Italy and Adolph Hitler, Nazi Germany. Yet the fair's advertising pamphlet projected a positive future. "The eyes of the Fair are on the future . . . in the sense of presenting a new and clearer view of today in preparation for tomorrow; a view of the forces and ideas that prevail as well as the machines." To its visitors the Fair will say: "Here are the materials, ideas, and forces at work in our world. These are the tools with which the World of Tomorrow must be made. . . . Familiarity with today is the best preparation for the future.'"

On September 1, 1939, Germany invaded Poland and World War II began. Italy, its ally in the Rome-Berlin Axis forged by the Pact of Steel, joined in. By the time the Fair closed in 1940 the "future" was one for which no country had adequately prepared.

Emigrants

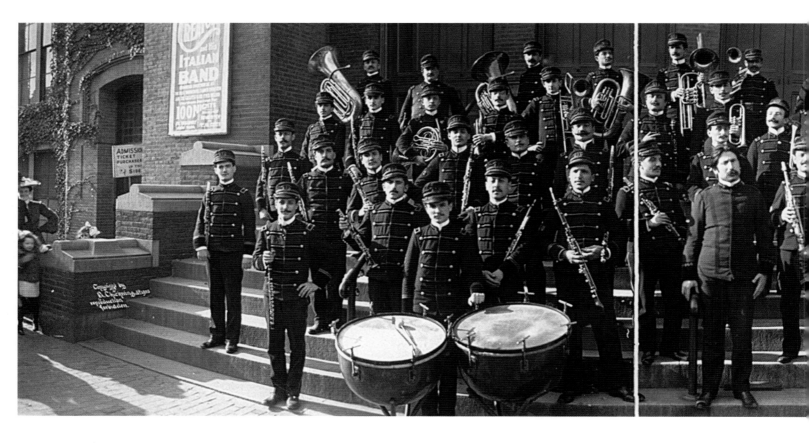

Italian Bands

The Italian band—or chorus, or orchestra—was a lively antidote to the day to day lives of Italian immigrants and their children. Giuseppe Creatore had one of the most famous. Born in Naples, he formed his own band in the United States in 1901. Not satisfied with his American musicians, he brought back sixty Italians to take their place in 1902. In this 1903 photo (above) Creatore's Band plays on the steps of the Mechanics Building in Boston. Marco Vessella, Alfredo Tommasino, and Don Philippini were other noted band leaders. The musicians came from different parts of Italy, so they played music from every part of the country. Richard Gambino remembered the Italian bands of his childhood "in uniforms with dark-peaked caps, white shirts, and black ties."

Opera was, of course, Italy's best known style of music. Coloratura soprano Luisa Tetrazzini made her American debut in 1905; here her fans wait in line for tickets (below). Giulio Gatti-Casazza, who had managed La Scala, took over as general manager of the Metropolitan Opera in New York in 1908; its rival was the Manhattan Opera House founded in 1906 by Oscar Hammerstein (grandfather of the notable lyricist and theatrical producer). The November 1908 cover of *Puck* (facing page, top right) illustrates their competition. Members of the La Scala orchestra (arguably the most famous opera orchestra in the world), pose on deck (facing page, bottom) as they travel on one of their international tours.

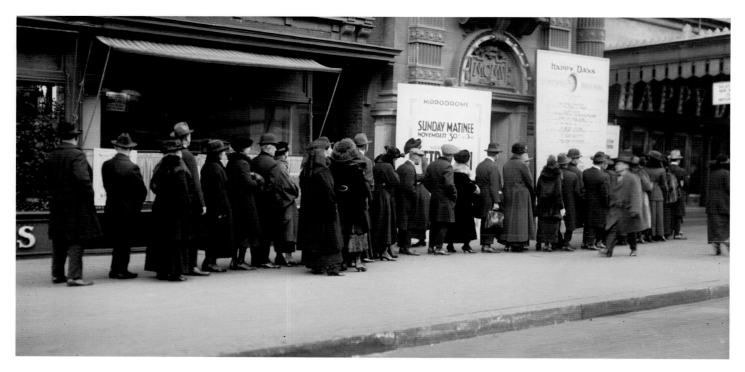

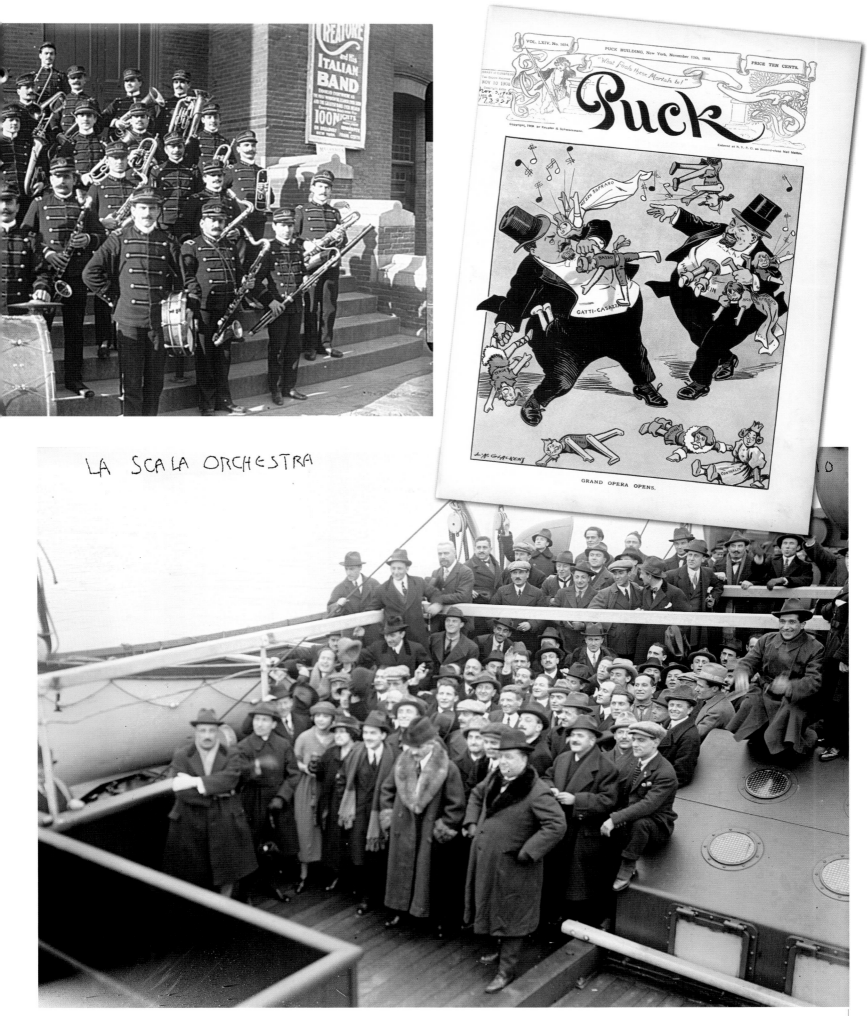

LA SCALA ORCHESTRA

The Stars of the Opera

Talented, temperamental, and adored by audiences, dozens of opera singers performed in the United States. They were the equivalent of today's Hollywood stars, and like them, they spent a great deal of their lives in front of the camera.

When legal disputes kept Luisa Tetrazzini (bottom), born in Florence, from singing at the Metropolitan Opera, she announced: "I will sing in San Francisco if I have to sing there in the streets, for I know the streets of San Francisco are free." She gave her free concert on Christmas eve in 1910.

Giuseppe De Luca (right), a baritone born in Rome, was well known for his comic performances. Yet he also won fame when he created the role of Sharpless in the premier of Giacomo Puccini's *Madame Butterfly* in 1904, and the title role in Puccini's *Gianni Schicchi* in 1918. He sang at La Scala from 1902-1910, and at the Metropolitan Opera for twenty years, from 1915-1935.

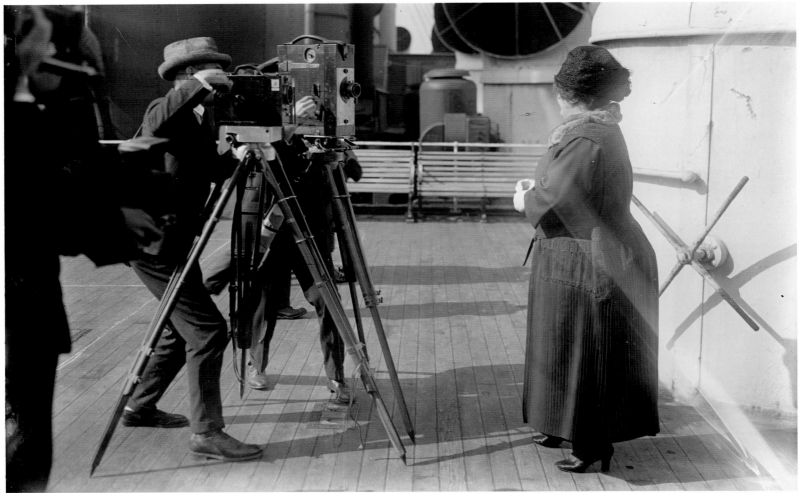

Amelia Galli-Curci (right) was a sweet-voiced coloratura soprano born in Milan. When La Scala offered her a minor part, she told the director, "Dear Mingardi, don't forget this—I shall never put my feet in this theater again." She was true to her word. Her 1916 American debut in Chicago was meant to be a short visit. Instead, she was so beloved as Gilda in *Rigoletto* that she stayed with the Chicago Opera Company until 1924. She also sang at the Metropolitan Opera from 1921-1930.

Impresarios were as important as performers in bringing opera to America. Alfredo Salmaggi (below), whom *Time* magazine called "the greatest producer of second-rate opera in the United States," charged 99 cents for his tickets. In 1934, *Time* described him as "a long haired, high-strung Italian who . . . carries Caruso's silver-headed cane, and specializes in *Aida* with horses, elephants, and camels." At their peak, his spectacular productions drew more than a million people in one season.

MUSICALE.

Mercoledì sera un' immensa folla di spettatori occupava perfino l'androne e le corsie dell' Accademia di Musica per assistere alla interpretazione del *Barbiere di Siviglia*, che riuscì stupenda. Vi presero parte la Gerster Rosina; Ravelli, Conte Almaviva e Del Puente, Figaro. La Gerster mostrò anche in questo spartito un' abilità non comune tanto vocale che drammatica e specialmente nella scena della lezione, in cui cantò divinamente il *Carnovale di Venezia* con variazioni rivoluzionò il pubblico. Alla ovazione fragorosa, alle generali richieste di replica, essa tradusse per ben due volte come meglio non si poteva la bellissima polka cantabile di Arditi "Fior di Margherita." Il Ravelli ed il Del Puente ottennero pure un vero trionfo. ...issimo dei direttori Arditi, ...iassimo parte lo stra-

Enrico Caruso

Enrico Caruso never became an American citizen, but he spent many years in the United States and, famous with the broader American public, was a symbol of pride for Italian Americans. "I heard all the great tenors of my time over and over again," said Metropolitan Opera director Giulio Gatti-Casazza. "Many of them were wonderful artists and had extraordinary voices. But in my opinion, not a single one of them ever sang an entire role with such vocal and artistic consistency as Caruso."

Born in Naples in 1873, Caruso started out as a street singer and performer at cafés. He formally debuted in the city in 1895, sang at La Scala in 1900, and in 1903 came to the Metropolitan. He was its leading tenor for eighteen seasons, giving 863 performances. In 1910 he appeared in the first public radio broadcast, live from the stage of the Met. He is shown (right) with Geraldine Farrar, who sang with him in Gustave Charpentier's *Julien* in 1914. In the photo (below) he may be drawing—he was, in fact, a talented caricaturist.

But Caruso was as notable for his recording career as for his live performances, singing on some 290 records, first for the Gramophone and Typewriter Company in Italy, and in the United States for the Victor Talking-Machine Company. His 1904 rendition of "Vesti la Giubba" from Leoncavallo's *Pagliacci* was the first recording of any kind to sell a million copies. He was one of the earliest singers to understand the importance of recordings for reaching a wider audience. All his work is still available today, when he remains emblematic of the art of opera.

Explorers, Emigrants, Citizens

Arturo Toscanini

Like Enrico Caruso, Arturo Toscanini (who traveled back and forth to Italy and kept his Italian citizenship) was recognized throughout the United States, the best known orchestra conductor of his era. He made the cover of *Time* magazine three times, in 1926, 1934, and 1948, a reliable measure of fame in America.

Born in 1867 in Parma, Toscanini was trained as a cellist. While traveling with an orchestra in South America, he was asked to take over as conductor, giving a spectacular performance. He was only nineteen years old. After directing at La Scala, he became the music director of the Metropolitan Opera (1908-1915) and the New York Philharmonic Orchestra (1926-1936).

While in Italy in 1931, when Mussolini ruled, Toscanini refused to play "Giovinezza," the Fascist anthem, at the opening of a concert at the Teatro Comunale in Bologna. Afterwards, as he said, he was "attacked, injured, and repeatedly hit in the face," by Fascist thugs. Increasingly harassed by the government—his passport was taken away until an international outcry forced its return—he came back to the United States in 1937.

The radio station NBC created the NBC Symphony Orchestra for Toscanini to direct (above, at Radio City Music Hall). The orchestra gave weekly radio broadcasts. The caricature by Miguel Covarrubias (left) compares S.L. Rothafel, *impresario* of the showy Roxy movie theater, to the serious Toscanini, standardbearer for classical music for every American household.

Ethnic Cinema and Theater

When the Italian silent films *Quo Vadis?* (1912) and *The Last Days of Pompeii* (1913) hit American theaters, they were instant blockbusters, not just with Italians in the U.S. but with the general public. But there were a host of lesser known Italian films distributed in the United States. In the 1910s, the Italian company Cines promised the "same artistic quality as the French [movies] with costume quality hitherto unknown."

The 1914 film *Cabiria* (poster, bottom left), an historical epic set in the 2nd century B.C., was directed by Giovanni Pastrone. It offered audiences everything from the eruption of Mount Etna to Hannibal's trek over the Alps.

Beginning in the 1920s Dora Film in Naples produced dozens of movies, including *E' Piccirella* (1922), *Il Miracolo della Madonna di Pompei* (1922) and *Sotto il carcere di San Francisco* (1923)—many of them starring Elvira Notari—and distributed them in the U.S. for the Italian immigrant market with the titles of *The Little Girl's Wrong, Mary The Crazy Woman,* and *Beneath the Prison. Santa Lucia Luntana* (1930), a sound film made just for the Italian market recently recovered and restored by Martin Scorsese, portrays the difficulties of being an immigrant, with a happy ending in Naples.

American companies also produced movies about Italian immigrants. In 1909 and 1911 D.W. Griffith directed *In Little Italy* (top right) and *The Italian Barber* (right, second from top), a doomed love story. In the 1915 movie *The Italian* (right center, second from bottom, and bottom), starring George Beban as Beppo, the dialogue appeared in the mashed-up English supposedly spoken by Italians—"I must get-a-de milk or my babe is die"—and the lengthy cast list shows no Italian names.

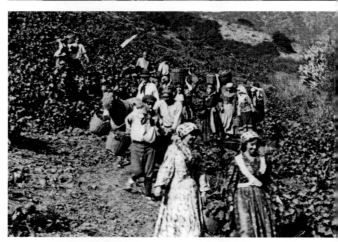

Stereotyping Tragedy

Little Italy: A Tragedy in One Act, was not written by an Italian but was intended to portray immigrant life, just as Griffith's movie was. ("Little Italy" seems to have been a popular title with non-Italian authors). Acclaimed actress Minnie Maddern Fiske made the play part of her repertoire (poster, above right), ensuring it would be produced on stage.

The melodrama featured Fabio, "a fat Italian baker of forty;" Giulia, "Fabio's wife, a nervous, hard-working Italian of twenty-two;" Michele, an itinerant singer and Giulia's great love; and Fabio's young daughter from a previous marriage. Giulia is lonely for Naples; then Michele appears in New York, singing in Neapolitan below her window. The photos (above left, top and bottom) depict two scenes from the play, which proceeds from longing, to desire, to guilt, and to desperation. There are no happy endings in the tenements.

Although the characters speak in stereotypical broken dialect, playwright Horace B. Fry does try to treat them with compassion and imbue them with dignity. Although he attempts to rise above it, he is conscious of his class and that of his non-Italian audience. *Little Italy* "truly depicts an obscure form of life in New York City, . . . and such a woman as Giulia really lived there," wrote Fry. "Nostalgia is a malady not confined to rich or poor, and true love, however humble, will scour the world to find its lost object. These themes appeal to all."

THE ITALIAN MAGICIAN.

AND HER TROUPE OF THE WORLD'S GREATEST

Pupi, Marionettes and Rollercoasters

"On the threshold of the [puppet] theater, you'll want to retreat psychologically far from America in time and space, since outside the locked door, over a colorful billboard, five or six knights masked and clad with iron mesh fight in a chapter of 'The Kingdom of France,'" wrote Amy Bernardy in 1911. "Inside the theater you will see the emigrants applaud the nice shot by Rinaldo, swear to the traitor of Maganza, and get thrilled for King Adrian . . . as if [President Theodore] Roosevelt and America and politicians . . . and bosses and contractors . . . never existed, or were twenty years away."

The struggling Italian immigrant could take pleasure in affordable entertainment like New York's Marionette Theater (facing page, top, shown with manager and staff); Professor Bollini's magic show (facing page, bottom); or Signorita Galetti and her troupe of the world's greatest performing monkeys (facing page, bottom right).

Perhaps even more spectacular, they could visit Luna Park (right), "the fabulous city built by the citizens of the City of Light [New York] on the shores of the ocean in Coney Island," wrote journalist Alberto Pecorini in 1910. "Thousands of electric lights shine on the doors, on the towers, everywhere a deafening noise of street vendors, of salesmen inviting the crowd to visit their shack, where you can find the most extravagant things in the world: the eruption of Vesuvius . . . a city of dwarves, an artificial fire, a menagerie of wild beasts." These included the free show at Col. Joseph G. Ferari's Dreamland's Trained Wild Animal Arena (bottom right) and the roller coaster ride at what was arguably the most famous amusement park in the United States.

Stereotypes and Racism

How Americans Saw Italians

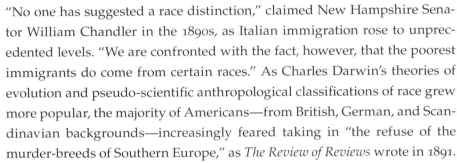

Organ Grinders and Knives

The organ grinder with his monkey (below) was a stereotype of Italians, as were images portraying the thirst for revenge. In this frame from the short film *At the Altar* (facing page, top), a rejected Italian lover buys a dagger from another Italian. He sets a trap to kill the woman he loves and her fiancée as they are being married. He kills himself, but before he dies, he leaves a written confession that is discovered in time for a policeman to rush to the church to save the couple. D.W. Griffith (a "white" American) directed the film in 1909.

"No one has suggested a race distinction," claimed New Hampshire Senator William Chandler in the 1890s, as Italian immigration rose to unprecedented levels. "We are confronted with the fact, however, that the poorest immigrants do come from certain races." As Charles Darwin's theories of evolution and pseudo-scientific anthropological classifications of race grew more popular, the majority of Americans—from British, German, and Scandinavian backgrounds—increasingly feared taking in "the refuse of the murder-breeds of Southern Europe," as *The Review of Reviews* wrote in 1891.

"Considering more or less equal conditions in location, economy and culture, migration is more common in families with mental illnesses than in families free of psychopathy. Emigration is a sign of anthropological inferiority," declared G. Boschi in 1913, further denigrating those who came to America. Boschi was Italian and considered a "scientist!"

At the 1901 World's Fair in Buffalo, New York, a "race chart" made plain the concept that a white complexion was superior to black. In between lay the Mediterranean and Central European peoples. "The color of thousands of them differs materially from that of the Anglo-Saxon," pronounced Congressman Thomas Abercrombie of Alabama. For decades, southern Italians were not considered white. In 1922, an appeals court in Alabama dismissed the conviction of African American Jim Rollins for having sex with a white woman when Rollins proved the "white" woman was Sicilian. Because of this, some Italian immigrants were able to overcome the strict racial barriers between black and white Americans, particularly legal segregation in the southern states. After five Sicilian shop-owners in Tallulah, Louisiana, befriended the town's African Americans, the Italians were lynched in a dispute with white citizens over a goat.

Skin color was only one factor in the stereotyping of Italian immigrants. Federico Garlanda wrote in *La Terza Italia, Lettere di uno Yankee* (1903) that Americans believed "most Italian immigrants come here in the most abject poverty, they work like beasts, live like animals in order to save as much as possible, and as soon as they can get a small hoard, they say goodbye to America. . . . They, therefore . . . are exploiters of our wealth." "Italian workers are viewed with the same curiosity with which we look at gypsies," observed Angelo Mosso in 1910. "Living in groups under a leader, cooking together, with modest clothing, lack of cleanliness."

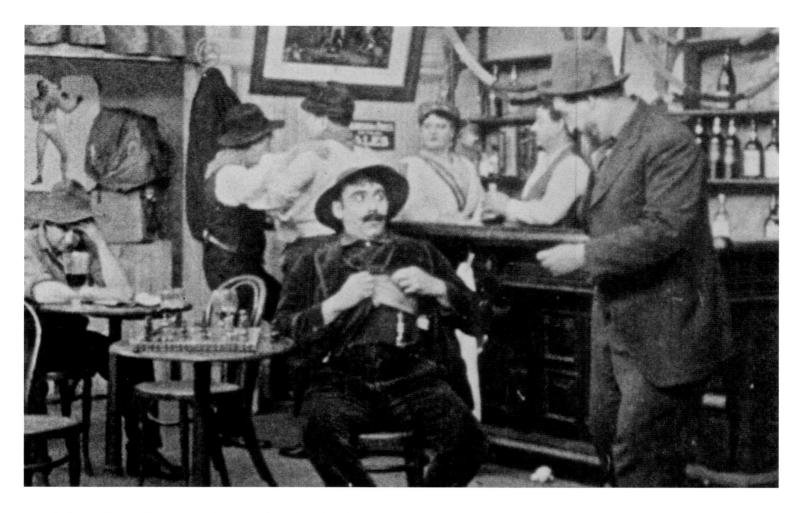

Italians themselves—in Italy and when they lived in the United States—had their own stereotypes that distinguished between northern and southern Italians. "The immigrants who come from the provinces under the 45th parallel are evil-doers, with very few exceptions. Those from the provinces to the north of that parallel are good workers and law abiding citizens," a reader wrote to the *San Francisco Chronicle* in 1904.

The most damaging and persistent stereotype was of southern Italians as violent. "The disposition to assassinate in revenge for a fancied wrong is a marked trait in the character of this impulsive and inexorable race," wrote the *Baltimore News* in the 1890s. Typical newspaper headlines at the turn of the 20th century included "Caro Stabs Piro," "Rinaldo Kills Malvino" and "Gascani Assaulted." The knife became the symbol of this alleged violence. One explanation for the racial slur "dago," which hounded Italian Americans, is that it derived from the word "dagger." (Another is that it derived from the common Spanish name "Diego;" it was also used to insult Hispanic people). The American son in a scene from *Un Italiano in America* (1894) says, "Ah, I know a few Italian words: *stiletto, maccheroni, brigante, vendetta* [dagger, macaroni, robber, revenge]."

It was only a step to the connection of violent to criminal. "New York will become a penal colony for the waste of Italy," asserted the *New York Herald* in 1872 in an article on immigrants as a dangerous class. "The Italian is not always despised because he is Italian, but because some Italians, unfortunately, in the public mind have associated themselves and Italy with the worst forms of outlawry," observed Italian ambassador Edmondo Mayor des Planches in 1913. The strength and pervasiveness of criminal organizations like the Black Hand and the Mafia, however, were vastly exaggerated, especially by the news media. Sensational stories fed on public prejudice at the same time that they reinforced it.

It is curious that Italians were reviled for "their sordid, degrading and incurable abstinence and their accepting the humblest and least paid jobs . . . show[ing] such a supine resignation to misery," as Giuseppe Giacosa wrote in 1908, at the same time that they were portrayed as criminal masterminds accumulating influence, money, and acts of vengeance. The real issue was that they were newcomers to America, learning to make their way.

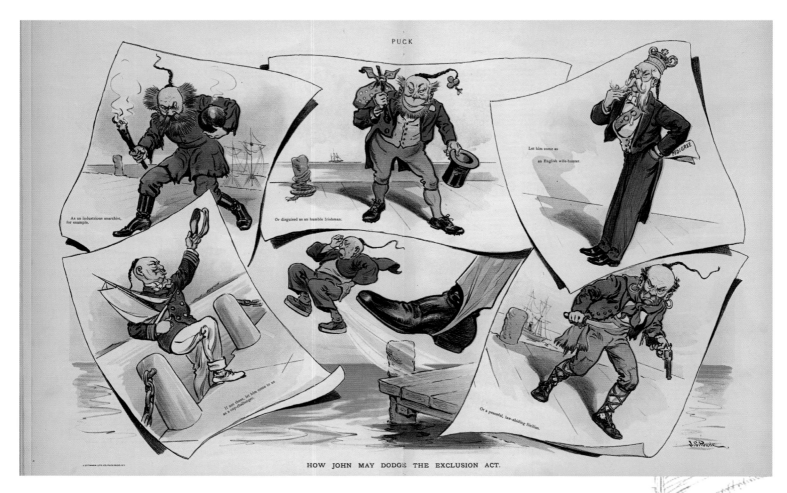

HOW JOHN MAY DODGE THE EXCLUSION ACT.

Portraying Italian Vice

Illustrations from the humor magazine *Puck* show the many types of negative portrayals of immigrants, including Italians. Some—such as the everpresent organ grinder—were relatively harmless. They did not prevent Italians from sitting at the sumptuously decked table to celebrate the 200th anniversary of Germantown, the first settlement of what the author calls "the healthiest of Uncle Sam's adopted children" (facing page, top).

In others, Italians become more threatening. These images anticipate what will become the most common—and the most difficult to shake off—stereotype of the 20th century: Italian connections with the Mafia. In the fierce anti-Chinese cartoon, "How John may dodge the exclusion act" (above), Chinese immigrants trying to elude the laws preventing their entrance into the U.S., disguise themselves as immigrants of other nationalities. The Italian—or, more accurately, the "peaceful, law-abiding Sicilian"—was represented with gun and knife.

In April 1891, *Judge* magazine printed "Where the blame lies" (facing page, bottom) in which the artist Grant Hamilton portrayed a perplexed Uncle Sam watching a horde of immigrants arrive at the port of New York. Along with the "German socialist," the "Russian anarchist," and the "Polish vagabond," there is also the "Italian brigand" with the inevitable monkey on his shoulder. But more importantly, a leaflet lies at Uncle Sam's feet with the headline "Mafia." The same word is picked up by the caption: "If Immigration was properly Restricted you would no longer be troubled with Anarchy, Socialism, the Mafia and such kindred evils!"

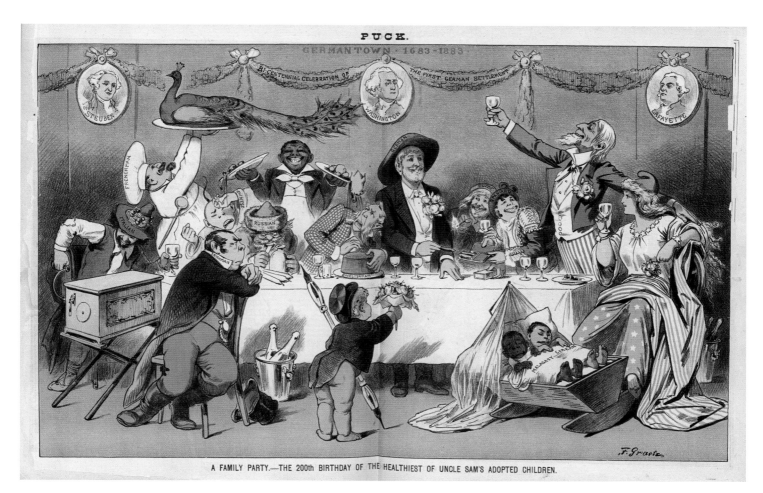

PUCK.

GERMANTOWN · 1683-1883

BI-CENTENNIAL CELEBRATION OF THE FIRST GERMAN SETTLEMENT

A FAMILY PARTY.—THE 200th BIRTHDAY OF THE HEALTHIEST OF UNCLE SAM'S ADOPTED CHILDREN.

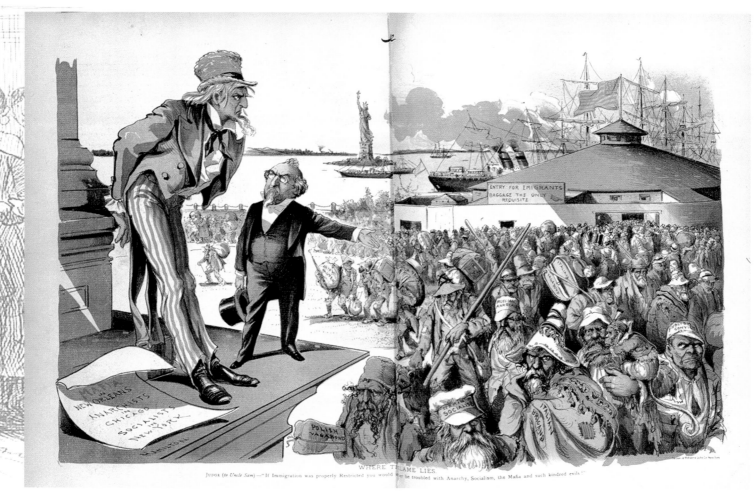

WHERE THE LAME LIES.

Juror (to Uncle Sam)—"If Immigration was properly Restricted you would not be troubled with Anarchy, Socialism, the Mafia and such kindred evils."

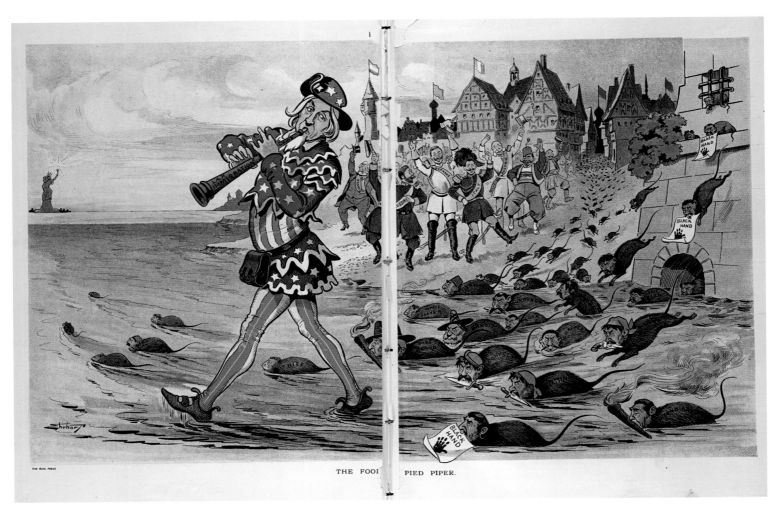

THE FOOL PIED PIPER.

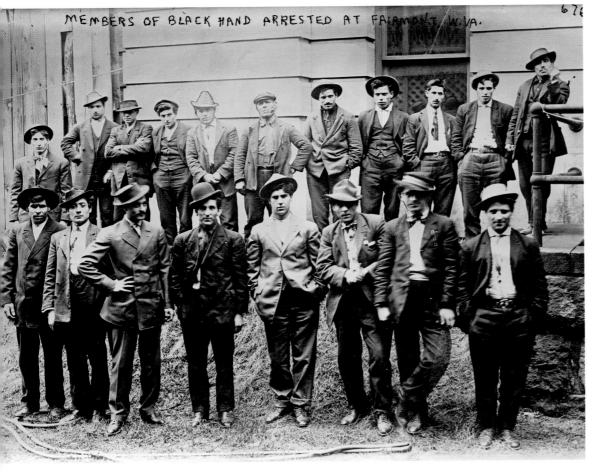

MEMBERS OF BLACK HAND ARRESTED AT FAIRMONT W.VA.

The Black Hand

In a time when the American public was considering the possibility of imposing restrictions on immigration, the letter with the Black Hand signature reflected what seems to be a collective psychosis. Not surprisingly, among the rats that leave the shores of the Old World—to the delight of European rulers—the one in the foreground holds the infamous letter between its teeth (top). Soon, the Black Hand became synonymous with crime—particularly Italian crime—so that even the rogues arrested in the small mining town of Fairmont, West Virginia (left) are labeled as belonging to it. In fact, the Black Hand was not an organization, but rather a criminal technique specifically related to extortion, through the delivery of a letter with the menacing signature. This method became so popular in the criminal world, it was imitated by those who had nothing to do with the Italian American groups from which it originated.

Explorers, Emigrants, Citizens

The New Orleans Lynchings

The March 14 and 15, 1891, editions (right and below) of the *Daily Picayune* describe the events that culminated with an angry mob storming the old Parish Prison in New Orleans and finally lynching eleven Italians accused of murdering the local police chief, David Hennessy. These events led to the suspension of diplomatic relations between Italy and the U.S., the only time in history, before World War II, that this happened.

A few years later the Italian Ambassador Mayor des Planches recounted: "The jury had legally acquitted them on the previous day. The Creoles wanted them dead, convinced that they were guilty and that the jury had acquitted them because intimidated or bought. And they were lynched, not by a blind and impetuous mob, but by a group of well-known and rich people: lawyers, merchants, members of the First City Club, lieutenants and sergeants of the police and of the militia. The mob, incited by them, followed, but did not rush to the prison until the slaughter was accomplished. Citizens felt the collective guilt of the crime, the more horrendous because, if there were several perpetrators among the lynched, there were certainly some innocent men."

The New Orleans case was just the tip of the iceberg. Lynching Italians was all too frequent in the South in the late 19th and early 20th centuries. They hold the unenviable record for the most lynchings of any ethnic group after those suffered by African Americans. This fact was very clear to the public in Italy. The newspaper *La Tribuna* wrote on July 24, 1899, "If Lynch 'law' is enforced against foreigners, ninety percent of the times it is against the Italians."

This article by the Roman newspaper came in the wake of what happened in Tallulah, Louisiana, where five Italians from Cefalù (Sicily) were lynched because of a dispute between neighbors. According to an article in a Louisiana newspaper, Carlo Di Fatta, one of the murdered Italians, yelled shortly before being hanged: "I liva here sixa years. I knowa you all—you alla my friends."

Cops and Gangsters

Italians and Crime in America

In 1972, Al Pacino played Michael Corleone, eventual head of the fictional Mafia family in *The Godfather*. A year later, he starred as Francesco "Frank" Serpico, the real life New York policeman who testified against department corruption in *Serpico*. All three—actor, mobster, and cop—share the same Italian background. Yet historically, the American media and public associated being Italian with crime, without noting that many more Italian Americans went into law enforcement. It is important to recognize that for every gangster, there were several Italian American policemen—as well as prosecuting attorneys and judges—working to keep the U.S. crime free.

The earliest Italian immigrants would not have recognized ideas like "organized crime," or words like *consigliere* (counselor) or *capo di tutti i capi* (top boss), which were not part of southern Italian dialect. There were criminals in every immigrant group and changing public perceptions about who held the most power as each assimilated into American society: first Germans and Irish, then Italians and Jews; now Russian immigrants are often portrayed as criminals in the media.

Italians did bring with them, however, the experience of injustice and inequality, since they had been ruled for so long by foreign, feuding governments or exploited by the upper classes. Their "feelings are obviously the legacy of unequal times, when police and all armed authority was often a tool of oppression and arrogance instead of justice and social defense, so much so that such feelings are not found in Italian regions which had the good fortune to have honest governments . . . where the police were there to protect the citizens, not to their detriment," wrote Federico Garlanda, an Italian scholar who lived in the United States in the 1880s.

Some of the generation of Italians who migrated from Italy acted criminally (*padrones*) by exploiting their countrymen or extorting money from the most prosperous, but most had little time to do anything but survive. Early Italian immigrants also included political exiles who had fought for Italian unity and against monarchist governments and were anarchists; and workers who became a strong voice in union organizing and the American labor movement. Both were

Media Portrayals

The 1906 short film *The Black Hand* (frames, facing page, bottom) was the first movie to portray the Mafia at work. Two men pen an extortion note in uneducated handwriting to a storekeeper, threatening his daughter and his livelihood. The film reinforced negative ideas about Italian immigrants.

The article in the *New York Herald* (facing page, right), published on February 20, 1909, revealed the formation of a New York Police Department organization to crush the Black Hand, headed by Joseph Petrosino. It also revealed Petrosino's secret mission to Sicily; he was killed in Palermo less than a month later.

This editorial cartoon from the *Washington Star* in 1963 (above) represents another revelation: Gangster Joe Valachi testified before a U.S. Senate subcommittee, giving the history of a secret crime organization that began in Sicily and operated in the United States, the Cosa Nostra. Valachi's picture of feuding mob bosses, assassinations, and organization into "families" contributed to the American public's concept of the Mafia.

viewed as disruptive and dangerous. For many Americans, political agitation was linked with crime; they imagined secret organizations responsible for both.

The first generation of Italians born in the United States were more likely than their parents to become involved in criminal activities. They grew up on city streets, scorned backbreaking work like ditch-digging, and had limited opportunities to advance economically because of prejudice. Being a gangster was a way of moving up in society; and illegal activity provided things Americans wanted, like alcohol during Prohibition or gambling. Al Capone could say, "Everything I do is to meet public demand."

Most Italian Americans took another path to social and economic improvement, however. Giuseppe "Joe" Petrosino, born in Padula in 1860, joined the New York Police Department. He rose to be head of the Italian Squad in 1908. This group of Italian American policeman targeted Italian American and Italian criminals. Petrosino was killed in the line of duty in Palermo, Sicily.

The FBI attracted Italian Americans like Joseph Pistone, who joined the bureau in 1969. From 1976 to 1981 he went undercover as "Donnie Brasco," infiltrating New York's Bonanno and Colombo crime "families." He was one of the first agents to go into "deep" undercover for years. Louis Freeh was an assistant U.S. attorney who led the prosecution in the "Pizza Connection" case in the 1980s. Sicilian criminals were using pizza restaurants as fronts for drug trafficking; sixteen of the seventeen defendants were convicted. Freeh headed the FBI from 1993-2001.

"The rules and the system of Italian Mafia have become a model for organized crime in the world. On the other hand, Italian anti-Mafia laws and law enforcers are also the best in the world," observed Roberto Saviano, an Italian journalist and author of *Gomorrah* (2006), which exposed a Neapolitan crime organization. Italian American law officers like Frank Serpico and Joseph Pistone became media heroes. (*Donnie Brasco* also became a film in 1997.) If the popularity of portraying the Mafia persists—witness the success of the television series *The Sopranos*—there are models of crime fighting as well, enlarging the idea of what it means to be Italian American.

HAIR IS A 'FRAT'

BINGHAM'S SECRET SERVICE STARTED

Crushing the Black Hand Is the Ostensible Purpose of the New Squad.

CAN BE USED OTHERWISE

Nobody Knows the Men Who Compose the Organization Except Two Who Are in Control.

PETROSINO IS AT ITS HEAD

Money for Support of the New York Secret Service Contributed by Citizens After Aldermen Had Refused.

Police Commissioner Bingham has at last established his secret service branch. He announced yesterday that the new squad will be used exclusively to crush the Black Hand and anarchists of the city, but it is admitted that the Commissioner may turn his secret service loose in any direction he chooses.

In effect New York city now has a secret police service similar to those in Paris, Washington and other national capitals, and which may be used for any purpose its head may see fit. President Roosevelt recently, it was recalled yesterday, set his secret service men on the trail of Representatives in Congress and United States Senators.

The beginning of New York's Secret Service branch has been made possible through the contributions of citizens who are willing to supply funds which

JOSEPH PETROSINO

the Board of Aldermen has refused to appropriate for the purpose.

There are fifteen men in the secret ser

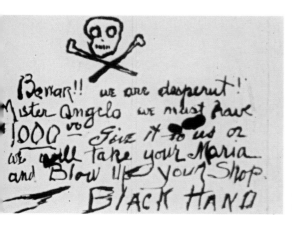

To Serve and Protect

A simple beat cop (right) can be seen as the positive symbol of millions of Italian Americans who lived by the rules and laws of their host society—and of thousands who took one more step and became defenders of those laws, wearing law enforcement uniforms.

One of them was Michael Fiaschetti who, after leading the New York Police Department's Italian Squad in the 1920s, published two autobiographical books: *The Man They Could Not Escape* (1928) and *You Gotta Be Rough* (1930, below). Fiaschetti also became a popular lecturer and was presented as "the Italian Sherlock Holmes."

Michael Fiaschetti, former Commanding Officer of the Italian Squad, New York Police Department

YOU GOTTA BE ROUGH

THE ADVENTURES OF DETECTIVE
FIASCHETTI OF THE ITALIAN SQUAD

AS TOLD TO PROSPER BURANELLI

BY

MICHAEL FIASCHETTI

PUBLISHED FOR
THE CRIME CLUB, INC.
BY DOUBLEDAY, DORAN & COMPANY, INC.
GARDEN CITY 1930 NEW YORK

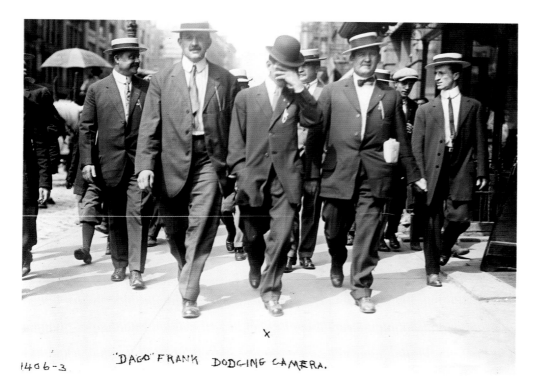

1406-3 'DAGO' FRANK DODGING CAMERA.

Dodging the Camera

Frank Cirofici (left), known as Dago Frank, tried to dodge the camera after being arrested by two detectives: Upton, a former member of Petrosino's Italian Squad, and Frank Cassassa. Cirofici's nickname was not particularly imaginative—law enforcers at the time stated that "there are at least five 'Dago' Franks known to the police." Louis Capone (below, no known relation to Al) was one of the few who did not hide from the photographer. He is shown in 1941 during the trial in which he was sentenced to death for murder, along with his accomplices Louis "Lepke" Buchalter and Emanuel "Mendy" Weiss, prominent members of the Jewish-Italian gang known as Murder Inc.

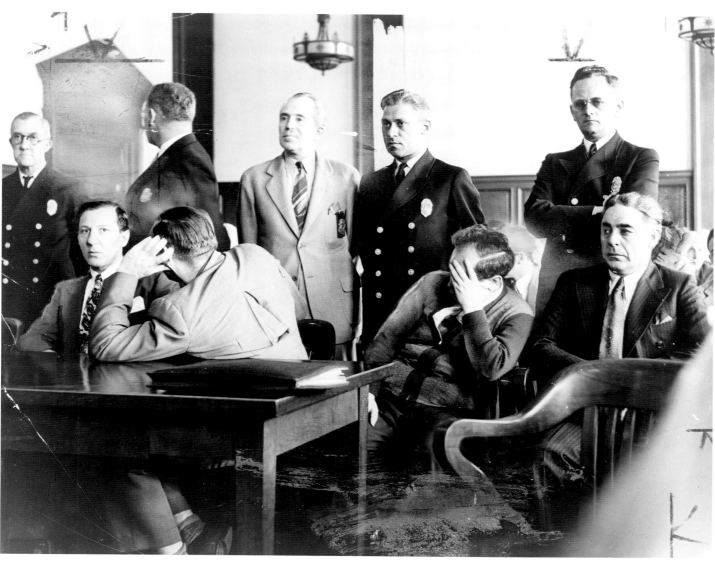

Joe Petrosino, the Forgotten Hero

Too often forgotten by history, New York detective Joseph Petrosino (right) is shown on the left in this photograph, after the arrest of Tommaso "The Ox" Petto. Petrosino was a positive hero in the struggle of Italian Americans against the stereotype that they were all connected to the Mafia. The New York Police Department did not encourage Italians to join until the turn of the 19th century, when the so-called Black Hand was thriving; they formed an Italian Squad to fight it, with Petrosino appointed as its leader. On the one hand, choosing an Italian to fight the Black Hand implied that only an Italian could understand the deeds of these criminals, but on the other, it led the way to the integration of Italians in law enforcement.

Thanks to his excellent police work, Petrosino became a very popular personality, until he was killed in March 1909 in Sicily, while carrying out a crucial mission against the Mafia.

The last letter he wrote to his wife (bottom left) is a testament by an Italian uncomfortable in his country of origin, who longs to return home: "Dear Wife, I arrived in Palermo, I'm very confused and it looks like it's been 1,000 years since I was here, I don't like Italy at all, when I come back I will tell you. Oh God, how much misery." Unfortunately, his hope did not become reality, and his wife could only cry over his coffin (bottom right).

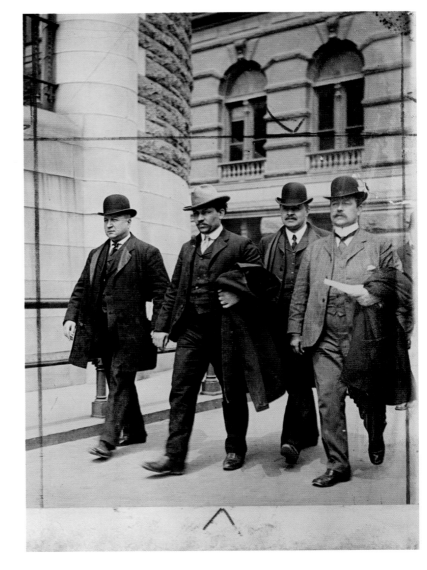

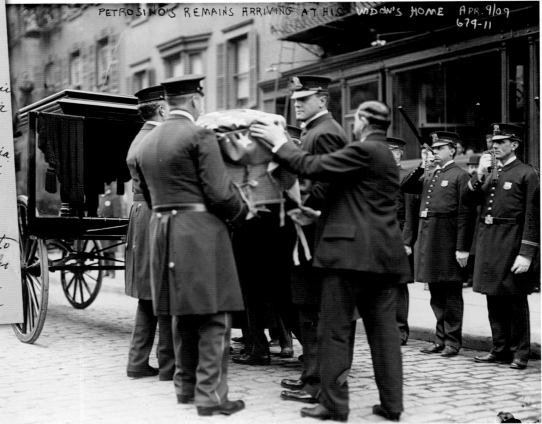

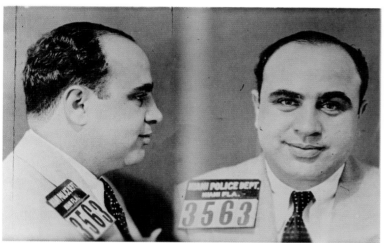

Al Capone, the Famous Villain

Alphonse Capone (above) was born in Brooklyn in 1899—one of his most famous quotes was "I'm not Italian. I was born in Brooklyn"—but he established himself as a crime boss in Chicago in the 1920s. Through violence and the unscrupulous use of his wealth, he became one of the most powerful men in the city. He was a public personality who could attend Wrigley Field and talk amiably with the Chicago Cubs catcher, Gabby Hartnett (top left).

It was only in 1931, when federal authorities charged him with tax evasion, that a satisfied Uncle Sam could proclaim: "Now you know me, Al!" (bottom right). His criminal career ended with a sentence of eleven years served at the Eastern State Penitentiary (his cell is shown top right) and Alcatraz.

Following the curious process that regulates public opinion, taste, and preference, arguably the most famous Italian American gangster in history enjoyed a more lasting reputation than that of Joe Petrosino. Hollywood dedicated dozens of movies to Al Capone, while Petrosino was portrayed only in *Pay or Die* (1960), with Ernest Borgnine as the hero detective of the Italian Squad.

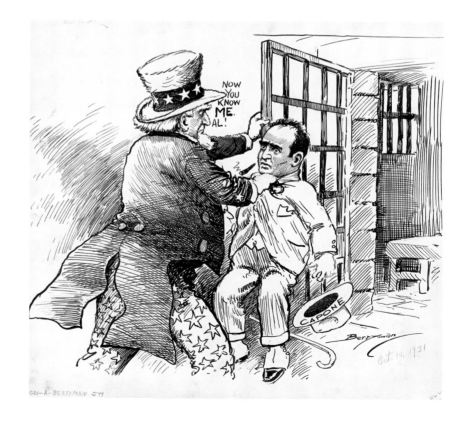

At the Movies: The Godfather and the Dark Side

With *Little Caesar* (1929) and *Scarface* (1931), the Italian American gangster became the negative hero of American cinema.

The consummation came with *The Godfather* (1972), winner of three Academy Awards. For the first time the topic was tackled by Italian Americans: Mario Puzo wrote the novel, Francis Ford Coppola was the director, and Robert De Niro, Al Pacino, John Cazale and Talia Shire were in the cast (Marlon Brando, below, played the mature godfather.) The three films in the *Godfather* series show the Mafia as a corollary to other aspects of the history of immigration, such as the arrival of little Vito Corleone on Ellis Island (bottom left), as well as of Italian culture in America, like the lavish wedding of Connie Corleone (bottom right).

Italian gangsters in movies and television shows are very controversial for Italian American communities. They clearly establish the idea that the Mafia pervades Italian life, but they also helped the emergence of great filmmakers (from Martin Scorsese to Brian De Palma), and generations of Italian American actors built their careers playing in Mafia-related shows.

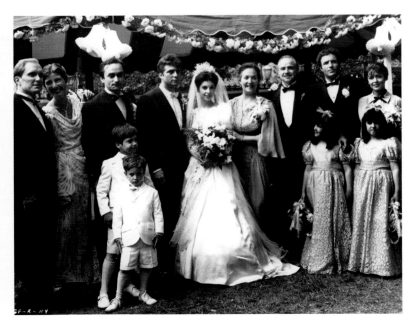

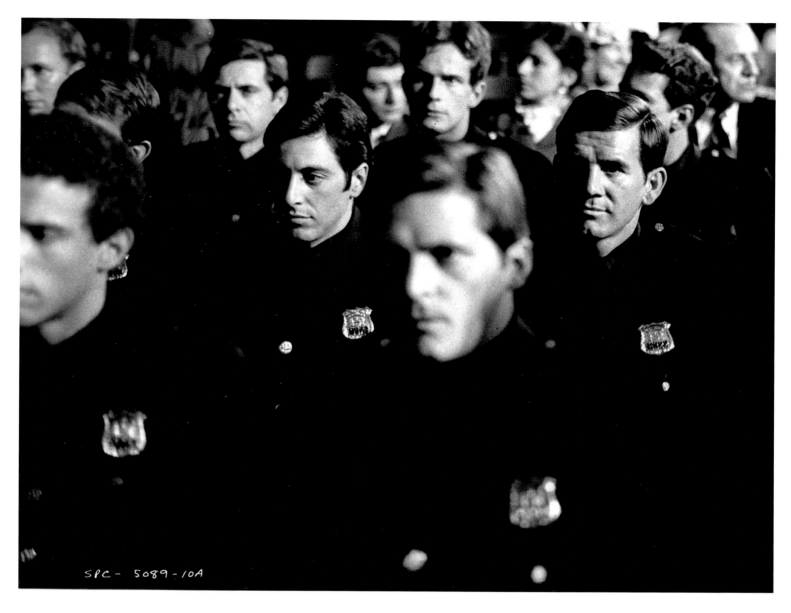

SPC- 5089-10A

At the Movies: Serpico and the Bright Side

Research in 2000 of over 1,000 movies filmed after 1928 shows that 73 percent of them present Italian characters in a negative way and only 27 percent in a positive way. They are portrayed as criminals 422 times (40 percent) and simple-minded, bigoted or stupid 348 times (33 percent).

One of the first positive Italian American movie heroes was Frank Serpico, the main character in the Sidney Lumet film (1973). It was inspired by the life of a Brooklyn plainclothes policeman who was the main testifier in a widespread corruption scandal among Manhattan police in the early 1970s. His complaints were disclosed in a *New York Times* article in April 1970. He stated that after delivering a bribe to his supervisor, "he was very grateful—he snapped it out of my hands like he was an elephant and I was a peanut."

After the article and his testimony, Serpico was marginalized and left the force. Al Pacino, playing Serpico in the sequence where he takes the oath (above), shows the pride with which this son of Italian immigrants, who grew up in the Brooklyn neighborhood of Bedford-Stuyvesant, wore the uniform.

A love of the uniform and the city it represents connects Serpico to the hundreds of Italian American police officers and firefighters who were at the World Trade Center after the 2001 terrorist attacks on the Twin Towers. Among them, Peter J. Ganci, head of the New York Fire Department, chose not to leave his men and was trapped in the collapse of the second tower. He was one of more than 120 Italian American fire fighters and law enforcers who lost their lives on 9/11.

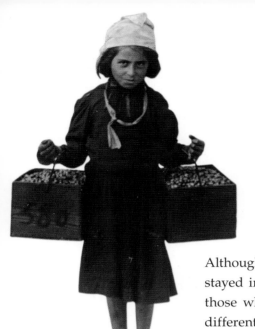

Rural Life Italians Move South and West

Although the majority of Italian immigrants stayed in New York and other East Coast cities, those who ventured beyond urban areas found different opportunities and, for some, a more amenable way of life. There was land to be farmed fairly close to urban centers. Long Island, New Jersey, Rhode Island, and Pennsylvania had successful Italian agricultural colonies. But Edmondo Mayor des Planches, Italian ambassador to the United States from 1901-1910, encouraged immigrants to head West and South. They "should go where the land, just as good or better [than in the East], is available at a better price, and the climate is milder and there is less competition, and the struggle for life is not so harsh."

In *Attraverso gli Stati Uniti* (1913), des Planches wrote about the Italian communities he visited. In Bryan, Texas, he found a "heartwarming welcome by . . . several hundreds of Nationals, all Sicilians. . . . Italians from the surrounding areas parade in their carriages, wagons, buggies . . . and in some vehicles sit six to ten people, women and children dressed in light, clean clothes; husbands, sons, brothers in their dark Sunday clothes. . . . They arrived some fifteen years ago. . . . Today, Italians own shops, selling fruit, colonial food, and import food. There are Italian tailors, shoemakers, and barbers. But the best of the colony are the farmers . . . mostly owning their own land, with only the newcomers renting."

Il Passaporto: Guida dell'emigrante, published in 1906 in Italy for potential emigrants, observed, "The price of food is increasing in America. This increases the profits that farmers derive from their fields and gardens, and it should be the strongest incentive for Italian immigrants to come into the country, where they can work and make a fortune. They should not be attracted by the good wages, that, sometimes, workers get in big cities. Remember that work in the city, for the most part, is only temporary and also remember that in the city crises occur frequently, sending thousands and thousands of workers broke."

The *Guida* then explains conditions in each of the twenty-four states. For example, in North Carolina, "the soil is fertile, and the

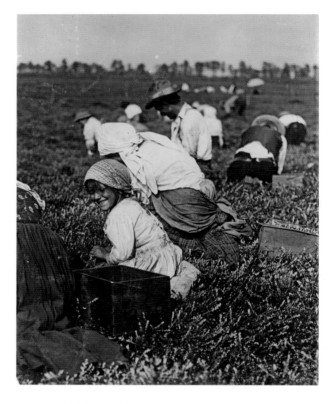

Seasonal Migration

"5-year-old Rosie Passeralla, 1116 Annan Street, Philadelphia. Been picking here two years. Whites Bog, Browns Mills, N.J. Sept. 28, 1910" (above). Many Italians of all ages along with little Rosie were moving from their homes in the big cities of the Northeast to the fields of New Jersey, Pennsylvania and other eastern states at the time of the harvest. There, they revived the habits and activities they had left behind in Italy, where many of them were farm laborers. According to statistics published by the Italian Ministry of Foreign Affairs in 1909, more than half of the Italians entering the United States claimed to be agricultural workers.

spring comes several weeks ahead of the North, and therefore horticulture is profitable because of the easy success of the early fruits in the big cities."

But not everything was perfect for Italian immigrants in the South and West. In the South under policies of segregation African Americans had no rights and very poor living conditions, and they supplied most of the unskilled labor. Europeans provided an alternative to African American labor, with the thought that they would fill unskilled jobs. Many Italians worked in the cotton and sugarcane fields, backbreaking work that paid very little. Even if more economically successful, they encountered bigotry and discrimination as a "race" somewhere between black and white Americans.

As the West was being settled by new arrivals from a variety of ethnic backgrounds, Italians fared somewhat better. But as miners they faced dangerous working conditions, fear of competition from American-born workers, and resistance from mine owners to make any changes. In Colorado, Italians who tried to unionize were branded anarchists and fired from their jobs. Mining camps were not appropriate for raising families; and as more wives and children joined their husbands, interest in mining work declined.

A fair number of Italians lived in California—first brought there by the Gold Rush—but land there was expensive, and they also faced discrimination from long-settled Americans. Nonetheless, they thrived as small farmers and established a place in the wine industry. The key to succeeding in the West and South—or anywhere—according to the *Guida dell'emigrante* lay with Italians themselves. "Any notable success is due to the work, and calls for 'iron arms and iron will.'"

Under the Big Sky of America

The American landscape—the vast distances, the wild natural obstacles—were psychologically challenging for immigrants coming from a nation with more than two thousand years of history, where man inhabited and built every corner of the land. That is one reason why it is rare to find a ranch with an Italian name (like the one above, Cerri Ranch in Nevada) in the unlimited spaces of the West. However, "in the suburbs of all major cities, the Italians now have beautiful vegetable gardens." For many immigrants keeping a garden where they could grow vegetables and fruit trees was a way to maintain some of their food traditions. At the same time, it ensured some level of self-sufficiency. The rural landscape titled "Pillars of Vermont" (left) was drawn by Luigi Lucioni, a native of the province of Varese (Lombardy) who grew up in New York.

Explorers, Emigrants, Citizens

Small Town Little Italies

In his book *Gli americani nella vita moderna osservati da un italiano* (1910), the journalist Alberto Pecorini asked himself: "How should we expect that poor laborers, without any resources and without any knowledge of the country, would venture to places where there are but a few of their countrymen? Telling the immigrant that he may have a much higher wage in Kansas, Colorado or California than in New York is of no avail; he comes to this country with a pain in the heart, dreaming one day to return and live quietly; . . . every kilometer away from New York is for him a new pain because it moves more and more away that indefinite, vague, impossible hope of returning to his homeland."

Even the few Italian immigrants going beyond big northeastern cities were concentrated in well-defined neighborhoods: artist Alfred Hutty depicted the Little Italy in the village of Glasco, on the banks of the Hudson River, in 1925 (left); Russell Lee photographed the sign promoting a dance organized by the Italian Progressive Club in Windsor Locks, Connecticut, in 1939 (right); and John Vachon documented the living conditions of Italian agricultural workers in Morrisville, Pennsylvania (bottom left).

Further west, Italians were more scattered, yet in Omaha, the most populous city of Nebraska, there is still an area that can be called Little Italy (middle below). In the tiny school in Sterling, in Logan County, Colorado, Lewis Hine portrayed the entire student population consisting of "Harold, a 9 yr. old American boy whose family hires beet-workers, and 6 yr. old Lena, who belongs to an Italian family with 9 children, Padroni."

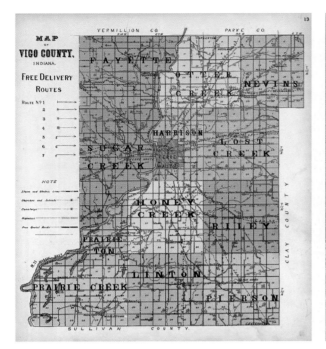

Towns with Italian Names

Rome is the Italian capital, but it is also the largest city in the county of Floyd, Georgia, is close to an American Revolution battlefield in New York, and the Rio Grande flows through it in Texas. In the U.S. there are eight towns that take their name from the Eternal City and hundreds of other towns and cities with Italian names. Some recall people or events related to American history, such as Vigo County in Indiana (above left), named after Francesco Vigo, who fought for American Independence. The settler Daniel Bayley, the founder of the town of Garibaldi, Oregon (above right) was an admirer of the "Hero of Two Worlds." The tobacco magnate Abbot Kinney decided to build Venice, California (below) in 1905 with the revolutionary idea of creating a Venetian theme park to accommodate the growing industry of tourism.

A name can also derive from the Italian origin of the founders. Adolfo Rossi, writer, journalist and diplomat, who came to Colorado as a laborer, wrote: "Shortly after noon we arrived at a small station located on a high plateau nearly eight thousand feet above sea level to the proximity of a wretched lake named Como," where he met only Italian workers.

Explorers, Emigrants, Citizens

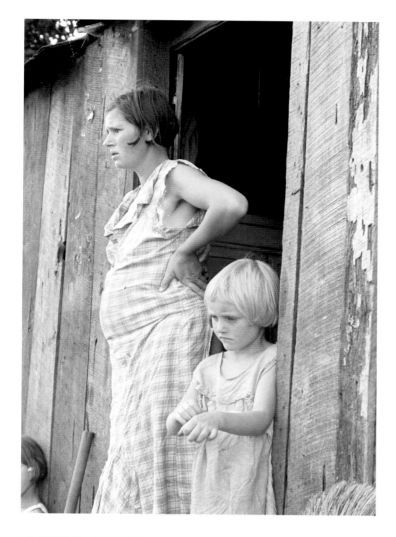

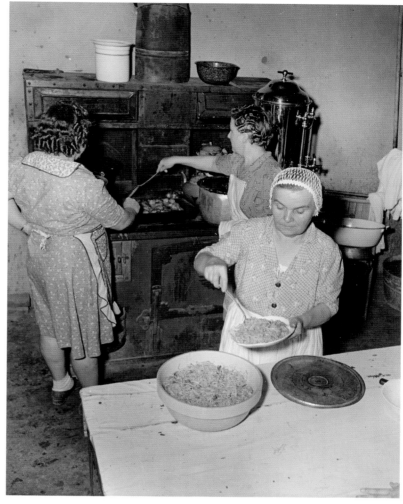

Ambassador Mayor des Planches

At the peak of the great migration, one of the few diplomats who tried to understand the living conditions of Italians in the U.S. was Edmondo Mayor des Planches (left), Italian ambassador in Washington from 1901 to 1910. He intended "to encourage the diffusion, in the vast territory of the United States, of Italians who are gathering in the large eastern cities, . . . where they live mostly in Italian neighborhoods leading a morally and physically unhealthy life, and economically miserable."

In his memoir *Attraverso gli Stati Uniti. Per l'emigrazione italiana* (1913) he described his travels to all major Italian settlements in rural America. The first was Valdese, a North Carolina town founded in 1893: upon his arrival "Valdese station [is] decorated with Italian and American flags. Men, women, and children greet us with cheers and greetings in Italian, in French, in Piedmont dialect. They are Italians from the Pinerolo Valleys." In Tontitown, Arkansas, founded in 1898 by Father Pietro Bandini, the beginnings were hard: "Settlers had just finished their first tasks, built the first hut, when a cyclone devastated everything, killing one of them, a young man. . . . Now, after seven years . . . the orchards multiplied, and the whole county became prosperous."

Tontitown, located in Washington County, was hit very hard by the Great Depression (top left, a family of sharecroppers), but the Italian community continued to prosper. They celebrated the harvest with a dish of spaghetti during the traditional Grape Festival in 1941 (top right).

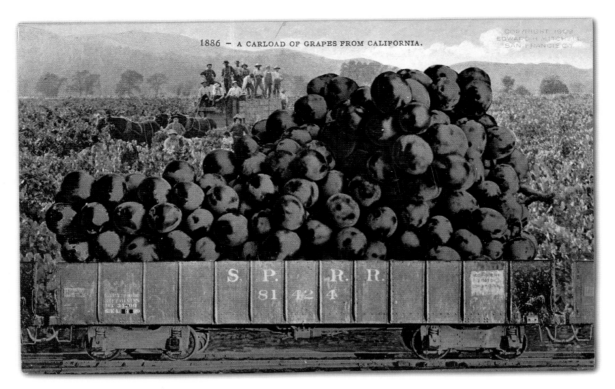

1886 – A CARLOAD OF GRAPES FROM CALIFORNIA.

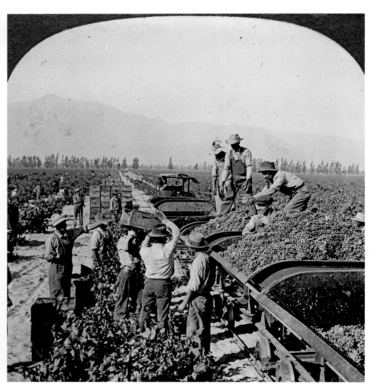

CALIFORNIA

VINO VINO VINO

Eccellente ed a buon prezzo, eguale se non superiore ai Bordeaux, Chianti e del Reno.

DA 75 CENTS A $1 PER GALLONE.

Condizioni speciali per la vendita all'ingrosso. I commercianti nelle città dell'interno che desiderassero informazioni e campioni si dirigano liberamente alla nostra casa.

S. ANTOLDI & CO., 244 Third Avenue.

Sunny California: Wine, Oranges and Olive Oil

The images on the facing page might have been taken in the Italian countryside at harvest time. Instead they are from California, the destination of a steady stream of emigrants since the 19th century. Philip Brigandi, an Italian born in Messina (Sicily), created the two pictures in the middle. He was known as the "wizard of stereoscopy" because he specialized in this photographic genre. The Californian climate and soil made it easier to plant typical Mediterranean crops such as citrus fruits, olives and especially grapes for wine. Ambassador des Planches visited some of the most important Italian wineries in California. In Cucamonga he noticed "Large signs saying: 'Italian Vineyard Co., 3000 acres'. Vines growing in low bushes, like in Puglia;" and in Asti, "Italian name, created by Italians, and with an Italian colony. The name of Asti, given to the colony, in accordance with the law, will allow the Company to produce and sell wines of 'Asti', just like the projected colony of Chianti, not far away, will be allowed to produce 'Chianti' wines. Fair-trading will require, however, to add the state name and to sell 'Asti, Cal.' and 'Chianti, Cal.' "

In the South, Italians became day laborers in agriculture (above, orange pickers in Ormond, Florida). There, however, they were often exploited and considered cheap laborers who could replace African American workers. Along the Mississippi River, in the late 19th century more than two hundred families, mainly from the Po Valley, were transplanted to the so-called "colony of Sunnyside". The living conditions and the unhealthy climate dramatically contributed to the failure of this experiment in targeted migration; it ended with the death or the departure of many Italians.

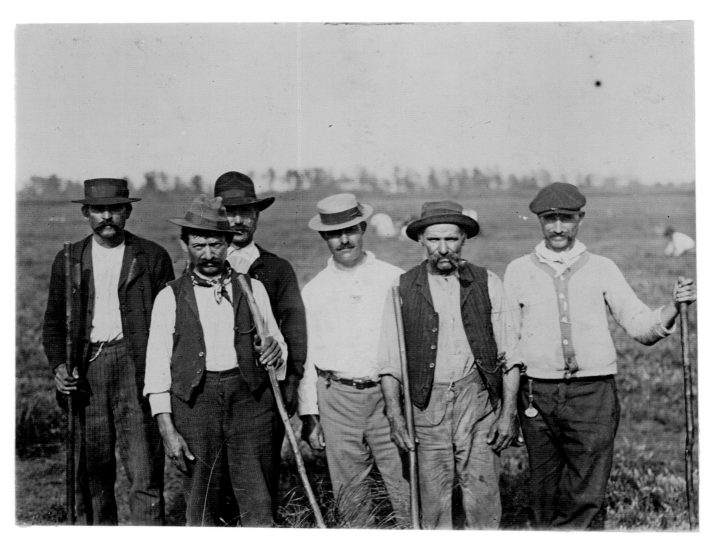

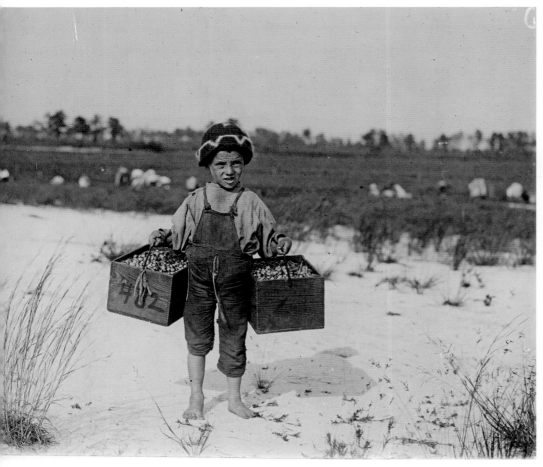

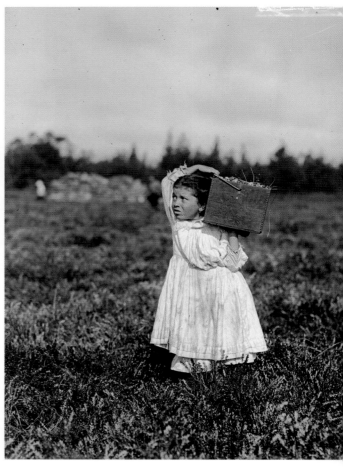

Explorers, Emigrants, Citizens

Working in the Fields under the Padrones

This photograph shows a group of *padrones* in 1910 in a field in New Jersey (facing page, top). In some regions of Italy, *caporalato*, an illegal system where landowners' agents directly hire farm labor for very low wages, is still common. The "*padrone* system" (*padrone* in Italian means "master") was very similar, and it worked for Italian emigrants in the U.S. The *padrones* hired groups of workers, sending them to all regions of the country where they built roads, worked in mines, or in the countryside. All contemporary writers agree that the *padrones* were exploiters and often fraudulent. According to scholar Angelo Mosso, however, in 19, this typical Italian system, "no matter how bad, has the advantage of giving an extreme mobility to migrants, who as a rapid current carry their arms where they are needed." These images show the terrible conditions in which whole families, including small children, were forced to work and live: Salvin Nocito, age five, of New Jersey (facing page, bottom left) the cabin housing ten members of the Di Marco family in Pemberton, New Jersey (bottom left); and the shacks called "Florence"—others were called "Palermo"—near the fields of Browns Mills, New Jersey (bottom right). The original captions revealed the social context in which these people lived: "Eight-year-old, Jennie Camillo, lives in West Maniyunk, Pa. (near Philadelphia). For this summer she has picked cranberries. . . . Her look of distress was caused by her father's impatience over her stopping in her tramp to the 'bushelman' at our photographer's request" (facing page, bottom right); and "Frances Frigineto, 3 years old. Marie Frigineto, 5 years old, latter been picking two years. . . . This is the fourth week of school and the people expect to remain here for two weeks more" (right).

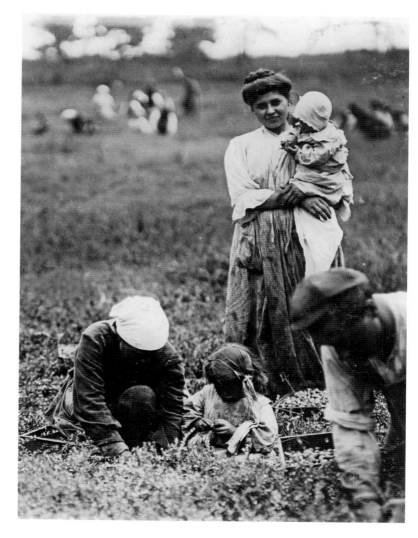

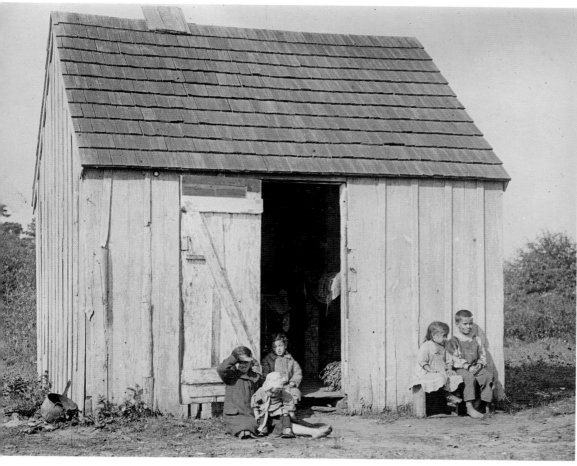

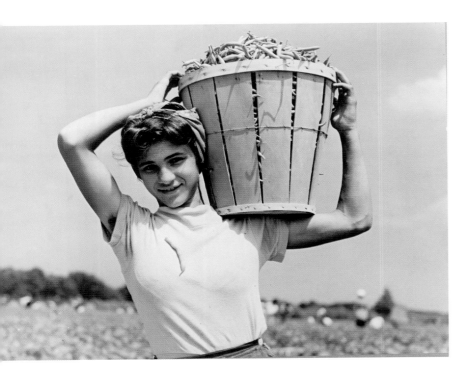

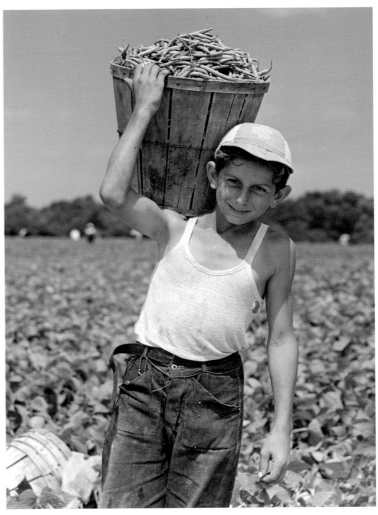

Young Workers

Two young Italians working in the bean fields in New Jersey are portrayed by Marion Post Wolcott (above and right): while working for the Farm Security Administration she tried to "chang[e] the attitudes of people by familiarizing America with the plight of the underprivileged, especially in rural America." In the summer months, many Italians who lived in nearby large cities moved to New Jersey for the harvest season to supplement the family budget. Typically, the whole family, even the youngest, carried out this hard work.

Out West

Although in 1890, Buffalo Bill's cowboys lost a famous challenge to *butteri,* as cattlemen from Maremma (Tuscany) are called, very few Italians became cowboys in the Wild West. Thanks to the research program "Buckaroos in Paradise," which the American Folklife Center at the Library of Congress carried out on the residents of Paradise Valley in Nevada, we know that many families came from Italy. Among those settling in remote locations and still living there in the 1970s were the Boggios (right, marking their cattle), the Cassinellis, the Recanzones, and the Pasquales (above, Al Pasquale driving a wagon).

Explorers, Emigrants, Citizens

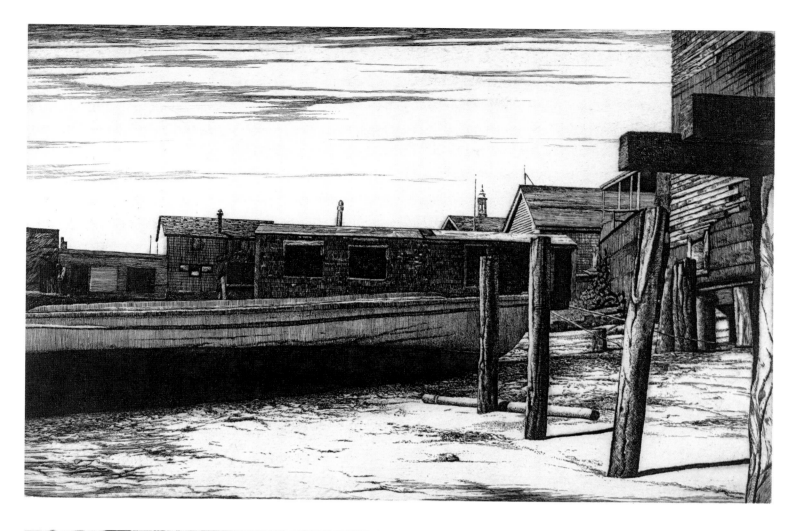

Fishermen

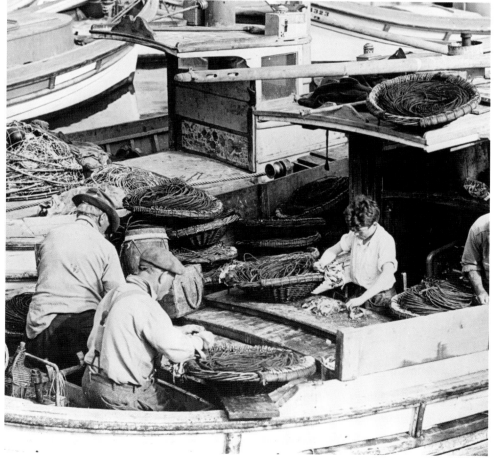

"The Waterfront" by artist Pasquale Masiello (top) shows that sea and fishing always fascinated Italians. The ancient seafaring culture in the Mediterranean was exported to both coasts, from Boston to San Francisco. There Italian fishermen—mostly Sicilians—made up the majority on the docks at Fisherman's Wharf (left). Ambassador Des Planches wrote: "The residents [of the Californian settlement] of Black Diamond, almost exclusively Italians, are fishermen, who came from Isola delle Femmine, and from Ustica. There are a few thousand, most of them prosperous. Twice a year, with their boats, they go fishing off the coast of Alaska, and, with the revenue, they live well and deposit money in banks."

Even Joe DiMaggio, one of the most famous Italian Americans in history, was born into a family of fishermen from Isola delle Femmine. However, few remember that at the outbreak of World War II, when DiMaggio was already a Major League all-star, authorities seized his father's boat. His parents, Giuseppe and Rosalia, being Italians, were considered "alien enemies."

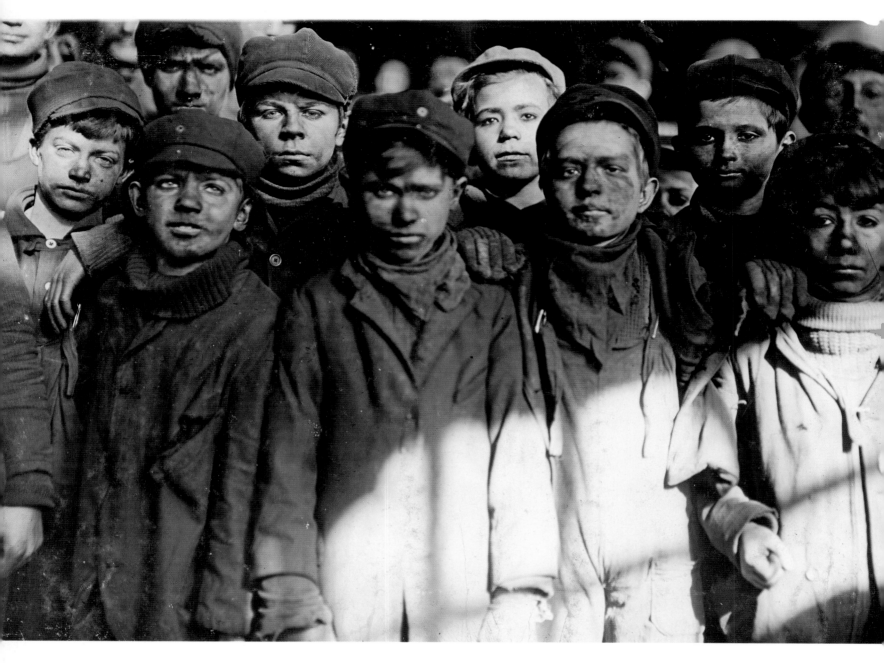

Life in the Mines

This photograph (above) shows a group of "breaker boys," children employed in coal mines to break the ore, select it and remove its impurities. In *Guida del minatore*, a book written in Italian and published in Pittsburgh in 1914, the author specified that "in mines in the United States boys can be used in two kinds of work inside the mines: they can wait outside the passageways, or they can drive the mules. Their outdoor work, however, is to separate the slate in the breaker and to drive the mules pulling the wagons to the surface. None of these works can overcome the physical forces of children of a right age." Pasquale Salvo and Sandy Castina (facing page, top) were two young muleteers photographed by Lewis Hine, who tirelessly reported the inhuman conditions in which small miners worked.

In some areas, mining jobs were among the most popular for Italians. In 1910 between 10 and 20 percent of the workers in the coal mines of West Virginia, the Southwest and Midwest were Italian. Except in Pennsylvania, where the Slavs were in the majority, Italians were the largest group of immigrants employed in coal mines. They started as inexperienced workers and were gradually promoted to the rank of skilled miners. Italians in the South constituted a significant presence in the extraction of coal, while in the central and northern regions they provided the majority of workers in the iron and copper mines around Lake Superior and in the Rocky Mountains.

Explorers, Emigrants, Citizens

Cherry Mine

The writer Giuseppe Giacosa in his book *Impressioni d'America* (1908) recalled: "From my small town in Piedmont, on March 1893 three good workers came to America, leaving home, wives, sons and debts. Upon their arrival, they found a mining job in Primrose, Pennsylvania. The money was good: no doubt! None dared to go down in those wells that had already flooded once, drowning all workers. Now the water vein had been welded and work had resumed. The employers knew the danger, but business is business, lasting as long as it can. And it did not last long. On April 20, the vein broke again, and those who were under remained there. My fellow countrymen had been at work for eight days, needless to say they did not leave a penny."

History is punctuated by terrible accidents that killed hundreds of miners. In Cherry, Illinois on November 13, 1909, 259 miners died; at least seventy-three were Italians. The photograph (bottom right) shows the desperation of the relatives of the dead, crying by the simple wooden coffins holding the recovered bodies.

Even a higher percentage of Italian miners died in the Monongah Mine Disaster in West Virginia, the worst in the history of the United States: out of a total of 362 dead miners, 171 were Italian.

In the U.S., those events have been recounted in books, like *Trapped* by Karen Tintori—dedicated to the Cherry Mine Disaster—and documentaries like *Monongah Remembered* by Peter Argentine. But Italians of every region who "traded daylight for a future, and lost both," as Karen Tintori wrote, are almost forgotten in the collective memory of Italy.

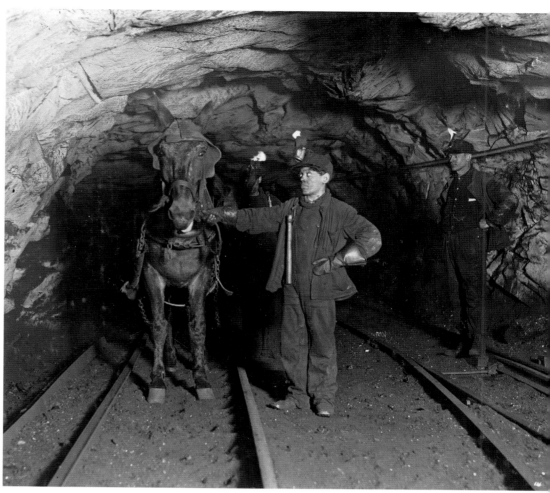

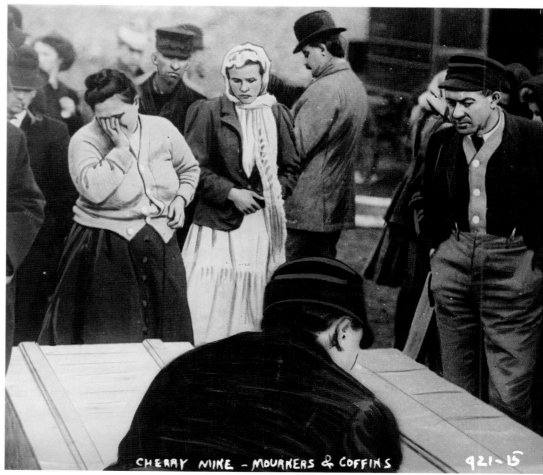

CHERRY MINE - MOURNERS & COFFINS 921-15

Italian Labor
Jobs and Politics

When Mary Cerone was two weeks short of her fourteenth birthday in 1910, her mother took her to downtown New York to get her working papers. Children could leave school at age fourteen. The official pointed out that she was still too young. Her mother argued that they needed Mary to work, and what difference did two weeks make anyway? "Signora," said the official, "give the girl her two weeks. She'll be working the rest of her life."

Italians came to America to work. Whether they wanted to stay in the United States or return to Italy, they were drawn by the chance of earning money—to survive, or to make a better life. Many of them, coming from farms or villages, did not have the skills an increasingly industrial society like the United States needed. They took on the hardest (and most poorly paid) physical work.

But the jobs Italian immigrants did were more diverse and required more expertise than the popular image of day laborers and ditch diggers. They were stonemasons, bricklayers, mechanics, barbers, shoemakers, tailors and seamstresses. They became an essential part of the building trades and the garment industry.

The use of child labor was an ongoing problem. Families took their children out of school and set them to work because they needed their income. Industries like mining and textiles used children because they were

A Babel of Languages and Cultures

This sign (below) outside a factory in West Virginia perfectly shows the multi-ethnic and multi-linguistic environment in which Italian workers found themselves. Many of them went directly from the landlordism of agricultural Southern Italy to the aggressive capitalism of the largest industrial power of its time. It was difficult to adapt to the new lifestyle, and the first victims were often children. They were exploited both in and outside the work environment, like newsboy Tony De Lucco in Hartford, Connecticut (above), and textile worker Secondino Libro in Lawrence, Massachusetts (facing page, top).

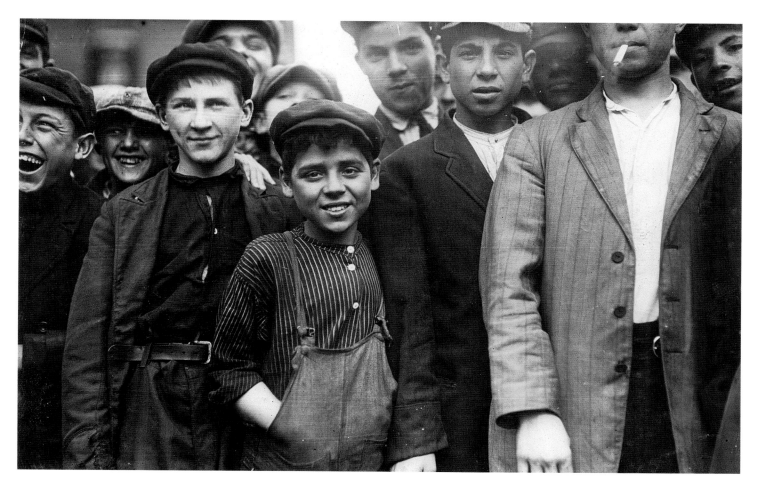

cheap to employ. Children worked in mines and factories, or with their mothers in dim tenement rooms turning out decorations for hats and clothing. There were no federal laws to stop child employment until 1938, when the Fair Labor Standards Act was passed.

Because, young and old, they worked in jobs where they were often exploited (poor working and living conditions, poor pay), Italian immigrants took part in labor organizing and strikes. Denied membership in large American unions due to ethnic discrimination, they formed their own unions, including the *Società degli stuccatori e decoratori italiani* (Society of Italian Plasterers and Decorators) in Chicago and the *Società dei sarti italiani* (Society of Italian Tailors) in Philadelphia.

Some groups advocated socialism or anarchy— ideas that political exiles and other immigrants brought from Italy. In the 1880s Italians founded the group "Carlo Cafiero," which demanded social revolution. Francesco Merlino, Pietro Gori, and Errico Malatesta started radical publications that encouraged groups of anarchists to form. Many of the Italian textile workers in the silk mills of Paterson, New Jersey believed in anarchy, including Gaetano Bresci, who assassinated the Italian king Umber-

to I in 1900. The owners of major industries and the U.S. government feared and reacted against labor agitation in any form. Anarchy was even worse, quickly associated with dangerous foreign influence. Italians who fought for labor reforms were linked with anarchy, whether that was their goal or not.

Sometimes political as well as economic goals motivated labor agitation. The Industrial Workers of the World (IWW), begun in 1905 (and welcoming all ethnic groups) called for aggressive unionization and socialism. Carlo Tresca and Arturo Giovannitti were among its supporters. Giovannitti (with Joseph Ettor) led a strike by textile workers against the textile mills in Lawrence, Massachusetts, in 1912. Strikers and police had violent confrontations and Giovannitti and Ettor were jailed. During a strike in 1913 at the Paterson mills, two Italian strikers were shot to death and more than one thousand arrested. The Lawrence strikers won (and gradually lost again) some of their demands; the Paterson strikers were defeated.

Despite setbacks, Italian workers continued to participate in the labor movement. It brought them closer to other ethnic groups and to the wider American society with which they had to interact.

Building America with 'Picca e Sciabola'

"They came at a time when the development of industry and commerce and the great railroad constructions required a large number of laborers; Italians, usually sober and conscientious, were immediately appreciated and sought after especially for construction work where they could replace the Irish for a lower salary. Tens of thousands of these humble workers scattered throughout the country, crowding along the railway in small wooden huts, saving what they could and meanwhile building forty thousand kilometers of railways, which would have cost the companies a billion and a half, if they had used Irish labor rather than Italian." This 1910 description by an Italian journalist confirms that even though Italian workers came with a thousand-year-old tradition in the building industry and with an uncommon will, what made them "the masons of America" was their willingness to accept lower wages than the competition.

Many of the emigrants found their first job working *picca e sciabola*, as they called it, an expression that crippled the English 'pick and shovel'. *Picca e sciabola* described all unskilled labor in the building and in the construction of roads and railways; they were also used by the workers, mostly Italian, who built the subway tunnels of New York in the early 1910s (below). Among the many skilled workers were stonecutters who settled in Barre, Vermont and masons who worked like acrobats to construct skyscrapers. The illustration (right) by Thornton Oakley, created in 1904, shows three workers suspended on the New York skyline.

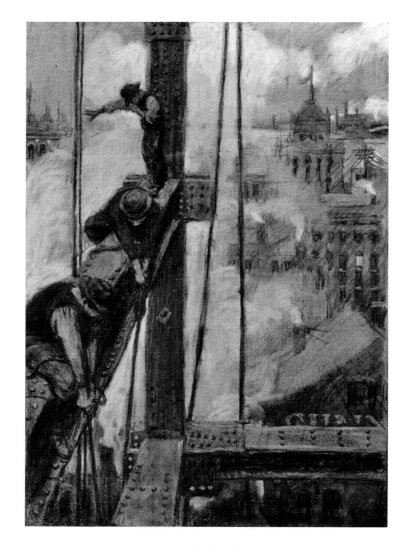

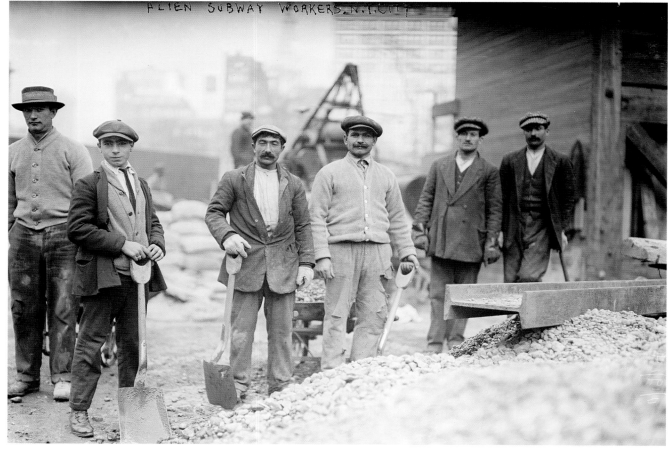

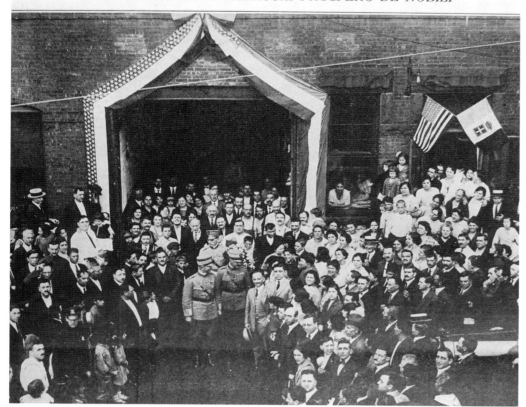

ALLA FABBRICA DI TABACCHI PROSPERO DE NOBILI

Working for Italians

The article published in the New York magazine *La Domenica Illustrata* (left) proclaimed that "Nobili, the [Italian] congressman . . . goes back and forth between his native Spezia and New York. Here in New York, he founded a large cigar factory, producing our Tuscan cigars which are slowly gaining favor with the public. For now he sells to the Italian public, which may be enough, even for a large factory, when you think of the 600,000 Italians living only in New York." Mary Cerone apprenticed there and rolled cigars for fifty years; she was the author Linda Osborne's grandmother.

The Maggioni, owners of an oyster packaging company in South Carolina, proved that they had adapted to the methods of American capitalism. They told Lewis Hine, who photographed the conditions of their workers (below): "We give them houses to live in." Hine noted that about fifty persons were "housed in this miserable row of dilapidated shacks."

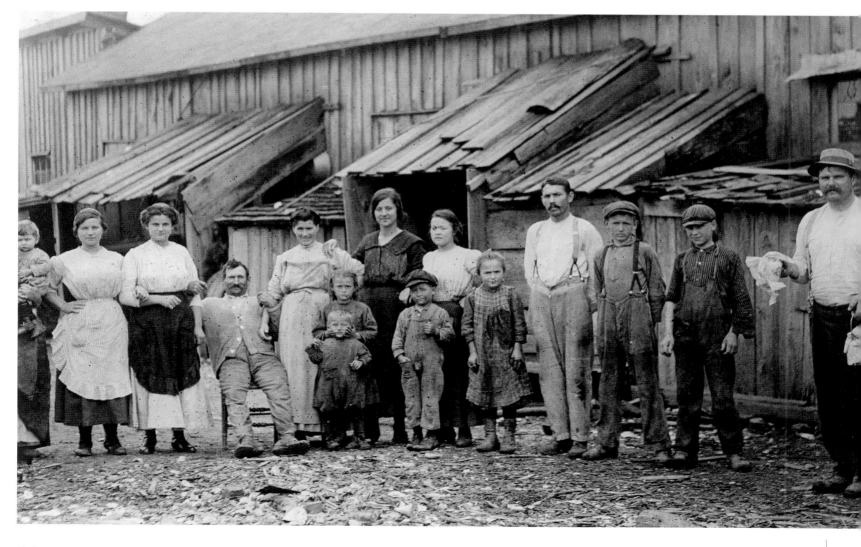

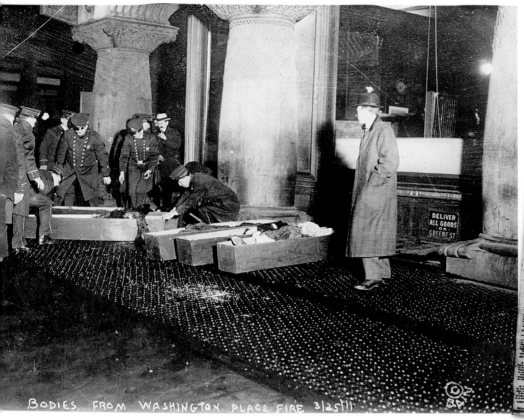

BODIES FROM WASHINGTON PLACE FIRE 3/25/11

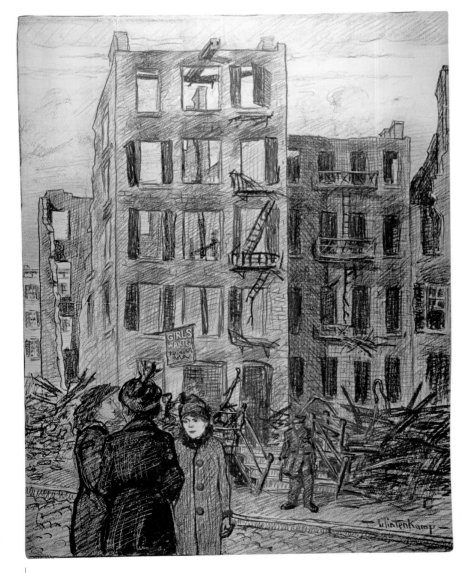

Triangle Shirtwaist Company

On March 25, 1911, all hell broke loose for more than five hundred workers at the Triangle Shirtwaist Company, which specialized in making women's blouses. A huge fire, which originated from the flames in a basket of paper, wrapped the top three floors of the building, standing at the intersection of Washington Place and Greene Street in Manhattan. When the workers, mostly Jewish and Italian girls, tried to escape, they realized that some of the exits had been locked: a common habit to prevent thefts. Many tried to save themselves by jumping out of the windows. The bodies of the victims—146, including thirty-nine of Italian origin—were lined up on the sidewalk next to the burning building (top left).

The incident crossed the line: the harsh words on the opening page (top right) of the usually moderate *Il Progresso Italo Americano* show it clearly: "The labor colony in New York . . . will stop working . . . We want long, endless marches, following the victims, we want the pain that broke the hearts to be evident on every face, we want the sad procession, in its solemn silence, to demonstrate to the foreigner [the American] with no excuse the protest that humanity rises towards the cruel abandonment with which lives of the guests of America—the lives of those who are factors in the prosperity of this world—are left to the embrace of Death." Despite the irony of the illustration (left) with the sign "Girls Wanted" hanging on the smoking ruins, after this tragedy, the laws of New York State improved safety and fire protection requirements for industrial buildings.

HOMEWORK DESTROYS FAMILY LIFE

Keeps the child from school

Encourages father to shirk responsibilities

Prevents proper care of home

Allows unsupervised, greedy manufacturers and parents to make a mockery of childhood

WOULD YOU LIKE YOUR CHILD TO GROW UP HERE OR HERE

Home Working

According to the Department of Labor, in 1906, Italians accounted for 98.2 percent of homework in New York's clothing industry. The work of Lewis Hine confirmed this fact. He was the photographer for the National Child Labor Committee, an organization founded to raise awareness on child exploitation through exhibitions (left, a panel on homework) and the publication of photographs in newspapers and magazines. Many of Hine's images portray families with Italian names. The original caption for the photo of the Zerpoli family (below) starts with, "Father loafs while children work." This recurs in a family environment where the father's role is often on the edge of the frame. The cases in which he is actively engaged are rarer, as in the photo of the Macola family (bottom).

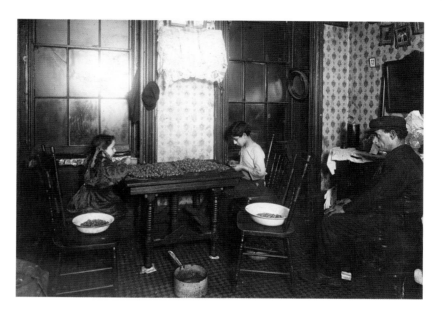

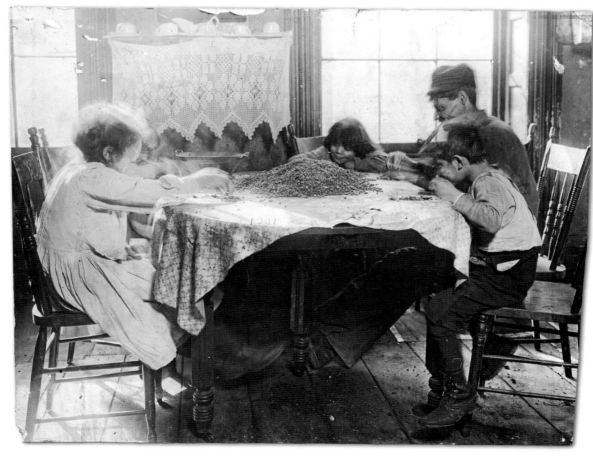

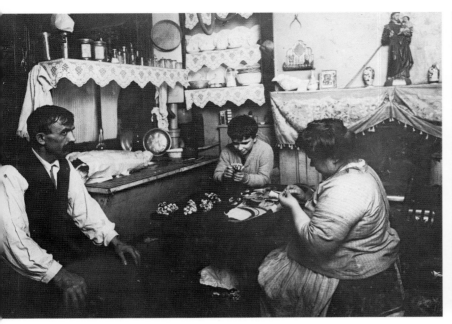

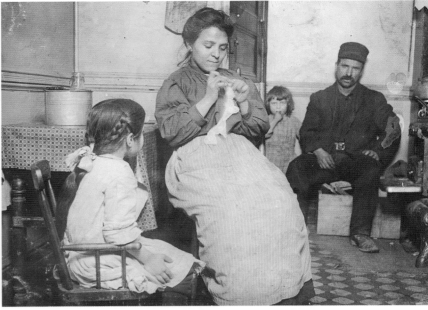

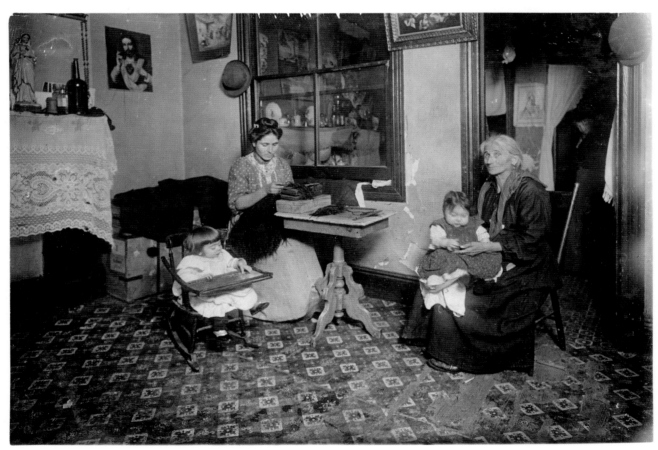

Women's Role

The role of women in Italian American society wavers between the respect for tradition subordinating them to men in all important decision making and the appeal of opportunities available to American women, which looked almost revolutionary to all Italian observers of the period, Alberto Pecorini wrote in the book *Gli americani nella vita moderna osservati da un italiano* (1910): "You might deplore that in a rich country like the United States, mothers still have to work and girls spend ten hours a day in crowded and unhealthy workplaces, but we must acknowledge that through economic independence, the American woman acquires self dignity and self consciousness, and a true spirit of resourcefulness."

In Little Italy, in the tenement apartments of the Cardinale family (top left), of *signora* Totore (top right), and *signora* Larocca (above), women always managed homework, thus acquiring a little independence from their fathers and husbands. Sometimes the work was done simultaneously by three generations of women, from grandmother to granddaughter. Even very small children helped to make clothes, artificial flowers, and umbrellas, carrying out simple but essential tasks. According to research in 1910, with more than five hundred New York families interviewed, 91.3 percent of girls over fourteen years old contributed to the family income, compared to 87 percent of the fathers and 86.6 percent of their male peers.

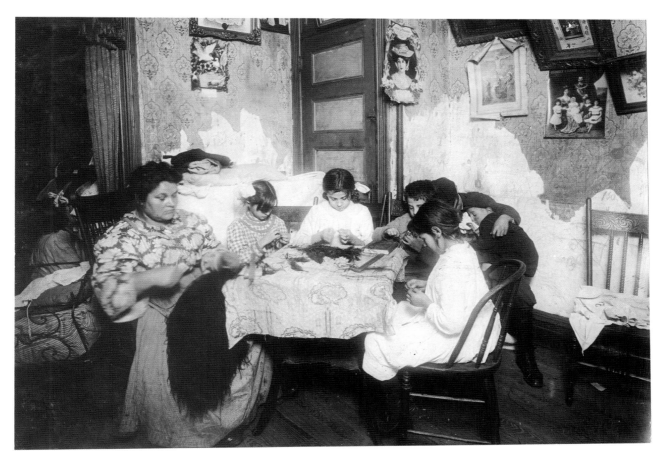

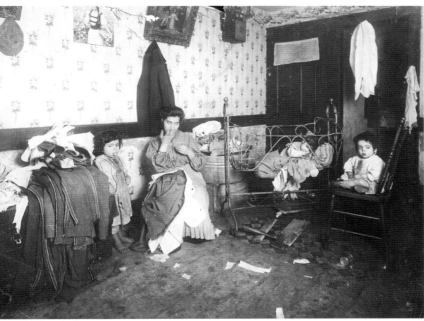

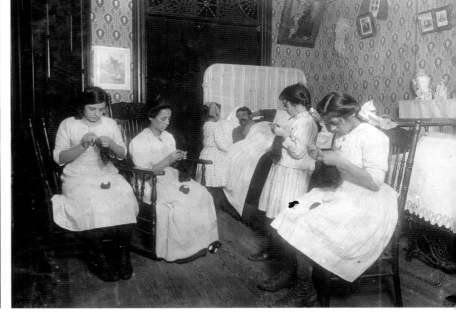

Documenting Life in a Tenement

Photographs taken by the National Child Labor Committee are exceptional documents of the living conditions of Italian American families in the tenements—those tiny, overcrowded apartments that were the main type of housing in Manhattan's Little Italy.

Portraits of the Italian royal family often hung on the walls, as in Mary Mauro's family (top), a habit that Ambassador Des Planches also observed far from the big city: "Distance makes emotions, which remain dormant at home, more intense. I remember meeting migrants in American small towns . . . in humble food emporiums (which make up the largest number of traders) you always see, next to the image of the Madonna, the portrait of the king and queen, and under them a shining lamp." Religious images were another common feature of Italian homes (above right).

The photographs and captions vividly display the misery that many families had to fight every day: *signora* Gualdina (above left) lived in "a dirty poverty-stricken home, and making a pittance by finishing pants. . . . She was struggling along, (actually weak for want of food) trying to finish this batch of work so she could get the pay. There seemed to be no food in the house and she said the children had had no milk all day."

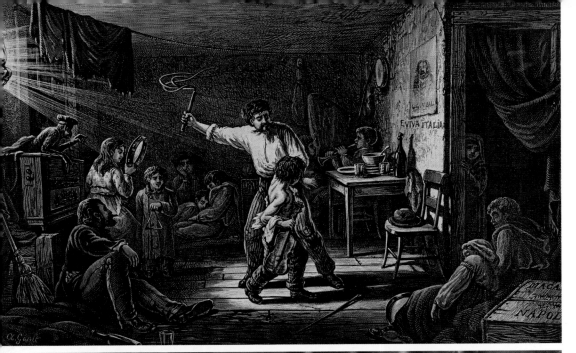

Child Labor

One of the worst accusations against Italian immigrants—and one of the hardest to refute—was that they exploited their children. The illustration published in *Harper's Weekly* on September 13, 1873 (top) was a clear example of how the public perceived the sordid environment of the tenement. It is an image comparable to the most gloomy descriptions in Dickens's *Oliver Twist*, where children were treated as slaves by violent and idle adults who exploited them as beggars or organ grinders. To make it clear that this was an Italian scene, the artist included a portrait of Garibaldi with "Eviva l'Italia" underneath; a case of "macaroni" from Naples; and the inevitable monkey. It is true that most children were forced to work at a young age by their parents. An Italian girl in Lawrence, Massachusetts, reported: "I was still in school, when one day, a man came home and asked my father why I did not go to work and my father replied that he did not know if I was 13 or 14 years. If so, the man says, give me $ 4 and I'll get you documents from your country, where there is written that the child is 14 years old. My father gave him $ 4 and a month later the documents arrived saying that I was 14. I went to work and after two weeks I got hurt."

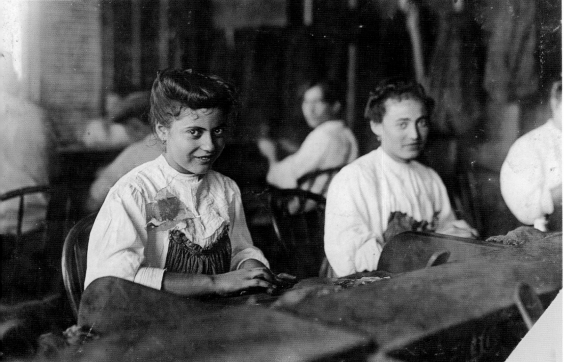

Both girls and boys were employed in industry. In Tampa, Florida, girls worked in the cigar factories (left center), while in Chicopee, Massachusetts, little Tony Soccha [sic] had worked for a year in a textile factory (below).

One of the worst problems highlighted by the research of the National Child Labor Committee was the lack of education of working children, such as Antonio Satera (facing page, top) described as "illiterate." Newsboys at the foot of the Capitol (facing page, bottom) were the best example of how child labor was a widespread plague—and one that was tolerated—in American society. "In comparison with governmental affairs newsies are small matters," read the caption. "This photo taken in the shadow of the National Capitol where the laws are made. This group of young newsboys sells on the Capitol grounds every day . . . Names are Tony Passaro, 8 yrs. old, . . . Joseph Passaro, 11 yrs. old, . . . Joseph Mase (9 yrs. old) . . . Joseph Tucci, (10 yrs. old) . . . Jack Giovanazzi."

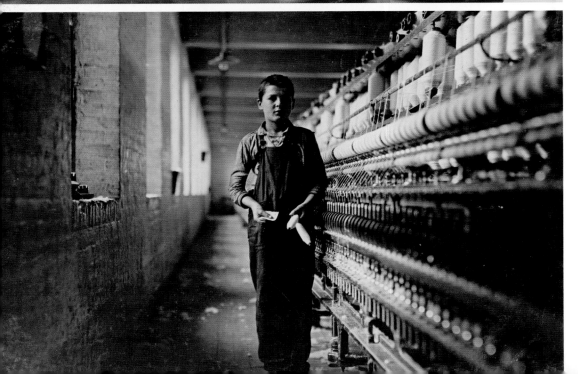

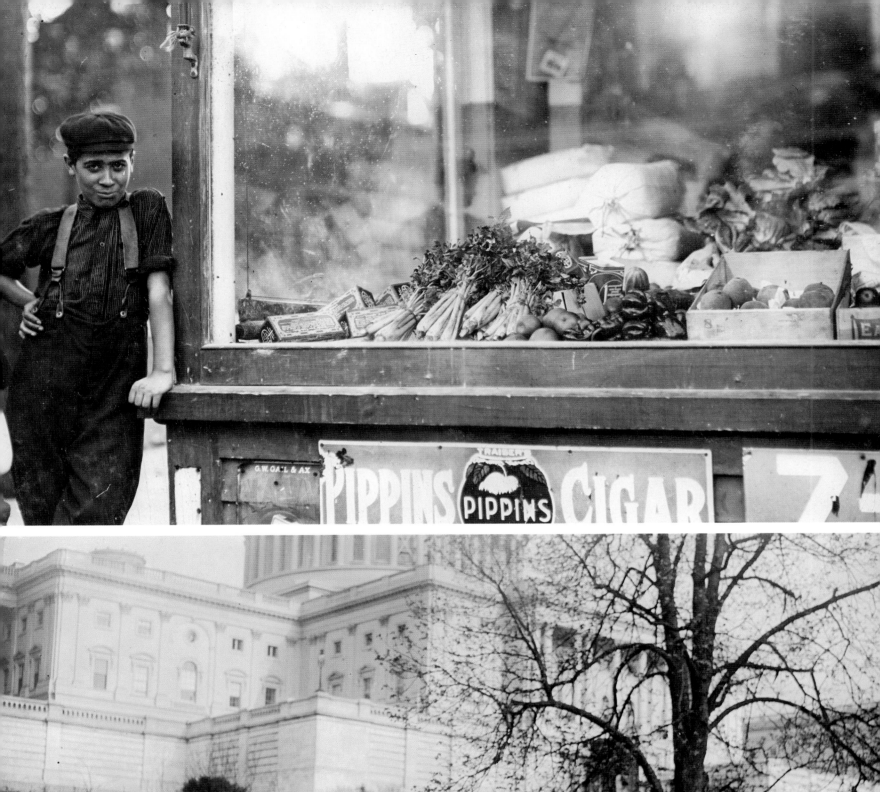

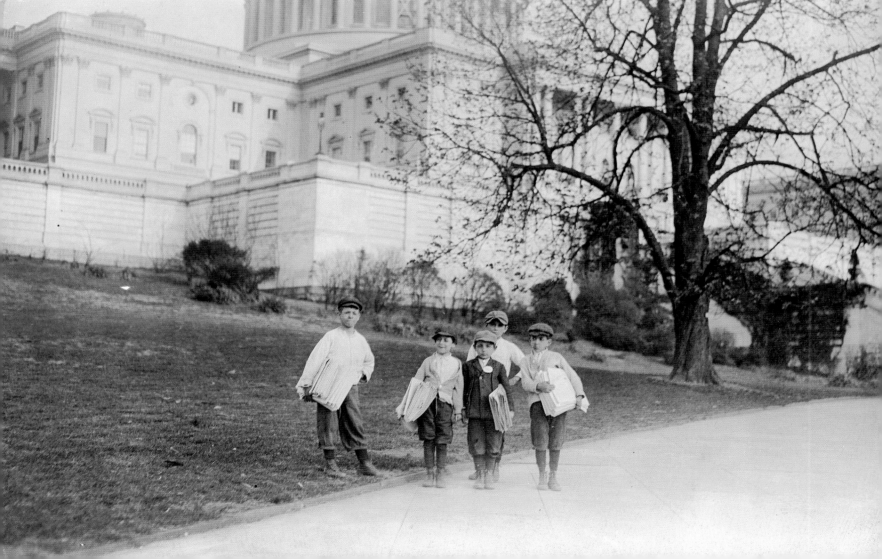

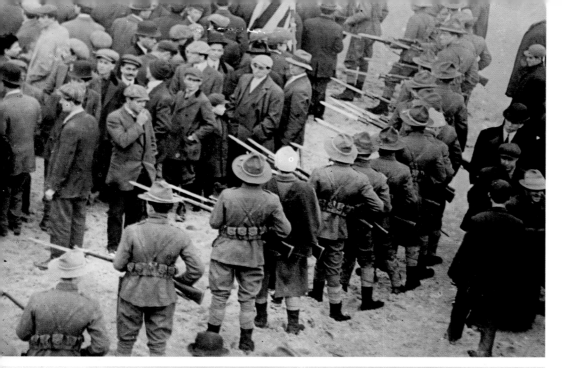

Italian Unionists

During the 19th and 20th centuries, labor struggles shook the industrialized world. Unions fought to obtain better wages and working conditions. In the United States, the struggles were often bloody, as shown by the images on the left: soldiers of the Massachusetts militia surround the protesters in Lawrence (top), where the Industrial Workers of the World involved more than twenty thousand woolen mill workers in a city where more than eight thousand Italians lived.

The ruins of the mining camp of Ludlow are shown (left center), where, in April 1914, the Colorado National Guard opened fire against the miners and their families. As many as nine out of twenty victims were Italian. Folksinger Woody Guthrie sings in "Ludlow Massacre" that "thirteen children died from your guns:" thirteen of those killed were children, including siblings Lucy and Onofrio Costa (four and six years old) and Frank, Joe and Lucy Petrucci (respectively four months, four and two years old).

Many of the migrant workers had not been part of any political or trade union affiliation in Italy. Thanks to leaders like Carlo Tresca and Arturo Giovannitti, respected by the entire labor movement, they started to approach the local labor organizations, overcoming the distrust of most American activists. In a very short time, trade unions became a field experiment in workers' internationalism, as shown by signs in Italian, Hebrew and English during a rally in Union Square, New York, in 1913 (bottom).

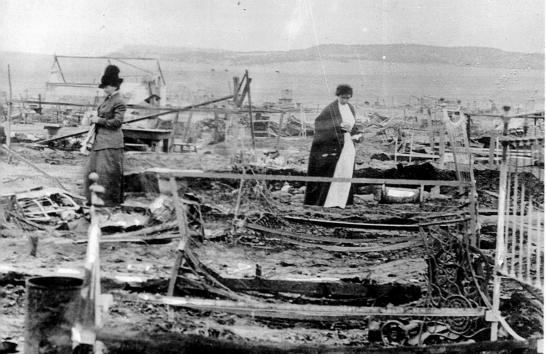

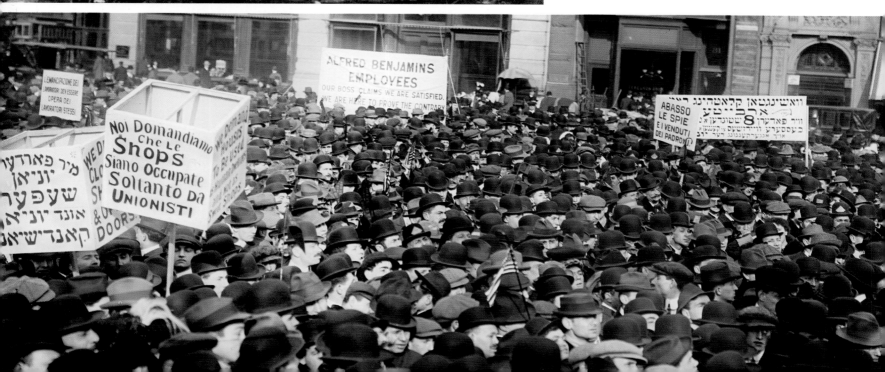

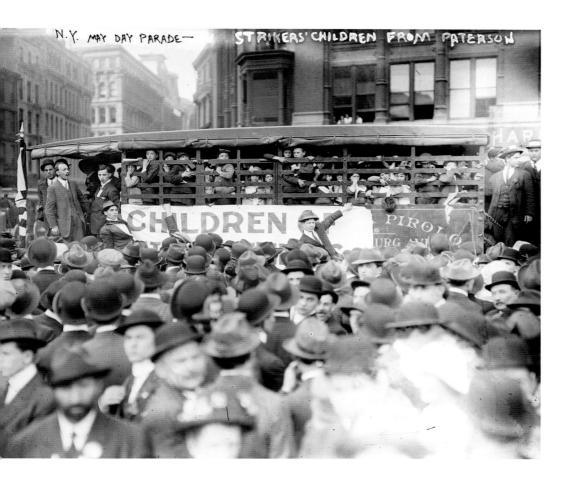

Solidarity and Education.

During the silk industry strike in Paterson, New Jersey, which lasted more than six months, trade unions developed solidarity networks. They adopted a tactic tested in Italy that enabled workers to keep up the violent struggle with owners and the authorities. In 1908, in the Parma countryside, during a strike of day laborers, children were sent out to live with families of workers in other regions; the children of Paterson, many of them from Italian families, were sent to other cities in the Northeast, including New York (left).

Trade unions and radical parties put a lot of effort into the education of workers through the publication of magazines, books, and almanacs. They were printed by publishers like the *Libreria Editrice dei Lavoratori Industriali Del Mondo* in Brooklyn, in the languages spoken by their members. Many unionized companies also had a reader: an employee who read aloud from books and magazines, usually in the language spoken by most of his colleagues. In this photo (below), taken in a cigar factory in Tampa, the language could have been Spanish or Italian.

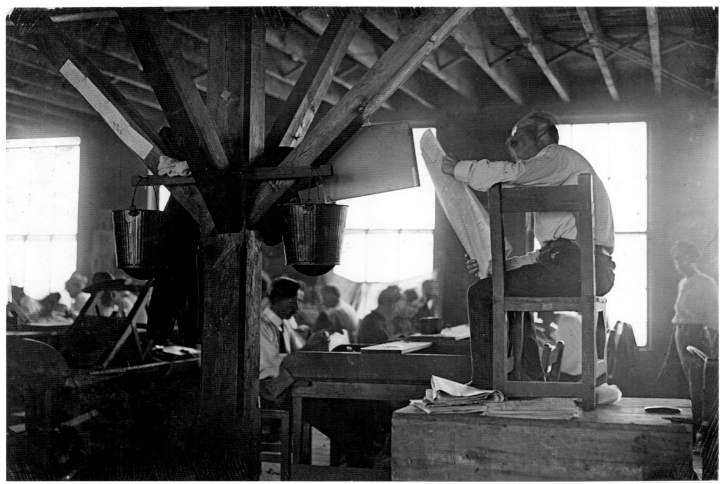

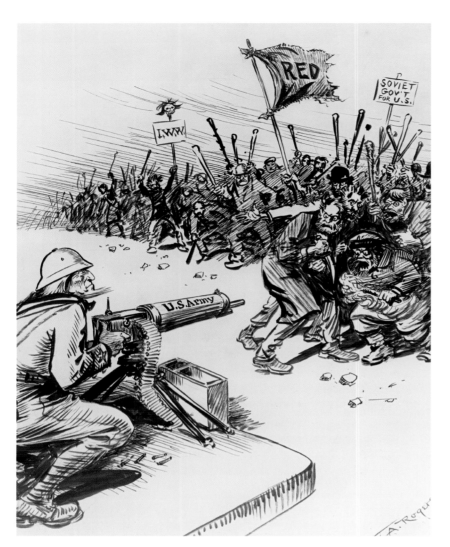

America Under Attack

At the turn of the 20th century, the Red Scare hit America. The country felt besieged by radicals, socialists and unionists (left). Attacks carried out by Italian anarchists frightened the whole world: in Italy, King Umberto I was killed in 1900 by Gaetano Bresci, who had lived in Paterson, New Jersey; in the U.S., President William McKinley was assassinated in 1901 by Leon Czolgosz, a Pole who was also from Paterson.

Joseph Caruso, Joseph Ettor, and Arturo Giovannitti (below) were trade unionists arrested on false charges for murdering the protester Anna LoPizzo during the Lawrence textile strike of 1912. "Smiling Joe" Ettor was one of the promoters of the strike. According to a Chicago newspaper, *The Day Book* of July 1912, it was "chiefly as a result of his efforts [that] 275,000 New England textile mill workers are getting better wages. He has added $11,000,000 a year to the pay envelopes of the poorest paid workers in the country. The mill owners had Joe put in jail to get him out of the way." Arturo Giovannitti was also a playwright. On October 10, 1918 his play *Come era nel principio (Tenebre rosse)*— "At the Beginning (Red Shadows)"—premiered in New York's "People's Theatre," starring Mimi Aguglia, who later became a Hollywood actress. Aguglia appeared in *The Rose Tattoo*, with Anna Magnani and Burt Lancaster, a movie depicting an Italian community in Louisiana.

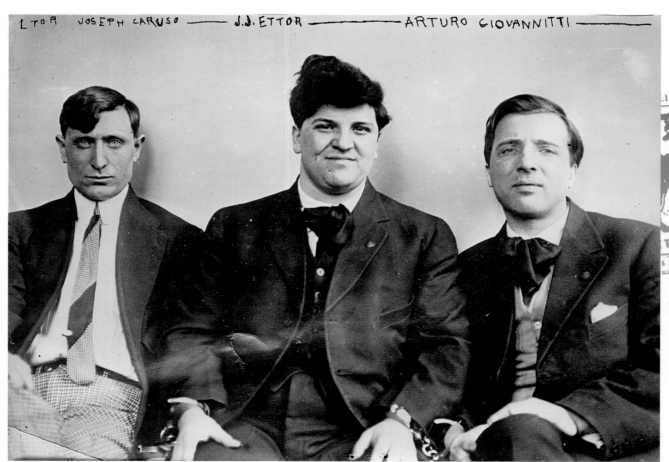

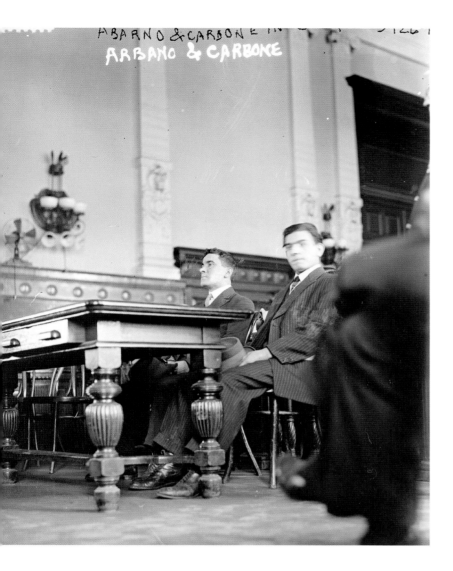

The Red Scare

Many countries feared the spread of the political ideals that led to the Bolshevik Revolution in Russia, including the U.S., where laws against radicals and anarchists were tightened up after World War I. In that same period, Italian anarchists were often involved in attacks in the U.S. The first was foiled by the Bomb Squad of the NYPD that captured Frank Arbano and Carmine Carbone (left, during the trial) while hiding a bomb in St. Patrick's Cathedral. The bloodiest act of terrorism occurred on September 16, 1920, when a bomb exploded in the heart of Wall Street, killing thirty-eight people. There were no arrests but investigators believed that it had been carried out by a group of anarchists from Romagna acting in retaliation for the arrest of Sacco and Vanzetti, which had occurred just a few days before. According to the Department of Justice, in 1920 out of a total of 222 radical newspapers published in languages other than English, twenty-seven were written in Italian (second only to the thirty-five written in Hebrew or Yiddish). More recent statistics show that there were nearly two hundred radical Italian publications in North America. One of the longest running newspapers was *L'adunata dei refrattari (The Call of the 'Refractaires')*: it was published in New York, and directed from 1927 to 1972 by Max Sartin—the alias of Raffaele Schiavina, one of the founders of Arditi del Popolo, an anti-Fascist armed movement established in Italy in 1921. Even *La Domenica Illustrata*, the usually moderate Italian magazine published in New York, was affected by the mood. The issue dedicated to the 1921 Worker's Day is illustrated by a young man armed with a baseball bat standing on a red background (below).

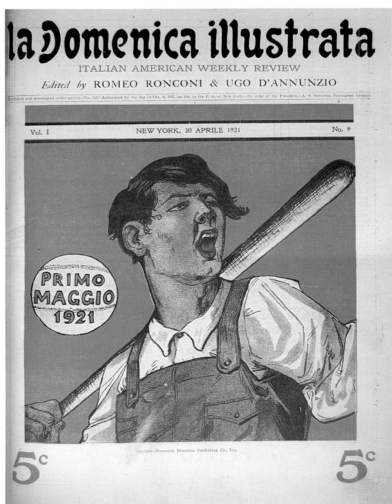

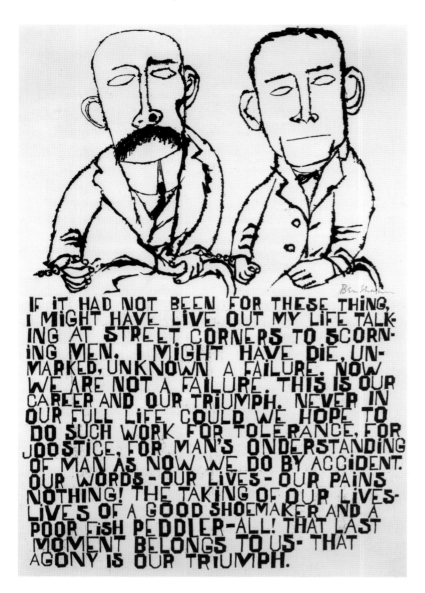

IF IT HAD NOT BEEN FOR THESE THING, I MIGHT HAVE LIVE OUT MY LIFE TALKING AT STREET CORNERS TO SCORNING MEN. I MIGHT HAVE DIE, UNMARKED, UNKNOWN, A FAILURE. NOW WE ARE NOT A FAILURE. THIS IS OUR CAREER AND OUR TRIUMPH. NEVER IN OUR FULL LIFE COULD WE HOPE TO DO SUCH WORK FOR TOLERANCE, FOR JOOSTICE, FOR MAN'S ONDERSTANDING OF MAN AS NOW WE DO BY ACCIDENT. OUR WORDS – OUR LIVES – OUR PAINS NOTHING! THE TAKING OF OUR LIVES – LIVES OF A GOOD SHOEMAKER AND A POOR FISH PEDDLER – ALL! THAT LAST MOMENT BELONGS TO US – THAT AGONY IS OUR TRIUMPH.

Sacco and Vanzetti

In 1921 the anarchists Nicola Sacco and Bartolomeo Vanzetti (left, portrayed by Ben Shahn in *The Passion of Sacco and Vanzetti*), were accused of robbery and murder. Despite conflicting evidence and testimony, they were sentenced to death. After the verdict, significant protests rose in the Italian community, not only among fellow believers: the entire ethnic press and associations such as the Sons of Italy took a stand against it. In Italy, even the Fascist government lobbied for a revision of the process. In April 1927, Mussolini himself wrote to his ambassador in Washington D.C.: "Plead for Sacco and Vanzetti to U.S. President."

Despite the protests, the sentence was enforced and on August 23, 1927, the *New York Times* chronicled the execution. The newspaper described the huge crowd of supporters (below left) and the fact that "Charlestown prison (below right) was armed and garrisoned as if to withstand a siege. Machine guns, gas and tear bombs, not to mention pistols and riot guns, constituted the armament and to man it were five hundred patrolmen, detectives and State constables besides the usual prison guard." The article went on to quote the last words of the two men: Sacco yelled, "Long live anarchy," while "Vanzetti spoke in English. His voice was calm throughout. There was not the slightest tremor or quaver. Then, addressing the witnesses, he said: 'I wish to tell you that I am innocent, and that I never committed any crime but sometimes some sin'. Then he spoke his last words: 'I wish to forgive some people for what they are now doing to me.'"

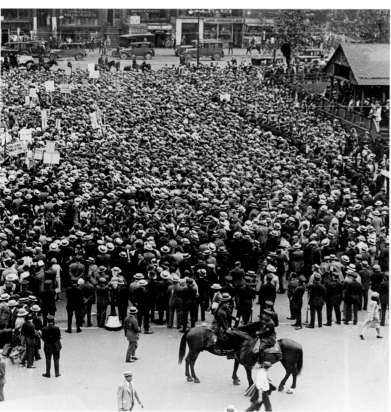

May 1º Sweet Easter of the Workers.

Dear Friend Mrs. Jack:

It is quiet long that I have wrote an answer to your antecedent letter. I kept it with the hope of an opportunity to delivered it. Really I have expected to see Mr. Eh- before than now— while I am yet waiting for me.

To day is the day of the revolutionists and of the workers. The mail has brought me your note and the two beautiful post-cards- which remember to me the earth's gardens, and the Spring in bloom, and the song of the unforgettable Gori:

"Give flowers to the rebels who failed
With the glance turned to the aurora,
To the gagliard that struggles and works (lavora)
To the vegent poet that dies (be Gory himself.

Also a letter from our good Mrs Evans- a letter full of hope, gladness, obtimism and life - has reach me together with your one.

And reading of Mr. Jack's improving, I was shaked by a fremit of joy. It is a great fiest of May's greeting, such a news

A word of greeting and of life.
B. V.

Mrs
Cherise J. Jack
East Walpoll
Mass.

Greetings, good wishes and hearty regards to you, from your friend.

Bartolomeo Vanzetti.

regards to you and all of yours dear

Always your sincere friend

Nicola Sacco

Nicola and Bart: The Cerise C. Jack Papers

The Library of Congress holds two major collections that reconstruct events related to the Italian American labor struggles and political subversion. The "Anarchism Collection" holds approximately 1,400 books, magazines and pamphlets published in the United States between 1850 and 1970. Many are in Italian, including the 1913 drama *La patria dei poveri* (*The Homeland of the Poor*); its frontispiece states that it was "for sale by the author in Locorotondo (Bari) and by Catello Elvira . . . [in] New York." *Rivoluzione e controrivoluzione: manifesto dei militanti e dei gruppi anarchici riuniti del Nordamerica* (*Revolution and Counterrevolution: Manifesto of Activists and Anarchist Groups in North America*) was published in 1944 in Brooklyn.

More personal recollections are contained in the "Cerise Jack Papers," comprising letters and postcards sent by Sacco and Vanzetti to one of their supporters, Cerise C. Jack, while they were incarcerated in Charlestown State Prison in Boston, Massachusetts. This page shows excerpts of letters with their signatures; the first page of a letter sent on May 1 (top left), and a postcard depicting the birthplace of Vanzetti, Villafalletto in the province of Cuneo (top right).

Business Ventures

From Peddlers to Entrepreneurs

Who created Mr. Peanut and founded the Planters Peanut Company? Italian immigrants may not come first to mind, but in fact, the business was established by Amedeo Obici and Mario Peruzzi in 1887 in Pennsylvania. Some forty years later, with four large factories, Planters was earning $12 million a year.

Not every Italian immigrant or American-born Italian had such spectacular results, but many of them moved from being workers and pushcart peddlers to become small, independent business owners. In New York and San Francisco in the 1880s, there were enough Italian businessmen to create the first two Italian Chambers of Commerce in the United States. For many, being self-employed was a cherished goal. In 1894, journalist Adolfo Rossi also credited the American attitude of moving up, contrasted with Italians unambitiously following in their father's footsteps: "This difference of ideas . . . is one of the secrets of North American prosperity."

With skills brought from Italy, a talent for entrepreneurship, and opportunities in the American market, they were able to expand their presence in the building, fishing, and winemaking industries; take over barbershops, arts and crafts workshops, and tailoring businesses; and fill the growing demand for Italian foods as grocers, local producers, and importers. In the 1930s, Ettore Boiardi, a chef in Cleveland, Ohio, carried this one step further, selling his own sauce and pasta in cans under the name of Chef Boyardee; it is now the best-known brand of pre-packaged Italian dinners.

An even earlier business success story is that of Amadeo Pietro (A.P.) Giannini. In 1904, he opened a store-front bank in the Italian North Beach section of San Francisco. Immediately after the 1906 earthquake, he began granting loans to residents to rebuild. Later, in 1919, Giannini pioneered the system of branch banking. He financed the Golden Gate Bridge, and the early years of the aerospace, agricultural, and film industries (including the making of *The Ten Commandments* by Cecil B. DeMille). Originally called the Bank of Italy, in 1928 its name changed to Bank of America, the largest bank in the country.

Generoso Pope was the first Italian American millionaire. He emigrated from Italy in 1906. One of his first jobs was to bring water

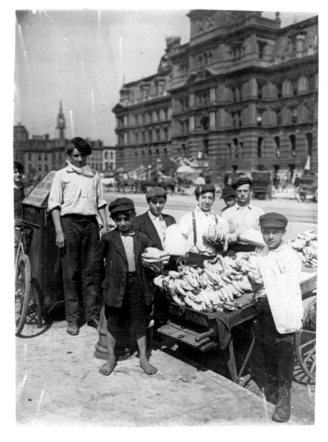

Expanding the Food Business

Italian immigrants became important players in the food business in several cities. In New Orleans, Sicilians dominated the sale of fruit and vegetables; in San Francisco the sale and making of wines were added to these products. In eastern cities, Italian Americans mainly started as peddlers such as the fruit vendors in Indianapolis (above). They then set up shops like the Italian bakery on New York's 1st Avenue between 10th and 14th Streets (facing page, top). Delmonico's, a restaurant founded in 1827, became the best-known Italian restaurant in the 19th century. The Delmonico brothers (above left, the portrait of Charles Delmonico) actually came from Ticino, in the Italian canton of Switzerland. When the Italian market in America became large enough, many industrial pasta manufacturing companies, including LaRosa, were established. In this LaRosa ad (facing page, bottom left), actor Tom Bosley plays Fiorello LaGuardia eating a huge dish of spaghetti with meatballs.

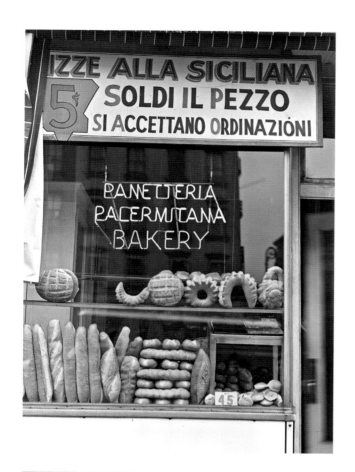

to construction workers; he earned $3.00 a week. In 1925 he bought the Colonial Sand and Stone Company, where he had also worked. It became the largest supplier of building materials in the United States for projects including the Empire State Building and the first Yankee Stadium. In 1928 he bought the Italian-language newspaper *Il Progresso Italo Americano*, and later several other ethnic Italian newspapers. One he turned into the *National Enquirer*, which his son Generoso, Jr. later ran. His other son, Fortunato, took over *Il Progresso*.

The roster of businesses begun or run by Italian Americans is diverse. One of the earlier ones was Radio Flyer, Inc., begun in 1917, which produced the Radio Flyer red wagon invented by immigrant Antonio Pasin. Anthony Rossi started Tropicana as a fruit packing company in 1947, and eight years later developed a process for pasteurizing orange juice so that the juice itself (not concentrate) could be sold in cartons. Leonardo Riggio transformed Barnes & Noble into the largest bookstore chain in the United States.

Lee (born "Lido") Iacocca (below) has demonstrated extraordinary skills, resilience, and fortitude in business and management. He became president of the Ford Motor Company in 1970, launching the popular models Mustang and Pinto. Eight years later he took over the ailing Chrysler Corporation, which was near bankruptcy. He rescued the company, in part through his personal television ads, which made his face instantly recognizable to Americans: an image of an Italian American very different from the one Americans held one hundred years ago.

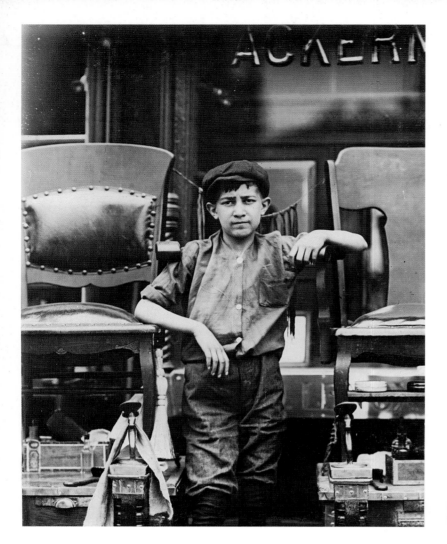

Sciuscià and Organ Grinders

The organ grinder (facing page, bottom) was one of the most common representations of Italians. According to Carlo Andrea Dondero, a Ligurian who emigrated in 1855, Italian organ grinders had been common since the 19th century. In New York, he wrote, "a parmesan raised in France started another industry, that of organ grinders, with or without monkey." Less common were the *zampognari* (bag pipers), such as the one portrayed by Joseph Stella (bottom left).

Other open-air activities employed large numbers of Italians including the shoe shiners, called *sciuscià* in Italian, such as Frank Villanello in New York (left), and fruit and vegetable peddlers like S. Romeo, selling tomatoes from his cart in Boston's market (facing page, top). Other people improvised as street vendors to escape poverty, including young Marie Costa, selling handmade baskets on the streets of Cincinnati (below). Others offered small services, like picking up rags, bottles, and wood, as reported by Marie Hall-Ets in her book *Rosa, the Life of an Italian Immigrant* (1970): "When we had nothing to burn Domenico and Visella went to pick up those blocks of wood that fell off the pavement of the streets. . . . My lil Domenico, he was 6 or 7 years, he was getting 5 cents a week from a lady to carry the coal and wood. Every day, carrying two buckets of coal, large buckets, up to the third floor, splitting the wood and also carried that."

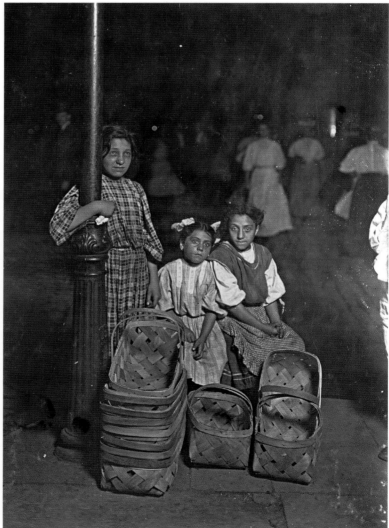

186

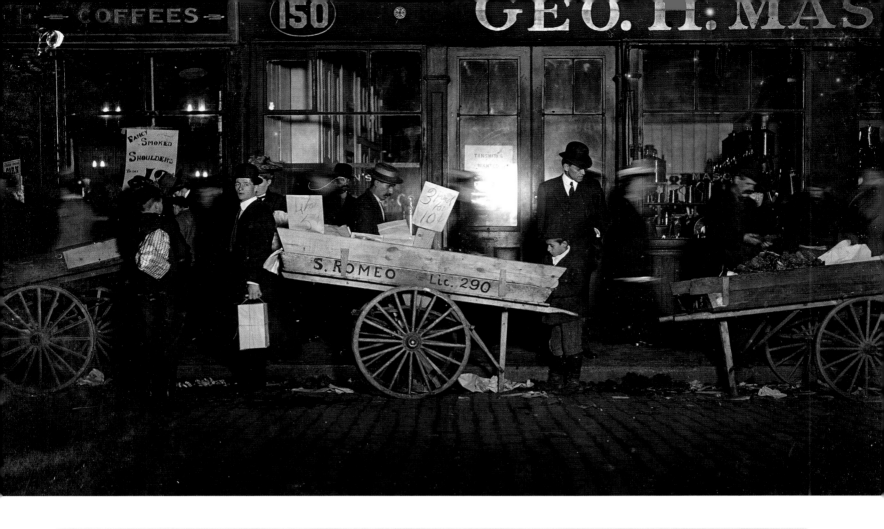

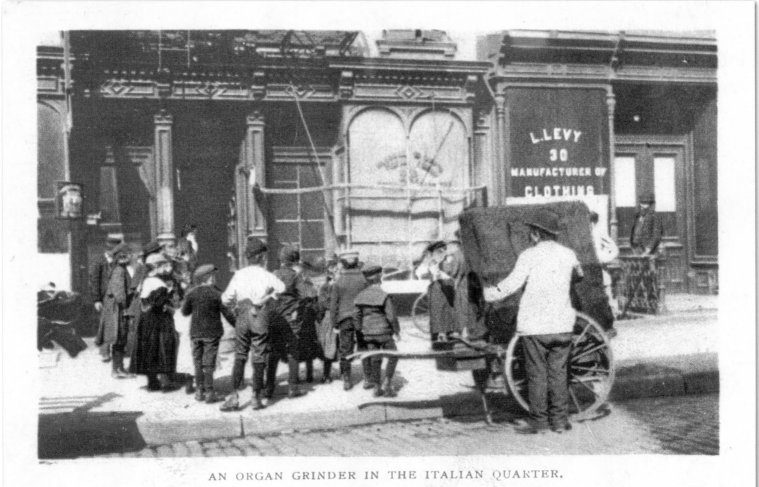

AN ORGAN GRINDER IN THE ITALIAN QUARTER.

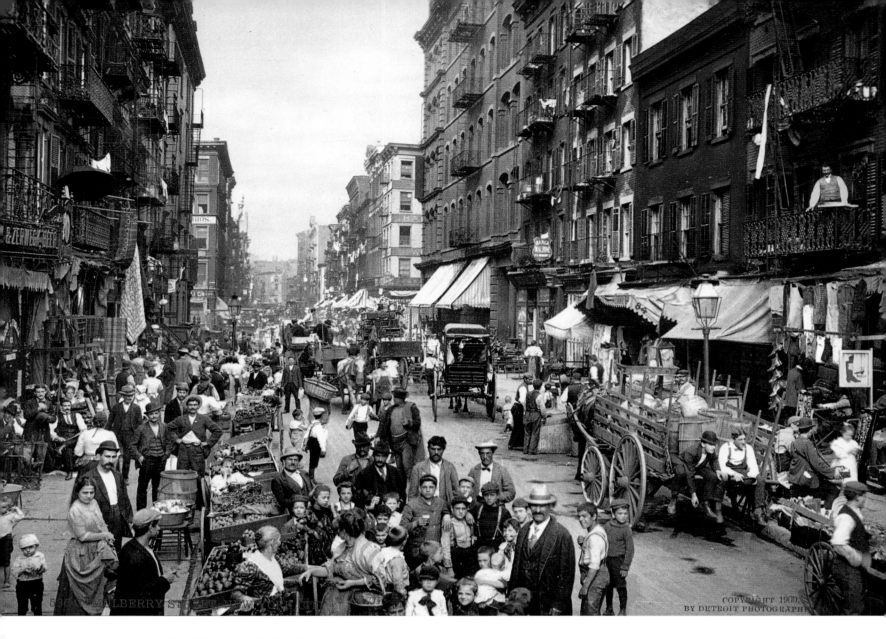

Ethnic Markets

In Little Italies with their large number of Italians, shopkeepers and street vendors could specialize in products intended only for the ethnic market. This was the case in the French Market in New Orleans (left, in a drawing by Elizabeth Lentz), largely run by Sicilian shopkeepers and on Mulberry Street in New York City, shown here (top) on a market day so crowded by stalls and people that they obstructed city traffic. Amy Bernardy described a typical scene: "The fruit and vegetable shops displaying their wares into the street, perhaps a little rotten by frost or parched by dusty air, and the price written in American cents does not mean that around you, you will not hear tittle-tattle in the dialects of Avellino or Termini Imerese."

Explorers, Emigrants, Citizens

Fulton Fish Market

Another typical Italian market was the Fulton Fish Market in the Bronx. Both the product—fresh fish—and the workers were very Italian. The drawing (below), by Antonio Frasconi, shows the headquarters of Sam Lenza Inc.—*lenza* is the Italian word for fishing line—specializing in lobster. Fulton Market had been visited by Italians since the mid-19th century: the author of *Da Biella a S. Francisco di California* (1882) wrote: "The first thing I wanted to see was the market across Fulton street. There you can see wooden sheds, huts, shacks, and you buy fish, game and meat. In the summer, when the heat is unbearable, just like winter's cold, it is still very cool because of the large amount of ice being deployed, and there is a true flotilla continuously bringing goods to the market and to citizens." A few decades later, in 1939, mayor Fiorello LaGuardia visited Fulton Market (right top), and in 1962, a photographer for the *New York World Telegram & Sun*, Dick DeMarsico portrayed fishermen Louis DeMarco and Michael Tolento dancing the twist with a freshly caught fish (right bottom).

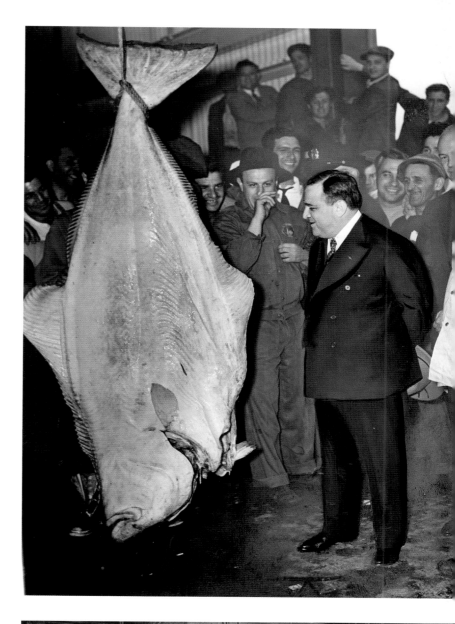

A SICILIAN CAFÉ IN NEW YORK.—Drawn by W. A. Rogers.—[See Page 875.]

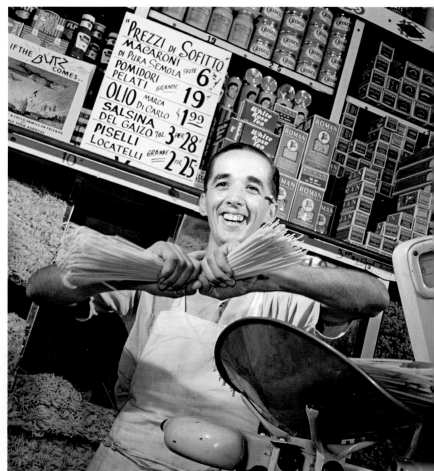

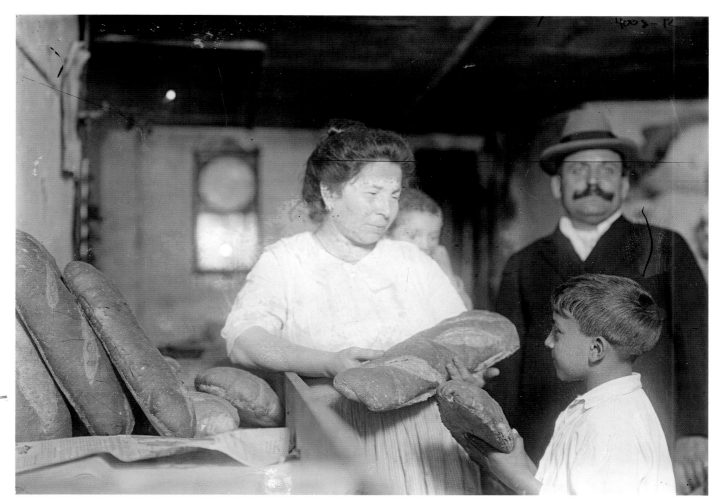

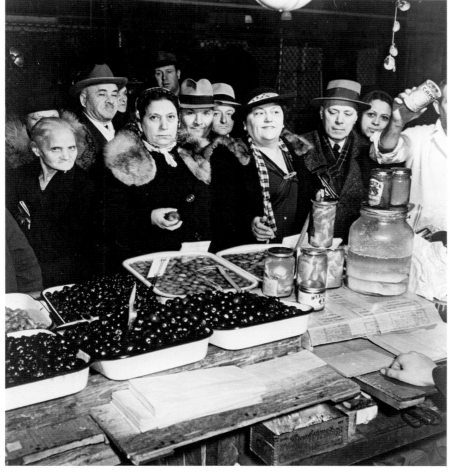

Coffee and Bread

Long before espresso became fashionable in America, Italian bars and cafés were a gathering place for emigrants. In the illustration "A Sicilian Cafe in New York," which appeared in 1889 in *Harper's Weekly*, a beautiful girl in traditional costume (and bare feet . . .) is serving at the table (facing page, top). In the bar on MacDougal Street in New York, photographed by Marjory Collins in 1942 (facing page, below left), customers drank a good cup of espresso made by the majestic coffee machine dominating the counter that, according to the original caption, "costs $1,000."

Bread was among the most common Italian products: it was cheap and it was the staple food of the lower classes since the time when they lived in Italy. A child is shown buying a loaf of bread in an Italian bakery in New York's East Side (above).

Food stores were a common meeting place for Italians. Italian physician Angelo Mosso wrote in his book *Vita moderna degli italiani*: "When I was in America and I felt homesick, I always knew where to find someone to exchange a word in Italian: I stopped in a grocery." Mosso could have entered shops like Charles Ruggiero's who, in 1942, "wishes the handful of spaghetti he is breaking were Mussolini's neck" (facing page, bottom right); or the one on 1st Avenue and 10th Street, with Italian and Jewish customers crowding near the counter (left).

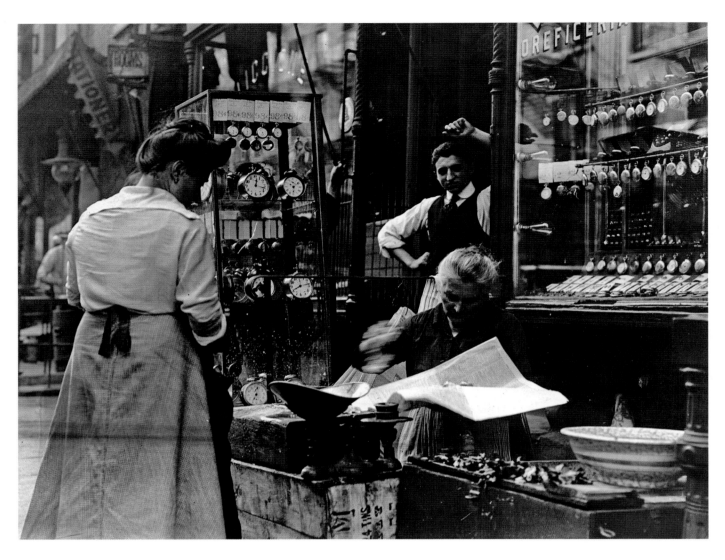

Shopkeepers and Barbers

Adolfo Rossi wrote in 1894: "In Italy, the son of a public officer often follows his father's steps, happy to earn four or five shillings a day and live meagerly rather than learn a manual job, rather than to 'stoop' and become a shopkeeper. In the United States the reverse is true, and this difference of ideas and things is one of the secrets of North American prosperity." Emigrants adapted well to this attitude. They worked in businesses other than food like this Italian goldsmith on Mott Street, in New York (above). Italian barbers were very common and renowned: in 1900 one Italian male immigrant in every twenty-five practiced this profession. In Boston, Frank De-Natale, a twelve-year-old barber, lathers and shaves customers in his father's shop (right).

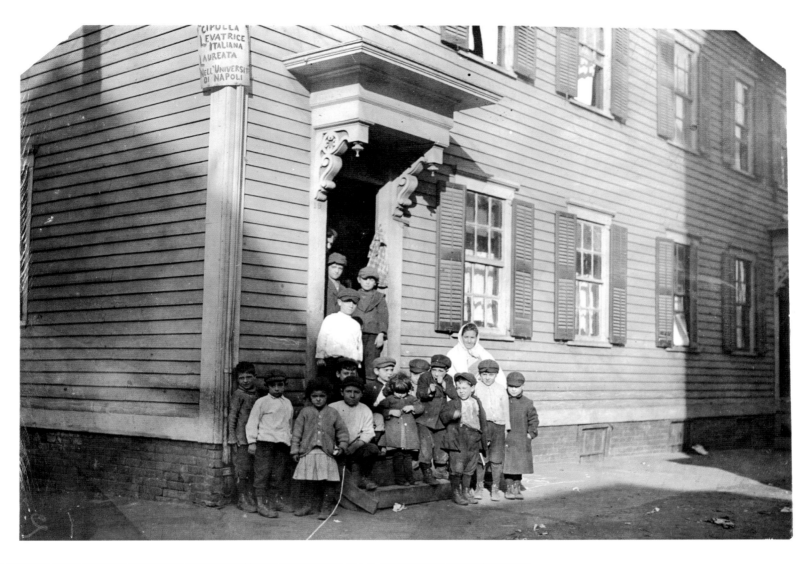

Working for the Community

In Italian communities, some activities thrived only with Italian customers. In the photograph above, on the edge of the frame, a sign advertises the services of signora "Cipolla, Italian midwife graduated from the University of Naples." Yet even some Italians maligned the credentials of Italian immigrants. "A veterinarian, in America becomes a first-class surgeon and opens a studio full of fake certificates and degrees," wrote Adolfo Rossi in 1894 "The primary school teacher becomes an improvised professor, and the priest or monk escaped from the old continent after committing some ugly sin, disguises himself as a martyr; and every former corporal or sergeant, pretends to be an officer or a fencing master, a choir singer jumps out and becomes a tenor and so on."

One job was particularly vital to the immigrants. The agency of Luigi Fugazy on Bleeker Street (left), in New York, booked tickets for passengers. Here immigrants bought tickets to send to relatives in Italy once they had enough money to bring them over.

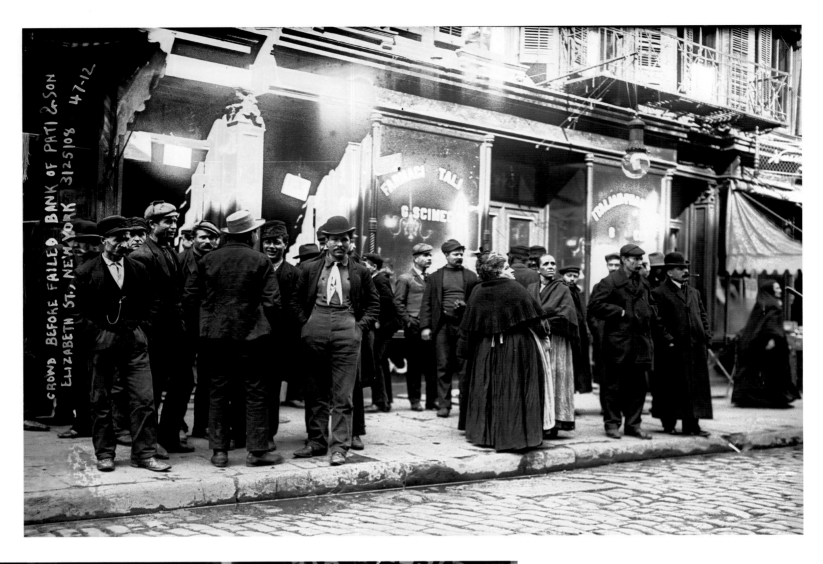

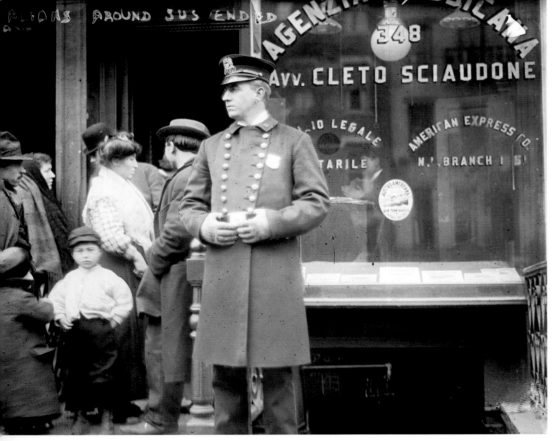

Banchisti

These images show the closure of two Italian banks and the desperation of their investors: Pati & Son on Elizabeth St., New York (above), and Cleto Sciaudone's Agenzia Marsicana (left). The *New York Herald* declared that the latter would be reopened: "Cleto Sciaudone, who could not be found last Tuesday . . . , has returned to business at that address. Mr. Sciaudone announced yesterday . . . that he had been taking a rest from his arduous duties of the holidays, and that his business is in good condition."

Bank failure was a recurrent problem, according to Italian travelers: "Sometimes it happens that one of these would-be bankers, who swarm in America and elsewhere, flees, bringing with him the hard-earned savings entrusted to him by Italian emigrants," wrote Federico Garlanda in *La terza Italia, lettere di uno Yankee*. "Ask an emigrant where he keeps his money: *u paesano* [his fellow villager] keeps it, trying to persuade him to do otherwise is impossible" Amy Bernardy wrote in *America Vissuta* "When *u paesano* escapes or fails, the victim cries, curses or resigns to it, according to his character, and then, back to work and save. And he gives his money to another *paesano*."

Explorers, Emigrants, Citizens

The Bank of America

The life of Amadeo Pietro Giannini is the opposite of those of *banchisti*—the name given to small bankers—swarming in Little Italy. *Time* magazine had Giannini on its covers twice (in 1928 and 1946) reminding readers of the time when this small Italian banker (he had founded the Bank of Italy in 1904) turned his life and that of his adopted city around. Immediately after the terrible 1906 earthquake that destroyed much of San Francisco "sifting through the ruins [of his bank], he discreetly loaded $2 million in gold, coins and securities onto the wagon bed, covered the bank's resources with a layer of vegetables and headed home. In the days after the disaster, the man known as A.P. broke ranks with his fellow bankers, many of whom wanted area banks to remain shut to sort out the damage. Giannini quickly set up shop on the docks near San Francisco's North Beach. With a wooden plank straddling two barrels for a desk, he began to extend credit 'on a face and a signature' to small businesses and individuals in need of money to rebuild their lives. His actions spurred the city's redevelopment" and he went on to become one of the most important bankers in the U.S. with his Bank of America (right).

The Prominenti

The *prominenti* formed the upper-middle-class bourgeoisie and acted as mediators between the Italian community and the rest of American society. Many times they were the substitute for the Italian diplomatic corps, which, especially in its consulates, often was not able to interpret and defend the emigrant's interests.

Some *prominenti* took on very important roles and took on an incredible number of functions and responsibilities. For example, Luigi V. Fugazy served as banker, travel and insurance agent, lawyer, and mediator. He was also known for his role as an intermediary between Tammany Hall, the dominant New York political machine, and Italian voters. In 1887 he established *La Fraterna*, the city's largest mutual aid society, with more than two thousand members. By 1900 he was the president of some fifty Italian associations and played an important part in 145 more. One of the most famous Italian *prominenti* was Generoso Pope, shown presenting a check for $3,000 for parochial schools to Cardinal Spellman in 1948 (left). The biography of Pope—owner of *Il Progresso Italo Americano* from 1928—is somewhat controversial, in particular for his support of Mussolini. However, from the moment Italy declared war on the United States, Pope contributed his considerable means to the American war effort.

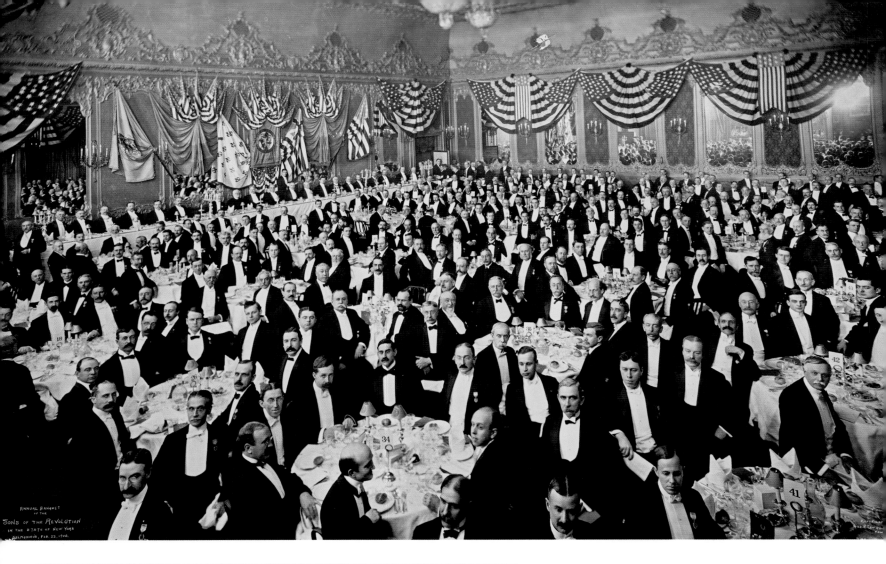

Eating Italian

Italian restaurants open to American customers were very rare. Among these the best known was Delmonico's, a lavish New York restaurant, where customers were greeted by a colonnade that was said to come from the ruins of Pompeii. Some of Delmonico's historic receptions included one for the Prince of Wales in 1860 and a reception given for the Sons of the Revolution in 1906 (above). Adolfo Rossi, before becoming a journalist of *Il Progresso Italo Americano*, had to start from the bottom. He wrote: "After ten days I had to be content, in the absence of anything better, to find a job as a busboy in the sophisticated Caffè Delmonico. It was a life even more difficult than when I lived in Brunswick. Every morning I had to help clean the large mirrors covering the walls, and throughout the day I had to provide the rooms with linen and silverware, set the table and clear, in short work twelve hours without a minute's rest."

A much humbler restaurant in San Francisco's North Beach (left) shows that Italian cuisine could be paired with an American classic like the diner counter. This photograph was taken during a blackout right after Pearl Harbor, a time when Italians were not popular, since Mussolini had just declared war on the U.S.

Explorers, Emigrants, Citizens

The Food Industry

Italian immigrants had to adapt to American eating habits: meat, eggs, milk and cheese had been almost absent in their diet when they were peasants in the South of Italy. For many, eating pasta as a staple food started in the United States, where Italians became *mangiamaccheroni* (macaroni eaters). As a consequence, a food industry specializing in Italian products thrived. The Atlantic Macaroni Company of Long Island marketed its products under the brand name Caruso. This photograph (top left) shows spaghetti during its drying phase.

For a long time typical Italian food was intended solely for the ethnic market. Chef Boyardee was among the first to break this barrier by making products like pizza popular for everyone, thanks to ready-made packaging (an advertisement published in *Look* magazine is shown top right).

Italian Americans were even successful in the candy business. Ghirardelli Chocolate was founded in 1852 by Domenico Ghirardelli. After stopping in Uruguay, he arrived in California from Rapallo (Liguria) in 1849 in search of gold, and ended up creating a brand so famous that the city of San Francisco dedicated a statue to him. In Times Square, New York, the statue of World War I hero Francis P. Duffy stands in front of an advertisement for Planter's Peanuts (bottom), the company founded in 1906 by Amedeo Obici and Mario Peruzzi in Pennsylvania.

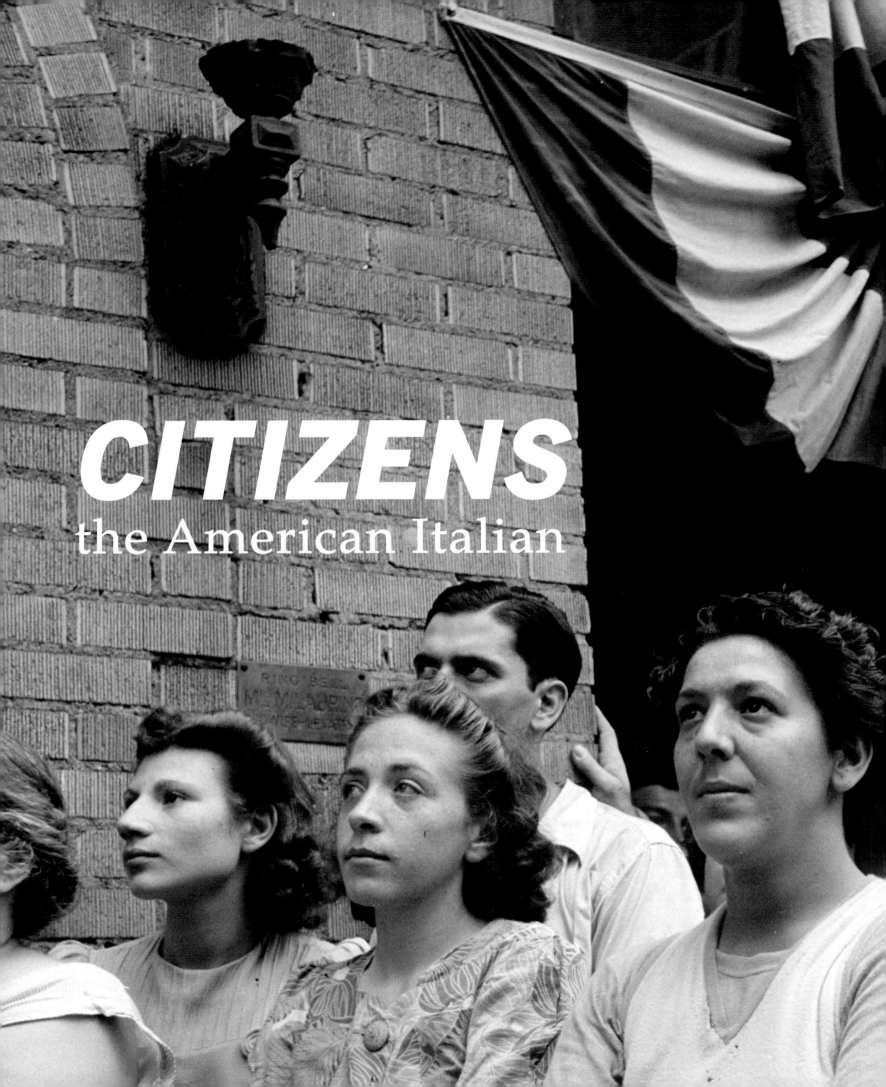

CITIZENS
the American Italian

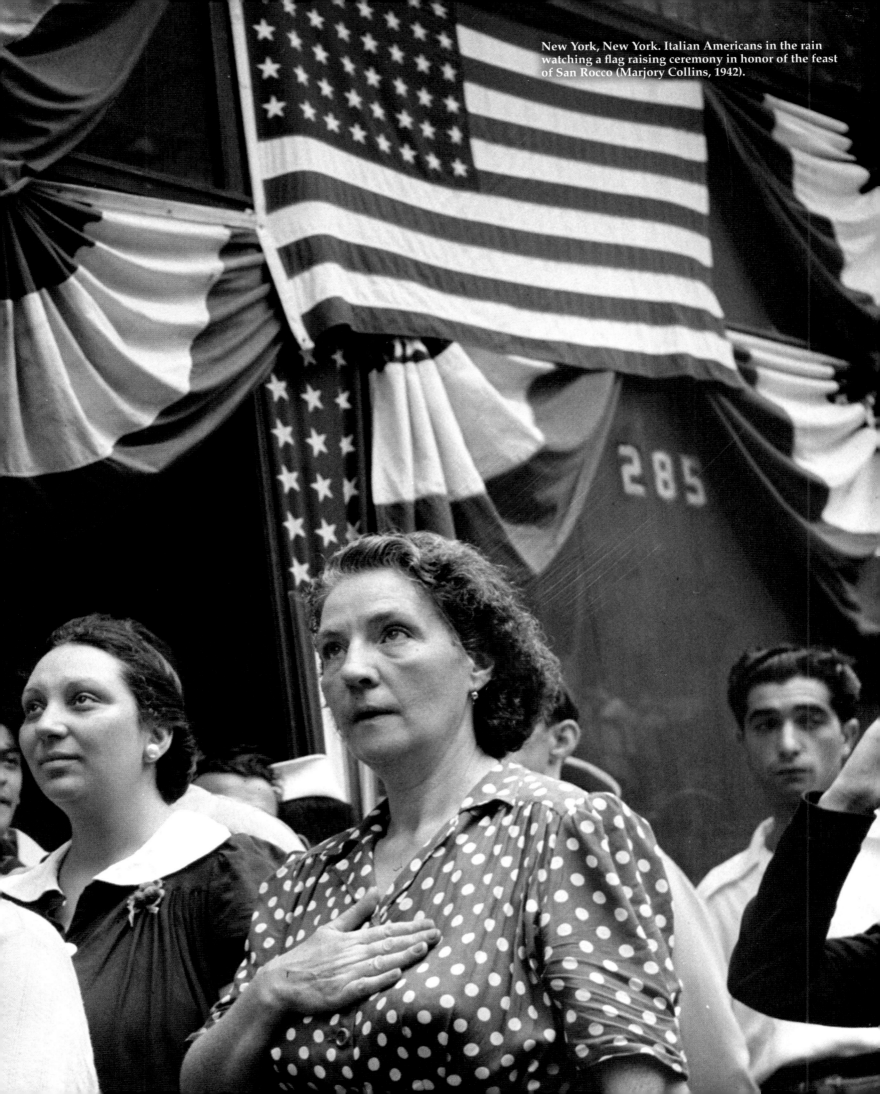

New York, New York. Italian Americans in the rain watching a flag raising ceremony in honor of the feast of San Rocco (Marjory Collins, 1942).

Italian American, American Italian

Antonio Canovi

It is a common opinion that Italians put family before politics, preferring private matters over public affairs. Surveys promoted at the beginning of the 20th century supported this belief. Among the nationalities that made up the "new immigration"—as it was defined by the Immigration Research Commission in 1911—Italians were the most numerous, but had the lowest rates of citizenship. At the time, only 17.7 percent of people born in Italy had acquired American citizenship; in 1930 a good half still maintained the Italian passport. These figures lead to two quite distinct readings: it could mean both an intimate cultural resistance to becoming American, and a substantial indifference to their status as citizens. At the same time, American politics began to pay attention to Italians, both first and second generation, beginning what could hardly be defined as virtuous practices. In St. Louis, in 1906, vote-buying of Italians became so blatant that it led to restrictions on the transfer of citizenship. But one element cannot be disregarded: those same immigrants were not entitled to vote in their motherland.

In the Italian electoral system, the threshold of property requirements for voting was lowered in 1882, but the constraint of literacy remained in a country where four-fifths of the population were illiterate in many regions. This is one reason why conquering universal adult male suffrage (1912) was not enough. In 1921, the percentage of voter participation remained under 50 percent in the South, reaching two-thirds in the regions of central and Northern Italy. Italians arrived in America with very little practice in voting. They were also penalized because it took a long time before they were recognized as a strong pressure group. One reason was their being Catholic, a characteristic that was already perceived as a distinction of an older immigrant group: the Irish.

As a corollary, the weak interest Italians showed in politics meant that they adapted to the existing balances and methods, be it local electoral machines or political leanings of employers. We also must not forget the presence of militant minorities, from anti-clerical republicans to anarchists (who did not vote) and socialists, who were more visible in the workplace than in the political arena. Italians, in 1915, provided just 1 percent of the electoral roll of the Socialist Party in New York, the undisputed capital of Italian immigration (800,000 people in 1920). Numbers in the press printed in Italian are more significant. In 1919, there were 190 publications, with about 800,000 copies in total: from *Il Progresso Italo-Americano*, founded in 1880 by Carlo Barsotti (a patriotic-nationalist daily newspaper reaching as high as 200,000 copies), to *L'Eco d'Italia*, founded in 1894 in New York by a Mazzini follower exiled in the U.S. "Subversive" periodicals had smaller circulations, led by *Il Proletario*, directed by Giacinto Menotti Serrati (7,800 copies sold in 1916).

But it is nevertheless true that many Italian workers, who were illiterate, were readier to unionize than to follow literary propaganda. Italian union organizers had important roles in the textile industry (International Ladies Garment Workers' Union, Amalgamated Clothing Workers of America) and the mining industries (United Mine Workers of America). We find them among the agitators of the great strikes promoted by the Industrial Workers of the World in Lawrence (Massachusetts), Paterson (New Jersey), Pueblo (Colorado), Cabin Creek (West Virginia) and in the mines of Minnesota.

In some cases, Italians linked their unions to specific professional crafts: *Società degli stuccatori e decoratori italiani* (Society of Italian plasterers and decorators) in Chicago, *Società dei sarti italiani* (Society of Italian tailors) in Philadelphia. In 1920, an all-Italian Chamber of Labor appeared in New York City. What did it mean for Italian workers to get organized? The racial prejudice expressed within the largest union of the time—the American Federation of Labor—surely weighed against them. Thus, union mobilization was one of the methods through which Italians expressed their right of citizenship. Italian scholar Alessandro Portelli

wrote that in the 1912 strike in Lawrence the crucial weapon for the strikers (led among others by an elite of Italian organizers, Angelo Rocco, Joseph Ettor, Arturo Giovannitti, and Carlo Tresca) was their decision to send out their children to a network of supporters around the country. The same tactic had already been used in 1907 in Italy during a strike in the steelworks in Terni (Umbria), and was again employed at different latitudes. Italian immigrants, among other things, carried in their bags of experience a widespread readiness for solidarity, commonly carried out through recreational clubs, popular universities, music bands, amateur dramatic societies, and mutual aid societies.

As immigrants, how much were they allowed to express their values and preferences in the new American society? An emblematic episode—recollected by the scholar Elisabetta Vezzosi—was the reenactment in 1908 of the Race of the Saints among miners of Jessup, Pennsylvania. The feast was originally from Gubbio (Umbria) and was known as *Corsa dei Ceri*. In this Pennsylvania town, the Italian community was mainly from Umbria, with a strong presence of emigrants from Gubbio—who in 1910 also founded a *Casa del Popolo* (House of the People)—and from the Apennine area near Nocera Umbra, Gualdo Tadino, and Sigillino. Celebrating Gubbio's most typical feast on May 15, however, was not easy. In the first place they had to convince mining companies, resolutely opposed to the idea of an additional day of festivities. Then they had to overcome any competition between miners of different ethnicities: after all, each one was the bearer of ritual traditions and each one thought that his or hers were inalienable. By contrast, the philosophy of the melting pot accelerated the process of assimilation: immigrants could, and should, participate in the Fourth of July holiday, celebrating, according to Vezzosi, their Americanization Day by observing Independence Day. Finally, against all expectations, the claim by the Gubbio residents of Jessup succeeded. Should we fully view this process under the sign of ethnic demands? Emigrants brought to the new country very distinctive skills and knowledge, but at the same time they were looking for a new social recognition from the host society. The *Corsa dei Ceri* in the working milieu of Jessup belongs under the flag of an all new nationality.

One way or the other, America changed the face of those who experienced it. A quick observation by Italian diplomat Ludovico Incisa di Camerana explains a lot: "When emigrating to Argentina, and even to Brazil, Italians expected to found or to find another Italy; the United States were virtually only America." Statistics show that although all the adaptations needed for survival were carried out to ensure an American future, Italians were not emigrating with the goal of becoming Americans. However, that was the myth that mobilized expectations and forged consciences: through the centuries, people went to America, expecting to find a mystical place; or instead, by reversing the meaning of such a pilgrimage, they refused to go. In 1928 engineer Francesco Mauro wrote enthusiastically of America as the place where everyone followed the saying "for the job" (the right man for his task), giving an eschatological dimension to a widely shared technocratic dream (these were the years when Ford developed the assembly line). Writer and director Mario Soldati wrote soon after that no landing was as overwhelming as that before the skyscrapers of Manhattan: "Then a woman on the deck called out, with a strong Tuscan accent: 'Jolanda! Jolanda! *Neviorche*! We arrived! Come see *Neviorche*!' And all the ship awoke. . . . And the strength with which they exclaimed '*Neviorche*' revealed the certainty of being in front of a wonderful and blessed world, in a land with so much air and plenty of space to live in that in Italy you could not even imagine, a country where instead of *lire* they had those huge coins called dollars."

In Fascist rhetoric, the "demoplutocratic" countries, thanks to "gold," were stealing what rightly belonged to other nations, primarily to Italy, the "great proletarian" as it was called. In fact, the contrast between Americanism and Fascism was not so clear at the beginning. The Fascist intellectual Franco Ciarlantini, in 1929, in one of his numerous articles inspired by ideological propaganda, described American individualism as the product of a social activity—so that, while a sense of collectivism becomes more common in American life, man is strengthened by his numbers. He radically changed his opinion five years later, when he described America deflated by the economic crisis of the Great Depression: "The wonder of this artificial firmament looks to us like a light illuminating an immense apartment, where a lively party has been consumed, and the hosts dis-

appeared before the guests, and the sleepy servants forgot to turn off the lamps."

Behind the temporarily overshadowed curtain of the glittering metropolis, there still was a nation without equal in Europe in geographical extension and demographic power, whose real substance—Giuseppe Antonio Borgese wrote in 1936—was "the Common Man." The Sicilian writer—one of only thirteen academics who refused the oath to Italian Fascism and because of that lost their positions—then wrote: "Its prosperity is not a peaceful and monumental abundance, but a motion, lean and quick, an action. It is a quality rather than an asset, more than a possession, it is a momentum."

The interplay between powerful vital energy and a standardization of lifestyles obviously intrigued the Italian regime that needed—according to Beniamino De Ritis's *La Terza America* (1937)—"reconciling the mass with the individual, the capital with labor, according to the guidelines of Mussolini's Century." After Wall Street collapsed and the dollar flow dried up, many started scrutinizing the details of President Franklin Roosevelt's New Deal to spot the beginnings of the world to be. It was clear that the new order would start in America, even though almost no one admitted it openly. A few decades before, the radical sociologist Guglielmo Ferrero, after a long American journey, wrote a report which earned him some recognition by the Italian public. In *Fra i due mondi* (Between Two Worlds, 1913) he affirmed that the real American "fever," more than gold, consisted in constant motion: it was all about going beyond. According to his view, the frontier was not a given time and place but a permanent way of existence that transcended geographical boundaries and physical limitations.

On July 12, 1893, Frederick Jackson Turner's speech at the American Historical Society, "The significance of the Frontier in American History," had officially closed the internal frontier. Almost seventy years after, John Fitzgerald Kennedy spoke before the Democratic Party in Los Angeles, on July 15, 1960. He indicated a "new frontier" to be conquered: "For I stand tonight facing west on what was once the last frontier. . . . and we stand today on the edge of a New Frontier—the frontier of the 1960s—a frontier of unknown opportunities and perils—a frontier of unfulfilled hopes

and threats." This frontier was not a promise of a happy future, but a constant challenge witnessing the expansive character of American life.

It is a challenge constantly flowing in and out of American society, with a lot of energy and just as many contradictions, as the history of Italian Americans demonstrates. For a long time they had been regarded as having little or no ability to integrate. In 1924, restrictive legislation against "new" immigration was passed, leaving Italy with a share of just 3,845 new departures a year, with family reunions remaining the only open channel. In the entire period between the two World Wars, total arrivals were around 600,000 people, mostly women and children, less than the emigration of a single year before World War I. In the 1930s, once the first generation stabilized at the approximate figure of 1,800,000 people, the second generation started to gain importance. This introduced migration dynamics tinged with strong intergenerational conflicts within the community. The attention of scholars concentrated on these new aspects. Rudolph J. Vecoli described them as the "old-country ways" going against the new American ways: on the one hand the microcosm of the family and the neighborhood, on the other hand the American macrocosm and the school of street-life. During that time, people were trying to escape the social stigma, and even changed their family names; for example Carpentieri became Carpenter. However, classification based on "race" remained to nail the immigrant. Mattia Giurelli, born in Umbria, emigrated in 1913 from Italy. In Pennsylvania and then in Paterson, New Jersey, where he acquired U.S. citizenship (in 1929) he is referred to as South Italian. It is an absolutely grotesque classification: if it is true that migrants left their country as individuals and became a population only after their arrival, Italians were denied even the right to be recognized according to the language of their homeland. A racial ordering principle prevailed over a national one, based on the observation of facial features and skin color, which we know is somewhat darker among populations of the southern regions of Italy surrounded by the Mediterranean.

The criteria that guided racial taxonomy were then modified in an attempt to take into account the most recent and massive migratory movements (such as those involving

Latinos). However in the process of construction of U.S. citizenship, the principle of strict ethnic distinction remained essential for a long time. At the time of the census, one used to declare his or her belonging to a single ethnic group, even if—as it was observed by Italian journalist and essayist Marco D'Eramo—the multi-ethnic biography is the norm for the U.S. citizen. Beginning with the 2000 census, people could choose in more than one category marked "race," including specific ethnic distinctions such as "Japanese." The choice of ethnicity is actually voluntary. The analysis of census statistics shows a dynamic at the same time demographic and cultural. The process of re-establishing identity on ethnicity was defined by Benedict Anderson as the creation of an imagined community. If it is true that to exist one has to have a name, the choice of the name (and of ethnicity) is surrounded by a kaleidoscope of expectations. And the image of Italians was confined for many years to the "pick and shovel" laborer. Even Al Capone's famous line, "I am not Italian. I was born in Brooklyn," went towards building his American identity.

Italianità is a very slippery category, but has undoubtedly fueled the American imagination. The culture of the United States today is a heritage acquired by the world; and it would not be the same without sports personalities, artists and performers such as Joe DiMaggio, Rocky Graziano, Jimmy Durante, Frank Sinatra, Frank Capra, Pietro DiDonato, Mario Puzo, Frank Zappa, Sylvester Stallone, Al Pacino, and Martin Scorsese. These famous names partly explain why in the census of 2000, in a cultural context much more favorable to the Italian style, nearly 16 million Americans were ready to recognize the existence of an Italian ancestor. Although we must give credit to the transnational syncretism that shapes every migration story, it is at the intersection with the processes of nation building that we must trace the moments that changed attitudes toward Italians in America.

When we analyze involvement in politics, Italian Americans took a longer time than other migrant groups. An emblematic case is that of Alfred E. Smith, the first Catholic candidate for president of the United States, in 1928. He had Italian ancestors but preferred to shape his public figure around his Irish heritage. And a Catholic of Irish descent is the only non-Protestant elected to the presidency (John Fitzgerald Kennedy in 1960). The pioneer figure of Italian Americans in politics is Fiorello LaGuardia, Republican congressman in the House of Representatives beginning in 1916 (the third Italian elected, after Francis B. Spinola in 1886 and Anthony Caminetti in 1890), and mayor of New York City between 1934 and 1945. Across the same period of time other Italians served as mayors in large cities, including Angelo J. Rossi in San Francisco (1931-44) and Robert S. Maestri in New Orleans (1936-44). The first Italian American governor was John Pastore in Rhode Island in 1945. In the mayoral elections of 1950 in New York City, voters were faced with the peculiar circumstance of three Italian Americans in contention: the Republican Edward Corsi, the Democrat Ferdinand Pecora, and the Independent Vincent Impellitteri (who won the election). Further along came Antonin Scalia and Samuel Alito, Jr. to the Supreme Court, vice presidential candidate Geraldine Ferraro in 1984, and Nancy Pelosi, Speaker of the House of Representatives (2007-11). However, the persistence of a cultural bias against Italian Americans forced a leading figure like Mario Cuomo, Democratic governor of New York, to choose a lower profile in national politics.

The presence of Italian candidates in the 1930s can be explained by the progress of the second generation, and their growing numbers in the 1950s by the appearance of the third generation. It would be wrong, however, to think of the processes of construction of citizenship as a "natural" movement of growth, one brick at a time, the same way we build houses. Putting aside the theory and practice of the melting pot, in the history of Italian emigration there is a precise moment in which this community was called upon to declare solemnly in favor of the United States: on December 11, 1941, the day of the declaration of war against the Axis powers, Imperial Japan (which had bombed Pearl Harbor), Nazi Germany, and Fascist Italy. Non-naturalized Italians still constituted a considerable number, about 600,000 people, and there were restrictions on personal freedom. The decision to exempt the Italians from the category of enemy aliens was announced on Columbus Day 1942, in a speech made by Attorney General Francis Biddle at Carnegie Hall in New York City. By the end of 1942, Italians detained as enemy aliens numbered 210, nothing when compared to the treatment suffered by Japanese Americans. With regards to German immigrants, we must remember that the real showdown for

them had been World War I, when they had to declare their loyalty to their host country. In the 1990s the book and exhibit *The Secret History* sparked a movement to investigate the history of the sufferings endured for being Italian during World War II. It was followed by an official report by the Department of Justice of the United States and the recognition by President Clinton of the injustices perpetrated (*U.S. Department of Justice, Report to the Congress of the United States. A Review of the Restrictions on Persons of Italian Ancestry during World War II, Washington, D.C., November 2001*).

The loyalty of Italians to their adopted country was all the more important if we think that Mussolini's propaganda had succeeded in Little Italies. He skillfully used two arguments: first, he was presented as the leader of a proud renewal of Italy's power in the world (just think of the extraordinary crowds greeting Italo Balbo in 1937 in Chicago, after he had flown across the ocean with a fleet of hydroplanes); secondly, Mussolini tried to take advantage of the political influence of naturalized Italians. Italy obtained an important diplomatic success when the U.S. did not enforce international sanctions issued by the League of Nations after Italian aggression in Ethiopia. A strong point in favor of Mussolini was also the signing of the Concordat with the Vatican, on February 11, 1929. According to Americanist Stefano Luconi, there were important Italian American community resources caught by the web of Fascist propaganda, like the Order Sons of Italy in America and Generoso Pope's *Il Progresso Italo-Americano*. Pope was also a supporter of the Democratic party, which, thanks to social support programs, increased its followers among Italian Americans. First and second generation Italian American union organizers, like Emilio Grandinetti and Ernie DeMaio, were crucial at the time of the declaration of war because they were able to sensitize Franklin Delano Roosevelt to the needs of their communities. Certainly, there were measures they had to accept at least for the length of the war: Italian American organizations were disrupted, the teaching of Italian was abandoned, appeared less in print, traditional celebrations were suspended, and names of family and of activities were anglicized. But that was not enough. There was a war, money was needed to finance it, and men to fight it: Italian communities contributed with the massive purchase of war bonds and the enlistment of young men. American flags hung in the windows of Little Italies across the U.S. and bore witness to the will to sacrifice for their new country. It should also be remembered that World War II was fought not only for the victory of America, but also to ensure freedom from Fascist dictatorships, an issue that certainly was dear to the most anti-Fascist sectors of the Italian communities. This is shown by the extraordinary film made by the Dover Social Club of Paterson, New Jersey, and recovered in 2009 in the basement of *Casa del Popolo* in Porchiano, Umbria. *Italian or American?*, a 1943 research project by Irving Child, further described the historic significance of what was happening.

Today, when comparing the many millions of people with Italian roots in the United States, with only just over 200,000 enrolled in the Italian Registry of Residents Abroad (and therefore with Italian citizenship or with double Italian American citizenship) we see that their official number is less than that of Italians in Belgium. The statistical evidence documents the success of the participatory process of Italians in American society, the long term outcome of which led to the rise of a new sensibility: from Italian American to American Italian.

Emigration scholars Patrizia Audenino and Maddalena Tirabassi wrote that Italians in America in post-war consumer society did everything they could to shake off the legacy of the Old World, in a race to Americanization that led to their perfect blending into the middle class. These are the years of affluent capitalism, with its promise of inclusion for all. The historian Giorgio Spini in *America* (1962) captured the mood well: "It seems that the good God created America so that each generation could be pioneers in their own way, exploring unknown spaces and new hopes." John F. Kennedy wrote *A Nation of Immigrants* in 1958 (it was released posthumously in 1964). The bullets fired in Dallas ended the president's life, but not the dream of the society put forward by his words: "This was the secret of America: a nation of people with the fresh memory of old traditions who dared to explore new frontiers, people eager to build lives for themselves in a spacious society that did not restrict their freedom of choice and action." We are well aware of the contradictions between that rosy view of inclusion for all and the permanent state of conflict that exploded in the 1960s and 1970s within U.S. society, because of the end-

less Vietnam War and the sufferings caused by segregation (with the tragic procession of famous murders: Martin Luther King Jr., Robert F. Kennedy, and Malcolm X).

It is not so paradoxical that the renewed promise of happiness coincided with the most radical critique of the paradigm of the melting pot. These are the years of the introduction of African American studies. In 1966 the American Italian Historical Association was founded, sponsoring a rich vein of Italian American studies; Rudolph J. Vecoli wrote *The Ethnicity, a Neglected Dimension of American History* in 1970, where the struggle for recognition claimed by African Americans became a universal claim for all those who had been forgotten by American history, immigrants and Native Americans leading the way.

What is the relationship between literature and life when we observe the Italian American experience? When observed from Italy, once the stereotypical *Godfather* is gone, we know very little of Italians in America. The long oblivion experienced by John Fante is exemplary: after his inclusion in *Americana*—the first anthology of 20th century American literature printed in Italy in 1942 and compiled by Elio Vittorini—Fante was almost forgotten until Charles Bukowski quoted him in his 1978 novel *Women*, just before Fante's death. This writer, whose family came from Abruzzo, was born in 1909 in Denver's Little Italy. He gave voice in his novels to the expectations and frustrations of a generation that was not Italian without yet being American. Not only did he do it long before the revival of ethnicity and the spread of affirmative action policies, but also achieved this by holding dear for himself, and for the other children of immigrants, the right to be recognized, even if not understood, in their new condition. Fante's writings hold a universal force and describe the struggles when the American experience confronts the American dream. His literary alter ego, Arturo Bandini, instills affection in the reader. He wavers constantly between nostalgia and irony, with a constant fatigue at having to recognize himself for what he is, the composite but indivisible identity of American Italian.

The Italian Way to the American Dream

Mario B. Mignone

Visitors who arrive in New York today will be surprised by the level of *Italianità* and the prominence of Italian Americans that will greet them at every level of American society. The pride of flying Italian colors at the Fifth Avenue Columbus Day Parade is matched by the spirit of American patriotism and sacrifice by over one hundred Italian American firemen and policemen who perished at Ground Zero, and the courage shown by Marines on the frontline of the war against terrorism. The vitality and dynamism of numerous Italian American TV talk-show hosts such as Jay Leno, Kelly Ripa, Rosanne Scotto, and Joy Behar (Josephina Victoria Occhiuto), and current-affairs and financial-show hosts Maria Bartiromo, Neil Cavuto, Andrew Napolitano, and Charles Gasparino, are matched by the explosive and lyrical voices and entertainment of two of the most popular female pop stars, Madonna (Madonna Louise Veronica Ciccone) and Lady Gaga (Stefani J. Angelina Germanotta). The enjoyment of a cuisine affected by the culinary creativity of Italian Americans hosting popular cooking TV shows, such as Mario Batali, Giada De Laurentiis, Rachael Ray, and Lidia Bastianich, is matched by the exceptional creative imagination of works by architects and designers Gaetano Pesce, Renzo Piano and Matteo Pericoli. Italian creativity, pride, passion, skills, and imagination are not only palpable everywhere but they are also appreciated and seen as America's assets. From fiction writing (Don DeLillo), to cinema (Martin Scorsese), to industry and business (Richard Grasso, of the NY stock exchange; Samuel Palmisano, CEO of IBM; Roger Enrico, CEO of PepsiCo; Patricia Russo, CEO of Lucent), to law enforcement (Louis Freeh, former director of the FBI), Italians are there, and they are on top.

In the 1920s Italian names had already begun to appear with some frequency among the success stories of the American dream. In the arts, business, sports, literature, entertainment, and government, names ending in a vowel were being noticed for their natural talents and acquired skills. By the 1930s, the national popular culture included Italian American among its heroes. In music, sports, politics, and cinema the careers of Frank Sinatra, Joe DiMaggio, Fiorello LaGuardia, Frank Capra, and Don Ameche suggested that national attitudes toward Italians were in transition. Second-generation Italian Americans had joined forces with others and had assumed leadership positions in labor unions to fight for the working class. They had also begun to make political gains as part of the Democratic Party's New Deal coalition. However, the critical benchmark in the emergence of Italian Americans is World War II. It was in the "big war" that Italian Americans were offered the supreme opportunity to demonstrate their loyalty to America and their true worth as essential fibers of the cultural and social fabric of America.

When Italy declared war on the United States in 1941, Italian Americans, who had been divided in their attitude toward Fascism, quickly reunited as a community, and in a disproportionately high ratio rushed to support the American struggle against the Axis powers. More than one million Italian American males in their late teens and twenties joined the U.S. military, serving on all fronts and in all stages of the war, including the Italian campaign. In fact, many were sent to participate in the landing of the Allies in Sicily and the rest of Southern Italy, a military strategy that was reflected in *Paisà* (1946), a very revealing Italian film produced immediately after the war. The sons and grandsons of the men and women who had been born there used their small vocabulary of words of southern dialect to communicate with the local people, and they shared their food rations with them. The encounter of the *paesani* helped to soften the military operation into a war of "liberation."

When the war was over many Italian Americans received top honors and recognition for their heroic efforts. For many, the war was their first experience beyond their own neighborhoods and the first real opportunity to integrate with the American youth of their times. Regardless of race, ethnicity, religious belief, language, and customs, they found themselves shoulder to shoulder to endure the same destiny and fight for the same purpose. All of them

were "Americanized" to one degree or another by the military, and most of them subsequently benefited from military service and the educational and home-loan benefits of the G.I. Bill.

The war also transformed many Little Italies, as men and women left for military service or to work in war industries and drew young Italian Americans away from the old neighborhood, its culture, and the Italian language. Upon their return, Italian Americans, as they became more affluent, left the crowded urban neighborhoods for spacious suburban locations. They joined in the nationwide movement to the suburbs, realizing their desire for a piece of land and the improvement in their standard of living. In the 1950s it appeared that Italian Americans, the second generation especially, having benefitted from its war service and the postwar economic expansion, enjoyed new levels of acceptance and integration as they experienced substantial social mobility and embraced mass consumerism and middle-class values. As the structural changes in the economy vastly expanded the availability of white collar, managerial positions, Italian Americans quickly took advantage. Such developments put them into more immediate and positive contact with other Americans who exhibited greater openness in the postwar years.

By the 1970s, Italian men born between 1930 and 1945, who were then at or near the maturity of their careers, had an average occupational prestige that was virtually the same as men of Anglo-Saxon ancestry of the same ages. Hand in hand with this mobility came a decline in the strength of Italian occupational niches and, therefore, they became less easily stereotyped according to specific occupational callings.

Ironically, as assimilation was taking place and ethnic groups experienced increasing integration into the larger society, a resurgent Italian American ethnicity was palpable in American society. While struggling in their search of equality, Italian Americans were giving clear indication of an ethnic revival through the search for their individuality. The ethnic reawakening took place while America was embarking on an anthropological revolution, which changed the nation at its core.

When my family and I arrived in America as immigrants in 1960, we could feel the air of novelty and change.

Prosperity, educational opportunities, and social transformations were breaking the rigid wall of class stratifications and racial barriers. Americans looked toward the future with sheer optimism.

My siblings and I, along with all the other new immigrants, were engulfed by this wind of transformation. America was opening herself up to us with a benevolent heart. Many times we would say, "What a country! God bless America." America appeared so full of life and offered so much hope.

Two months after we had arrived in America, J.F. Kennedy was elected president, the first and only Catholic and the first Irish American president. At his inaugural address on January 20, 1961, Kennedy challenged the people of the United States with the statement: "Ask not what your country can do for you, but rather what you can do for your country." He wanted the young people of the country to help the undeveloped world. He announced the establishment of the Peace Corps, a program that intended to send ten thousand young volunteers to serve in Africa, Asia, and Latin America, to help in areas such as education, farming, health care, and construction.

It was a new era also for *Italianità*. On the radio, Italian American singers were dominating the magnetic waves. As one turned the knob, station after station, the melodious voices of Italian American singers were reverberating in the air with love songs, very often with Italian words. Perry Como, Tony Bennett, Frank Sinatra, Dean Martin, Julius La Rosa, Louis Prima, Frankie Avalon, Bobby Darin, Vic Damone, Tony Orlando, Nicola Pericoli, and Dion were entertaining the wide American audience with "Beyond the Sea," "I Love You Because," "Al di là," "Night and Day," "It's Impossible," "That's Amore," "Return to Me," "Cara Mia," "Buona sera," and "You Light up my Life." 1960 was the year when *Where the Boys Are* was released. The movie revolved around a group of college women spending spring break at the beach in Fort Lauderdale. The title song, "Where the Boys Are," was sung by an Italian American star, Concetta Rosa Maria Franconero, known professionally as Connie Francis. *Where the Boys Are* was one of the first teen films to explore adolescent sexuality and the changing sexual mores and attitudes among American college youth. It started a process that completely changed sexuality, which contin-

ues today. It was the first movie that I saw in America. My cousin Gianni, with a couple of his friends, took me out and, although I could barely make sense of the language spoken on the screen, I was fully taken in by the American youth energy. That youth and energy were later given powerful expression by the blooming Italian American star John Travolta as Tony Manero in *Saturday Night Fever* (1977) and as Danny Zucco in *Grease* (1978).

In the early 1960s, pizza had not yet replaced hot dogs as the most popular American food, Starbucks had not yet invaded the world with its "espresso" and "Cappuccino Grande," and wine still was practically an ethnic or elite drink, Wonder Bread was the most popular sandwich bread, and Italian restaurants were confined to Italian neighborhoods, mostly catering to Italian Americans. But not for much longer. The walls of ethnicity were being broken and assimilation was increasingly giving in to integration and a different kind of acculturation.

We arrived in America when the emerging youth subculture was steadily increasing its impact on the rest of society through its tastes in fashion, music, and consumer culture. Education, in particular, was among the factors that accounted for the gradual and inexorable rise of Italian Americans in American society. And, with the improved economic status of the second and third generations, the ties of the Italian family began to loosen enough to accommodate greater individual ambition. While education was almost anathema to the first generation, second- and third-generation Italian Americans were almost obsessive in seeking a quality education for their children. This attitude has had a dramatic impact on the number of college-educated Italian Americans. In 1964 America was opening on average a college per week and new social classes were entering the walls of academia. Italian Americans, too, were sucked in by the anthropological revolution. When I enrolled in City College of the City of New York, I was part of a student body composed mostly of first generation college-bound students, mostly children of blue-collar families, and we, the students, were holding either part-time or full-time jobs. City College was the place where I met my future brother-in-law Rocco Pallone, and Michael Pesce, Dominick Salvatore, Vincenzo Bollettino, Vito De Simone, Nino Piscitello, Pasquale Perretta, the Sclafanis, the Battistas, the Criscuolo twins, and so

many other Italian immigrant friends; young men headed to become well known university professors, assemblymen, chief court judges, successful entrepreneurs. Our *Circolo Italiano* on campus, made up mostly by Italian American students, attracted the attention of students of other ethnicities, especially Jews and Latinos. The smell of our pizza and spaghetti parties pulled in students of every ethnic extraction: assimilation was flowing into multiculturalism, which then grew into the mosaic of cultural diversity. The view of many social scientists that as ethnic assimilation advanced with social mobility, ethnic group identities would fade away was being proven wrong.

In the reawakening of racial and ethnic identities, Italians played a role in the civil rights movement. Probably the most prominent figure was Monsignor Geno C. Baroni. He was assigned as pastor from 1960 to 1965 to the Washington, D.C., parish of Sts. Paul and Augustine, a merger of white and black parishes, applying Catholic social doctrine in ministering to the urban poor. His dedication to civil rights propelled him into a national leadership role. In March 1963 he was coordinator for Martin Luther King Jr.'s March on Washington; and in 1964 he went to Mississippi and marched in the 1965 Selma civil rights demonstration. His work was complemented by another priest, James E. Groppi, who in 1963 also took a leading role in the civil rights march on Washington; the following year he went to Selma, Alabama, to support the reverend Martin Luther King Jr. Unlike King, he advocated direct and violent response. The struggle for civil rights was also a struggle for human rights and a fight against all forms of oppression and discrimination. Italian Americans, too, were vindicating their ethnic identity with pride.

The high volume of sales of *The Italians* by Luigi Barzini in 1964 was another strong signal that Italian Americans were eagerly interested in the recovery of their cultural roots. They purchased and read with great interest a book that delved deeply into the Italian national character and presented, not always finding favor with the reader, both its great qualities and its imperfections. The image of an Italy in the grip of an "economic miracle" and a society interested in embodying the life of spectacle was also reflected in movies by Fellini, Antonioni, Visconti, Pasolini and so many other directors who were being presented on American screens.

They certainly provided new energy to the desire to reconnect with the ancestral land. Self-discovery was taking place by building a bridge between the past and the present of the "old country" and the cultural and social environment of the American landscape.

After the publication of *The Africans* (1967) by Harold Courtlander, but before *Roots* (1976) by Alex Haley, which with its huge popularity increased interest in genealogy and ethnic identity, Richard Gambino's *Blood of My Blood: The Dilemma of the Italian Americans* (1974) offered to many Italian Americans a voyage of discovery into their ethnic identity. Gambino's best-selling exploration of the psychological impact of the ethnic identity of America's Italians was another clear indication of the blossoming self-confidence of Italian Americans in their ethnicity. In the same year, a pioneer work in the field of Italian American Studies appeared on the American literary scene: *The Italian-American Novel* (1974) by Rose Basile Green. This systematization by an Italian American scholar of narratives by Italian American writers in a critical cultural and literary context gave yet another stimulus to the desire to assess and expose the American *Italianità*. The creation of the American Italian Historical Association (AIHA) in 1966 to systematically and scientifically assess Italian American experience and to launch Italian American Studies pulled together a network of dedicated scholars from various disciplines. Its first multidisciplinary conference, held in New York City at the Casa Italiana of Columbia University on October 26, 1968, put into motion a process that through the years has constructed the history and the story of the Italian American experience in a deeper and broader way than that presented by Hollywood. And in 1975, a coalition of business, political, educational, labor, and community leaders organized the National Italian American Foundation (NIAF) to promote Italian American culture and heritage through lectures, symposia, conferences, scholarships, fellowships, and scholarly and community cultural grants. Clearly, what was happening, years later, was well defined by New York State Comptroller Tom Di Napoli in public remarks:

> The problem of my grandparents who came from Italy was how to survive in the New World, with a new language, new culture, new set of rules. The problem of my parents was how to grow and prosper in an environment full of obstacles for Italian Americans; in essence it was a struggle about how to become Americans. The problem of my generation of Italian Americans is how to recover our cultural heritage and find the essence of our identity.

Once a marginalized, despised minority, Italian Americans gradually became one of the most highly successful and accepted national groups. In 1910 Italian Americans were the lowest paid workers in the United States, averaging $10.50 a week when the average American wage was $14.37, 27 percent higher. It took a while, but they kept improving their conditions until most of them had risen to heights few had dreamed possible; achieving success in all walks of life, Italian Americans gradually moved from the lower rungs of the economic scale in 1890-1910 to a level above the national average by the end of the 1970s. By the 1960s national statistics showed that for the first time there were more Italians working in white-collar occupations than in blue-collar jobs, a far cry from the days when most Italians could find employment only as menial laborers on the railroads, in factories, in mills, or on farms. By 1990, more than 65 percent of Italian Americans were managerial, professional, or white-collar workers. They had gained prominence in politics, sports, the media, the fine arts, the culinary arts, and numerous other fields of endeavor.

All of the statistical data point to a high level of structural assimilation in American society, although Italian American ethnicity has not disappeared. That Italian American identity has lost much of its former negative weight is suggested further by recent census figures for claiming ancestry groups. The 1980 census recorded 12.1 million individuals who claimed Italian ancestry (5.4 percent of the national population). By 1990 this figure had risen to 14.7 million (5.9 percent), and to 15.9 million in 2000, indicating that ethnicity remains an important and acceptable component of self-identification for substantial numbers of Italian Americans. The change in the percentage indicates something else extremely important: several hundreds of thousands who had not declared that they were Italian American years earlier, made that choice because of regained pride in their ethnicity.

Italian films helped to give a new view of the Italian culture and its carefree lifestyle through popular films such

as Fellini's *La Strada* and *La Dolce Vita*, and De Santis' *Bitter Rice* and *Divorce, Italian Style*. The new films that were released were different from the neo-realistic war tragedies that depicted destruction, ruins, and poverty. Americans gladly appreciated actors like Marcello Mastroianni in romantic color movies and they were happy to accept this new stereotype, a new image of Italy, a new brand that depicted the Italian lifestyle.

There is no question that Italian film directors helped to stir America's emotions. Overall, the Italian lifestyle appealed to the average moviegoer, who began to copy that style. At the same time that Italy was becoming Americanized, America was enriching itself with Italian flavors and style. Indeed, in the 1960s, Italy's style icons and trendsetters were largely responsible for America's fashion. Fashion models, movie stalwarts, fashion and car designers, and Formula 1 drivers had attracted the American imagination. The trend was so strong that, if a fashion item was made in Italy, and if the fashion designer's logo or brand name ended with a vowel, then it was certain that the average American would buy it.

In a *New York Times Magazine* article, on May 15, 1983, Stephen S. Hall stated: "Italian-Americans have sometimes been regarded as being slow to assimilate and climb America's social and economic ladders, even by their own historians, but now—as they swell the ranks of the middle class, amass power and wealth, and help set the decade's social and political agendas as never before—it may be that they have simply measured success, as Mario Cuomo has done, by a different yardstick, and made their way to the mainstream by a slightly different route." On its cover page the magazine published the pictures of twelve Italian American national leaders in various sectors of American society. It was an impressive list: Martin Scorsese, film director; Mario M. Cuomo, governor of New York; Salvador E. Luria, Nobel Prize winner in medicine; Eleanor Cutri Smeal, former president of NOW; Lee A. Iacocca, chairman of Chrysler; Joseph Vittoria, president of Avis; Geraldine Ferraro, congresswoman; Robert Venturi, architect; Joseph Cardinal Bernardin, archbishop of Chicago; A. Bartlett Giamatti, president of Yale University; Pete V. Domenici, U.S. senator; and Alfonse M. D'Amato, U.S. senator. It was certainly a very revealing sample of achievements by Italian Americans covering the wide spectrum of American economic, political, social, and cultural life.

It must be pointed out that the Italian American communities produced individuals of distinction from the very beginning, but those of earlier generations flourished in highly circumscribed worlds. In stadiums there was Joe DiMaggio; under the entertainment spotlights, it was Frank Sinatra; and in city government, it was Fiorello LaGuardia. But today's Italian Americans have stepped out in large numbers and have become players with national impact as well as a national following, taking the initiative in crucial political and social issues, keeping in mind that the prominence of women has been much bigger and more relevant than it might appear.

In the second and third generations, as American society became more culturally and socially elastic and working opportunities expanded, Italian American women were gradually accepted in the workplace and as entrepreneurs. They also had much better job opportunities because they had a high school and, later, college education, and were willing to leave the Little Italies and commute to work. Consequently, the second half of the 20th century was a period in which Italian American women excelled in virtually all fields. They were responsible for a significant number of firsts: Governor Ella Tambussi Grasso of Connecticut was the first American woman elected governor in her own right (1975) and the first Italian American woman in Congress. She created an "open government," which gave ordinary citizens easier access to public records. Geraldine Ferraro was the first woman nominated for U.S. vice president by a major political party when she ran with Democratic presidential candidate Walter Mondale in 1984. Her earlier career included service as assistant district attorney in New York and two terms in the U.S. Congress. Nancy Pelosi was the first woman Speaker of the U.S. House of Representatives. Janet Napolitano was the first woman to be named Secretary of Homeland Security. In 1989 Mother Angelica (Rita Rizzo), a Franciscan nun, founded the Eternal Word Television Network (EWTN), a network viewed regularly by millions of Catholics. JoAnn Falletta was the first woman to become a permanent conductor of a major symphony orchestra (with both the Virginia Symphony Orchestra and the Buffalo Philharmonic Orchestra). Penny Marshall (Masciarelli) was one

of the first female directors in Hollywood. Catherine DeAngelis, M.D., was the first woman editor of the *Journal of the American Medical Association*. Patricia Fili-Krushel was the first woman president of ABC Television. Bonnie Tiburzi was the first woman pilot in commercial aviation history.

This list of firsts is enriched by a long list of women who have also made a profound impact on American society. They contradict or deflate the stereotypes, sometimes even repeated by Italian American scholars, presenting or portraying Italian and Italian American women as historically oppressed in social and cultural structures, especially in a patriarchal family structure where women had a subordinate role to men. Sometimes the traditional protective attitude towards women, especially in the old agrarian society, is confused as a form of subjugation. Most Italian women, especially mothers, have a strong character and have been central to household organization and family life. Especially in agrarian society and in families where the husband/father had emigrated, women had roles of responsibility and leadership. When Italian women arrived during the period of mass immigration and had to adapt to new and unfamiliar social and economic conditions, they commonly demonstrated great courage and resourcefulness in meeting these obligations, often under adverse living conditions. Their cultural and social roles, requiring the highest priority be placed on the family, remained strong, while at the same time they adapted to new circumstances. It is, therefore, not surprising that Italian American women have emerged as great leaders.

When we speak about the strong emergence of Italian Americans in the wider American landscape, it was in the world of sports and entertainment, for both men and women, that they were first noted in large numbers for their varied endeavors and special talents. Why was their first notoriety achieved in those fields? It was unquestionably due to their exceptional skills. But both areas of endeavor required discipline, enduring persistence, and practice, and the norms and values of Italian Immigrants played an important role in establishing the necessary preconditions for participation and achievement in American sports. Immigrants practiced the ethics of hard work and discipline, which transferred well to the rigors of athletic training. This probably explained why sports were the area where Italian Americans emerged first. From the beginning, the children of Italian immigrants eagerly took part in the games and sports of America, especially baseball. The Catholic Church played an important role in the development of ethnic ballplayers among the poor. In the Italian section of St. Louis called Dago Hill, Father Causino was aware of gang violence on "the Hill," and devoted himself to direct that energy into sports.

Long before the emergence on the national scene of superstar Joe DiMaggio, Italian Americans had achieved fame and respect on the baseball field. It started with Ed Abbaticchio, whose place in baseball history as one of the first players of Italian origin to succeed in the Major Leagues, as noted by scholar Lawrence Baldassaro, is interesting for the way he was perceived on the national scene. Between 1897 and 1910, Ed Abbaticchio spent all or part of nine seasons playing for Philadelphia, Boston, and Pittsburgh in the National League. For one year, at least, he was one of the highest-paid players in baseball. He played in an era when Major League rosters were dominated by players of Irish descent and his ascent to national attention revealed how difficult it was for an Italian American to gain respect and appreciation. One reporter wrote that baseball was an Irish sport: "The finest athletes in the world are Irish and it is due to the predominance of the Irish in baseball that the American nation's chosen pastime is the most skillful in the world." In this kind of controlled environment, it would be difficult for Italians to have a role.

On June 7, 1903, (Abbaticchio's first season with the Beaneaters), the *Boston Sunday Journal* ran a story under the headline, "Boston May Contribute to Italian Supremacy in Baseball." The story began by posing a sociological question: "Does the entrance of an Italian into baseball presage another great ethnological movement such as has taken place in the American labor world?" Noting that while a decade earlier, "the large majority of laborers seen in the city streets were Irish" but now "the majority are Italians," the writer posed yet another question: "Will the Italians supplant the Irish on the diamond as they have supplanted them with the pick and the shovel?"

Although there is no indication that Abbaticchio encountered open prejudice during his career, by demonstrating that an Italian American could be a successful and respected Major League ballplayer at a time when anti-Italian sentiment was widespread, he opened the door for all those

who followed. His display of skill and character on the highly visible stage of America's pastime may have helped in some small way to alter the public's perception of Italian Americans in general. The Boston writer who predicted that the appearance of Ed Abbaticchio signaled the beginning of an Italian invasion of baseball was not wrong. Italians did achieve a strong presence within a generation, but it was not easy to win the benevolence of the media and of the political establishment. It was not easy even for superstar Joe DiMaggio. Quentin Reynolds, associate editor of *Collier's Magazine*, recounted the following exchange among baseball writers covering spring training in 1936:"'He [Joe DiMaggio] says you pronounce it Dee-Mah-gee-o,' one of the sports writers said gloomily. 'That's a very tough name to pronounce and also tough to spell,' another added. 'DiMaggio sounds like something you put on a steak,' one writer said in disgust." That same spring, following several letters from readers offering the correct pronunciation of the DiMaggio name, an editorial note pointed out that in a recent interview with a *New York Times* reporter, DiMaggio himself said that "if there is any further argument on this point he will have to change his name to Smith."

From the time Italian Americans first appeared in the Major Leagues, sportswriters and typesetters were baffled by their names. Compared to the more familiar Anglo-Saxon and Celtic names that dominated baseball rosters, Italian names seemed long and confusing. Both phonetically and culturally, their foreign-sounding names set Italians apart, a reminder that they were somehow not quite as American as those who had come before them. This provides some explanation of why many players and so many entertainers changed their names. Indeed, so many Italian immigrants changed their names precisely to be less "different" and more easily accepted.

Many of the early Italian players were with the St. Louis Browns, whose policy was to sign up as many players as cheaply as possible, sell those who did well to other teams, and discard the rest. Among the players who came up via this route were Gus Mancuso, who later had a long career with the New York Giants, and Joe Cicero of Boston. Francesco (Frankie) Crosetti began his major-league career with the Yankees in 1932 and later became a well-known Yankee coach for many years.

By the 1930s second-generation Italian Americans were socially ready to compete in American sports, despite the tepid feelings the general American public had towards Italians. Once they were admitted on the field to show the magic of their skills, they attracted men, women, boys and girls from every cultural background, filling arenas and stadiums and gathering them around radios and televisions. Italian American boys and girls especially were inspired by the DiMaggio brothers, Marciano, Retton, Sarazen, and other Italian American players; they created another generation of extraordinary athletes. Sports have functioned as a means of upward social and economic mobility for all young men and women of minority backgrounds, including Italian Americans.

Thus, success in baseball, the classic American sport, signified success in American society. The Americanized second generation competed in this cooperative yet individualistic game and became enthusiastic spectators. The list of great stars in baseball is truly extensive; at least 454 Italian Americans have played in the Major Leagues since 1897, a statistic that even the most fanatical of fans would probably not know. Not only have Italian Americans contributed to baseball at every level, all the way up to commissioner, but baseball itself has contributed to the Americanization of Italians. This most American of sports became a quick way to counter the negative immigrant identity as an outsider.

Whether on the field, coaching from the sidelines, in the front office or reporting on camera, by the 1960s Italian Americans, as they moved into the middle- and upper-classes, achieved places of distinction and leadership positions within every sport—including football, basketball, golf, and motor sports. By the time many Italian Americans had become successful in baseball, others began appearing on the college and professional football fields of America.

Toward the end of the 20th century, Italian American athletes were moving into managerial and administrative positions. At the time of his death (1970), legendary Vince Lombardi had the most wins of any coach in professional football; he was the personification of tenacity and commitment in American sports. He inspired Alan Ameche, Mark Bavaro, Nick Buoniconti, Anthony Castonzo, Joe Flacco, Ed Marinaro, Dan Marino, Dan Pastorini, Joe Paterno, and Vinny Testaverde. Probably the best-known Italian Ameri-

can was quarterback Joe Montana, known as the "Comeback Kid" because he never gave up during a game. Montana is perhaps most famous for his last-minute, come-from-behind drive to win Super Bowl XXIII. He credits his parents with developing his inner drive to succeed. All these athletic achievers built upon their Italian American background to ascend to the level of American legend.

Together with baseball, boxing was the other sport that attracted the children of first generation Italian immigrants. They became undisputed world champions in all eight traditional weight divisions, with an overrepresentation in the lighter classes.

In future years, upward mobility could lessen Italian American participation in professional sports but increase it in recreational sports, as more Italian Americans fill the professional arena as executives, journalists and sports broadcasters on radio and television.

The extraordinary success in sports was accompanied by one in entertainment. Italian Americans have helped shape American popular music as composers and performers since 1914, when Dominic James "Nick" LaRocca, a cornetist, and Anthony Sbarbaro, a drummer, formed the first jazz band, the Original Dixieland 'Jass' Band. In 1917, the quintet made the first jazz record, "Darktown Strutters Ball," which sold a million copies. LaRocca wrote the classic "Tiger Rag," now known as "Hold That Tiger," the official song of Louisiana State University.

The "magic" of film, theater, and then of television brought such performers as Frank Sinatra, Dean Martin, Jimmy Durante, and Perry Como into American homes, reinforcing the popular view of Italians as artistically and musically talented.

Italian American singers shaped the voice art in all shapes and forms. Mario Lanza was a famous tenor who appeared on radio, in concert, on recordings, and in motion pictures. Vocalist and television star Perry Como (born Pierino Roland Como) hosted one of America's most popular television shows in the 1950s. Frank Zappa, musician, vocalist, and composer, founded the influential rock group Mothers of Invention in the 1960s. Noted for his social satire and musical inventiveness, Zappa was named Pop Musician of the Year for three years in a row in 1970-1972.

Many singers were able to sing in Italian or at least incorporate English versions of Italian song into their repertoire or inject Italian words into their American songs.

The achievements of Dominick Argento, John Corigliano, David Del Tredici and Gian Carlo Menotti also had an impact on classical music and opera. Menotti is the first composer to write American operas that have become part of the international repertory. Among his most famous works are *The Consul* (1950); *The Medium* and *The Telephone* (1947); *Amahl and the Night Visitors* (1951); and *The Saint of Bleeker Street* (1955), an opera set in a modern Little Italy. His operas *The Consul* and *The Saint of Bleeker Street* won him Pulitzer Prizes. *Amahl* was the first opera ever televised while *The Consul*, *The Medium*, and *The Telephone* were produced on Broadway. Menotti also founded the Festival of Two Worlds in Spoleto (1958) and its American counterpart in Charleston (1977), which celebrates Western music. Although he was born in Italy in 1911, he came to the U.S. when he was only seventeen and has made his career here.

Italians left their imprint on Hollywood. Frank Capra directed more than twenty feature films and won three Academy Awards for Best Director. His films, stamped with an upbeat optimism, became known as "Capra-corn." Capra won his Oscars for *It Happened One Night* (1934), *Mr. Deeds Goes to Town* (1936), and *You Can't Take It With You* (1938), but he is also well known for *Lost Horizon* (1937), *Mr. Smith Goes to Washington* (1939), and *It's a Wonderful Life* (1947). In addition to directing, Capra served four terms as president of the Academy of Motion Picture Arts and Sciences and three terms as president of the Screen Directors Guild.

In a different era, Francis Ford Coppola earned international fame as director of *The Godfather* (1972), an adaptation of Mario Puzo's best selling novel, a film which won several Academy Awards, including Best Picture. Among numerous other films, Coppola has made two sequels to *The Godfather*—the second film of this trilogy, released in 1974, also won multiple awards, including an Academy Award for Best Picture. Martin Scorsese, film director and screenwriter, directed *Mean Streets* (1973), *Taxi Driver* (1976), *Raging Bull* (1980), and *Good Fellas* (1990), among others, all of which draw from the urban, ethnic milieu of his youth. Sylvester Stallone, actor, screenwriter, and director, has gained fame in each of these categories but he is perhaps best known as

the title character in both the *Rocky* (1976), which won an Academy Award for Best Picture (and spawned five sequels), and the *Rambo* series. Don Ameche, whose career spanned several decades, performed in vaudeville, appeared on radio serials ("The Chase and Sanborn Hour"), and starred in feature films. Ameche first achieved national acclaim in *The Story of Alexander Graham Bell* (1941), and appeared in many films, earning an Academy Award for Best Supporting Actor for his performance in *Cocoon* (1986). Ernest Borgnine (born Ermes Effron Borgnino) spent his early acting career portraying villains, such as the brutal prison guard in *From Here to Eternity*, but captured the hearts of Americans with his sensitive portrayal of a Bronx butcher in *Marty* (1956), for which he won an Academy Award. Borgnine also appeared on network television as Lieutenant Commander Quinton McHale on "McHale's Navy," a comedy series that ran on ABC from 1962 to 1966. Liza Minnelli, stage, television, and motion picture actress and vocalist, won an Academy Award for *Cabaret* (1972), an Emmy for *Liza with a Z* (1972), and a Tony Award for *The Act* (1977). Other stars of the entertainment business include Michael Cimino, the Coppolas, Brian De Palma, Quentin Tarantino, Nicholas Cage, Stanley Tucci, Steve Buscemi, Robert De Niro, and Al Pacino—and the list could go on.

In literature, Pietro DiDonato published the classic Italian immigrant novel, *Christ in Concrete*, in 1939, one of the few proletarian novels written by a blue-collar worker, which received critical acclaim. The son of an Italian immigrant and himself a bricklayer, he captured the life and death of his father, who was foreman of a construction crew of Italian immigrants. He also recreated the immigrant experience in later works, including *Three Circles of Light* (1960) and *Life of Mother Cabrini* (1960). Novelist Jerre Mangione wrote *Mount Allegro* (1943), an autobiographical work describing his upbringing among Sicilian Americans in Rochester, New York. Mangione is also noted for his *Reunion in Sicily* (1950), *An Ethnic at Large* (1978), and *La Storia: Five Centuries of the Italian American Experience* (1992), written with Ben Morreale. Gay Talese is one of the founders of the 1960s "New Journalism," which incorporates fictional elements (dialogue, scene description, and shifting points of view) into news writing. He began his career as a reporter writing about sports and politics for the *New York Times* (1956-65), but later earned fame for his national best-sellers. Among them is *The Kingdom and the Power* (1969), a critical history of the *New York Times*; *Honor Thy Father* (1971), the story of crime boss Joe Bonanno and his son, Bill; *Thy Neighbor's Wife* (1980), which examines America's changing sexual mores; and *Unto the Sons* (1992), a largely autobiographical book about his Italian heritage, which dealt with his own family's immigrant experience.

Lawrence Ferlinghetti and Gregory Nunzio Corso were two prominent poets of the 1950s Beat Generation, coming from a small group of artists based in San Francisco and New York who were dissatisfied with conformity. Ferlinghetti began writing at age sixteen. After earning a doctorate in poetry he moved to San Francisco, where he founded the magazine *City Lights*. His San Francisco bookstore, City Lights Books, became a gathering place for literary activists. Corso, born in New York City's Greenwich Village, started his writing career at age twenty and published his first poem in 1955. Son of Italian immigrants, John Ciardi, poet, translator, and literary critic, published over sixty books of poetry and criticism and impacted the literary world as the long-time poetry editor of the *Saturday Review*. Ciardi's translation of Dante's *Divine Comedy* is regarded by many as definitive. He taught at Harvard and Rutgers universities, hosted a weekly radio commentary on National Public Radio in the 1980s, and was the only American poet ever to have his own television program (*Accent*, on CBS in the early 1960s). Novelist Mario Puzo published two critical successes, *Dark Arena* (1955) and *The Fortunate Pilgrim* (1965), prior to *The Godfather* in 1969, which sold over ten million copies and reached vast audiences in its film adaptations. Helen Barolini, poet, essayist, and novelist, explored the experiences of Italian American women in her *Umbertina* (1979) and *The Dream Book* (1985). Barbara Grizzuti-Harrison, one of the most well-known contemporary writers, is the author of *Italian Days* (1989), considered a masterpiece of travel writing thanks to her acute powers of observation and broad cultural knowledge. She also wrote *The Islands of Italy*, *A History and a Memory of Jehovah's Witnesses* and *The Astonishing World*.

It is evident that Italian Americans in all fields constitute a vibrant and humanizing force—as political leaders, educators, writers, artists, musicians, scholars, actors, athletes, jurors, physicians, and more. Their influence will contribute considerably to a more civilized and enjoyable society shared by all Americans.

If political success represents some ultimate referendum on ethnic acceptability, then Italian Americans are unquestionably better off than they were a generation ago. Their prominence in politics has been strong especially in the states with a consistently large Italian American population. In 2010, New Yorkers had no choice but to elect an Italian American for governor. Andrew Cuomo, who was elected governor, did not have an opposition in his party primaries; in the Republican primaries there were two Italian American candidates, Rick Lazio and Carl Palladino. It was a repeat of the Italian political match seen in 1950-New York's mayoral elections.

The growth of Italian American political relevance reflects the various stages of ethnic group politics. New immigrants appeared only occasionally in the political arena. Like others of peasant extraction, they possessed little experience in participatory democracy. Because of lack of knowledge of the English language, and their preoccupation with earning a living, they did not get involved in politics in high numbers. Thus, the Italian community celebrated the election of Michael Rofrano to deputy police commissioner of New York City in 1914 as a great achievement.

The increasing numbers of Italian Americans on the American political landscape after World War II was the product of improved economic conditions and more extensive education, which resulted in stronger participation in the exercise of voting rights. The combination of the assertive role of Italian American elected officials and the vigorous political clout of Italian American communities forced political leaders of both parties to open the door to increasing numbers of political offices. Consequently, not only did Italian Americans make tremendous gains in local government, they also emerged strongly on the national level. In some states Italian Americans held offices in proportion to or above their percentage of the population. By 1992, 22 percent of the members of the New York State legislature were identified as having Italian ancestry, even though they formed approximately 16 percent of the state's population. States with large Italian American populations such as New York, New Jersey, and Connecticut elected Mario Cuomo, James Florio, and Ella Grasso governors, respectively. Today Italian Americans constitute the largest ethnic group in the New York State legislature.

However, the success of Italian Americans in politics and government, part of the blossoming of *Italianità* in America, raises some questions:

1. Why is the presence of Italian Americans in Congress proportionately much lower than that in local and state governments?
2. Do Italian American voters still strongly support their ethnic candidates?
3. Do Italian American legislators have an Italian American agenda?
4. What is the future of ethnic politics and ethnicity?

There are several reasons for the proportionately lower presence of Italian Americans in Congress; some (especially those of a political nature) are obvious, some (those of a psychological and cultural nature) are less evident. Is it possible that *Italianità* may be a factor in holding back some Italian American politicians? Is it possible that the culture of *campanilismo*, so pervasive in the Italy of their grandparents, is still part of their collective unconsciousness? Attachment to the village, the family, friends, the familiar habitat and the desire to serve them on a personal basis, very much part of southern Italian culture, may still affect the behavior of Italian American politicians.

There is no question that Italian American voters support their fellow Italian American candidates; surveys and polls clearly indicate a strong connection between the two.

Italian American legislators don't have an Italian American agenda. Unlike the Jewish political block which has the preservation of the independent State of Israel as their unifying glue, the Italian Americans do not have a strong issue that cements their unity. Their political leanings range across philosophies, reflecting prevailing societal concerns on public issues. Italian American politicians do not act as a cohesive "ethnic" political bloc. They may benefit from, but do not aim in particular for the Italian vote, and they do not necessarily run on ethnic issues nor govern or legislate in terms of ethnic interests. In fact, because they are not stereotypically ethnic, American politicians of Italian origin can gain party nominations and elective offices in districts and areas where their fellow ethnics are a minority of the population. However, individually and/or collectively they address specific concerns that may be of interest to Italian

Americans. For example, Representative Frank Annunzio from Chicago spearheaded a campaign in Congress to have Columbus Day proclaimed a national holiday. More recently, Congressman Vito Fossella Jr. from New York introduced a resolution, which was passed, to recognize Meucci's invention of the telephone.

Although Italian Americans unquestionably still tend to vote in large numbers for Italian American candidates, their votes also reflect political affiliations and ideological beliefs. When Italian Americans first gained a political consciousness they adhered to the Democratic Party. However, by the 1990s there was a clear movement to the right of the political spectrum with an apparent trend away from the Democratic Party and towards the Republican Party, with the result that the leaders of today tend to be more mainstream or conservative. In 1979, twenty-seven of the thirty-one Italian American congressional members were Democrats, with four Republicans. In 1995, figures continued to show a majority of Italian American members of Congress as Democrats, yet only by a very slim majority. If New York is taken as an example, a similar inclination can be detected. For the better part of the past century the overwhelming majority of Italian Americans in the New York state legislature were Democrats. However, in 1974 there began a persistent trend for Republican Italian Americans to outnumber Democrats as members of the state legislature.

This shift may be easily explained. With the migration of Italian Americans from urban centers to the suburbs, any community identity that survived had to be based on a unified body of interest that developed almost entirely from voluntary associations and self-conscious identification with Italianness. Today the city cannot be the reference point to assess the position of Italian Americans in politics; the metropolis is not the main place of residence for most Italian Americans. For instance, outside the city of Chicago, Italian Americans now play meaningful roles in suburbia as county executives, mayors, district attorneys, and legislators. Westchester, Nassau, and Suffolk counties in New York provide similar examples.

The end of the 20th century found Italian Americans moving from distinctly peripheral to major political positions. The history of their involvement over the course of the past century is one of evolution from a marginal to a leadership role. As they began to be perceived as less ethnic, their presence at the national level increased. The candidacy of Geraldine Ferraro for vice president played a significant part in this evolving process. Scores of Italian Americans have served in presidential administrations and a number of Italian Americans have served as top-ranking generals in the military. Two out of nine justices of the Supreme Court—Antonin Scalia and Samuel Alito— are Italian Americans, appointed by Republican presidents. John J. Sirica, chief federal judge for the U.S. District Court of the District of Columbia, presided over the Watergate case and ordered the enforcement of the subpoena which obliged President Richard Nixon to turn over the infamous tapes. Judge Sirica's decision ultimately led to President Nixon's resignation in 1974. Under the leadership of U.S. Congressman Peter Rodino, chair of the House Judiciary Committee in 1974, the bipartisan committee investigating President Richard Nixon's actions recommended that he be impeached. It would have been the second impeachment trial of a sitting president in U.S. history, but instead, Nixon resigned. Elected to Congress in 1948, Rodino also helped introduce the law that made Columbus Day a national holiday in the 1970s.

The future of ethnic politics is difficult to predict even for students of ethnic politics. They are puzzled by the fact that in the face of increasing assimilation, ethnics continue to vote as ethnics with almost the same frequency as in earlier decades. It seems that social changes do not reduce the political importance of national origins. In our multicultural society, where we take pride in our cultural heritage, ethnic voting may be with us for a long time to come. Part of the reason for the persistence of ethnic voting may rest in the political system itself: the system (i.e., party, precinct workers, candidates, elections, patronage, etc.) continues to rely upon ethnic strategies. In addition, family-political identification plays a role: voting studies show that as many as four-fifths of all voters maintain the same party identification as did their parents. Also, the emergence of highly salient ethnic candidates and issues may cause a dramatic realignment, so that a particular party becomes the repository of ethnic loyalty even after the ethnically salient candidate and issues have passed. This general assessment is certainly valid for Italian Americans.

What is it, then, to have an Italian American identity? Can it survive the growing numbers who have grown up in ethnically mixed families and outside of very ethnic environments? Ethnic identity has its own unavoidable dynamics. The greater intensity of Italians' ethnic identity is linked to their demographic distinctiveness as a group, a distinctiveness that is being eroded by rising intermarriage, educational and residential mobility, and generational change. Perhaps intermarriage, as a genetic integration, will hasten assimilation; where hate has failed, love may succeed in obliterating the ethnic consciousness. However, the acceleration of social assimilation does not imply a faster acculturation. Indeed, what we have been witnessing is a slow-down of acculturation in our multicultural society. In the case of Italian Americans, we have seen the reverse process.

In fact, people of Italian heritage identify more strongly with their roots than any other group of European ancestry, according to the U.S. Census Bureau. They also are the only European group whose number increased in the last census. This difference can be explained by the fact that Italian Americans have gained a stronger sense of pride about their cultural heritage. Today no Italian American suffers an inferiority complex because of his or her name. Certainly education has made a big difference; but equally important is the impact of the high achievements of a large number of Italian Americans in every sector of American life. That has unquestionably boasted our collective ego. And Italy's image in the world not only as an economic power, but especially for the creativity and flair of the life of its people, has also had an impact on our image. Ethnic identity is not only reactive but proactive, not only a defense against derogatory stereotypes or a compensatory assurance of group worth, but a positive enjoyment, a celebration of our history and culture in this country and in Italy. It is a way of connecting with others in what too often is a friendless and ruthless market society, a nurturing identity that is larger than the self yet smaller than the nation.

In this way Italian ethnicity, seen out of the context of a struggle for social justice and economic survival, acquires a dimension that goes beyond nostalgia and sentimentality, and flies in the face of the stereotypes that have weighed down upon Italians. Thus, not only do we realize more of ourselves, but we connect to more of the world, especially to the class realities that compose so much of life, yet remain too often unmentioned and unnoticed.

Fascism in Little Italy

Dividing Italian Americans

Thomas Edison called Benito Mussolini "the greatest genius of the age." Winston Churchill told him, "If I were an Italian, I am sure I would have been with you from beginning to end in your struggle against the bestial appetites of Leninism [Communism]." In the aftermath of World War I, as Communists and Fascists battled each other throughout Europe, Mussolini's strong hand in governing Italy (beginning in 1922) impressed world leaders and the international press. How could he—and his Fascist philosophy—not win some favor with Italian immigrants and their children who responded to his message of pride in Italy's history and its future? Mussolini seemed to be remaking Italy as a player on the modern stage, a staunch defender against Communism with a vision of a second Roman Empire.

Fascist Italy was intent on expanding territory and building up colonies. Weren't those emigrants already living overseas a kind of colony? In 1927 the Italian government established the *Direzione Generale degli Italiani all'estero* (General Directorate for Italians Abroad) to spread political and ideological propaganda and form *Fasci* in countries, like the United States, with large Italian populations. The directorate appealed to Italians in America who had suffered insults to their national character and personal discrimination for decades.

Much of the Italian American press supported the Fascists. *Il Progresso Italiano*, owned by Generoso Pope, lauded Fascism. It had the widest circulation of any Italian American newspaper in the United States. Pope himself was knighted by Mussolini in Rome. The stridently anti-semitic Domenico Trombetta called his Italian language newspaper, *Il Grido della Stirpe* (The Cry of the Tribe), "the faithful voice of Fascism in North America." (Carlo Tresca, an anarchist and ardent anti-Fascist, labeled the newspaper *Il Grido della Trippa*—The Cry of the Tripe.)

There were also Italian American Black Shirts, mirroring the paramilitary groups formed by Mussolini in Italy to silence resistance and ensure that the people were uniformly Fascist. In 1925, under Mussolini's order, the Fascist League of North America was or-

First Friend, Then Enemy

The majestic landing of seaplanes led by Italo Balbo on Lake Michigan on July 15, 1933 (above) was highly praised in America. The fleet of ninety-five hydroplanes that had crossed the ocean was presented as "Italy's roaring Armada of good-will." A street in Chicago was named after Balbo; as of May 2013, it is still dedicated to one of the closest collaborators of Mussolini, despite many petitions, the last signed in 2011 and supported by numerous personalities linked to the Italian community in Chicago.

The United States did not fully understand the horror of Fascism in Italy until after the declaration of war on the United States. The declaration was signed by Adolf Hitler and Mussolini after the Japanese attack on Pearl Harbor. Russell Lee photographed a caricature of the two dictators, mocked by Uncle Sam, painted on a wagon in Texas (facing page, bottom).

ganized. About fifty Fascist clubs formed in New York. The movie theater Cine Roma showed Italian-made films like *Dynamic Fascism* and *Decaying Democracy.*

The height of Mussolini's popularity came in 1929 when the Lateran Accords were signed under the papacy of Pius XI. Since the 1870 takeover of Rome, the Catholic Church's relationship to the government was wary and problematic. The treaty made Vatican City a sovereign state, mandated religious instruction in every Italian school, and required the state to pay parish priests. It made Mussolini a hero to Catholics worldwide, including in the United States.

Although many Italian Americans admired Mussolini, many fewer embraced Fascism or understood what was really happening politically in Italy. Political exiles arriving from Fascist Italy helped to set the record straight. These included Count Carlo Sforza, who had been the Italian Minister of Foreign Affairs; the novelist Giuseppe Antonio Borgese; conductor Arturo Toscanini; Luigi Sturzo, a Sicilian priest, and a staunch anti-Fascist who encouraged opposition to Mussolini's policies from his home in Brooklyn.

Many of the earlier political exiles already living in the United States, though aging, expressed anti-Fascist sentiments. Labor leaders and anarchists also spoke out. Arturo Giovannitti and Gildo Mazzarella, veteran unionists of the Lawrence, Massachusetts textile strike, promoted anti-Fascism. American organizations included the Anti-Fascist Alliance and the Mazzini Society—named after Giuseppe Mazzini, the Italian unification leader. Anti-Fascist newspapers included *The Free Press* and *The New World.*

Carlo Tresca, already well-known as a leader of the militant IWW union, published a series of virulently anti-Fascist newspapers. When Mussolini assumed power in 1922, he called the event "a return to the happy days of the Inquisition." Tresca produced and wrote *Il Martello* (The Hammer), a newspaper Mussolini's government considered slanderous. Tresca was jailed several times, and American Black Shirts destroyed *Il Martello*'s offices and printing presses. In turn, Tresca and other anti-Fascists disturbed Fascist meetings, causing enough furor to summon the police and fire departments, which effectively shut down the meetings. Fighting between Fascist and anti-Fascist Italian Americans led to the murder of two Black Shirts in 1927. Tresca himself was shot at four times.

One of the anti-Fascists' most powerful messages was that love for Italy and love for Fascism was not the same thing. They tried to point out contradictions between what the pro-Fascist press said and what really happened in Italy. But what completely eroded support for Fascism among Italian Americans in the United States was Italy's declaration of war against the U.S. on December 11, 1941. The pro-Fascist publisher Generoso Pope was among the millions who declared and demonstrated their loyalty to the United States.

ARTURO TOSCANINI

Critics and Supporters

Steamers coming from Italy indiscriminately carried supporters and opponents of Mussolini—the Duce: on one side the opera singers Giovanni Martinelli and Giuseppe De Luca openly showed their support with the Roman salute (above); on the other, Arturo Toscanini (right), who left Italy in 1938, became one of the most vocal opponents of Mussolini. He also directed the concert celebrating the fall of the dictator in July 1943. Italian newspapers abroad were crucial in convincing the "colonies" to support Italian foreign policy. Writers for the "subversive" periodicals, however, rallied against Mussolini's propaganda, including Girolamo Valente (bottom left), editor of the progressive Italian weekly, *La Parola*. Behind him is a portrait of the socialist congressman Giacomo Matteotti, murdered on the orders of Mussolini in 1924. Still, in 1939, Italian officials were invited to Washington, D.C. to attend demonstrations on new methods for training pilots (bottom right).

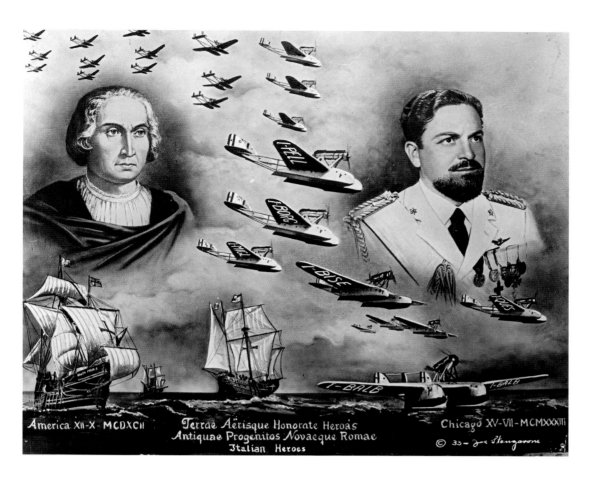

America XII-X · MCDXCII

Terrae Aërisque Honorate Heroäs
Antiquae Progenitos Novaeque Romae
Italian Heroes

Chicago XV-VII · MCMXXXIII

© 33 - Joe Stengarone

The Italian Communities

For the first time since the unification of the country, Fascists presented Italy aggressively on the international stage, expressing their desire to recover the glories of the ancient past when Italians ruled the Western world. This strong image of the distant homeland naturally appealed to emigrants who from the first day that they set foot on foreign soil—not only in America—were labeled as inferior. Admiral Italo Balbo's venture became an example of greatness compared to that of Christopher Columbus, the noble father of all Italians in America (left).

Fasci Italiani

Fascists based their policy towards Italian communities worldwide on the slogan, "We must abolish the word emigrant and replace it with 'Italians abroad.'" To increase political control over emigrants, Mussolini created the *Fasci Italiani all'Estero*. Pietro Parini, who led them from 1928, wrote in the article "To the Comrades across the Alps and Overseas," published in *Il Legionario*, "You cannot nor should insist that all Italians abroad are heroes or integral Fascists. Remember that the tumultuous and uncontrolled emigration for over 40 years has been a real shame for Italy. . . . These poor brothers went abroad like whipped herds and with a great discouragement in their heart. For them, our country had been for decades a country where there was no bread. . . . What do they know of the new Italy and of Fascism? You have to approach them, educate them, turn them into the pride of the new Italy that does not forget its distant children. With kindness, education and willing assistance, you will gain the hearts of your brothers who will be the best among the Italians, because they have experienced the unforgettable hours of the struggle for survival." These words conquered many emigrants despite the dissolution of *Fasci* in the U.S. in 1929. They were replaced by a subtler propaganda, carried out by associations, clubs and other Italian organizations in the United States (right, an illustration printed in New York with the symbol of *fasci*—the bundle of rods—and the Roman eagle).

The Image of a Dictator

For a long time, Benito Mussolini was perceived in the United States as a strong and determined man, perhaps the only one able to bring back Italy's past glories. Only as war approached and he allied with Hitler beginning in 1936, did the American public begin to grasp the most dangerous aspects of his government.

Three cartoons by Herbert Block—known as Herblock—drawn between 1935 and 1940, show the evolution of this process. In 1933, he became the cartoonist for the Newspaper Enterprise Association, which distributed his work to newspapers across the nation. He won the Pulitzer Prize four times.

The first cartoon (left, July 1935) shows the *Duce* on horseback dominating his new empire, with the title referring to the ancient Roman empire: "The roads that stretch across 20 centuries." The second illustration (bottom left, 1937) portrays Mussolini with irony, but also with some admiration: his theatrical poses could inspire Hollywood celebrities. His intense gaze would work for Lionel Barrymore, his statuesque physique for Tarzan, and his roar for the MGM lion. The last cartoon (bottom right) shows that the time for joking is over. Europe is already at war. All the inhabitants of the old continent must raise their arms in salute in front of a German soldier with Mussolini's features; while on the other side of the ocean, the raised arms are those of the Statue of Liberty, the last bastion of democracy, and those of Franklin Roosevelt and Wendell Willkie's supporters. They are competing in free elections for the U.S. presidency.

Explorers, Emigrants, Citizens

Jewish Italians Fleeing to America

The first dramatic rift between Italian public opinion and the Fascist regime came with the racial laws issued in November 1938. They marked the point of no return in the alliance with Nazi Germany and abolished all civil rights for Italian Jews. Those who taught were expelled from schools, as were Jewish students. Businessmen were forced to close their stores. About five thousand Italian Jews were able to leave the country and make their way to other European countries and North and South America. Some brought their immense and diverse talents to the United States. Among them, were Mario Castelnuovo Tedesco (left), who after fleeing from his native Florence, found refuge in Hollywood, where he became a popular soundtrack composer; and Franco Modigliani, a future Nobel Prize winner for economics. But it was Enrico Fermi (bottom right) who left the deepest impression. Married to Laura Capon, of Jewish descent, he decided to join his colleague Isidor Rabi at Columbia University (bottom left, is a letter from Fermi to Rabi). He continued the research he began in Italy at the University of Chicago and was instrumental in the development of the atomic bomb.

ITALIAN SCIENTIST JOINS COLUMBIA

Professor Enrico Fermi, a leading scientist of Italy and winner of the Nobel Prize in physics in 1938, declared today at Columbia University that he came to this country to work and will remain here indefinitely.

He will be a visiting professor in theoretical physics at Columbia for an indefinite period. He was interviewed briefly in the office of Dean George B. Pegram, of the

Prof. Fermi Denies He Came Here Because of Race Laws

Professor Fermi declared published reports from Rome that he had left Italy to settle in the United States because the discriminatory racial laws of Italy had convinced him it would be impossible for him to continue his work satisfactorily there, were not entirely accurate.

"I did not leave Italy because of any racial considerations," he said. "I have work to do here and I will remain here indefinitely. I have not yet decided whether I will return to Italy when my work here is completed."

REALE ACCADEMIA D'ITALIA Rome, May 8 th, 1938

Dear Rabi,

Dr. Antonio Rostagni, who is now professor of Physics at the University of Messina, has asked me, to write to you about the possibility of coming this summer to Columbia in order to work under your supervision.

He has just received a fellowship of the Accademia d'Italia, and would be able to come to New York towards the 15 th of June.

His experience has been so far mostly in the field of neutral rays, cross sections for ionisation and neutralisation of molecules and similar topics; he worked some time in Berlin with Kallmann on this subject.

Now he would like to learn the tecnique of molecolar rays, from your school.

So far as I know Rostagni is a very serious worker, and certainly does not lack of good will and endurance. His age is from 30 to 35.

Please let me know whether you can receive him. You can write directly to me, or to Rostagni himself. His adress is: Istituto Fisico-R.Universita'-Messina

I whish you the best success for your work; I am playing now, without many results, with the cosmic radiation.

Best greetings to you and to all the members of the laboratory

Enrico Fermi
(Enrico Fermi)

World War II

Italian Americans Choose America

World War II was a turning point for Italian Americans. After Japan bombed Pearl Harbor on December 7, 1941, and its ally Italy declared war on the U.S., thousands of Italian Americans enlisted to fight for the United States. It is estimated that anywhere from 500,000 to 1.2 million Italian Americans served in the armed forces. As a government policy, Americans of Italian heritage were usually sent to war in the Pacific. (Japanese American troops were sent to Europe.) But some did fight in Europe and served in the Italian Campaign (1943-1945), which liberated Italy from Nazi control. Armand Castelli, who fought there, had some doubts "at the thought of having to possibly kill my own blood . . . maybe my relatives . . . but we were Americans above all."

Again and again this sentiment was repeated by Italian American soldiers and sailors. Al Miletta believed "we were American soldiers [not Italians] doing a nasty job, and we did it proudly." "There were no Italian Americans, French Americans, or German Americans," recalled Hal Cendela. "We're just plain Americans." Jim Caruso said of Italy, "They were the enemy against my country."

In the first months of war, the American government was not so sure of this loyalty. More than 600,000 Italians living in the United States—not yet American citizens—were declared to be "internal enemies" or "resident aliens." They had to register at a U.S. post office, carry identification cards, restrict travel to five miles from where they lived, and could not own guns, cameras, or short wave radios. Italians who lived on the country's coasts were moved inland for security reasons; many lost their homes and businesses. Italian-language newspapers that had supported Mussolini had to close. Hundreds of Italians were held in detention centers.

Although these measures were far less drastic than those applied to most Japanese Americans—who spent much of the war in isolated internment camps—they were a breach of civil rights. When the restrictions against Italian resident aliens were lifted in October 1942, ten months after the U.S. entered the war, it was also

"Give 'em the stuff to fight with..."

The Portrait of War

After studying photography in Milan, Valentino Sarra moved to the United States in 1921. Within a few years, he had established himself as one of the most respected advertising photographers of his time. In the early 1940s he joined the war effort by becoming one of the photographers of the Office of War Information.

The OWI chose his image for the poster "Give'em the stuff to fight for." Sarra's photo shows an American soldier trying to drag a wounded comrade behind friendly lines as the battle rages. It was hoped that this dramatic image would encourage Americans to contribute funds to support American troops fighting in Europe and the Pacific.

a sign that the government accepted Italians as loyal. As early as two months after Pearl Harbor, 10 percent of Italians who were not citizens had family members who joined the U.S. Army and Navy.

Italian American soldiers and sailors earned many honors; fourteen of them received the Congressional Medal of Honor, including Sgt. John Basilone, whose father came from Naples. He held the defensive line against Japanese troops at Guadalcanal, was sent back to the U.S. to promote war bonds, repeatedly requested to return to active duty, and was killed on Iwo Jima. Capt. Don Gentile, who joined the Canadian Air Force so that he could fight before the U.S. entered the war, downed twenty-five German planes. Col. Henry Mucci headed a group of Army Rangers in a raid that liberated some five hundred survivors of the Bataan Death March from a Japanese prison camp. Biagio Max Corvo followed a different path of service. He developed and directed the Office of Strategic Services spy operations in the Italian campaign. Hollywood film director Frank Capra headed the U.S. Army's Motion Picture Service, making informational movies for American troops.

On the home front, Italian Americans raised money through war bonds, held patriotic parades, and supplied food for the military. Ettore Boiardi—Chef Boyardee—provided more rations to the American and allied forces during World War II than any other supplier. (The U.S. War Department awarded him a gold star for excellence.) So many jobs opened up to produce planes, weapons, and other materiel that Italian Americans, including women, had unprecedented opportunities for employment. Working side by side with other Americans, they were drawn into mainstream American society.

Italian American soldiers, too, were becoming more American. They could advance quickly to more responsible positions in the armed services. "Because the Army was expanding so fast," said Tony Cipriani, "I moved up in grade from private, to private first class, corporal, sergeant, and staff sergeant." Samuel Lombardo was born in Calabria; but as an American infantry officer, he and his unit made the first American flag to fly east of the Rhine River, in German territory. Those who served and were not American citizens were offered the opportunity to become one. Tony Pilutti, who parachuted into Normandy on D-Day, chose to be an American citizen: "It was one of the proudest moments of my life."

World War II took Italian servicemen and civilians beyond their Little Italies. Two or three generations removed from their 19th century forebears, they were American-educated, acquired job skills that increased their earning potential, increasingly married non-Italians, and chose suburban over city living, following the course of the American dream.

The Italian Campaign

The cover of the book *The Final Campaign Across Northwest Italy* shows American troops crossing the Po river, the last obstacle in the conquest of the Italian territory. The German Army was finally driven out of the country on April 25, 1945. The creator of the cover is Sergeant Anthony Battillo, from Brooklyn. He became a "combat artist" during the latter stages of the conflict. Battillo is one of many Italian Americans who participated in the Italian campaign, begun nearly two years before with the invasion of Sicily on July 10, 1943. After September 8, 1943, and the armistice with the Italian Army, Allied troops were joined by a growing number of young Italians who fought on the frontline to liberate their country from dictatorship.

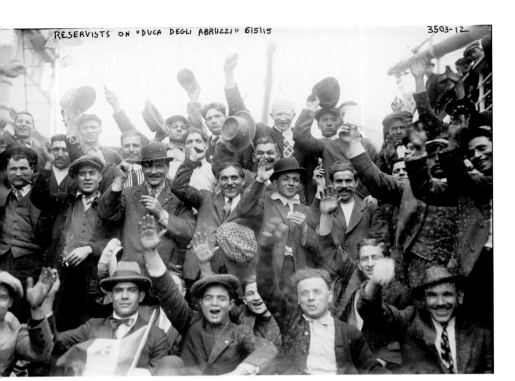

RESERVISTS ON "DUCA DEGLI ABRUZZI" 6/5/15 3503-12

Italians in World War I

World War I was a crucial time for the formation of a national consciousness in Italy. Before America entered the war, some Italian emigrants returned to fight in their country's army (left), while others accepted the call to save food to be sent to the troops in Italy (bottom left).

In April 1917, the U.S. joined the conflict (bottom right, Uncle Sam is portrayed supporting the democratic powers allied with the U.S.). The American government stressed the contribution of new immigrants with posters such as "Americans All" (facing page, top right) listing the names of soldiers of all nationalities, from the French Du Bois to the Spanish Gonzales, passing through the Italian names Andrassi and Villotti. The photograph of little Peter Randazzo alongside the gigantic Alf Jacobson (facing page, top left) also emphasized that different ethnic groups contributed to the war effort.

Many Italians enlisted in the U.S. Army: among the 2,285 New Yorkers (facing page, bottom), the first name in the list is Abbate J. followed by Acchiardi, Addonizio, Alto, Altrano, Ammaturo, Angeletti, Antonelli—and those are only the names starting with "a."

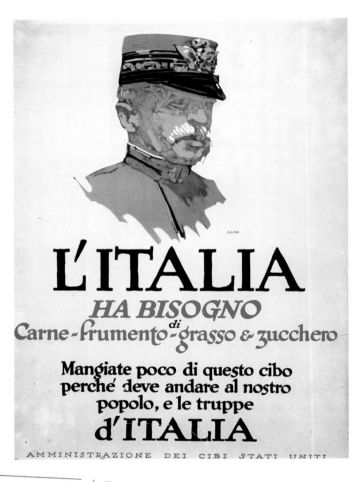

L'ITALIA
HA BISOGNO
di
Carne - frumento - grasso & zucchero

Mangiate poco di questo cibo
perché deve andare al nostro
popolo, e le truppe
d'ITALIA

AMMINISTRAZIONE DEI CIBI STATI UNITI

NOW, ALTOGETHER!

צו אלע אויסלענ...

A TUTTI I FORESTIERI

SE LA GUERRA ha mutato le vostre condizioni di VITA
o di LAVORO.

SE VOLETE imparare la LINGUA AMERICANA e diventare un CITTADINO.

SE DESIDERATE IMPIEGO, CONSIGLIO o INFORMAZIONE,

senza nessuna spesa.

Rivolgetevi alla—

STANZA 1820, PALAZZO MUNICIPALE
COMITATO DEL SINDACO PER LA DIFESA NAZIONALE
COMITATO per i FORESTIERI

TO ALL

ALIENS

IF the WAR has affected your LIVING or
WORKING conditions,

IF you WANT to learn the AMERICAN LANGUAGE and become a CITIZEN,

IF you WISH Employment, Advice or Information,

Without Charge.

AN SÄMTLICHE NICHT NATURALISIERTEN AUSLÄNDER:

Diejenigen, deren EXISTENZBEDINGUNGEN oder ARBEITSVERHÄLTNISSE infolge des KRIEGES geschädigt sind,

Die die AMERIKANISCHE SPRACHE zu erlernen und das BÜRGERRECHT zu erwerben wünschen.

Die BESCHÄFTIGUNG finden oder RAT bezw. AUSKUNFT einholen möchten, und zwar kostenfrei, sind aufgefordert, sich zu melden in

MUNIZIPALGEBÄUDE, Zimmer 1820

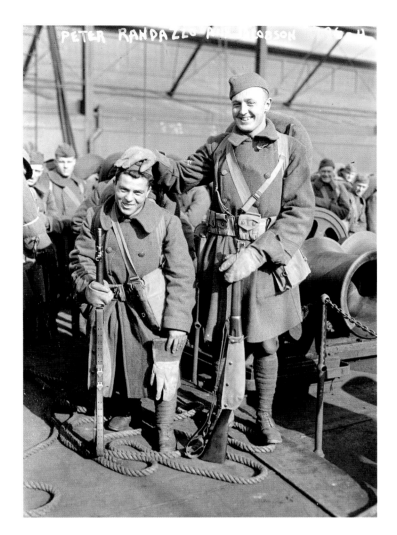

PETER RANDAZZO PAUL ROBSON

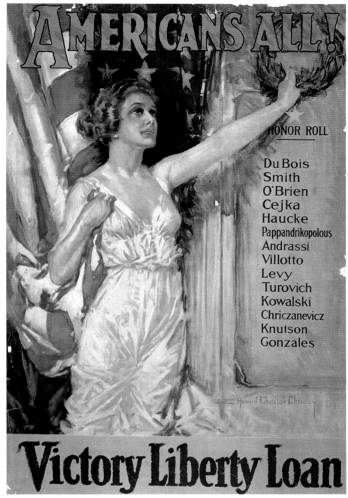

AMERICANS ALL!

HONOR ROLL

Du Bois
Smith
O'Brien
Cejka
Haucke
Pappandrikopolous
Andrassi
Villotto
Levy
Turovich
Kowalski
Chriczanevicz
Knutson
Gonzales

Victory Liberty Loan

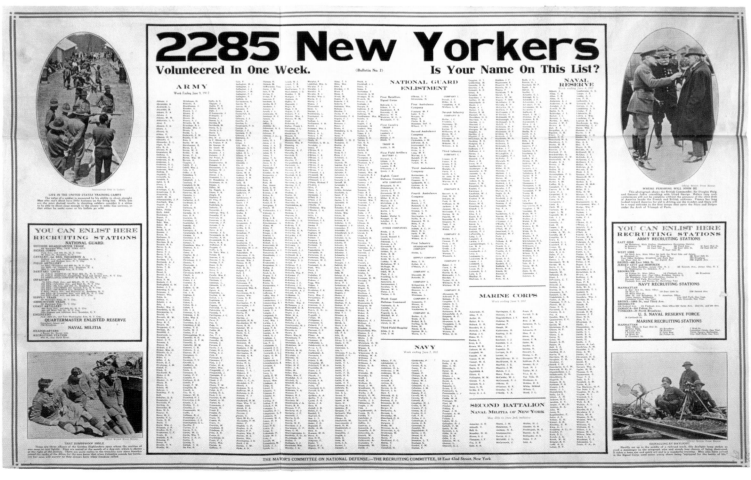

2285 New Yorkers
Volunteered In One Week. (Bulletin No. 2) Is Your Name On This List?

Going to War against Italy

A few days after the Japanese attack on Pearl Harbor, the words of the leaders of two nations decided the fate of millions of Italians on both sides of the ocean. Roosevelt solemnly declared before Congress, which would vote unanimously for the declaration of war against Italy and Germany: "The forces endeavoring to enslave the entire world now are moving toward this hemisphere . . . Never before has there been a greater challenge to life, liberty and civilization." Mussolini, standing on the balcony of the Palazzo Venezia in Rome, vehemently proclaimed: "The powers of the steel pact, Fascist Italy and Nationalist Socialist Germany, ever closely linked, participate from today on the side of heroic Japan against the United States of America. . . . The formidable blows that on the immense Pacific expanse have been already inflicted on American forces show how prepared are the soldiers of the Empire of the Rising Sun."

Italians in America sided with Roosevelt without hesitation, entering war against their country of origin, a decision expressed in the cartoon (right) showing Italian barber Tony Spumani and Greek restaurant owner Nick commenting on the progress of American troops, declaring, "Our country—she's doing hokay."

When Italians could not enlist they contributed by volunteering, like the shoemaker (bottom left) who was on duty as an air warden; and the children (bottom right), who collected and separated waste.

© The Herb Block Foundation

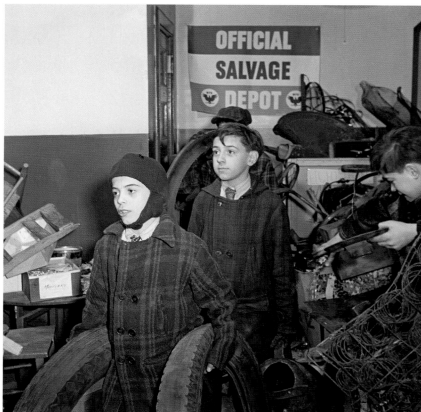

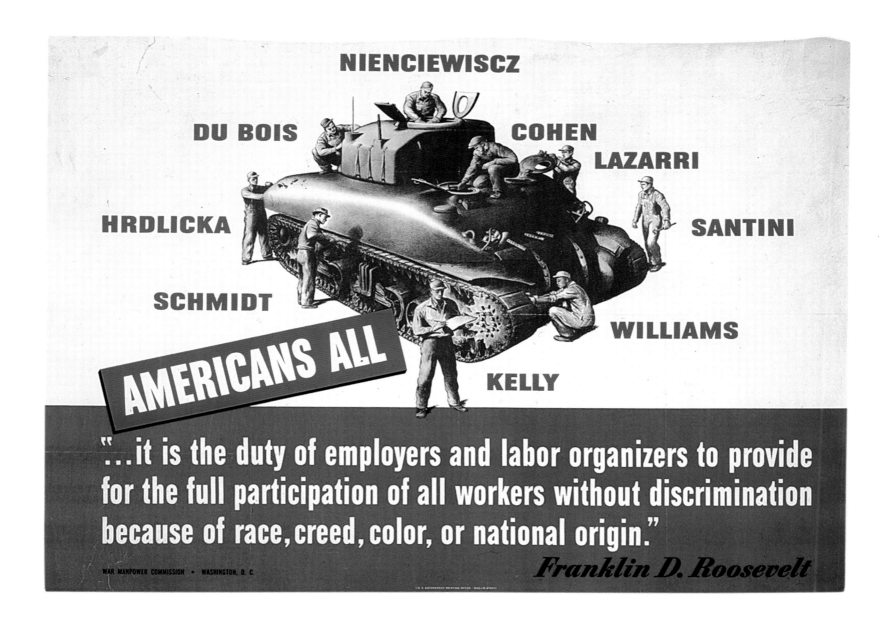

NIENCIEWISCZ

DU BOIS

COHEN

LAZARRI

HRDLICKA

SANTINI

SCHMIDT

WILLIAMS

AMERICANS ALL

KELLY

"...it is the duty of employers and labor organizers to provide for the full participation of all workers without discrimination because of race, creed, color, or national origin."

Franklin D. Roosevelt

WAR MANPOWER COMMISSION • WASHINGTON, D. C.

Americans All

U.S. propaganda again used the "Americans All" concept that had been popular in World War I, updating it with a quote from President Roosevelt. The support of Lazarris and Santinis (the two Italian names that appear in the poster above) for America's war effort is well documented. This was not true for the stories of the so-called "enemy aliens," as emigrants from one of the Axis powers were defined. *Una Storia Segreta*, edited by Lawrence DiStasi, and the exhibition "Enemy Alien Files: Hidden Stories of WWII" (both in 2001) described the struggles of Italians who were discriminated against and, in some cases, imprisoned. More than three thousand Italians were held by U.S. authorities during the war. There is a sadly ironic side of this story: on the Atlantic coast, those who were interned (like opera singer Ezio Pinza and boxer Primo Carnera) were sent to Ellis Island, the place that had for decades represented the entrance to American soil. It was a symbolic moment for the whole nation, that this same place should deny freedom to foreigners whose only fault was to come from an enemy nation. For Italians, the classification of "enemy alien" ended in 1942; after the armistice signed with Italy on September 8, 1943, all those who had been deported or interned were released.

The testimony of Sergio Otino, a resident of Berkeley, California, illustrates the confusion felt by Italians who were subjected to restrictions: "I saw my Japanese friends moved out of their homes and taken away, former classmates and childhood friends. My first reaction was one of disbelief. Shortly afterwards we Italian Americans and Germans were similarly treated because they were part of the Tripartite Alliance, the Berlin-Rome-Tokyo axis . . . Non-citizens, my mother among them, were forced to move from their homes to other designated areas, but not to detention centers."

The Home Front

The iconic image of the contribution of women to the American war effort is definitely "Rosie the Riveter," the tough girl in overalls with a scarf on her head, who proclaims, rolling up her sleeves, "We can do it." The model who posed for J. Howard Miller, author of the famous illustration, was a girl of Irish descent, but the real life Rosie was Rosa Bonavita-Hickes. She made the news with her co-worker Jennie Florio for having secured 3,345 rivets in the tail end of a Grumman TBF Avenger torpedo bomber during one six-hour overnight shift in June 1943. Photographers who documented the home front portrayed many Italians, like Helen Gusmerotti and Mary Mignogna, working in Pitcairn, Pennsylvania (right) and a man of Italian descent working in the Douglas Aircraft plant in Santa Monica, California, who is helped by an Italian woman wearing clothes almost identical to Rosie's (below).

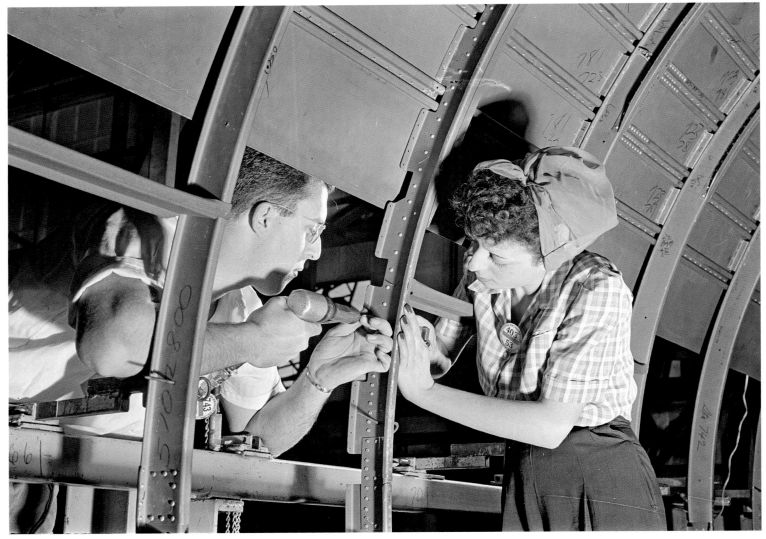

Propaganda

The Office of War Information (OWI), established in 1942, was an important U.S. government propaganda agency during World War II. It included two photographic units that documented America's mobilization and wartime production. This documentation is now preserved at the Library of Congress.

Giuliano Gerbi, standing on the left in this photograph (right), was a sports journalist who left Italy after the racial laws were issued in 1938. He became famous as a radio commentator using the alias "Mario Verdi" when broadcasting a program on "Voice of America."

Below are two posters printed in Italian to increase the support of Italians for the Allied armies: "Fuori i Tedeschi" ("Germans out") shows the German army after the war, represented by Hitler with blood on his hands (left). "Ricominciamo" ("Let's start over") was an invitation to Italians to roll up their sleeves and join forces to rebuild Italy, which, after more than two years of hard fought war, was reduced to rubble.

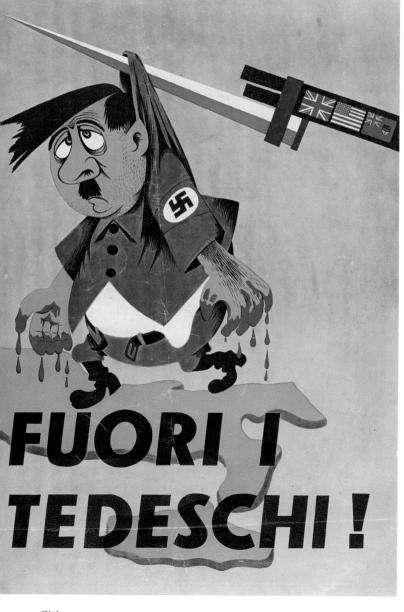

FUORI I TEDESCHI !

Ricominciamo

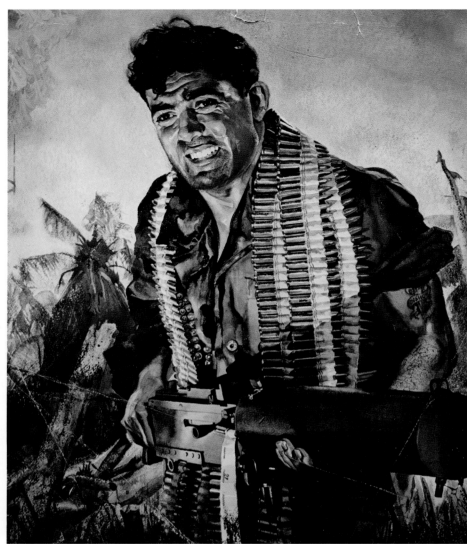

Italian Heroes

Being the mother of a soldier is as difficult in its way as being in the trenches. The strength of mothers forced to watch their children leave, fearing that they won't see them again, represents a particular kind of heroism.

The photograph (top left) shows "Marianna Castorella [who] came to America from Italy forty-odd years ago. She has three sons in the United States Army: Ettore, formerly a bookkeeper in New York, is training at Camp Forrest, Tennessee, and is a lieutenant; Flavius, a lawyer, is a private at Fort Ontario, New York; and Antonio, who worked in Wall Street, is in the Army in Africa."

John Basilone (top right) and Frank Petrarca (right) are two of fourteen Italian Americans awarded the Medal of Honor, the highest award for military valor of the U.S. Army. The medal is given to a member of the U.S. military distinguished for an act of courage, who risks his or her life beyond the call of duty while engaged in battle with an enemy. Both illustrations portray them as popular heroes, halfway between a movie star and a comic book superhero. This kind of representation made it possible to exalt acts of heroism without highlighting the most disturbing aspects of the war. They struck the imagination of young people who might volunteer as soldiers. (The oldest Italian American to receive the Medal of Honor was twenty-nine, the youngest only nineteen, followed by one twenty-year-old and two twenty-one-year-olds.) It is no coincidence that John Basilone became the protagonist of the comic book *Joe Manila Moves Out*, published in October 1943, in the series *War Heroes*.

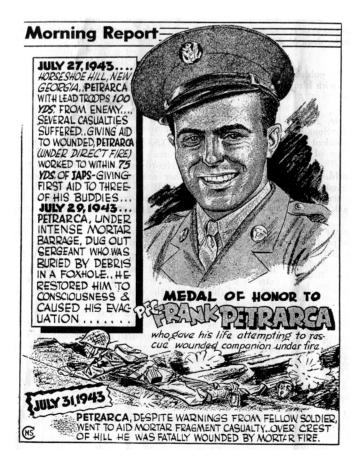

Lieut. Col. Charles Poletti (left), regional commissioner, at his desk in Rome with Capt. Maurice F. Neufield (center), Albany, N. Y., and Maj. William A. S. Dollard, New York City, two members of his staff.
Associated Press

Charles Poletti

Born to a family from Piedmont, Charles Poletti graduated from Harvard Law School, started his political career in New York, and became deputy governor in 1938. He joined the army as a colonel. As the Italian territory was freed from Nazi control, Poletti was assigned the role of military governor of Sicily, Naples, Rome, and Milan from 1943 to 1945. During his tenure he faced both everyday problems such as food supply and the moral and political reconstruction of the country.

In a draft of a document on the history of AMG (the Allied Military Government) he wrote that Italy needed "the foundation on which Italians could bring their country back between those who respect freedom and peace . . . We believe one of the worst sins of Fascism is the destruction of the sense of public morality and civil responsibility." The same report makes it clear that Poletti never considered Americans as conquerors of Italy:

"Never before has a conquering army allowed an occupied nation to have a voice in the management of its own territory while the war is still in progress," he wrote.

Poletti's aide Maurice Neufeld (shown with Poletti in the photo, top right) donated his collection of documents to the Library of Congress. One can read the draft of the first report on the Ardeatine massacre when some 350 Italians were killed in retaliation for an attack by Roman partisans against the Germans; Poletti signed this document (top left) to control the distribution of flour after the liberation of Rome on the letterhead of the Ministry of the Interior. The collection includes letters from well-known personalities such as the Vatican Secretary of State, Giovanni Battista Montini, the future Pope Paul VI (bottom left), and cartoons from the first newspapers published in free Italy (bottom center and right).

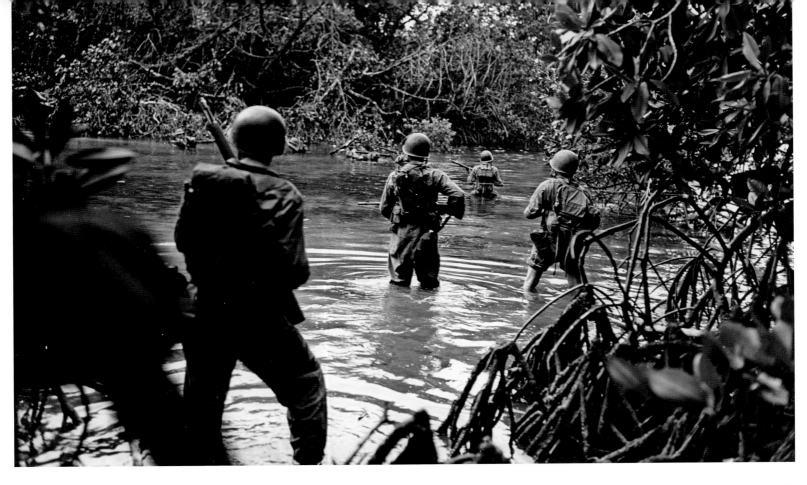

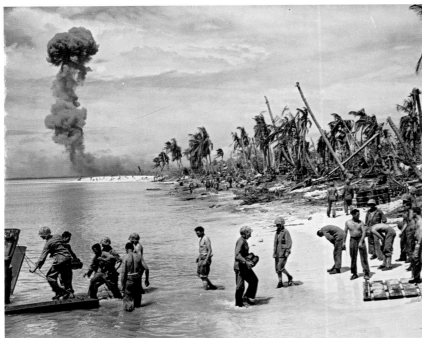

Documenting the War

In the aftermath of Pearl Harbor, Frank Capra left Hollywood to enlist. He directed the documentary series *Why We Fight,* which is still considered a masterpiece of combat movies. Photographers and camera operators assigned to the troops, like John Bushemi and Nick Parrino, documented all fronts of the war. Parrino followed the invasion in Sicily capturing the silhouette of an American soldier before the Monreale cathedral (right). John Bushemi, a native of Indiana, was killed on the beach of Eniwetok (Marshall Islands) in February 1944. He was a well-known photographer for *Yank, The Army Weekly,* the magazine dedicated to the troops. The photo (top) was taken in the Solomon Islands, and the one above on Ennubirr (the Marshall Islands).

Nick Parrino's Sicily

Photographer Nick Parrino followed the Allied troops that landed in Sicily in July 1943. His interesting reportage focused on the historical and architectural beauty of the island, at the same time documenting the meeting of two nations. His images showed Vincent J. Orivello of Milwaukee, Wisconsin who found his relatives in Sicily, portrayed eating ice-cream at a sidewalk cafe in Palermo with three of his cousins (right); a meeting of freed Italian prisoners with their relatives (bottom left); and an Italian policeman joking with an American soldier (bottom right).

Parrino worked with Don Whitehead, a war correspondent and future winner of the Pulitzer Prize, who in his memoirs recounts the time they were questioned by a Maori soldier of the British army: "'Your name sounds Italian' he said accusingly, 'Sure, but I'm American' Nick said, showing his identity card 'See, Henry, in America you can be Italian, German, English, even African and still be American. This is what we call Democracy. If you came to America and got your documents, you may become American too.'"

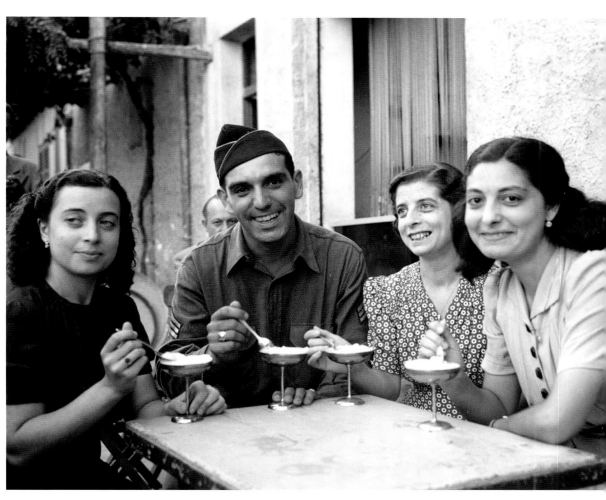

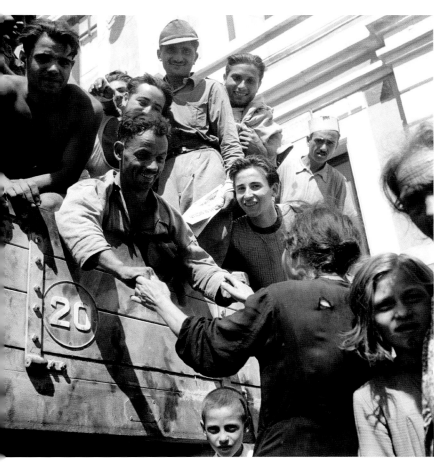

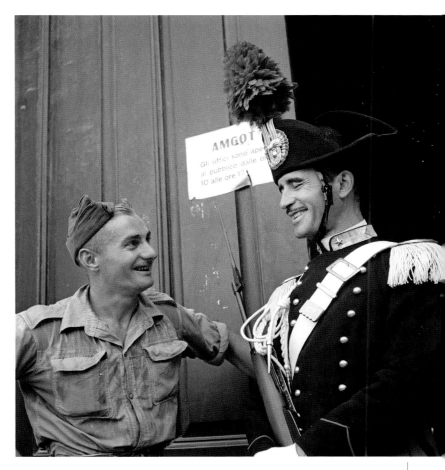

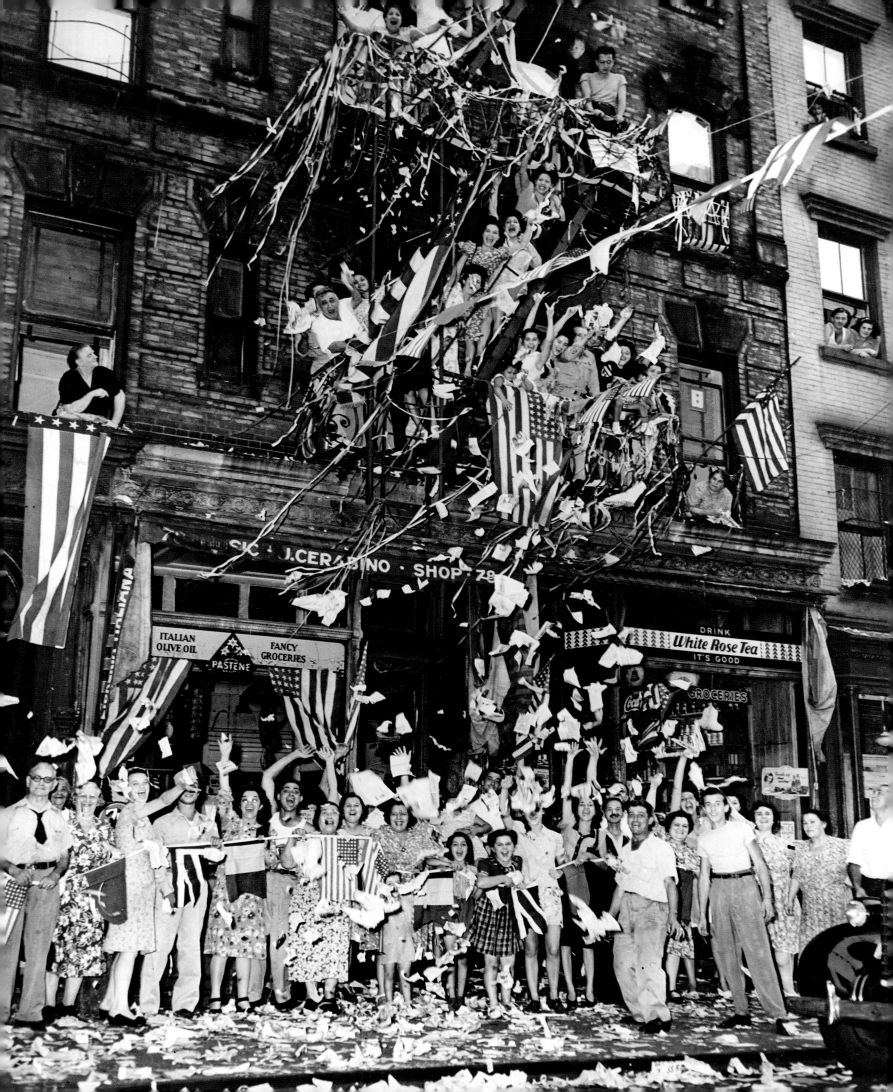

The Aftermath

War ended in Italy on April 25, 1945, but for Italian American soldiers it went on until August with the surrender of Japan. This photograph shows the celebrations on Mulberry Street in Little Italy after Japan's surrender (facing page).

Michael A. Musmanno (right) was a judge at the Nuremberg trials. In his procedural decisions he wrote: "The present trial is one chapter in the book which will forever condemn *Mein Kampf* and offer to the new German nation a volume of proved fact, whose every page will tell of the sorrow awaiting any people which permit any man or men to hoist deceit above truth, power above justice, oppression above tolerance, war above peace."

After the war, Italian Americans tried to influence U.S. policy toward Italy, asking for an extension of support to reconstruct the country. According to this cartoon, "It was an ambitious dream" (bottom right)—the riches promised by Columbus in 1492 finally arrived in Europe through the European Recovery Program known as the Marshall Plan. The complicated political situation in post-war Italy was summarized by the cartoon "Middle of the Road," (bottom left) recommending that Italians keep to the political middle. Supporting the Christian Democrats would avoid the ravine of Fascism and monarchy on the one hand and of Communism on the other. Italians followed this advice: in the 1948 elections the party led by Alcide De Gasperi won, excluding the Communist Party from the government, although it had participated in the struggle for liberation and in drafting the constitution.

It Was An Ambitious Dream—

COLUMBUS, 1492

IF THERE ARE RICHES IN THIS NEW LAND, WE SHALL TAKE THEM ALL BACK TO EUROPE

AMERICA

—BUT THEY MAY MAKE IT *YET!*

1951 -

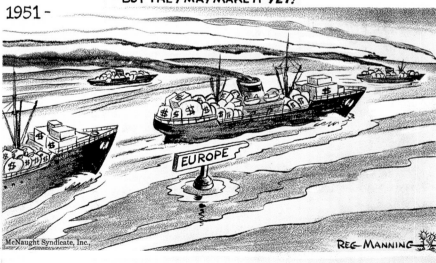

EUROPE

McNaught Syndicate, Inc.,

REG MANNING

Oct 12, 1951

The American Italian

"There are no more ethnic communities precisely defined in terms of space and distributed in a defined area," wrote Italian professor Carlo Carboni of the post-World War II United States. "And probably it is not even correct to speak . . . of hyphenated Italians or hyphenated Irish but there are just Americans: of Italian origin, of Irish origin, and so on, scattered in all states. . . . These Americans showed a strong upward social mobility, and have dramatically increased the percentage of marriages with people from other ethnic groups. However, they still possess . . . the sense of their origins, a sense of ethnic identity."

The idea of the melting pot—that immigrants from different countries would assimilate American language, culture, and values and become more completely American—became reality for second and third generation Italian Americans. By 1920, there were more ethnic Italians born in the United States than Italians who had themselves immigrated. At school and work they wanted to be like other Americans. They spoke English, dressed in up-to-date clothes, moved out of Italian neighborhoods, and changed their names to ones that sounded American. This caused sadness and conflict with the immigrant generation, who saw their children and grandchildren shedding their Italian identities and embracing what to them still seemed like a "foreign" way of life.

The break was not absolute; family remained central to their lives. They were still Catholics—ironically, by the standards of the American church, more Catholic than the immigrants because they regularly attended church, discarding folk traditions. They ate pizza and pasta, which more and more Americans were enjoying. In fact, while American Italians were steeped in American popular culture, they were also contributing to it. Ethnic Italians like Frank Sinatra, Joe DiMaggio, and Jimmy Durante were mainstream American entertainers and athletes, appreciated for their talent and no longer derided for their heritage.

1917 Micca House + Model T Ford

Symbols of Assimilation

A Ford Model T parked before the Micca Ranch in Nevada is the symbolic fulfillment of Ambassador Des Planches's expectations In 1913: "Not only settlers and immigrants generally must not live separately from the Americans, but they also must do their best to become indistinguishable from them: by learning the language, by adopting, for the good part, their uses and customs." An Italian woman (facing page), the mother of two soldiers, portrayed while sewing the Stars and Stripes in Verona, New Jersey offers another visual symbol of assimilation. A pupil in an Italian American class in New York displayed the same flag with pride (above).

Italian Americans in Politics

The Power to Vote

A MOST PRECIOUS HERITAGE- USE IT WISELY

YOUR RIGHT TO VOTE

X

BONELLI

THUR
5-17-62 ← 34 PICAS →

Lessons of Democracy

Carl Bonelli, cartoonist for *The Oregon Journal* and *The Oregonian*, created the cartoon "A most precious heritage," (above) stressing the need to wisely use the right to vote. Although Bonelli's drawing was addressed to the general public, Italians were among those who needed to be educated to democracy more than others. In Italy, most had never had the opportunity to participate in political life: the property requirements for male voters were only eliminated in 1911 and Italian women had to wait until 1946 to vote. That is one of the reasons for the prolonged and marked abstention from voting of Italian immigrants and their American descendants. Furthermore, the immigrant's hope to one day return to Italy led many to postpone requesting citizenship, a basic requirement to become a voter.

Italian writers' and observers' advice to Italian immigrants in the early 19th century was universal: become a U.S. citizen!

"You must become a citizen for the love of your country of origin," was the seemingly paradoxical claim of the 1906 *Guida dell'emigrante*. "In the United States the most respected and honored foreign nations are precisely those whose emigrants become, in greater numbers, citizens." If not for Italy, "a man is worth nothing in the United States until he becomes a voter. As soon as you become a citizen and a voter, you will enjoy high esteem, not only by the general public but also by the police, by the judges, and by all the authorities."

"All immigrants . . . sign the naturalization paper because without it you do not acquire the right to vote, and in America those who do not vote would not succeed," wrote Giuseppe Giacosa in 1908.

Attraverso gli Stati Uniti. Per l'emigrazione italiana explained in 1913 that "naturalization is immediately beneficial to the immigrant, [making] him equal to Americans, who otherwise consider and treat him as inferior. . . . The one who votes is something, the one who does not vote is nothing; voters are feared and respected, those who do not vote, nobody really cares about them."

Italian immigrants had little experience with democratic elections. Italy did not grant universal male suffrage until 1911, and Italian women only got the vote in 1946. However, experience in the United States taught them that political power and its benefits lay in numbers. In the beginning of the 20th century, Irish Americans controlled politics in cities like New York, granting few political offices to Italians. But it was in New York especially that Italian Americans began to emerge as a distinctive political force. In the first and second decades, Italians organized themselves in various ways to form a structured society that connected them to the American cultural and political establishment. This was a time when hundreds of mutual aid societies, as well as the much larger Order Sons of Italy, were founded. Social and cultural organizations strengthened ethnic identity and created political clout. The establishment of this groundwork provided immense benefits to aspiring politicians.

The Democratic Party, in particular, began wooing new voters and candidates, sharing the favors granted by political machines

(entrenched groups, not always honest, which held political power) in major cities. Americans of Italian descent constituted a significant voting block. Political bosses cultivated working relations with an increasingly assertive Italian American population in an effort to maintain their own positions or support allies. In states where Italian Americans made up a large portion of the electorate, such as New York, New Jersey, Connecticut, Pennsylvania, and Rhode Island, their numbers in state legislatures showed gains as did their representatives in the judiciary.

Between 1924-1928 the percentage of Italian Americans voting for Democrats increased significantly in several cities: Philadelphia went from 3 percent to 57 percent; Chicago from 31 percent to 63 percent; Pittsburgh, from 6 percent to 69 percent; and New York from 48 percent to 77 percent. In Rhode Island, Louis Cappeli was elected Secretary of State in 1930. In Pennsylvania, Anne Brancato became the first Italian American woman elected to a state legislature in 1932. The first Italian American to become a U.S. senator, John Pastore, was not elected until 1950. Three mayors were elected in major cities in the 1930s: Angelo Rossi in San Francisco in 1931; Robert Maestri in New Orleans in 1936; and Fiorello LaGuardia in 1933.

LaGuardia was a force in his own right. Elected to Congress in 1916, 1918, and every two years between 1922-1930, he served three terms as New York's popular and energetic mayor from 1934-1945. La Guardia was a Republican (and an Episcopalian). Italian Americans crossed party lines to vote for him. Rudolph Giuliani, another Italian American and a Republican, was elected mayor of New York in 1993 and 1997.

Although judges are usually not elected, but appointed, and are called on to be nonpartisan, it is worth noting that two Italian Americans sit on the Supreme Court in 2013: Antonin Scalia and Samuel Alito.

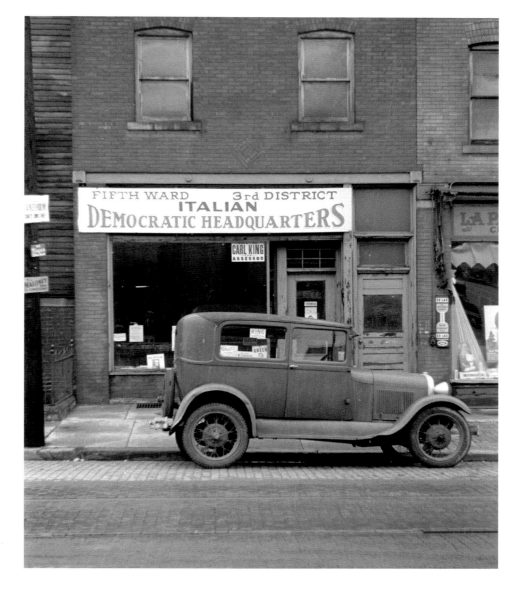

Political Machines

The historian Sergio Bugiardini, in his essay "L'associazionismo in USA," states that "more than political commitment, at the beginning it was vote exchange that pushed the Italian-American vote in North America." In northeastern cities, Italians soon came into contact with political machines (the most famous one was Tammany Hall in New York), which facilitated access to the labor market in exchange for electoral support.

The Democratic party was the first to open its ranks to members of the Italian community (right, the Italian Democratic headquarters of the Third District in Omaha, Nebraska). It opened the way for Italian American candidates, relying on ethnic solidarity to gain votes. Again quoting Bugiardini, "In Rhode Island, for example, the nomination of Italian-American lawyer Louis Cappelli and his election as Secretary of State in 1930 corresponded with the growth of his ethnic group's support of the Democratic Party."

Holding Office in the 19th Century

One of the first Italian Americans to hold a public office was John Phinizy (originally from Parma), mayor of Augusta, Georgia in 1834 (Phinizy's residence, left). Other Italian Americans attained important positions in the South, mentioned by Ambassador Des Planches: "I receive the visit of Mr. Andrew Houston Longino, who [served] . . . in the office of the Governor of Mississippi. . . . He was born in Mississippi to an Italian father and an American mother." Only two Italian Americans were elected to the House of Representatives in Washington D.C. in the 19th century: Francis B. Spinola in 1886 and Anthony Caminetti, from California, in 1890. Spinola, a former Union officer in the Civil War, became one of the most influential members of New York's Tammany Hall. He is shown (below) with other Democrats, disappointed at not receiving senior positions in President Grover Cleveland's administration.

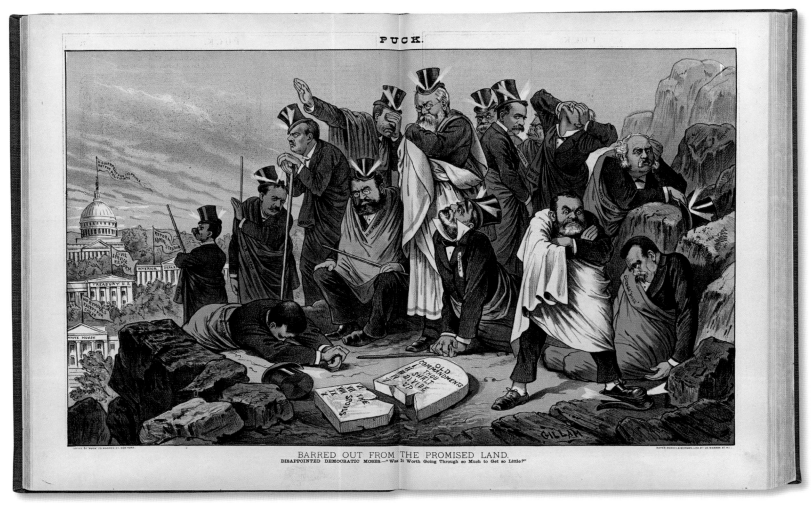

Almost Italians

Charles Bonaparte, secretary of the Navy under Theodore Roosevelt (above, shown with Roosevelt) and Alfred E. Smith, the first Catholic candidate for President of the United States, are often mentioned as politicians of Italian origin. Smith is shown (right) on his 1928 electoral poster, and throwing out the first pitch at a Yankees game when he was governor of New York (below). In fact, it is a stretch to consider Charles Bonaparte of Italian origin since Corsica, where Napoleon Bonaparte's family originated, was under French rule as early as 1768.

Al Smith was of very humble extraction—the *New York Times* said that "no other city urchin, earning a precarious living in the streets in his early days, ever rose so superior to his lack of youthful advantages and had so distinguished a public career." He came from a family of Irish, German and Italian descent. During his career, he never claimed his Italian origins (according to some sources, the name of his father was Ferrara), but thanks to the fact of being Catholic, he had many Italian supporters.

★ **FOR PRESIDENT** ★

ALFRED E. SMITH

HONEST - ABLE - FEARLESS

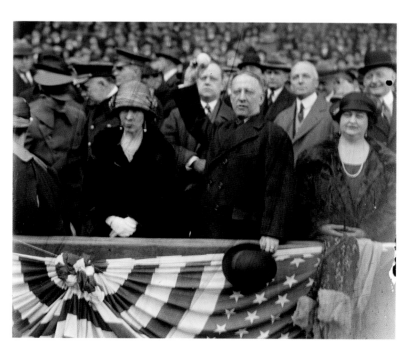

Fiorello!

Fiorello LaGuardia was certainly one of the most well-known Italian politicians of the 20th century. Nicknamed "the Little Flower," LaGuardia (above) is shown with President Roosevelt (to his right is the first lady Eleanor). One of LaGuardia's first jobs was as an interpreter at Ellis Island where he looked on the procession of thousands of compatriots that came to seek their fortunes in America. In 1916, at the age of thirty-four, he was elected for the first time to Congress as a Republican. He served as a congressman until 1933, when he initiated the tradition of Italian American mayors in New York City.

During his political career he held numerous offices, as cartoonist Herblock highlighted in "LaGuardia at Work" (facing page, top left). LaGuardia enjoyed an immense popularity, confirmed by this caricature (left) by Irving Hoffman, who specialized in portraying showbiz celebrities. Even Broadway dedicated the musical Fiorello! to him. In the musical poster (facing page, top right) he was represented with his trademark hat.

The naming of New York's first airport—opened in 1939 and officially named after him in 1947, the same year La Guardia died—recognizes the affection felt for him by the city where he served as mayor for over twelve years.

IRVING HOFFMAN
247 PARK AVE
PLAZA 3

THEY CAN'T DO THAT TO CAROLINE......

Italian Mayors

This photograph (right) shows Fiorello LaGuardia (seated on right), president of the U.S. Conference of Mayors, and Angelo J. Rossi meeting the mayor of Havana, Cuba, Antonio Mendieta Beruff at a mayors conference in Washington, D.C., in 1937.

LaGuardia was the most celebrated of a generation of Italian Americans administrators, some of whom served as mayors of important cities. Angelo Rossi, the son of a man who immigrated to California at the time of the Gold Rush, was elected mayor of San Francisco in 1931. During his mandate, the Golden Gate Bridge was built. Robert Maestri, a New Orleans real estate investor, started his political ascent by supporting Louisiana Governor Huey Long. He quickly became the mayor of New Orleans. "Rarely were his methods conventional," noted scholar Edward F. Haas in the essay "The Maestri Era," "but they invariably evinced a basic directness that clearly reflected the Maestri personality and the Long training. Good or bad, the new mayor got things done."

New York 1950: the Italian Campaign

In 1950, New York voters could choose between four mayoral candidates, and three of them were Italian American.

Vincent Impellitteri (left, with General Douglas MacArthur) was born in 1896 in Sicily and arrived at Ellis Island as a child. A graduate of Fordham Law School, he had already served twice as president of the city council and ran in the mayoral election as an independent candidate. Ferdinand Pecora (bottom, left) came from Sicily too: he was born in Nicosia in 1882. Despite growing up in poverty in New York, he was a lawyer at twenty-nine years old. Before the 1950 election he had served as a judge on the New York Supreme Court. He was the Democratic candidate. Edward Corsi (below) was the son of Filippo, an Italian congressman and socialist activist. At his death, the family moved to New York, where Edward became Commissioner of Immigration at Ellis Island in 1931. In 1950 he was the Republican candidate. Impellitteri won the mayor's seat, beating Pecora and Corsi, Paul Ross, the only non-Italian American candidate, was fourth by a considerable distance.

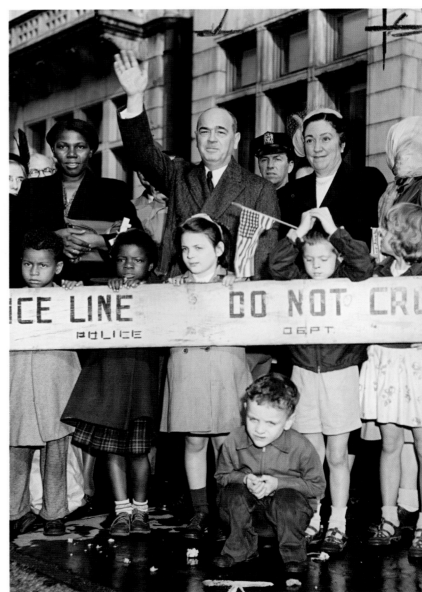

Explorers, Emigrants, Citizens

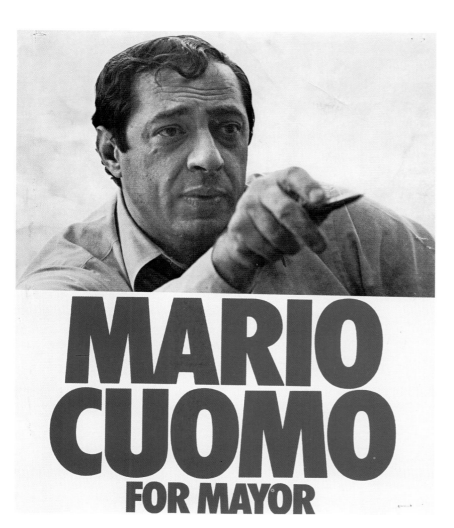

New York Political Tradition

Italian participation in politics peaked in several parts of the Northeast, but it was in New York that Italian American politicians gained enough visibility to affect public opinion in Italy. After Mario Cuomo was elected governor of New York in 1983 (a position he held until 1994), the *New York Times* reported the sudden fame of the name Cuomo in Nocera Inferiore (Campania), the town of origin of his family: "When a local television station invited five Cuomo first cousins to the studio for a chat, via satellite, with the Governor-elect last month, 50 people showed up, some vaguely related, many not at all. Big News in Italy." Rudy Giuliani, who served as mayor of New York City from 1994 to 2001, found his way into the Italian news too. As early as 1988, when he was a federal prosecutor, Italian newspaper *La Repubblica* described him as: "Rudolph Giuliani, Rudy to his wife and a few friends, 43-year-old idol of Italian Americans. He is an Attorney General by profession: he put in jail Mafia hitmen, financial swindlers, corrupt administrators and whores." Giuliani is portrayed by courtroom artist Marilyn Church during a trial (below). He worked with Italian judges Giovanni Falcone and Paolo Borsellino in the "Pizza Connection" investigation involving the Mafia's international affairs.

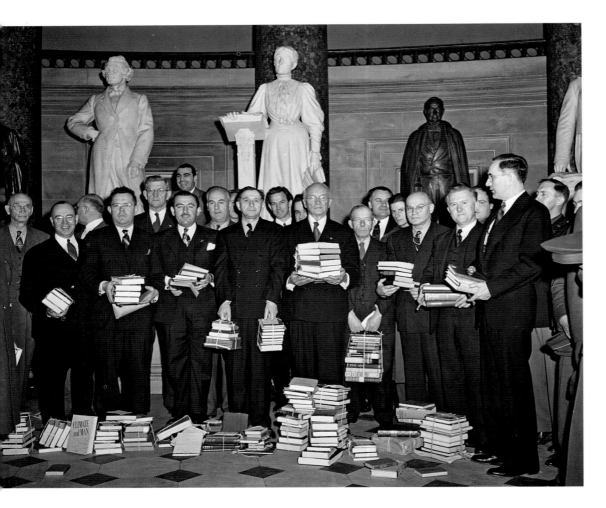

Italian Congressmen

After World War II, the number of congressmen of Italian origin steadily increased, and in more recent legislatures they have been an ever growing group.

Two Italian representatives are in the group of congressmen supporting the Victory Book Campaign (left), which sponsored the donation of books to troops all over the world. The first is George Dondero of Michigan, the second Thomas D'Alessandro Jr. from Maryland, the father of the former House Speaker Nancy Pelosi. Peter (Pelligrino) Rodino was another Italian American representative from New Jersey. He wears butcher's clothes (below) to overhear the opinions of consumers on the price of food. Years later, Rodino led the inquiry commission ruling on President Nixon's impeachment.

Italian Americans had to wait until 1950, however, to see one of them crossing the threshold of the Senate. He was John O. Pastore, former governor of Rhode Island.

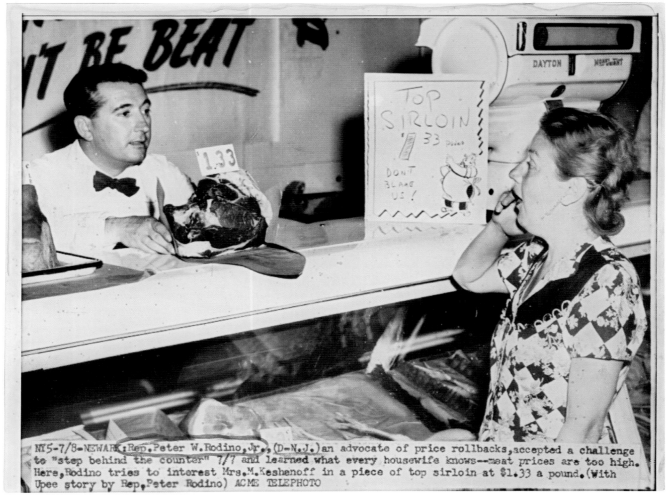

NY5-7/8-NEWARK: Rep. Peter W. Rodino, Jr., (D-N.J.) an advocate of price rollbacks, accepted a challenge to "step behind the counter" 7/7 and learned what every housewife knows--meat prices are too high. Here, Rodino tries to interest Mrs. M. Keshenoff in a piece of top sirloin at $1.33 a pound. (With Upee story by Rep. Peter Rodino) ACME TELEPHOTO

Explorers, Emigrants, Citizens

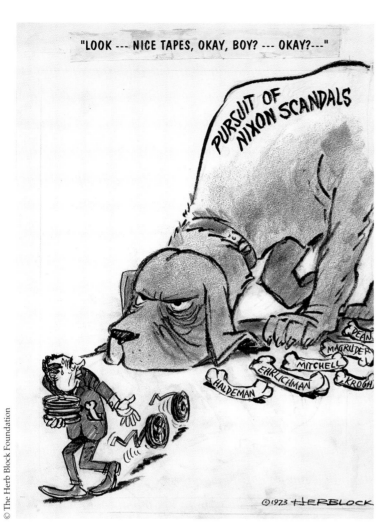

"LOOK --- NICE TAPES, OKAY, BOY? --- OKAY?---"

PURSUIT OF NIXON SCANDALS

DEAN
MAGRUDER
MITCHELL
EHRLICHMAN
HALDEMAN
KROGH

©1973 HERBLOCK

The Watergate and Judge Sirica

Judge John J. Sirica was assigned the difficult task of presiding over the Watergate trials. His firm and determined attitude towards defendants (similar to that of the dog sniffing the trail left by Nixon in Herblock's cartoon, left) helped to divulge the names of the principals and finally led to the resignation of the president.

After his experience with Peter Rodino, yet another Italian determining Nixon's political fate, Italian Americans became a kind of nemesis for the politician. In tapes made public in later years, Nixon declared about Italians: "They're not, you see, they are not like us. The differences lie in the different smell, different appearance, they act differently. After all, you cannot blame them. Oh, no. You cannot. They never had what we had. The trouble is . . . The trouble is that you cannot find one that is honest."

The letter from Anthony Tartaro, a floor reporter for Congress, (below) thanks Sirica for what he did, along with men like him, whose actions contradicted the stereotype of the Italian criminal.

OFFICIAL REPORTERS TO COMMITTEES
HOUSE OF REPRESENTATIVES
WASHINGTON, D.C. 20515

Feb. 20, 1975

RECEIVED

Hon. John J. Sirica
United States District Court
for the District of Columbia
Washington, D.C.

FEB 24 1975

OFFICE OF JUDGE SIRICA

My dear Judge Sirica,

Your kindness is greatly appreciated. We are indeed honored.

Whenever a conversation turns to the connection between crime and Italian-surnamed individuals, I inquire whether the speaker has heard of surnames such as Sirica, Rodino, et al. Silence--followed by flushed faces.

Adriano Ricci sends his warm regards.

Wishing you continued good health and long life, (per al meno centi anni), I am

Sinceramente,
Anthony F. Tartaro

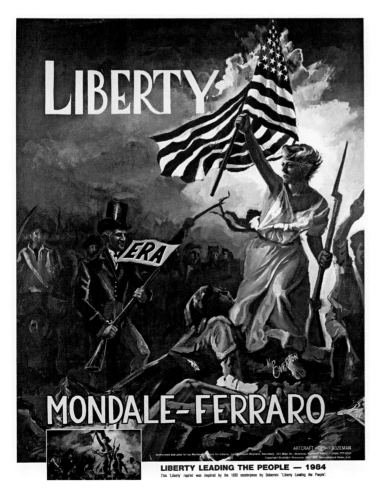

LIBERTY

ERA

MONDALE-FERRARO

LIBERTY LEADING THE PEOPLE — 1984
This 'Liberty' reprint was inspired by the 1830 masterpiece by Delacroix "Liberty Leading the People".

Italian Women and Politics

In Italy, women voted for the first time on the occasion of the 1946 referendum that let Italians choose between monarchy and democracy. Across the Atlantic, Italian American women had been voting since 1920. In only a few years they achieved major elective offices: Anne Brancato, in 1932, became the first female to be elected to the Pennsylvania state legislature.

Geraldine Ferraro and Nancy Pelosi are two Italian American women who also made history in American politics.

Ferraro, like many Italian American women of her generation (she was born in 1935), was the first in her family to get a college degree. The peak of her career was her candidacy as vice president as the running-mate of Walter Mondale, the Democratic challenger to the Reagan-Bush team in 1984. She was the first woman to be nominated for this position by a major party. The campaign poster (left), portraying Ferraro as Freedom, is a recreation of a painting by French artist Eugene Delacroix.

Nancy Pelosi served as the 60th Speaker of the United States House of Representatives from 2007 to 2011, the first woman in history to hold the office.

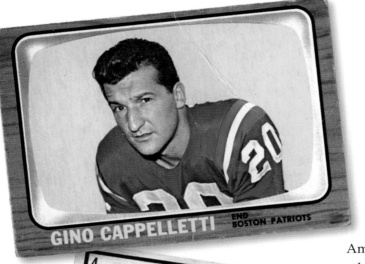

GINO CAPPELLETTI END BOSTON PATRIOTS

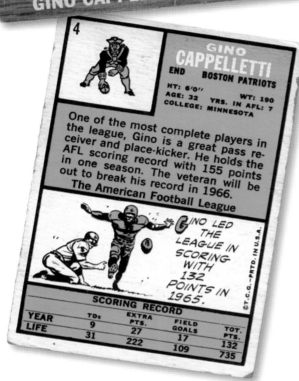

Leaders of the Game

Both at the college level and on professional teams, Italian American football players achieved the most important individual goals. Seven won the Heisman Trophy: Alan Ameche (Wisconsin), Gary Beban (UCLA), Joe Bellino (U.S. Naval Academy), Angelo Bertelli (Notre Dame), John Cappelletti (Penn State), Gino Torretta (Miami) and Vinny Testaverde (Miami). More than ten athletes and coaches were inducted into the Pro Football Hall of Fame. Others, like Gino Cappelletti (above), have not yet received this honor, despite the results they achieved: he is still one of the most prolific scorers in the history of the sport, forming a lethal duo with quarterback Vito "Babe" Parilli. This New England Patriot pair was dubbed the "Grand Opera." Super Bowl's Most Valuable Player (MVP) was awarded to Joe Flacco. Two other players of Italian descent had already won it: Joe Montana (three times) and Franco Harris.

All-Americans

Sports Triumphs in the U.S.

Americans of all ages love their sports and have always applauded their star athletes. In 1911, Amy Bernardy compared sports in the U.S. to sports in Italy. "And the news came. Yale [University's football team] won by eighteen points. And I recalled then the miserable gymnastic exercises of our [Italian] Gymnasia and of our schools, our universities, without the gym. And I imagined the expression that some of our teachers would have, if they felt that their students gave more emphasis to a good kick than they would give to a possible conjecture of some unknown German scholar."

"In the life of American universities, athletic games are the most popular and sensational, if not the most important thing," wrote Alberto Pecorini in 1910. "The fact is that students love it and want it because they understand the benefits. Athletic games are a passion of American students; a passion sometimes exaggerated, for which they neglect study, but which is a thousand times preferable than hanging out in cafes and brothels, too common a thing among Italian college students."

Pecorini was on to something. For kids trying to find a straight path away from poverty and discrimination, athletic achievement has always been (and still is) one way to enter the American mainstream. "Sports transcends ethnicity in America better than any other field," said George Randazzo, founder of the National Italian American Sports Hall of Fame. Italian American athletes and coaches like Joe DiMaggio and Vince Lombardi have even attained the status of national hero.

Football is arguably the most popular sport in the United States. Some 17.9 million television viewers, on average, watch every professional football game, and they have seen several Italian Americans become superstars. Joe Montana (his name anglicized from "Montani") made football history when he completed eight passes in two-and-a-half minutes during the 1984 Super Bowl. Dan Marino, quarterback for the Miami Dolphins, held at one time, or still holds, every major passing record in the National Football League (NFL). Franco Harris—whose father was an African American soldier in World War II and his mother an Italian war bride from Lucca—was a record-breaking rusher for the Pittsburgh Steelers. His Italian American fans in Pittsburgh called themselves Franco's Italian Army.

Lou Little (born Luigi Piccolo) was a star tackle at the University of Pennsylvania in 1916-1919—when it was still thought that Italian Americans would never make good Americans and many were branded anarchists. He went on

to coach at Georgetown and Columbia Universities for more than thirty years. Legendary coach Vince Lombardi, whose parents emigrated from Salerno, racked up ten titles for the Green Bay Packers, including five NFL championships, two Super Bowl wins, and three world titles.

Italian Americans also gained fame in other sports. Charles Atlas, born Angelo Siciliano in Acri, Calabria, in 1892, immigrated to Brooklyn in 1905. He became one of America's most celebrated body builders, developing a technique ("Dynamic Tension") that he successfully marketed across the country. Bruno Sammartino, who was born in the Abruzzo region of Italy in 1935, hid from Nazi German soldiers during World War II and came to the United States a malnourished teenager in 1950. He became a professional wrestler and was the longest running champion of the World Wide Wrestling Federation; he held his title for twelve years. Mario Andretti, born to Italian parents in Montona, Istria (now part of Croatia), one of the best racing car drivers in the world, became an American citizen in 1964. He was named U.S. Driver of the Year for three consecutive decades, in 1967, 1978, and 1984.

The success of these athletes boosted the spirit of Italian Americans and was a source of pride, helping to change their self-identity. They countered the common stereotypes about Italians, replacing them with images of skill and determination. Italian American fans who attended games were out in the wider world, away from their communities, mixing with people of all backgrounds. Even if Italian Americans only followed sports in the media, they shared something in common with other Americans, something to talk about when buying a newspaper, chatting across a lunch table, or working on a factory line or in an office. And Italian American athletes themselves were showcased on a worldwide stage. The first thing Americans thought about them was not that they came from Italy or had been immigrants or the children of immigrants, but that they were All-American superstars who brought glory to their teams and to the United States.

Mixing Sport Cultures

Mario Andretti (above) was one of the few racing drivers to excel both in the American NASCAR and IndyCar series and in Formula 1, the most popular racing series in Europe and especially in Italy, his country of origin. He won his first Formula 1 Grand Prix in South Africa in 1971, driving Italy's most popular sports car, a Ferrari. In 1975 he became the Formula 1 World Champion by winning the Italian Grand Prix in Monza. As he was competing in Formula 1, he continued to race in the United States, piling up dozens of victories in his thirty-year career (1964-1994).

Italy's most popular sport by far is soccer. The photograph (below) shows a match between two amateur teams from New Jersey, one of the states with the highest percentage of Italian Americans.

Sports and Leisure

Historically, sport was reserved for gentlemen, upper class young people who could devote themselves to purely entertaining activities. Obviously, in this context, very few Italian Americans emerged as well-known athletes.

One of the famous names was that of Gene Sarazen (born Eugenio Saraceni, right). He became one of the most popular golf champions of his time, excelling in a sport that seemed decidedly out of reach for the son of an Italian carpenter. He tackled a game that "was only played by bankers and brokers" when he was eight years old, working as a caddy, and at seventeen he was already a professional player. Between the 1920s and 1930s he was a sports personality. His fame grew when he won the Masters series in 1935, thanks to what is perhaps the most famous shot in golf history—the ball went in from 235 yards in one shot. It was dubbed "the shot heard 'round the world."

Another Italian to excel in elite sports was the race driver Ralph De Palma. He arrived as a child from the province of Foggia (Puglia), and grew up in Brooklyn. He was one of the most successful drivers of his era, winning, among other competitions, the Indianapolis 500 in 1915 in a Mercedes, the same car he drove to win the Vanderbilt Cup in 1914 (below).

In the U.S., sports became popular among the working classes sooner than in other countries, especially Italy, where their spread as a social activity started under Fascism. Workers had the opportunity to spend their free time in activities such as running, cycling, football, boxing, and baseball.

GENE SARAZEN 5795-4

DE PALMA IN MERCEDES WINS VANDERBILT CUP 1914

Football, the Italian Way

In a conversation between an Italian and an American the term "football" inevitably generates confusion because for Italians—as for most of the world—"football" means soccer. Each nation's "football" is a sport with a large fan and player base.

In the U.S., soccer has long been considered a sport reserved for ethnic minorities (in the past it was the sport of Italian Americans, today Latinos and Africans). One of the first times soccer made the headlines was in 1950 during the World Cup played in Brazil, when the U.S. national team defeated England in an epic game. The U.S. team was composed largely of players coming from St. Louis. (A 1949 exhibition game between a selection of St. Louis players and the Scottish team is shown, above). The much more titled Italian national team had to wait until 1973 before it was able to defeat the English team.

Many Italians took advantage of their ability to kick the ball, becoming kickers on football fields (like the player Costello, shown before a game between Georgetown and Virginia, right). However, one of the most famous of them, Gino Cappelletti always said "I don't consider kicking as playing."

Coaching Legends

Italian Americans had great tactical, as well as performance skills. In fact, the Italian community gave birth to two of the greatest coaches in the history of the sport: Lou Little, and Vince Lombardi.

Lou Little, born Luigi Piccolo in Boston in 1893, coached two prestigious college teams, first at Georgetown, then Columbia. He leads a workout of the Columbia Lions (top left). At Columbia, Little coached the writer Jack Kerouac.

Vince Lombardi (top right, shown with Tom Landry, another great coach in football history) was born in New York in 1913 to a family from Salerno (Campania). Lombardi's name is today synonymous with victory, since the trophy awarded annually to the winning team of the Super Bowl bears his name. He became famous not only for his victories with the Green Bay Packers (above, he stands in front of the Wisconsin team's trophies) but also for the motto, "Winning is not everything. It's the only thing."

Golden Boys

Every kid that starts playing football dreams of becoming a quarterback. It is the position that excites fans and the media because it combines athletic and mental skills with charisma. Admired quarterbacks with Italian names made a whole community proud. Italian Americans had been frequently mistreated, but on the football field they saw their children display undisputed leadership, often paired with good looks—they redeemed the image of scruffy immigrants of the turn of the 19th century.

Dan Pastorini and Mike Taliaferro (above) were among the forerunners in the 1960s and 1970s. But it was in the 1980s that two Italian American quarterbacks initiated a fierce and memorable rivalry. On one side of the continent, Dan Marino (bottom left) threw for the Miami Dolphins and still holds many individual records; on the other side was Joe Montana of the San Francisco 49ers (bottom right), who won the Super Bowl four times. This tradition continues thanks to Joe Flacco, a young Italian American quarterback who had his best season in 2013, when he led the Baltimore Ravens to a Super Bowl victory.

THE STORY OF
JOE
MAGGIO
AMERICA'S GREATEST
BASEBALL PLAYER

also featuring a new
TRUE FBI ADVENTURE
behind the scenes in the
MOVIE INDUSTRY
and
"VOTE FOR PRESIDENT" CONTEST
50 WONDERFUL PRIZES
Easy Rules Inside

Who's on first?

Italians and the American Pastime

Joe DiMaggio, whose parents were Sicilian immigrants, is one of the greatest American baseball players of all time. In 1941, he had successful hits in fifty-six consecutive games, the longest hitting streak in baseball history. He had a lifetime batting average of .325 and was chosen as the American League's Most Valuable Player three times. But when *Life* magazine did a cover story on DiMaggio in its May 10, 1939, issue, they came out with this backhanded compliment: "Instead of olive oil or smelly bear grease he [DiMaggio] keeps his hair slick with water. He never reeks of garlic and prefers chicken chow mein to spaghetti." If *Life* was trying to pack in stereotypes and insults with its praise, it succeeded.

Italian American baseball players faced discrimination and ridicule just as other Italian Americans did. Announcers thought their names were difficult to pronounce. The first Italian American player in the major leagues—in 1878, playing as an outfielder for the Cincinnati Reds—was Buttercup Dickerson, who was known by only part of his birth name, Lewis Pessano Dickerson.

Ed Abbaticchio was the first major leaguer to keep his Italian name. He started with the Philadelphia Phillies in 1897 and later played for the Pittsburgh Pirates. His story shows the biases of recent Italian immigrants as well. His parents emigrated from Naples in 1875 and thought that playing baseball was a frivolous and childish occupation. It is said his father offered him a hotel to manage if he gave up the sport, but he didn't.

Born in the United States in the first half of the 19th century, baseball began as a rural game, and a democratic one that everyone could play. It later became popular in cities; urban laborers home-

BODIE, SAN FRANCISCO. P. C. L.

ABBATICCHIO, PITTSBURG

Changing Names

For Ed Abbaticchio (above right) even his name was problematic. From his early days in professional baseball sports writers spelled his polysyllabic name in a variety of ways. In one story in a Nashville paper it appeared as both "Abbatticcio" and "Abbittico." Abbaticchio was also the first in a long line of Italian names to fall victim to box-score shorthand; in the box scores of his first three Major League games, his name appeared as "Abbatchio." Writers soon resorted to abbreviating his name to "Abby" and "Batty."

Nicknames are an integral part of baseball lore, ranging from the merely descriptive (Three-Finger Brown) to the whimsical (Dizzy and Daffy Dean) to the derogatory. In the case of Italians, complications arose from other issues. In 1911 Francis Pezzolo chose a different approach to overcome the problem: he made his debut in the major leagues, with the name Ping Bodie (above left)—Bodie was the mining town he grew up in, in California. He played center field for the Chicago White Sox, Philadelphia Athletics, and New York Yankees.

In 1954, Al Ravenna photographed the "Boys Stadium" (facing page, bottom), an open space between buildings in East Harlem where kids played baseball.

sick for the country life, formed recreational leagues. When professional teams were organized in the late 19th century, players of English, Irish, and German heritage were predominant. Italian Americans had a slow start in the sport. But by the 1930s and 1940s they were gaining more acceptance. Players like Phil Rizzuto, who was a shortstop for the New York Yankees from 1941-1954 (with a break to serve in the U.S. Navy during World War II), was one of the most popular players of his time. He was known nationwide as an announcer for the Yankees for forty years.

Yogi Berra—the Yankee catcher who debuted in 1946 and was a baseball legend—was born to Italian immigrant parents. "My father came over first. He came from the old country [Milan]. And he didn't know what baseball was. He was ready to go to work." Berra also managed the Yankees and the New York Mets. He was the first Italian American manager to win a league championship (with the Yankees in 1964). Billy Martin (son of Joan Salvini Pesano) was the first Italian American manager to lead his team (the Yankees) to a World Series win, in 1977.

Tommy Lasorda, who started as a player with the Brooklyn Dodgers in 1954, and managed the team in Los Angeles from 1977-1996, is one of baseball's most famous and capable managers. He was a leader with a sense of humor who continually boosted his team's morale. The son of Italian immigrants, he credited his father for his values: "hard work, self-confidence, faith in a better tomorrow, and the strength of family." He also said, "Every night I thank God that my father did not miss the boat. However, if he had missed it, I would have been Pope Thomas XXVI."

As with football, playing baseball or even being a fan of the sport, helped Americanize Italian Americans. An estimated 454 Italian American players have been in the major leagues since 1897. The list includes Joe DiMaggio's brothers Dom and Vince, Vic Raschi, Rocky Colavito, Carl Furillo, Joe Garagiola, Tony La Russa, and Mike Piazza. Roy Campanella, whose father was the son of Sicilian immigrants and whose mother was African American, could not play major league baseball until 1947, when the leagues were integrated, because he was considered black. (He played his first game for the Dodgers in 1948.) Prejudice and discrimination have been a part of sports as they have been of every aspect of American entertainment and culture. That Americans are now proud of their Italian American—or African American, Latino, or other ethnic—superstars is a sign of American evolution. Yogi Berra may have got it right when he famously said, "It ain't over till it's over."

Being a Yankee

The New York Yankees are the most successful team in base-ball, the most followed, and at the same time the most hated by fans of opposing teams. Comparing them to Italian soccer, they are the Juventus of the Major Leagues. Since the days of Babe Ruth, some of the greatest players in the history of baseball wore the Yankees' white and blue uniform, and among them were quite a few Italians. The first was Tony Lazzeri, who won five World Series between 1927 and 1937. He passed the baton to Joe DiMaggio, a second generation Sicilian who played from 1936 to 1951 and served as a role model for teen-age urban ballplayers. In his thirteen years with the New York Yankees, the team appeared in ten World Series, winning nine times. Known as the "Yankee Clipper," DiMaggio was voted the Greatest Living Player in baseball and the record he set with his fifty-six consecutive game hitting streak in 1941 still stands. He kisses his bat after setting the record (right). There were two more DiMaggios playing pro baseball, Joe's brothers Vince and Dom; the latter was inducted into the Hall of Fame of the Boston Red Sox, the Yankees' archrivals.

Phil Rizzuto, Yogi Berra (below, both shown in an article from *Look*), and Billy Martin were instrumental during the golden age of the Yankees, when they won sixteen World Series from 1936, the season of DiMaggio's debut, to 1964, the season of Berra's retirement. After Billy Martin, the son of an Italian moth-er, retired, he became the Yankee's manager and led the team to yet another World Series win in 1977.

JOE DI MAGGIO
Salutes His Bat

© 1941..The Sporting News Pub. Co.

The Other Side of New York

The biologist and science historian Stephen Jay Gould said: "My favorite trivia question in baseball is, 'Which Italian American player for the Brooklyn Dodgers once hit forty home runs in a season?' Nobody ever gets it right, because the answer is Roy Campanella, who was as Italian as he was black. He had an Italian father and a black mother, but he's always classified as black. You see, American racial classification is totally cultural, and it's based on the unfortunate and sad legacy of racial distinction based on this ridiculous metaphor, the purity of blood." For the same reason Campanella (below in a portrait by sports cartoonist Murray Olderman) played in the Negro League until Jackie Robinson broke the color line in 1947 when he became the first African American to play in modern-era pro baseball.

Campanella made his Major League debut only one year later, becoming Robinson's teammate on the Brooklyn Dodgers, a team wanting to break the dominance of the Yankees in the 1940s and 1950s, rekindling a strong city rivalry. In addition to Campanella, the team had other Italian American players: Carl Furillo, Cookie Lavagetto and Al Gionfriddo all made spectacular plays in the 1947 World Series, although they lost to the Yankees. Even after the heartbreaking move of the team to Los Angeles, the Dodgers had many stars of Italian origin on their roster, including Tommy Lasorda, who led the team as a manager to World Series wins in 1981 and 1988 (he had already won it as a player in 1955); and Mike Piazza who, because of his origins, even played some games with the Italian national baseball team.

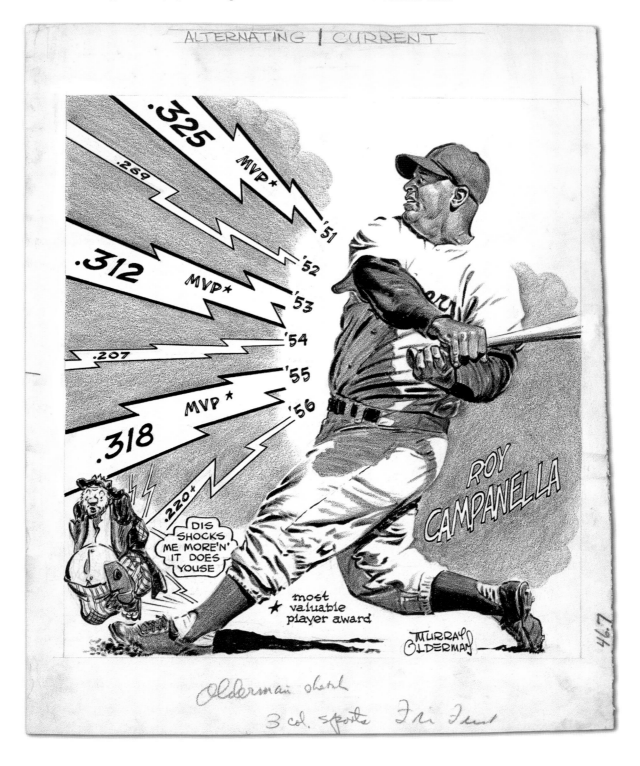

The Yankee Clipper

From the day Joe DiMaggio, acquired for $25,000 from the San Francisco Seals, made his debut in the Yankees' uniform, he became one of the most celebrated personalities in sports and, consequently, in American society. *Joltin 'Joe DiMaggio* (right) was a tribute to "one of baseball's immortals" and in a July 1950 article in the *New York Times*, the writer pointed out that his earnings were almost doubled by contracts "for performing on a recorded radio program, and he endorses a cigarette (which he smokes in moderation), a line of toiletries (which he uses with discretion), a boy's T-shirt, a sport shirt, a sweater, a rubber ball with his signature stamped on, and a baseball glove. He has made an album of children's records known as *Little Johnny Strikeout*."

Despite his outstanding athletic career, in DiMaggio's native land, where baseball is not nearly as popular as it is in America, the news started noticing him only after retirement—when he announced his engagement to Marilyn Monroe. The two sweethearts were in Canada where Marilyn was filming *River of No Return* (below). DiMaggio and Monroe were married in January 1954. Theirs was a stormy marriage lasting only ten months, but according to some evidence, in the early 1960s they were again getting close, and when Monroe died in 1962, they were thinking of remarrying.

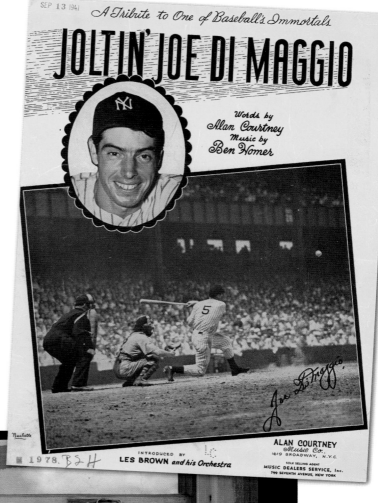

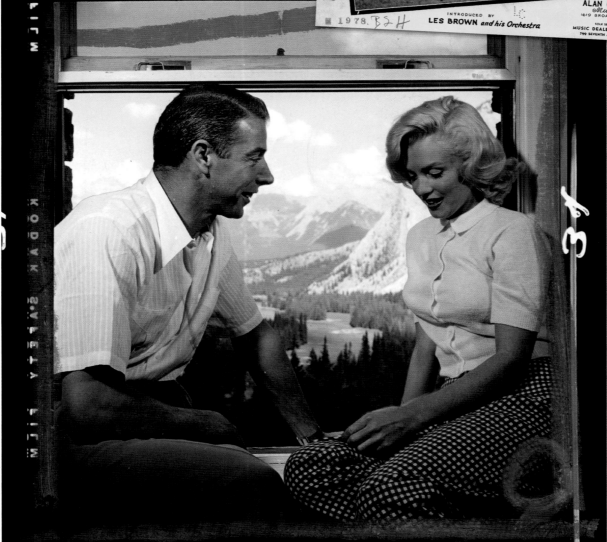

Boxing Italians in the Ring

When Primo Carnera won the World Heavyweight Championship against Jack Sharkey in 1933, Italian flags flew in New York. Pictures of Carnera went up in shops. "In the right uppercut that knocked out Sharkey," wrote the *New York American*, "the strength of all 43 million Italians is concentrated." The victory embodied the memories of a beloved homeland and the will to persist in the hard life of being an immigrant.

Boxers with an Italian heritage were not only world class fighters, but Italian Americans were world class fans. They drew inspiration and a sense of achievement from the success of their countrymen. They identified with their strength. And they filled the stands at matches, important to the boxer because his fee was a percentage of the ticket sales.

Of course, boxing attracted mainstream American sports fans too, and they watched as one Italian American after another became champions. Rocky Marciano was the only undefeated heavyweight champion. He held the title from 1952-1956. Rocky Graziano, whose sixty-seven wins included fifty-two knockouts, was a world middleweight boxing champion. (The third "Rocky," Rocky Balboa, was the fictional hero in Sylvester Stallone's series of movies.) Jake LaMotta, Willie Pep (born Guglielmo Papaleo), Pete Herman (born Peter Gulotta) and Tony Canzoneri were other outstanding Italian American boxers. By the 1950s, many Italian Americans had become successful in the business of boxing. Jack Fugazy and Chris Dundee (born Cristofo Mirena) were well known promoters; Cus D'Amato and Don and Lou Duva, managers; Angelo Dundee (born Angelo Mirena) and Richie Giachetti, trainers; and Arthur Mercante a referee. The profession offered another example of the ways Italian Americans were moving up and becoming assimilated in the U.S.

Primo Carnera, the Ambling Alp

The Italian boxer Primo Carnera enjoyed a long-lasting fame in the United States (right, "Baer Carnera" a painting by Robert Riggs, who portrays the world title fight at Madison Square Garden). A letter from an immigrant to the Ambling Alp, so called because of his height, clearly shows that victories of Italian athletes offered redemption to the whole immigrant community: "Dear Italian boxer, I wish you a great victory. Because if you win, I win too. My fellow Americans make fun of me and they told me that you will lose because all Italians have to lose. Then I clicked on, I showed my fists Then I got beat But it doesn't matter. If you win, I'll laugh in their face, show all these stupids my fists and no one will laugh no more. Because my fists look like yours. Am I not Italian like you? Win then, . . . otherwise I will be forced to hide in the cellar."
Above is a photo of Johnny Dundee, the Irish name under which the boxer John Curreri concealed his Sicilian origins.

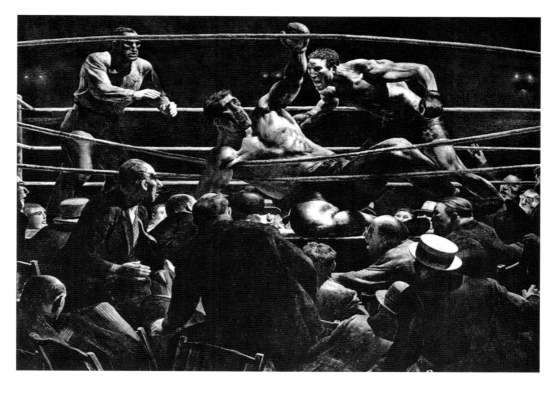

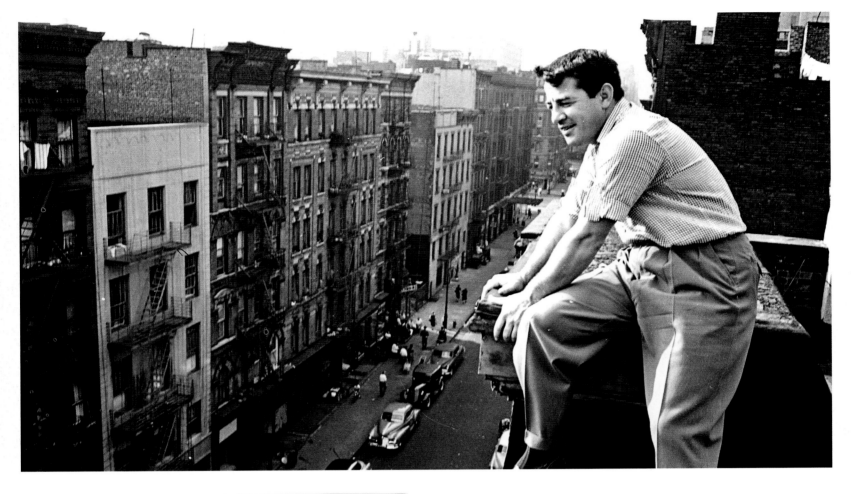

The Rockys

Two of the greatest boxers of the postwar period were Rocky Graziano and Rocky Marciano. Marciano's first love was baseball, but when he turned to boxing he exhibited his ancestral peasant characteristics in his tenacious style of fighting. There was much of the transplanted Italian peasant in Marciano—patience, the capacity to absorb punishment while dishing it out, loyalty to family and friends, and the ability to endure both during the fight and in training (facing page, top are two images of Marciano during training). Born Rocco Marchegiano, and known as the Brooklyn Bomber, Marciano won the heavyweight championship over Jersey Joe Walcott in 1952 (facing page, bottom) and held it until his voluntary retirement in 1956.

Thomas Rocco Barbella, known as Rocky Graziano, middleweight champion of the world, had troubled life. This *Look* magazine article (left) opens with "An underprivileged New York East Sider, Rocky grew up throwing rocks at cops. In the Army, he got jailed for slugging an official." He was also known for his fights with Tony Zale. Using some of the classic stereotypes of Italians, a *New York Times* article in 1946 described the two boxers as the gentleman and the beast: "Zale was tastefully dressed in a trim blue suit, blond hair slicked down neatly, and looked every inch the junior executive about to swing the big deal . . . But Graziano—wow! He had on a red-and-white striped polo shirt that resembled an animated peppermint stick! . . . Rocky's hair obviously hadn't felt a comb since his mother prettied him up for first-grade grammar school." Graziano dominates the neighborhood from the roof of his childhood home in Brooklyn (above).

The spread of boxing among Italian Americans is evident simply from looking at the career of the two Rockys; they crossed their gloves against boxers with Italian names at least thirty times.

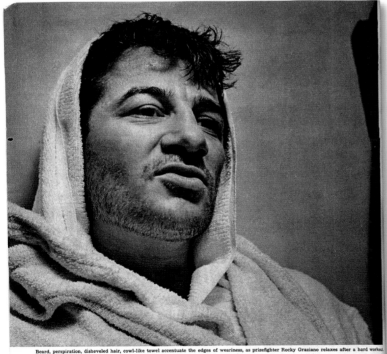

Beard, perspiration, disheveled hair, cowl-like towel accentuate the edges of weariness, as prizefighter Rocky Graziano relaxes after a hard workout.

Rocky Graziano
HE'S A GOOD BOY NOW

Rocky fondles baby Roxie, one of his two daughters.

HARD-HITTING, scienceless Rocky Graziano is campaigning to regain the middleweight championship. And he's finding it a tough fight. But Graziano's life has always been a tough fight.

An underprivileged New York East Sider, Rocky grew up throwing rocks at cops. In the Army, he got jailed for slugging an officer. Back in civilian life, he drew an unfair suspension from New York rings for failure to report an alleged bribe attempt before a fight that never did take place. Later, Illinois barred him from its rings because of his war record.

Reinstated by New York, Rocky is happy again. He can bang away in Madison Square Garden and other familiar rings and perhaps win back his championship.

For a picture story of Graziano on the day of a fight, see following page.

58

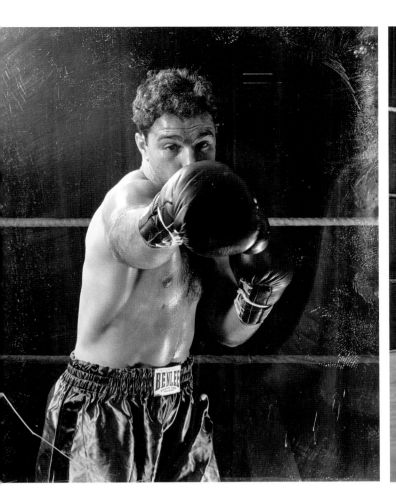

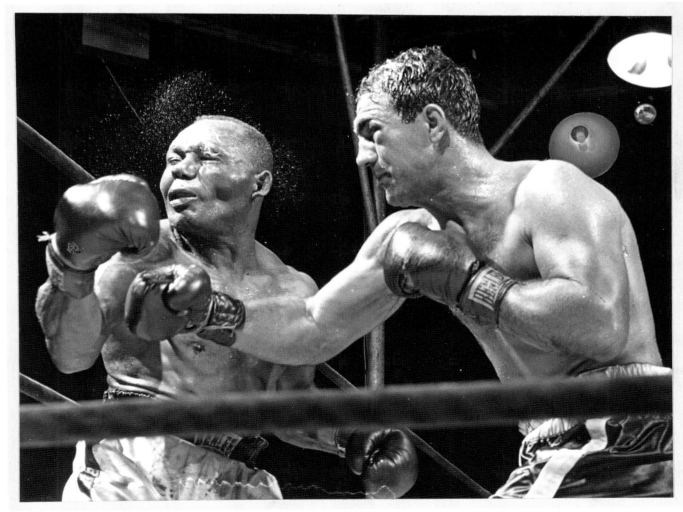

Boxing on the Screen

The image and caption taken from *La Domenica Illustrata* (below) describe boxer Luigi Montagna: "Bull Montana, the second Maciste," who trained with the boxing champion Jack Dempsey and played villainous roles in many Hollywood films in the 1920s.

The film industry has always shown a great interest in stories related to the world of boxing. The Academy Award-winning *Somebody Up There Likes Me* (1956, right) was based on the life of Rocky Graziano played by Paul Newman. Graziano was on the set giving advice (bottom). Italian actress Pier Angeli played Graziano's wife, Norma. She was born Anna Maria Pierangeli in Cagliari, Sardinia, and later married the singer Vic Damone.

The above illustration taken recently shows Jack Dempsey training with "Bull" Montana the famous wrestler and moving picture man. "Bull," in private life, is none other than Luigi Montagna of Voghera, Italy, and known throughout this country as the second Maciste. His funny face, his enormous build and strenght are familiar to millions of movie fans as the rough man with the Douglas Fairbanks Picture Co. Jack Dempsey, an ardent admirer of Montagna, brought him from California to help in training for the coming world championship match with Carpentier.

Between Reality and Fiction

Two of the greatest boxing movies in history are Italian American to the core.

The first, *Rocky*, was imagined, written, and played by a young Italian American actor who kicked off his extraordinary career with this movie: Sylvester Stallone. Released in 1976, followed by five sequels, tells the story of a small-time Philadelphia boxer, Rocky Balboa, known as the Italian Stallion. With the same determination shown by Stallone in convincing Hollywood producers to give him the leading role, Rocky finally challenges the World Champion, Apollo Creed. *Rocky* won the Oscar for best film and best director. The image (right) is a frame from *Rocky III,* when a statue dedicated to Rocky Balboa is placed in front of the Philadelphia Museum of Art. In a short circuit between reality and fiction, the statue still stands at the foot of the staircase known as the Rocky Steps.

The second movie is *Raging Bull*, based on Jake LaMotta's autobiography (bottom left). LaMotta was the middleweight champion of the world from 1949 to 1951 (he also defended the title against the Italian boxer Tiberio Mitri). In Martin Scorsese's movie (bottom right), filmed in raw black and white, "The Bronx Bull" was played by Robert De Niro in one of the most challenging roles of his career. According to the *New York Times* movie critic Vincent Canby, he was able to recreate "a titanic character, a furious original, a mean, inarticulate, Bronx-bred fighter" in a performance that earned him the Academy Award for Best Actor.

Arts and Literature

Italian American Creativity

"I am not deserting the legions of toil to refuge myself in the literary world," wrote poet Pascal D'Angelo, who immigrated to the United States in 1910. "No! No! I only want to express the wrath of their mistreatment. . . . I am a worker, a pick and shovel man—what I want is an outlet to express what I can say besides work."

Italian American artists and writers like D'Angelo gave a vision and voice to the immigrant experience, and later, as younger generations were born in America, to the conflict between parents and their children, and finally to the ways they themselves had become American.

Italian painters, sculptors, and graphic artists were part of a respected tradition that stretched back to Roman Italy and had made Italian art a prominent influence in the United States. Their challenge was not so much to win acceptance in American culture, as to create pieces that would reflect their time and their personal sensibilities. Ralph Fasanella, born in the Bronx to Italian parents, was a garment worker who began painting later in life, capturing the environment and history of the urban working class.

Artists like Letterio Calapai and Joseph Stella found ready work in the Federal Arts Project of the 1930s and 1940s. Stella, born Giuseppe Stella near Naples, came to the United States in 1896. His "Pittsburgh Portraits" (1909-1914), done on assignment as an illustrator, portrayed Italian workmen. He became internationally known for his futurist paintings. Frank Stella (no relation to Joseph), whose parents were born in Italy, pioneered minimalist art and "color field painting." He has also transcended classification as an Italian American painter.

It was easier for artists to avoid ethnic categories than for many Italian American writers. Ethnic consciousness, the clash of Old and New World values, and the nature of Italian American identity—how much are they fully American? How much Italian?—were often themes in their work. The titles of John Fante's novels and stories, like "The Odyssey of a Wop" (1933) and *Dago Red* (1940), have a bitter quality about them. Pietro DiDonato's *Christ in Concrete* (1940) is a scathing portrait of discrimination against Italian immigrants. Novelist and playwright Dorothy Bryant, born in 1930 to Italian immigrants Joe

Italians Draw

Talented Italian American artists found careers in the arts in the 1930s, despite high unemployment during the Great Depression. Jack Rivolta worked for the Works Projects Administration Federal Art Project, creating posters that often advertised entertainment (above) in a distinctive Art Deco style.

Al Taliaferro (born Charles Alfred Taliaferro)—with family links back to the early Italian settlers of Virginia—started in animation at the Walt Disney Studios and soon switched to drawing comic strips. He began by lettering Mickey Mouse comics in 1931, but he is best known for drawing Donald Duck cartoons (twelve-frame strip, facing page, bottom) for thirty-one years. At its height, Taliaferro's work appeared in 322 newspapers across the country. He is also credited with co-creating other Disney characters, including Donald's nephews Huey, Dewey, and Louie.

and Giuditta Calvetti has said, "The experience of immigration is very similar for all of us." In *Miss Giardino*, her character considers going back to Italy to live, but decides "Return would be like saying that my parents' struggle was totally useless. . . . However I think I'm too American, I would be longing for home."

For the Italian American authors of the second and third generation, the United States is home. Being Italian American may be central to their stories, like books by Jerre Mangione, Mario Puzo, and Gay Talese; or they may be mainstream American like the novels of Don DeLillo or the police procedural mysteries of Ed McBain (who was born Salvatore Lombino and was cautioned by his publishers to change his name). Decades earlier Francesca Vinciguerra had also been told by her publisher to change her name or she would not be taken se-

riously as an author. She published her novels and biographies as Frances Winwar.

Helen Mollica Barolini, an American writer whose husband was Italian, expressed her concern about the creative dilemma in 2000. Earlier Italian American writers were marginalized, not only in their first decades in the U.S., but in Italy. Emigrants left a country that could not support them, only to live in a country that wanted their labor but did not accept them as equal. Their culture—the new culture they were creating in the United States—was slow to become part of the American mainstream. Italians, too, traditionally ignored or looked down upon the works by emigrants and their descendants. There is an Italian American literary tradition beyond Mario Puzo that remains to be rediscovered.

Between Tradition and Innovation

Joseph Stella came to the U.S. in 1896 to study medicine, but soon devoted himself to art, attending the Art Students League. The words of the *New York Times* celebrating the one hundredth anniversary of his birth decribed well the path followed by many Italian American artists: "Stella was at once a modernist and a traditionalist, a Futurist who still worshipped at the shrine of the old Masters, an artist with a passion for the romance of industrial America who constantly fled to more venerable and exotic locales—in Europe, North Africa and the West Indies—to renew his inspiration." The portrait of an elderly lady with a veil (left) clearly belongs to his first side, the traditionalist.

America provided access to formal art education to young Italian Americans from humble immigrant families, like the sculptor Oronzio Maldarelli. He immigrated in 1901 and after only five years was already attending the Cooper Union for the Advancement of Science and Art, a college created in New York to be "open and free to all." Maldarelli shown in his atelier (bottom left), became a professor of sculpture at Columbia University.

Despite the fact that his family, originally from Sicily, was very poor, Letterio Calapai, creator of the wood engraving "Labor in a Diesel Plant," (circa 1940, bottom right) attended prestigious art schools such as the School of Fine Arts and Crafts in Boston.

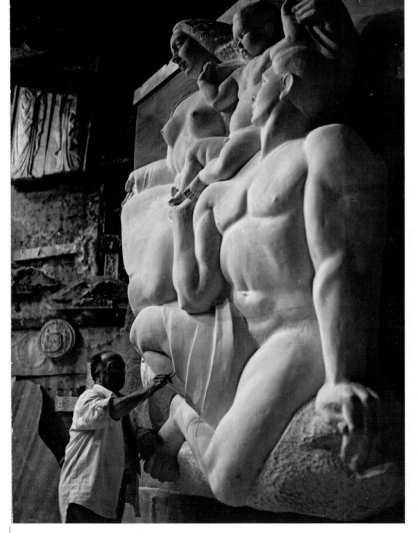

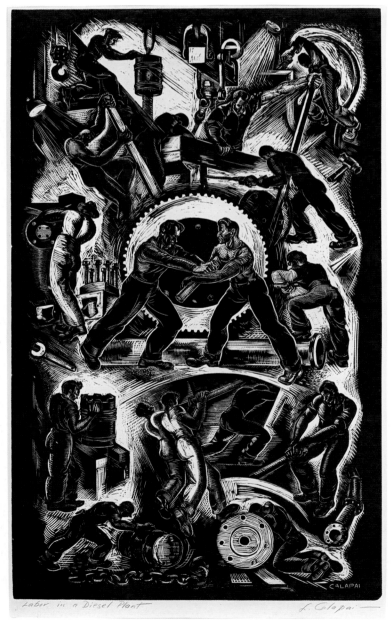

Explorers, Emigrants, Citizens

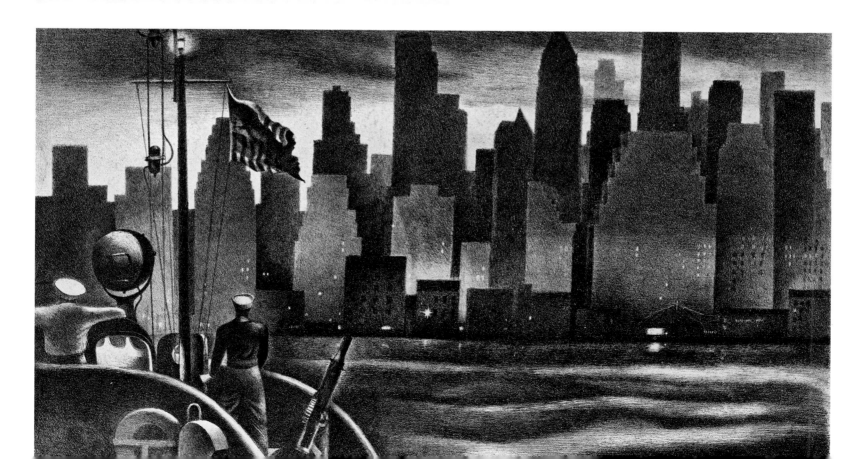

HARPER'S WEEKLY

EDITED *by*
GEORGE HARVEY

NEW YORK
INDUSTRIAL
NUMBER

March 23 1912 HARPER & BROTHERS, N. Y. Price 10 Cents

Representing a New World

The urban landscape of the United States was a challenge for Italian artists who grew up between medieval towers and spires of ancient cathedrals.

The Bolognese artist Athos Casarini was able to interpret it with both a figurative approach and a style following the new dictates of the European avant-garde. Called to the United States by his brother Alberto, who after trying many different jobs had become an editor of *Il Progresso Italo Americano*, Athos arrived in New York in 1907. He had attended art school in Italy, but the American city became his muse: "The smoke from the chimneys, the sound of tugboats docked on the East River, the geometries of fire ladders, the illuminated signs, the twinkling lights, the yellow dots of lighted windows in the skyscrapers of Manhattan, seen from his studio in Poplar Street in Brooklyn: these are the things that attracted him" wrote Claudio Bacilieri in the article "Poesie, dipinti, grattacieli." He soon became a popular illustrator working with the *New York World* and *Harper's Weekly*, which dedicated the cover of its March 23, 1912, issue to Casarini's painting "New York seen from Brooklyn" (left). Casarini followed the "Futurist Manifesto," and Filippo Tommaso Marinetti called him "the Italian Futurist painter in America." At the outbreak of World War I, he decided to return home to fight on the front line and died in the trenches in September 1917. Before leaving America he wrote: "After six years of residence in this great, futuristic city of New York, I return to my country, fortified with the iron I breathed in this exciting atmosphere."

Below, another Italian American artist, Vincent La Badessa, portrays the world's most famous skyline in the lithograph called "U.S. Coast Guard."

"*Dallas, November 22, 1963*"
AN EXHIBITION OF DRAWINGS AND WOODCUTS BY
ANTONIO FRASCONI
TERRY DINTENFASS, INC. 18 E. 67 ST. N.Y.C. OCTOBER 27 - NOVEMBER 14, 1964

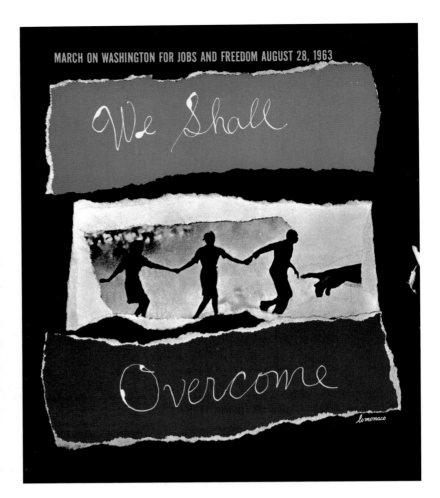

American Icons

Three Italian American artists, Antonio Frasconi, Louis LoMonaco, and Allan D'Arcangelo, created icons of popular culture and American history, using one of the pop art mediums *par excellence*: the poster. Their work was proof that Italian American artists had completed the transition from traditional Italian artistic sensibility—one that had made the fortune of artists such as Brumidi—to modernity. Antonio Frasconi's "Dallas, November 22, 1963" (top left) spoke for all Americans recovering from the loss of President John Fitzgerald Kennedy.

Louis LoMonaco's poster "We Shall Overcome" (top right) captured the image of the great March on Washington for civil rights (August 28, 1963), which ended on the steps of the Lincoln Memorial with Reverend Martin Luther King Jr.'s historic speech, "I Have a Dream."

Allan D'Arcangelo designed "The Highway" poster (right) for the Institute of Contemporary Art at the University of Pennsylvania. It was his interpretation of the iconic journey on American highways, which, after Jack Kerouac's *On the Road*, fascinated generations of young people on both sides of the ocean.

Explorers, Emigrants, Citizens

Comics and Cartoons

Italian American artists created a host of iconic American cartoon characters. Joe Barbera, son of Sicilian parents, founded Hanna Barbera Productions with Bill Hanna. They invented cat and mouse duo Tom and Jerry, and became major players in developing TV cartoons, including *The Flintstones, Scooby-Doo, and Yogi Bear.*

John Celardo began drawing the *Tarzan* comic strip (top right) in 1954. In the 1960s he also wrote the narrative for the cartoon. He drew 4350 daily, and 724 Sunday strips before he stopped working on *Tarzan* in 1968.

Silvio "Sal" Buscema's father was also born in Italy; He followed his older brother John, another noted cartoon artist, to Marvel Comics in 1968. His work included penciling and inking for *Captain America* (bottom left, courtesy of Marvel Comics), and ten years drawing the Incredible Hulk.

Casper the Friendly Ghost (bottom right) first appeared in three children's books illustrated by John Oriolo. Casper went on to become a star in both comic books and films. Oriolo also co-created Felix the Cat, first as comic art, later as a long-running TV series. Most of these characters are still popular in the 21st century.

Beat Generation

The Beat Generation was a group of 1950s poets and authors joined together by common values and experiences. They rejected convention, experimented with writing styles—as well as drugs and sexuality—were drawn to Eastern religion, and were anti-materialist. Allen Ginsberg and Jack Kerouac were two of the most famous authors, but Italian Americans also played a prominent role. Lawrence Ferlinghetti opened City Lights Book Store in San Francisco and published the City Lights Pocket Poets Series, begun in 1955, which introduced many of the Beat writers. He also wrote plays, as in the volume *Routines* (bottom left). His father had changed the family name to Ferling; Ferlinghetti took it back in 1955. Gregory Corso—born Nunzio Corso in Little Italy (he took Gregory as his confirmation name)—who wrote "Bomb" (bottom right), published *Gasoline* in 1958, with a very Beat-like expression of the creative process: "It comes, I tell you, immense with gasolined rags and bits of wire and old bent nails, a dark arriviste, from a dark river within." Diane Di-Prima—whose Italian grandfather was an anarchist—wrote the story collection *Dinners and Nightmares* (top right) and published the fictional *Memoirs of a Beatnik* (1969). These Beat writers were not labeled "Italian American writers," but had an integral role in the development of poetry, fiction, and autobiograhy in the United States.

Cover design & photograph by Remy Charlip

DIANE DI PRIMA
DINNERS AND NIGHTMARES

A CORINTH BOOK
DISTRIBUTED BY THE CITADEL PRESS
$1.25

Stories by a new voice in American writing

ROUTINES

FERLINGHETTI

BOMB

Budger of history Brake of time You Bomb
Toy of universe Grandest of all snatched-sky I cannot hate you
Do I hate the mischievous thunderbolt the jawbone of an ass
The bumpy club of One Million B.C. the mace the flail the axe
Catapult Da Vinci tomahawk Cochise flintlock Kidd dagger Rathbone
Ah and the sad desperate gun of Verlaine Pushkin Dillinger Bogart
And hath not St. Michael a burning sword St. George a lance David a sling
Bomb you are as cruel as man makes you and you're no crueller than cancer
All man hates you they'd rather die by car-crash lightning drowning
Falling off a roof electric-chair heart-attack old age old age O Bomb
They'd rather die by anything but you Death's finger is free-lance
Not up to man whether you boom or not Death has long since distributed its
categorical blue I sing thee Bomb Death's extravagance Death's jubilee
Gem of Death's supremest blue The flyer will crash his death will differ
with the climber who'll fall To die by cobra is not to die by bad pork
Some die by swamp some by sea and some by the bushy-haired man in the night
O there are deaths like witches of Arc Scarey deaths like Boris Karloff
No-feeling deaths like birth-death sadless deaths like old pain Bowery
Abandoned deaths like Capital Punishment stately deaths like senators
And unthinkable deaths like Harpo Marx girls on Vogue covers my own
I do not know just how horrible Bombdeath is I can only imagine
Yet no other death I know has so laughable a preview I scope
a city New York City streaming starkeyed subway shelter
Scores and scores A fumble of humanity High heels bend
Hats whelming away Youth forgetting their combs
Ladies not knowing what to do with their shopping bags
Unperturbed gum machines Yet dangerous 3rd rail
Ritz Brothers from the Bronx caught in the A train
The smiling Schenley poster will always smile
Impish Death Satyr Bomb Bombdeath
Turtles exploding over Istanbul
The jaguar's flying foot
soon to sink in arctic snow
Penguins plunged against the Sphinx
The top of the Empire State
arrowed in a broccoli field in Sicily
Eiffel shaped like a C in Magnolia Gardens
St. Sophia peeling over Sudan
O athletic Death Sportive Bomb
The temples of ancient times
their grand ruin ceased
Electrons Protons Neutrons
gathering Hesperean hair
walking the dolorous golf of Arcady
joining marble helmsmen
entering the final amphitheater
with a hymnody feeling of all Troys
heralding cypressean torches
racing plumes and banners
and yet knowing Homer with a step of grace
Lo the visiting team of Present

Italian American Novelists

To write about Italian Americans or not to write about Italian Americans? That is the question Italian American novelists face when they create their work. Yet even when well-reviewed, those who write about the Italian American experience are often marginalized, unless their subjects are sensational, like the Mafia. One of the first novels to be widely read, published in 1943, was *Mount Allegro* (below), by Jerre Mangione. Written as a memoir of the Sicilian immigrant community in Rochester, New York, his publishers had him change it to fiction.

In the 1970s and 1980s, as the idea of multicultural diversity and the value of ethnicity took hold, some novelists were interested in exploring their backgrounds, including Lou D'Angelo (*What the Ancients Said*); Joseph Papaleo (*All the Comforts*); Tony Ardizzone (*In the Name of the Father* and *Heart of the Order*); and Tina DeRosa (*Paper Fish*). Dorothy Bryant, daughter of Italian parents, published *Miss Giardino* (right) in 1976.

As the era of immigration fades, and Italian Americans are thoroughly Americanized, they have become prominent in mainstream American fiction. Jay Parini's *The Last Station: A Novel of Tolstoy's Last Year* (1990) was made into a 2009 film. In 2010 he published *The Passages of H.M.* (Herman Melville). Don DeLillo, postmodernist and satirist, portrays a violent world where consumerism runs rampant, the mass media has too much power, and conspiracies are probable. His work includes *White Noise* (1985), *Underworld* (1997), and *Point Omega* (2010). Robert Viscusi's *Astoria* (1996) focuses on a contemporary character who believes that the Italian neighborhood in Queens where his mother grew up is the capital of the world.

MISS GIARDINO

A Novel by
Dorothy Bryant

MOUNT *Allegro*

BY JERRE MANGIONE

ILLUSTRATED BY PEGGY BACON

HOUGHTON MIFFLIN COMPANY
BOSTON · The Riverside Press Cambridge · 1943

History and Books

Nonfiction writer Gay Talese said he writes with "a sense of history. . . . I try to tell the reader where my characters come from, and how they got to the point where I've found them. It never is just present tense. It's always about past tense. Origins." Talese pioneered "new journalism," a literary approach to research and reporting. *Honor Thy Father* (below), about the Bonanno crime family, is one of his best known works. John Fante's fiction was often autobiographical, including *Ask the Dust* (1939), about the hard times of a writer in Depression-era Los Angeles. His character, Arturo Bandini, appeared in three other novels, known as "The Bandini Quartet." *Dago Red* (right) was a collection of short stories published in 1940. It was reissued in 1985 (with additional stories) as *The Wine of Youth*, a sign that ethnic slurs were no longer suitable to express in public.

The Odyssey of a Wop

I PICK up little bits of information about my grandfather. My grandmother tells me of him. She tells me that when he lived he was a good fellow whose goodness evoked not admiration but pity. He was known as a good little Wop. Of an evening he liked to sit at a table in a saloon sipping a tumbler of anisette, all by himself. He sat there like a little girl nipping an ice-cream cone. The old boy loved that green stuff, that anisette. It was his passion, and when folks saw him sitting alone it tickled them, for he was a good little Wop.

One night, my grandmother tells me, my grandfathe

161

HONOR THY FATHER

marvelous
ce of work....
book about
nishing way of
e in America:
the Mafia."
—*Newsweek*

NEWLY

PDATED

BY

THE

UTHOR

Gay Talese

WITH A NEW FOREWORD BY PETE HAMILL

"...everything
Is bigger, but less majestic ...
Italy is a little family
America is an orphan
Independent and arrogant,
Crazy and sublime,
Without tradition to guide her,
Rushing headlong in a mad run which she calls
Progress."

<div align="right">Emanuel Carnevali, from the poem "In America"</div>

When the Italian widow and her son go to the Workmen's Compensation Bureau after her husband is killed in an accident: "they saw the sleek flaccid state employees and heard the correct American voices. . . and other passionless soaped tongues that conquered with grammatic clean cut: 'What is your name?' Your maiden name? How many children? Where were you born? This way please. Sit here please. Please answer yes or no. Eyetalians insist on hurting themselves when not personally supervised . . . directly his fault . . . substantiate . . . disclaim . . . liability . . . case adjouorned.' And they saw the winning smiles that made them feel that they had conspired with Geremio to kill himself so that they could present themselves there as objects of pity and then receive American dollars for nothing. . . . The smiles that made them feel they were un-Godly and greasy pagan Christians . . ."

<div align="right">Pietro DiDonato, *Christ in Concrete*</div>

"What happens to a person who is raised in a passionate, furious, comic and tragic emotional climate, where the ghost of one's grandmother is as real as the food on one's plate . . . ? What happens to a person who is raised in that environment, and then finds herself in a world where the highest emotional charge comes with the falling of the Dow Jones average, or yet another rise in the price of gold?"

<div align="right">Tina DeRosa, author of *Paper Fish*</div>

Cinema and Television

Italians on Screen

To Be or Not To Be Italian

The original caption of this photo (top right) reads "Pretty Italian film actress listens to her favorite selection over the radio." The actress is actually Nita Naldi, an Irish actress who had taken the stage name Naldi as a tribute to her childhood friend Florence Rinaldi.

On the other end of the name game, Anne Bancroft's real name was Anna Maria Louisa Italiano (above) and she was a second generation Italian American born in the Bronx. Her first stage name was Anne Marno, with which she is credited in several television shows in the early 1950s. She finally changed it to Anne Bancroft for her Hollywood debut in *Don't Bother to Knock* (1952) with Marilyn Monroe. She won an Academy Award for Best Actress for *The Miracle Worker* (1962), in a role that had already earned her a Tony Award for her stage performance.

Prize fighter, gangster, impassioned lover, stock broker: if all these were characters in a movie or television show, which one would not be the Italian American? The earliest film representations of Italian immigrants and Italian Americans were made by non-Italians. D.W. Griffith directed *The Greaser's Gauntlet* in 1908, and *In Little Italy* in 1909, and Reginald Barker made *The Italian* in 1915. By the 1920s, more than fifty American films portrayed Italians from a condescending or denigrating mainstream American perspective. In the 1930s, the gangster movie became a popular genre. Midwestern American Lew Ayres played the Italian criminal Louis Recarno in *Doorway to Hell*. Romanian-born, Jewish actor Edward G. Robinson defined the role of the Italian American gangster in *Little Caesar* (1931) and later as Rocco in *Key Largo* (1948). The Ukrainian actor Paul Muni developed the type in *Scarface* (1932).

Hollywood was after a good story, and immigration and crime made good stories. Good actors of any ethnic background could play any kind of character. Nor were movie makers necessarily interested in depth, but entertainment. But the role that Italian Americans played in the movie business was more varied and influential than many films would suggest. Italian Americans were influential in launching the film industry, not only as actors but off-screen as set builders and decorators, costume designers, and other skilled technicians. (Italian craftsmen had always been valued.) Tony Gaudio, born in 1883 in Cosenza, was an Academy-award-winning cinematographer (for *Anthony Adverse* in 1936), who pioneered the use of a montage sequence in film. American-born Santo Loquasto is a scenic and production designer who has worked on several Woody Allen films, including *Bullets Over Broadway*.

Italian American producers include Albert R. Broccoli, who made all but one of the first seventeen James Bond films; and Dino De Laurentiis, who came to the United States from Italy in 1976 and backed dozens of science fiction and horror films, including the remake of *King Kong* (1976) and *Dune* (1984). Garry Marshall—whose father changed the family name from Masciarelli—produced the television hits *Happy Days* and *Laverne and Shirley*. His sister Penny Marshall, who starred as Laverne, is a pioneer female producer and director.

Her work includes *Big* (1988) and *A League of Their Own* (1992), which have nothing to do with being Italian American.

Sicilian-born Francesco (Frank) Capra directed some of the best-loved Hollywood movies; none of them dealt with Italian Americans, although his own rise from struggling immigrant to fame embodies the American dream. Capra won three Academy Awards as best director, for *It Happened One Night* (1934), *Mr. Deeds Goes to Town* (1936), *You Can't Take It With You* (1938). In *Mr. Smith Goes to Washington* (1939), an ordinary American is elected to Congress, where he speaks out for honesty and decency. "The more uncertain are the people of the world, the more their hard-won freedoms are scattered and lost in the winds of chance, the more they need a ringing statement of America's democratic ideals," wrote Capra of the movie, which was released in the same year World War II started. His film *It's a Wonderful Life* (1946), in which a depressed man realizes his contributions to his community, is an all-American classic.

Italian Americans have changed since these Capra movies and so have American perceptions of them. Some of the best and most applauded Italian American directors make films that deal with Italian crime. Yet Francis Ford Coppola's *The Godfather* (1972) and *Godfather II* (1974), Martin Scorsese's *Mean Streets* (1973) and *Goodfellas* (1990) and David Chase's (born David DeCesare) TV series *The Sopranos* (1999-2007) are such compelling and excellent works that they have earned their place as great American dramatic art.

Films about Italian Americans have expanded their subject matter to explore family life and personal relations, including Norman Jewison's *Moonstruck* (1987); Nancy Savoca's *True Love* (1989) and *Household Saints* (1993); John Turturro's *Mac* (1992); and Stanley Tucci's *The Big Night* (1996). Some of the characters may flirt with stereotypes, but these movies portray, not just what it means to be Italian American, but what it means to be human.

When it comes to actors of quality, the list is enormous. One of the most famous stars noted for playing Italian Americans, Robert De Niro, is actually only one quarter Italian, although he grew up in New York's Little Italy and has said that he identifies "more with [his] Italian side." Al Pacino, whose grandparents came from Sicily, is a star of equal eminence. Sylvester Stallone, John Travolta, Joe Pesci, Talia Shire and Nicholas Cage (both born Coppola), Stanley Tucci, John Turturro, Marisa Tomei, Sophia Coppola (also an outstanding director), Chazz Palminteri, Danny DeVito, James Gandolfini, Paul Sorvino, Danny Aiello, and Paul Giamatti have all been, literally, major players. Anne Bancroft, born Anna Maria Louisa Italiano, and Susan Sarandon, whose mother was Italian American, have not been cast in ethnic roles, which leads one to ask: what's in a name, and what really makes an Italian American?

The Fonzie Syndrome

Cinema historian Gian Piero Brunetta in his essay on Italian Americans and cinema, "Emigranti nel cinema italiano e americano" reminds us that "American cinema—from Griffith to Howard Hawks, from Robert Aldrich's *Kiss Me Deadly* (1955) to *Gloria* by John Cassavetes (1980) up to the TV show *Happy Days*—lived on the productivity and stability of the stereotypical portraits of Italian immigrants, on their immediate recognition for a number of characteristics where the negative elements exceed by far the positive ones." Even Arthur Fonzarelli (above, *The Official Fonzie Scrapbook*) one of the most beloved characters for an entire generation of Italian viewers, is an example of the stereotypical trivialization of the Italian American as a little-educated roughneck.

The Latin Lover

Rudolph Valentino (bottom left), stage name of the ponderously named Rodolfo Alfonso Raffaello Pierre Filibert Guglielmi di Valentina D'Antonguella, was born in 1896 in Puglia. In 1913 he immigrated to New York where, along with gimmicks and small jobs, he managed to make a living as a taxi dancer. In 1917 he went to California and soon connected to the film world. His success started in 1921 with *The Four Horsemen of the Apocalypse* (bottom right). From then on, his enigmatic gaze conquered women all over the world, creating the prototype of the Latin Lover.

Valentino died in New York of peritonitis when he was only thirty-one years old, at the height of his success. Tens of thousands of people waited for days outside the New York Polyclinic Hospital where he had been hoping for a cure. The *New York Times* pointed out that "despite the fact that Valentino had been cited as an illustration of the fact that 'all the world loves a lover,' he died alone save for his three doctors and two nurses." According to the *Chicago Tribune* correspondent, not even in Castellaneta, his town of origin in the province of Taranto, did anyone weep for the death of their illustrious countryman: "Indifferent to the *furore* that the death of the American movie idol has created in the United States, the little village continues its humdrum activities and in the entire town the *Tribune* correspondent found only one family that could be said really to be in mourning."

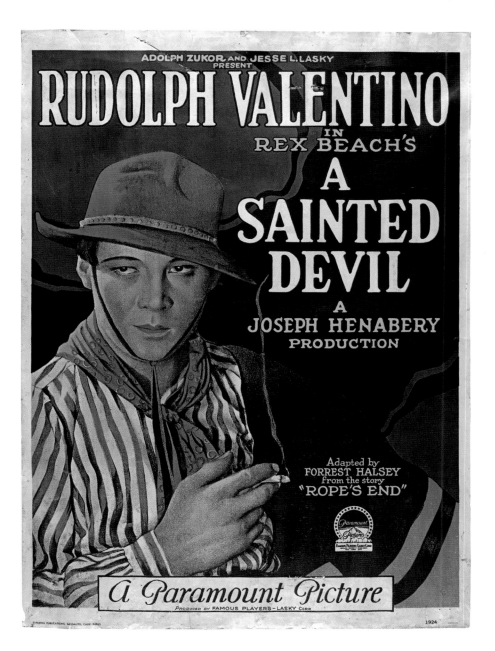

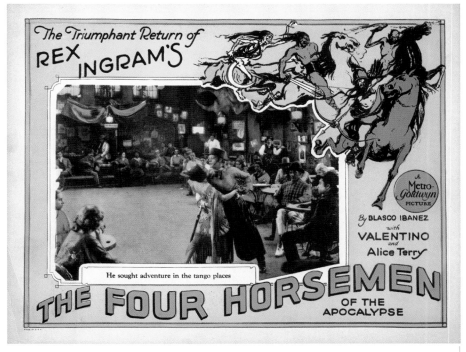

American Indians and Comedians

Iron Eyes Cody (below) is remembered for his portrayal of an American Indian moved by the havoc to the American environment created by white men in an anti-pollution commercial of the 1970s. The actor played Native American roles (including Crazy Horse twice) in dozens of films and TV series, but he was actually born Espera Oscar de Corti to a Sicilian family in Louisiana. He entered the world of cinema in the 1930s, specializing in American Indian roles. Later in his life he married a Native American woman and adopted two young Native Americans. Although he kept his origins hidden, Native Americans in Hollywood knew he was Italian. Nonetheless, they honored him in 1995 for publicizing the problems faced by American Indians. Italian American actors distinguished themselves in vaudeville and comedy. Jimmy Durante (top right, in a caricature by Irving Hoffman) was born in New York to a family from Salerno (Campania) and was commemorated by the *New York Times* as "the Lower East Side youngster who parlayed a raspy voice, a nose [called schnozola in his famous gigs] that tickled a nation's funnybone and a talent for bringing down the house into triumph as one of America's most dearly held comedians."

The comedians Abbott and Costello (bottom right) became Gianni & Pinotto in Italy. Costello (right in photo), who was born Louis Francis Cristillo in Paterson, New Jersey, became the funny man of one of the most popular comic duos in America for over twenty years.

The Directors

Frank Capra was the first great director of Italian descent, the winner of three Academy Awards for Best Director. One of his best known films is *It's a Wonderful Life* (left); in his movies no reference to his origins was ever made. But Italian Americans today are ubiquitous in American film, and they have been able to share the American experience without sacrificing their specific cultural identity.

The filmography of all leading Italian American directors includes at least one movie where the entire plot takes place in an Italian American milieu (like Martin Scorsese's *Mean Streets*, bottom left). At the same time, they successfully directed movies dealing with broadly American themes, like the Vietnam War, portrayed in Francis Ford Coppola's *Apocalypse Now* (bottom right) and Michael Cimino's *The Deer Hunter*. Even Brian De Palma's *The Untouchables*, although it shows events related to Al Capone (played by Robert De Niro), is filmed from the point of view of Elliot Ness, the law enforcer and an all-American icon.

Music in the Movies

Italian Americans were stars—whether as directors, composers, or performers—in every arena of movie music and musicals. Vincente Minnelli, whose grandfather took part in the failed Sicilian revolution of 1848, directed *Meet Me in St. Louis* and *An American in Paris*, as well as MGM's *Ziegfield Follies* (top right). His daughter Liza Minnelli (facing page, top left, in a print by Al Hirschfeld) is a singer almost as famous as her mother, Judy Garland. Daughter of Italian immigrants (her father was a music teacher and her mother an opera singer), Adriana Caselotti was the voice of *Snow White* in the 1937 Disney movie (facing page, top right). The clear purity of her singing virtually defined the character.

Two sons of Italian immigrants stand out as composers: Harry Warren (born Salvatore Guaragna) and Henry Mancini (born Enrico Nicola Mancini).

Three-time Academy Award winner Warren wrote one of music's most delightful rhymes—"When the moon hits your eye/ like a big pizza pie"—in "That's Amore" (bottom left), as well as "Lullaby of Broadway" and "I Only Have Eyes for You." Mancini (shown conducting, facing page, bottom right) was nominated for a record-breaking seventy-two Grammys. (He won twenty). His standards include "Moon River," the theme to *The Pink Panther* (facing page, bottom, left and center), and "The Days of Wine and Roses."

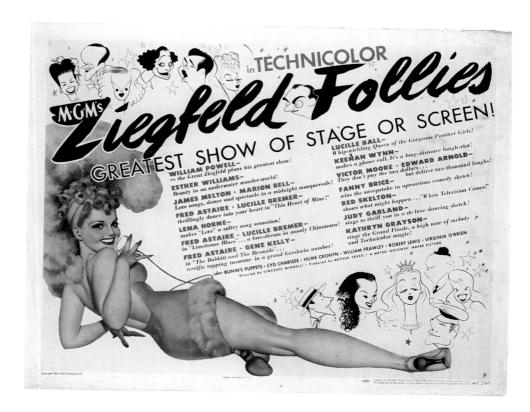

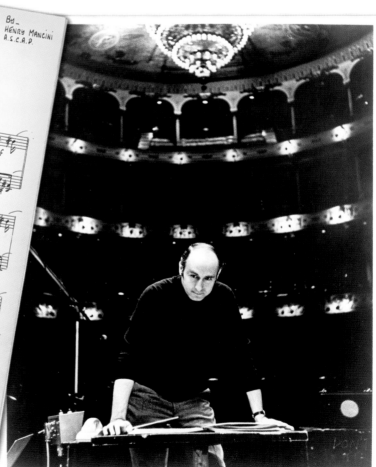

Acting Italian

The first Italian American actor to win an Oscar was Ernest Borgnine (born Ermes Borgnino) in 1955 for *Marty*, in which he played an Italian butcher from the Bronx. After that, many Italian American actors gave life to typically Italian characters.

A symbol for an entire generation, John Travolta's Tony Manero in *Saturday Night Fever* (1977, directed by John Badham, left, top and bottom), was the prototype of the Italian cool guy from Brooklyn who tries to redeem his cheap existence by becoming the king of the dance floor.

Do the Right Thing (bottom right) by African American director Spike Lee shows Italian Americans from a totally different point of view. Lee portrayed the conflicts between the owners of an Italian pizzeria and their African American customers in the Bedford-Stuyvesant neighborhood of Brooklyn. Sal, the owner of the pizzeria, played by Danny Aiello, thinks it is essential to safeguard his workplace, while his son Pino, played by John Turturro, is disgusted by his work and openly racist. There is an interesting footnote to the supporting cast: the actor who played Buggin' Out, one of the most hostile to the presence of the Italian pizzeria in his neighborhood, is Giancarlo Esposito, who was born in Denmark to an Italian father and African American mother. This offers another confirmation of the fact that today identifying race and ethnicity is not only difficult, but meaningless.

Very American

Victor Mature, born into a family from Pinzolo (Trentino), was aware that the success he achieved was greatly due to his physical presence, so much so that he declared to *Life* magazine: "I can act, but what I've got that the others don't have is this," indicating his body. His physique kept him from being labeled Italian, who, according to the stereotype of the time, had to be short and weak. He starred in numerous films, playing anything from a prehistoric man to a Greek slave to the American Indian chief in *Crazy Horse* (right).

Annette Funicello (bottom left) and John Beradino (bottom right) rose to fame in shows that exemplified mainstream American television. Funicello was a very popular Mouseketeer, the child stars of the show *The Mickey Mouse Club*. Her career continued with the "Beach Party" movies, where she worked with another Italian American actor and singer, Frankie Avalon.

John Beradino, after a career in pro baseball, became Dr. Steve Hardy on *General Hospital*, one of the longest-running soap operas on American television. He played the role from the first episode in 1963 until his death in 1996.

El Rancho Vegas
Presents
VIC DAMONE
BAMBI LINN &
ROD ALEXANDER
DINING DANCING
GAMING
COMING ATTRACTIONS

From Crooners to Rockers

Singing to the American Mainstream

Post World War II America was a time of mobility and opportunity, and, for Italian Americans, the fast track to assimilation. No career exemplified this more than vocal music. From 1947 through the early 1960s, Italian American pop singers were mainstream America's idols. Francis Albert Sinatra—Frank Sinatra—pioneered this rise, singing with the Tommy Dorsey band from 1939. Although he lost popularity in the late 1940s and early 1950s, he rebounded to become an enduring musical legend.

Although Sinatra kept his Italian surname, many of the applauded singers of the 1950s onward did not. Anthony Benedetto performed as Tony Bennett, Pierino Como as Perry Como, Vito Farinola as Vic Damone, Francesco LoVecchio as Frankie Laine, and Dino Crocetti as Dean Martin. Regardless of their names, they were the voices of their era. Sometimes they sang Italian-inspired songs, like Vic Damone's "I Have But One Heart," based on the Neapolitan song "O Marenariello." Dean Martin debuted "That's Amore," composed by Harry Warren (born Salvatore Guaragna), a song he didn't like that was a big success. But nearly all of what they sang was mainstream American pop and their versions became part of the canon.

Italian Americans continued in the 1960s as rock stars, again with some adjustment to their names, including Sonny Bono (Salvatore Bono), Lou Christie (Luigi Sacco), Dion (Dion DiMucci), Bobby Darin (Walden Cassotto) and Frankie Valli (Francis Castelluccio), lead singer of The Four Seasons. There were Italian American doo wop singers (a style dominated by African Americans) like Johnny Maestro, who sang with the Crests, and Joey Dee, with the Starliters.

Madonna (Madonna Louise Ciccone) burst onto the music scene in the 1980s, bold, irreverent and sexual, alarming the Catholic Church in which she had grown up. She wore crucifixes on her jewelry, and her first compilation album, released in 1990, was *The Immaculate Collection*. It sold more than 30 million copies.

In the 21st century, singers with Italian backgrounds are up front about their heritage, as they are about their music. Ani DiFranco, Gwen Stefani, and Lady Gaga (Stefani Germanotta) have Italian fathers and Italian names. They also have strong personalities and are not shy about self-promotion. Lady Gaga went to Catholic high school, where, she has said, "I used to get made fun of for being either too provocative or too eccentric." Look at her now.

From Tarantella to Jazz

Italian immigrants came to America with a wealth of popular music. Besides amateur orchestras, they developed a circuit of professional groups and solo artists who recorded exclusively for the Italian American market. One of the most appreciated artists was Farfariello (stage name of the Neapolitan actor and singer Eduardo Migliaccio), who in his record "Parla come t'ha fatto mammata" ("Talk like your Ma taught you") combined the Neapolitan dialect with Italian American slang.

Americans are inclined to think that all immigrant Italians played the mandolin, and are surprised to discover that two of the five musicians of the Original Dixieland 'Jass' Band—the group that made the first jazz music record in history at the beginning of 1917—were Italian. Dominic James "Nick" LaRocca and Tony Sbarbaro, also known as Tony Spargo, were, respectively, the trumpet player and drummer of a band formed in New Orleans in 1916. They achieved success on the New York stage with the help of Jimmy Durante. Both LaRocca and Sbarbaro were born to Sicilian parents in Louisiana. They are considered the noble fathers of a new generation of Italian jazz musicians emerging today. The image (right) shows side B of the 78 rpm record that contained "Livery Stable Blues" on side A.

The Music Business

The list of Italian American jazz musicians is very long, and it starts from the very beginning. Some performers, like Chick Corea, are known to the wider public, while others like Buddy De Franco (above left) and Marty Marsala (above right) are known to jazz enthusiasts and are especially valued by colleagues. Marty's brother, clarinetist Joe, was appreciated for his technical skills—Louis Armstrong considered him one of the best in the world—and because he promoted racial integration in jazz. He admired the quality of the African American musicians whom he often invited to perform with him, challenging the conventions of a period that called for segregation in music.

These photographs are by William Gottlieb, creator of the portraits of many jazz artists—both solo players and session men—of the Golden Age of Jazz from the 1930s through the 1940s. He also created the portraits of Frankie Laine (facing page, top) and James Petrillo (facing page, bottom), the powerful president of the American Federation of Musicians from 1940 to 1958.

Italian Voices

From Enrico Caruso to Andrea Bocelli, Italian voices seem to exercise a special fascination for the American public. The images on this page present a gallery of some of the many singers of Italian descent who established themselves in the American music industry after World War II.

Louis Prima (above), whose career kicked off in his hometown of New Orleans, sang during John F. Kennedy's inaugural address. Frankie Laine (top right), born Francesco Paolo Lovecchio, had a very eclectic repertoire that ranged from gospel to rock. Tony Bennett (bottom right), born Anthony Benedetto, won three platinum records, the first in 1962 and the last in 2006. Liberace (facing page, top left), a singer and pianist of Polish-Italian origin, was for many years the highest paid entertainer in the world.

In the April 16, 1957 issue, *Look* dedicated its cover (facing page, top right) to Perry Como. Pierino Como was born in Pennsylvania to a family coming from Abruzzo. Besides selling millions of records around the world, he was a popular TV host, like Dean Martin (facing page, below), who hosted his own show on NBC from 1965 to 1974. Martin, whose real name was Dino Crocetti and who came from Ohio, was born, like Como, into a family that emigrated from Abruzzo.

COLUMBIA LP

TONY
BENNETT
MORE
TONY'S
GREATEST
HITS

Climb Ev'ry
Mountain
I'll Bring You
a Rainbow
Put On
Happy Face
You'll Never Get
Away from Me
Firefly / Baby
Talk to Me
Love Look Away
Ask Anyone
in Love / Smile
I Am / You Can
Love 'em All
The Night That
Heaven Fell

LOOK

INSIDE RED CHINA First American picture story on the forbidden country

APRIL 16, 1957 ★

PERRY COMO:
IS HE REALLY
MR. NICE GUY?

A LOOK
READER BONUS

COMPLETE
NERO WOLFE
MYSTERY

The
DEAN
MARTIN
Show

... and the Voice

The greatest of all Italian American singers was Frank Sinatra—in case there's any doubt, he was nicknamed "The Voice." Francis Albert "Frank" Sinatra was born in Hoboken, New Jersey. His father was a native of Sicily, while his mother was from Liguria. He began singing with the Harry James Band in the late 1930s, then moved to the Tommy Dorsey Band. He became America's first teenage idol in the early 1940s (right, a 1947 portrait by William Gottlieb). Rising to stardom as a "crooner," Sinatra established a new career in acting. He won an Academy Award for his performance in *From Here to Eternity* in 1953. He made thirty-one films, released at least eight hundred records, and participated in numerous charity affairs. Throughout his long career—spanning seven decades—he won many other awards, including another Academy Award, two Golden Globes, twenty Grammy Awards, and an Emmy Award.

Sinatra is shown with Dean Martin and Sammy Davis Jr. (bottom left), the core of what came to be known as the Rat Pack, a group of actors, singers and performers whose members included Peter Lawford and Joey Bishop. They often performed together. Their most famous movie was *Ocean's 11*, whose 2001 remake starred George Clooney and Brad Pitt.

Frank Sinatra was idolized by women (bottom right, he greets his young, adoring fans during a charity event in 1949). Italian Americans, in particular, loved him until the end.

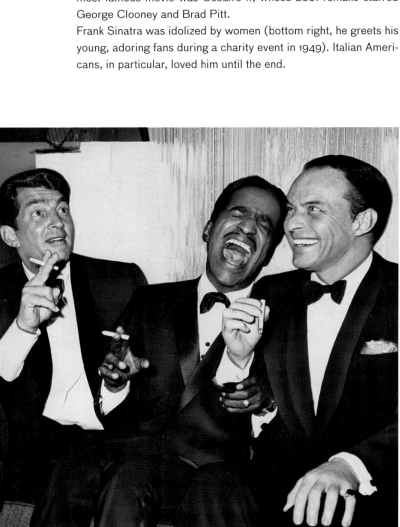

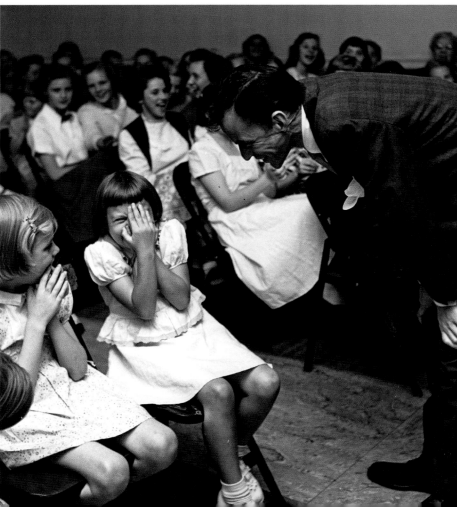

Female Singers

In the 1940s and 1950s, Italian American girls were coming out of their shells and Americanizing. Some established themselves as singers: Connie Francis (top left), Connie Stevens (top right) and Joni James (bottom left) were famous names to teenagers of the time. It is no coincidence that all their names were Americanized. The American public was not yet ready to buy the records of Concetta Franconero (Francis), Concetta Ingolia (Stevens) and Giovanna Babbo (James). All but one: for Nancy Sinatra (bottom right), it would certainly have been counterproductive to abandon her father Frank's last name.

Bobby Darin ATCO 33-102

THE FABULOUS FABIAN Chancellor CHLX 5005

BACK TO THE ROOTS

B
R
U
C
E

Z
I
R
I
L
L
I

Born in the USA

Rock music captivated young Italian Americans in the same way it did young people from all over the world. For teenagers, listening to rock music and adopting the clothing and behavior that came along with it, were a further step from the Little Italy of the previous generations.

Some of the most popular teenage idols of the 1950s hid their Italian American identities behind their stage names. Bobby Darin (top left) was born Walden Robert Cassotto; Fabian (top right), a teen idol launched by the TV show *American Bandstand*, was Fabiano Anthony Forte; and Lou Christie (facing page, top left) was Luigi Alfredo Giovanni Sacco. Frankie Valli was one of the few to use an Italian name, although it was not his birth name: that was Francis Stephen Castelluccio.

Among the heirs of the first generation of Italian American rockers are some of the biggest names in New Jersey rock, from Little Steven (born Steven Lento) to Jon Bon Jovi (John Francis Bongiovi). Perhaps the most famous of them all is Bruce Springsteen: on this rare cover (left) of the bootleg recording made on the occasion of his first Italian concert in 1986, he is presented with the last name of his mother, Adele Ann Zirilli.

Explorers, Emigrants, Citizens

Pop Music Innovator

"Frank Zappa, composer, guitarist, band leader and producer was one of the great iconoclasts of rock music," began the Associated Press in an article on December 4, 1993, on the death of the founder of the Mothers of Invention (top right, the poster for a concert at the Fillmore West in San Francisco). Zappa, the son of a chemist and mathematician born in Partinico (Sicily), devoted the final part of his career to his beloved classical music. Throughout his life he had been influenced by his idols, Igor Stravinksy and Edgard Varèse, a composer born in France of Italian origins, adopted by America.

The project *Francesco Zappa* (left) carried Zappa further away from pop music. In this 1984 record, he played for the first time music by the 18th-century Italian composer Francesco Zappa. (They had the same name but were not related.)

Shaping Traditions

Religion, Food, and Family

"I know everything from the old-world methods [of making wine]. I mean, this has been handed down to my grandfather, my great-grandfather, and keeps on going down the ladder. And there are lots of new techniques I'm learning. . . .But the basic principles are still the same," said Scott Burr, a fourth generation vintner in Gilroy, California. His great-grandfather Anselmo Conrotto started the winery in 1926. His grandfather Chino and his mother Jean kept the business going. Family businesses passed down through generations—whether they are farms, restaurants, stores, or corporations—have been an important part of shaping Italian American traditions.

Italian American traditions are not identical to Italian traditions, although they are drawn from them. They have been modified by emigration, demography, changing times, and individual communities. Religious *festas* honoring saints are still popular, but instead of revolving around a rural church, they take place on the streets of large cities and small towns. Italian Americans still honor St. Joseph's Day on March 19 to thank the saint for granting what they have prayed for during the year. In Buffalo, New York; New Orleans; and Pueblo Colorado, women create St. Joseph's tables, filled with candles, flowers, and specially prepared foods.

Celebrations have evolved beyond religion to embrace Italian American culture in general. "We invite you to stop by and experience what Italians already know; sharing the day with great friends and family, authentic Italian foods, fantastic live entertainment, and strolling the many wonderful arts and crafts merchants is 'La Vita Dolce Italiana,'" reads the announcement for the Italian Family Festa in San Jose, California, which has been organized by the Italian American Heritage Foundation for the last thirty-three years. More than 35,000 people attend each year.

Perhaps the most enduring traditions take place within the family. Many serve the Feast of the Seven Fishes on Christmas Eve, their version of the *Vigilia di Natale* (vigil for the birth of Christ). In the Catholic tradition of meatless meals on holy days, they eat seafood like *baccalà* (salted cod), calamari, and eel—often they have more than seven kinds of fish, including shrimp and lobster, in the abundant land of the United States. Some families still display elaborate *presepi*—figures of the nativity—a tradition that comes out of Naples.

Flags of Italianità

Once Italians got to participate fully in the American dream, they tended to express their origins only in the private sphere. There are very few remaining external manifestations of *Italianità*; shown here are two of the most typical. Above is a religious procession—behind the statue of the saint, in this case San Rocco, an Italian flag is waving on the other—a combination of the spiritual and the secular that would look very surprising in Italy. The white, red, and green flag is the backdrop of this picture of the national soccer team (opposite page), another symbol of Italian identity in America, especially meaningful in 1994 (the year in which the photograph was taken), when the World Cup was played in the U.S.

USA: Campionato del Mondo 1994

Most Italian Americans no longer marry other Italian Americans, but if one of the couple has an Italian background, the bride often carries a *busta*—a satin purse that the guests fill with checks because money is still deemed the best gift. Guests in turn receive *confetti*—almonds coated in white sugar candy, which are still sold in Italian specialty stores.

"It's not Sunday unless I have my spaghetti and my wine," said Paul Palermo of his weekly visits to his parents. Food remains of primary importance, a meal is the gathering place of the family, and recipes are handed down from mother to daughter (and now, to sons as well). A third generation Italian American remembered her grandmother "stuffing her grocery basket with peppers, tomatoes, celery, fennel, olives, provolone, and pepperoni. From these she constructed the *antipasto*, a giant, gaudy flower arranged in concentric circles. I thought my grandmother was an artist, chopping, slicing, considering and placing each piece. Although I filled my plate like everyone else, I secretly thought the *antipasto* was too beautiful to eat."

Tradition comes through in the vegetable gardens, filled with tomatoes and basil, that Italian Americans considered part of their "pantry" for generations. The idea of good craftsmanship and beauty was also passed down. In the Italian American section of Philadelphia in the late 1980s and 1990s, homeowners "dressed" their front windows, arranging holy images, family mementoes, and pretty objects artistically. "Showing an object in the window tells the people passing that a warm person is living in the house," said Anthony Mancuso.

Marguerite Novelli, an early female executive at General Motors, believed that the values she learned from her parents are her heritage. "If you've learned to take care of the family, you're going to act in the same manner towards other people. If you've grown up believing that the sun rises and sets on you, you don't realize that other people need your help and consequently your life has very little meaning." Not so for Italian Americans like Rose Conatore. "The main thing is family. When you've got family, you've got hordes of things to talk about, to remember, to cherish."

The New Italy

The assimilation of Italian Americans to the culture of their adopted country corresponded with a more general appreciation of Italy. Once the country no longer held the negative connotations associated with being home to poor emigrants, it resumed its role as cradle of civilization and art, which had inspired American elites up to the 19th century. By traveling in search of their roots, Italian Americans rediscovered the richness and cultural diversity of a land that only a few decades earlier had promised no future to the first generation of emigrants. The two advertisements that appear in magazines aimed at Italian American communities (left, top and bottom) invited them to visit Italy. Interestingly, while one is in Italian, the other is written only in English: by that time, it could not be taken for granted that new generations understood the language of their fathers.

Some aspects of Italian culture spread outside the Italian American milieu. "Made in Italy" quickly became an asset that American consumers appreciated for products beyond food and music. The poster of the Festa d'Italia in New Orleans (below) in 1986 highlighted this idea. For the first time, next to more traditional icons of *Italianità* (wine, mandolin, spaghetti) the symbols of luxury and fashion appeared, along with a red carnation, a tribute to the Italian Socialist Party, which in those years was at the height of its political success.

Calcio and Bocce

Italian Americans established themselves in all major American sports, but traditional Italian sports and pastimes are different. Among the most popular are soccer and bocci (*calcio* and *bocce* in Italian). Soccer is still played more often and followed more fervently than any other sport in Italy. Finally, after many failed attempts, it is also gaining ground in the United States with a professional league (Major League Soccer) that increasingly interests American fans and media.

For Italians the most important events are those involving the soccer national team, seen in the two images from 1994 (top, left and right) taken in Ralph Venezia's store in Paterson, New Jersey. The original caption noted "soccer memorabilia" related to the national soccer team's participation in the 1994 World Cup. Italian television news made it clear that for the World Cup to be played in the U.S. was a great source of pride for the Italian American community. They had the chance to cheer for the national team of their country of origin, favored to win the championship (after reaching the finals, it unfortunately lost to Brazil). Bocci in Italy is not just a pastime for elderly people, but a real sport in which Italian athletes excel globally. This photograph (left) shows Joe Boggio, a bocci player in Nevada.

In the Family

In 1911, Amy Bernardy wrote: "The Italian woman who is in the U.S. represents only one third or one fourth of our emigration, and when she comes, she is mostly a mother or bride or daughter or sister who follows her transplanted family and works in the house as if she were still at home, and she becomes a laborer in the factory to make money for the day. She is mostly southern and the strict and jealous customs she retains from the native village prevent her from going out of the house." This description of the Italian woman was less and less accurate as integration into American society proceeded. Yet in the case of the Forgetta family (below) in Andover, Massachusetts, the eldest daughter worked outside the home as a laborer in a textile factory but continued to live with her parents. Assimilation led to the creation of mixed families, in which husband and wife had different ethnic backgrounds, as in this photo (right), where the man was Swedish and the woman Italian. This mixing watered down the traditions each brought from his or her homeland. The contrast between these two images is striking: on the one hand is a couple, apparently with no children; on the other, an extended family in which three generations lived in the same house, a more common situation in traditional Italy.

On the table

Late 19ᵗʰ-century immigrants contributed to an Italian food revolution by creating what, to the mainstream American public, is the typical Italian cuisine: spaghetti and meatballs (below, in the version of Chef Boyardee). The addition of meatballs occurred in America, where immigrants could afford to add meat to their diet. In the Italian countryside from which they came, meat was reserved for rich people. For poor people, even white bread was almost unattainable.

Another example of food syncretism is the counter of a Paterson shop selling typical Italian products (bottom). The shop is dominated by a deer head. Hunting was a popular rural pastime in the U.S., unlike in Italy.

The pride Italians took in their food traditions is clear in this photograph (right), showing the singer Ezio Pinza and his family preparing homemade pasta. The habit of making dishes from scratch, including very complex ones, was curious in the eyes of Americans living in an age of packaged foods; and surprises some even today, when Italian haute cuisine has established itself as one of the finest in the U.S.

Religion

Americans, both Protestants and Irish Catholics, looked down on Italians for living their religion primarily through processions, popular ceremonies, statues and portraits of saints. One might be tempted to make the same observation when looking at the images on these pages: the honorary girl in St. Joseph's procession in Chicago (below); a religious float during the Columbus Day Parade in Pasadena, California (bottom left); and the procession of the "Comitato Festa Patronale San Rocco" in Paterson, New Jersey (facing page, above and bottom left). But it would mean forgetting that often these religious celebrations were the only ones available to strengthen the sense of identity in Italian American communities.

In addition to the overlapping of religious icons—the statue of the saint—and lay symbols—the Italian and the American flag—another peculiarity of religious events in Little Italy was the all-American ostentatious presentation of dollars. Vico Mantegazza, in his 1910 book *Agli Stati Uniti - Del pericolo Americano*, noted "Here it is not enough to be rich: you must show it." In the U.S. dollar bills are tacked onto a statue of the saint or openly displayed on the offering plate.

More intimate examples of religious moments are found in two photographs from the Library of Congress collection, "Buckaroos in Paradise," showing the communion of Al Pasquale in 1920 (right), and the tomb of John Boggio in the cemetery of Paradise Valley, Nevada with the inscription, "Native of Italy" (facing page, bottom right).

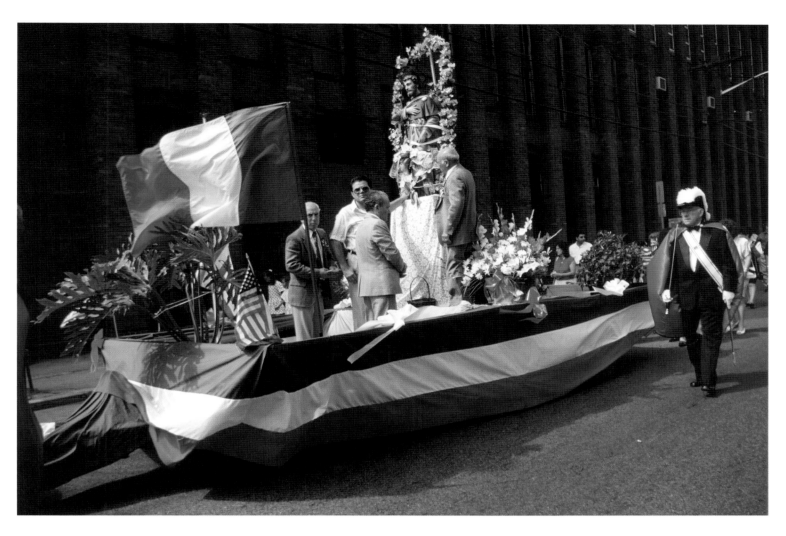

IN MEMORY OF
JOHN B. BOGGIO
NATIVE OF ITALY
BORN SEPT.15.1875
DIED SEPT. 26.1914

Old Ties, New Attachments

In 1992, the American Folklife Center at the Library of Congress published the research of authors David A. Taylor and John Alexander Williams entitled *Old Ties, New Attachments: Italian-American Folklife in the West*. The book (left) focused on the western states, filling a void in the representation of Italian immigration, which is usually more studied—because it is far more numerous—on the Atlantic coast.

These two photos (above and below) document the Folklife Center's research on Italian popular music in California; they show the family of Francesco Sanfilippo, a fisherman originally from Sicily.

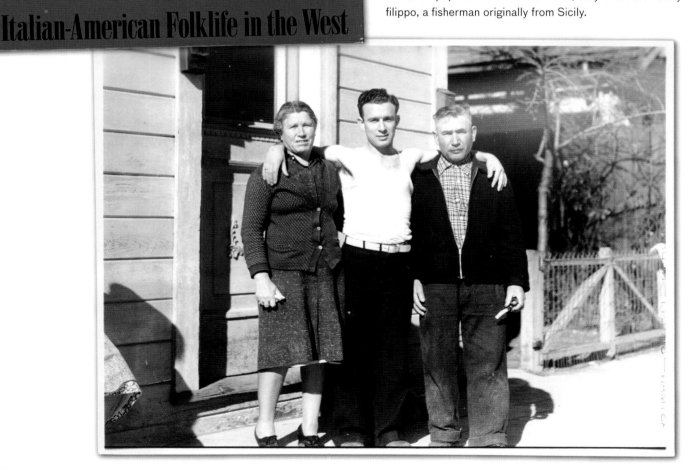

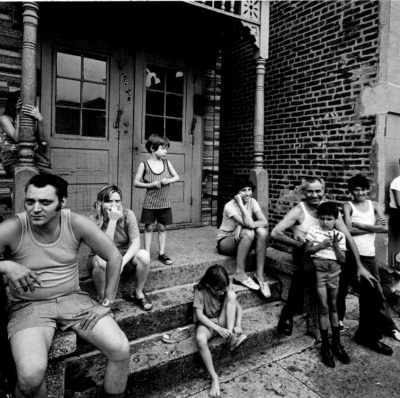

Italian Folklore

The American Folklife Center is an inexhaustible source of documentation on the oral culture, uses and customs of ethnic groups that make up the American population. Within its collections are materials related to Italian American communities, including the images on this page, taken in Chicago in 1977. They form a small sample of the themes explored by Folklife Center researchers: family and food in the photo of the Sottile family (top left); typical products and activities in the photo of Al's bakery (top right); living conditions and social customs in the photo of the extended family on the steps of a building in Chicago (bottom left); and popular culture, in the picture of *morra* players (bottom right).

Today

Between Assimilation and the Brain Drain

"My parents were born in Italy and came to America when they were children. My father came when he was 7 years with his mother; my mother was a bit older. Many children came from Italy at the time, growing up in America but overall they were educated as Italian. And then they became Americans. My generation is already fully American. At home I heard people speak Italian, but we were not particularly encouraged to learn it and speak it. Assimilation took place in two generations: my grandmother lived fifty years in New York without ever learning English."

Don DeLillo, novelist

In the United States census of 2000, when asked about their ethnic background, some 16 million Americans claimed Italian ancestry. At the same time, more Americans than ever, when given the opportunity to name two ethnic groups to which they belonged, chose only one: American. So the concept of Italian American still has meaning, even as the third, fourth, and fifth generations born in the U.S. grow farther and farther away from the roots their immigrant ancestors laid down. It is not a question of how many Italian grandparents one can name. Americans who are one quarter or less Italian can still have an affinity for the culture. While ethnic identity by descent is shrinking, a self-defined identification with ethnic roots is growing stronger.

Italian Americans are no longer looked upon as an inferior, debased group. Names like Cuomo and Pelosi, Alito and Scalia, Pacino and Iacocca don't seem too hard to pronounce—although they would be pronounced with an American accent, as they should be, not the way they would be pronounced by an Italian speaker. Bart Giamatti's paternal grandparents were immigrants, but he fit none of the stereotypes—he was an English Renaissance scholar, the president of Yale University, and the Commissioner of Major League Baseball. In a 2012 list of America's fifty greatest foods compiled by the news network CNN, macaroni and cheese came in thirty-first, cioppino (fish stew) twenty-eighth, Chicago-style pizza, seventh, and the Philadelphia cheese steak (created by Pat and Harry Olivieri) was number five. These are not traditional Italian dishes, but Americanized ones—new creations that became part of the mainstream. They show the influence of adapting Italian immigrants and their descendants, who blended their traditions with American ingredients, tastes, and customs to contribute to the host culture.

As with other ethnic groups that are continually assimilating, Italian Americans both want to be accepted as simply Americans and want to preserve traditions. Many organizations in the U.S. promote Italian culture, as well as learning the Italian language. The Order Sons of Italy in America (OSIA), the largest and oldest (founded in 1905) also encourages Italian Americans to further their education through a scholarship program, promotes relationships with Italy, and fights negative images of Italian Americans. The National Italian American Foundation (NIAF), begun in 1975, facilitates networking between Italian and Italian American businesses and is a liaison with the Italian American Congressional Delegation, in addition to working to preserve heritage. Earning respect and recognition for what Italians have contributed to the United States is no small part of what these organizations do. In the 1960s, the Italian Historical Society of America (formed in 1949) succeeded in eroding opposition against naming the new bridge from Staten Island to Brooklyn after the first European to discover New York Harbor, Giovanni da Verrazzano. There are Italian American study centers at several universities and regional and local clubs, museums, and organizations throughout the United States.

Acceptance of Italian Americans is helped by the fact that American perceptions of Italy itself have changed, from a country of revolution and anarchists, a source of organized crime, and an enemy in World War II. Always associated with high art, it is now a star of high design, producer of cars, clothes, shoes, architecture, and furniture, influential in literature and film. Americans recognize, and want to buy, luxury brands like Armani, Ferragamo, Gucci, Missoni, and Prada, and Fiat, Ferrari, and Alfa Romeo. Umberto Eco is a bestseller in the United States. Italian Americans can share in the pride and build

businesses around importing these products, as well as foods, once considered specialties, that have become mainstream, like pasta, tomato sauce, and olive oil.

And what of the Italian perception of Italian Americans? While most Italian Americans feel at least a sentimental connection to Italy, the same has not been true of Italy towards its emigrants. Perhaps partly because of the differences between Northern and Southern Italy, and the fact that most emigrants came from the South, they have been looked down upon or ignored. Yet the number of people of Italian origin outside of Italy was estimated at 58.5 million in 1994, a little more than 25 percent of them living in the United States. While immigration to the U.S. decreased drastically after this country passed quota laws in the 1920s—even after quotas were lifted in 1965 the numbers were modest—today, Italy is experiencing a "brain drain," since educated professionals find it difficult to get employment; at the same time, the current U.S. immigration policy welcomes those with professional skills.

Today, Italy shows more interest in its emigrants and their descendants. The *Iure Sanguinis* (Right of Blood) law allows Americans with a parent, grandparent, or great-grandparent who were Italian citizens to obtain Italian citizenship with all its rights. They are able to retain their U.S. citizenship as well. The future Italian American—or American Italian—may be the one who carries both passports. The Council for the United States and Italy (*Consiglio per le relazioni fra Italia e Stati Uniti*) promotes transatlantic relations. Another sign of connection is the website www.wetheitalians.com, put together in Rome, a "web portal where everybody can share, promote, be informed, and keep in touch with anything regarding Italy happening in the U.S."

An article in the *Huffington Post* on March 21, 2013, suggested that a strong relationship between Italy and the United States is important not only to Italy, but to the United States: "Historically, the U.S. and Italy share close ties and a bond reinforced by the presence of a significant Italian-American community in the U.S. Since World War II, Italy has been a faithful ally of the U.S. Today, Italy may be more than a historical friend for the U.S.: In the current scenario of a European Union that is struggling to find its new perspective, Italy—more than others—can be the partner for helping the U.S. in finding a consensus in Europe for a renovated era of transatlantic relations and for a new vision on economy and trade between the two sides of the ocean."

International politics is beyond the purview of this book, but *Explorers Emigrants Citizens* was researched and written in a spirit of collaboration between an Italian publisher, a distinguished American institution (the Library of Congress), and an Italian American whose great-grandparents came to the United States. It does not shy away from depicting, in images and words, the deprivations and degradations Italians immigrants faced for more than eighty years. They lived isolated from other Americans not only because they sought solace and strength in their own communities, but because most Americans did nothing to welcome them, teach them, accept them, or encourage them to thrive. Yet they literally built the United States from the ground up, they fought America's wars, and they succeeded in becoming an integral part of this country.

Now, Italy has become a destination for emigrants from Eastern Europe and Africa. The United States continues to be a destination for people from around the world, especially from Latin America. Debate about immigration policy is a daily feature of the news. Legislators and ordinary people in their encounters with others could both learn something from the experience of Italian Americans, and the difference that tolerance, opportunity, and respect can make in the lives of fellow human beings.

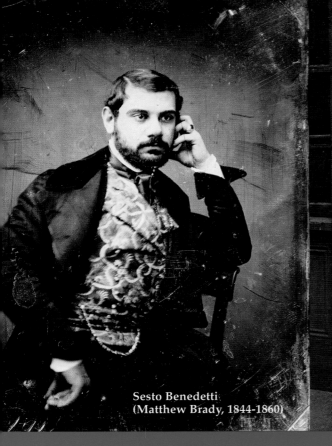

Sesto Benedetti
(Matthew Brady, 1844-1860)

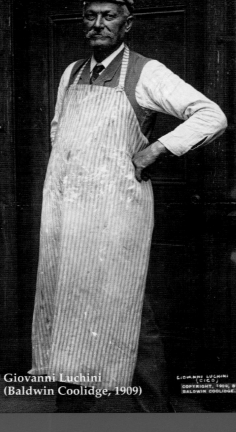

Giovanni Luchini
(Baldwin Coolidge, 1909)

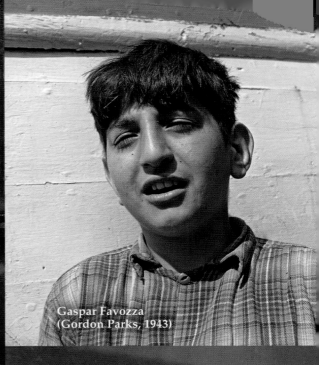

Gaspar Favozza
(Gordon Parks, 1943)

Joseph Buonasari
(Lewis Hine, 1910)

Faces and Names

Look at the faces on these pages. In them you can read the story of Italians in America. Do they look Italian? Are their names Italian? It doesn't matter. They are not just Italian Americans, they are *Americans*, who each contributed to the creation and the growth of the United States. These are the images that document America, provided by pioneering photographers like Lewis Hine, who captured immigrant life in the early 20th century, preserving not only the faces but the names of otherwise nameless workers; or by Marjory Collins, Jack Delano, and Gordon Parks, who traveled across the U.S. during the Great Depression and World War II recording American history. These are the lives that form the background of this book—whether explorer, emigrant, or citizen.

Nick Pilisotta
(Lewis Hine, 1911)

Costello
(Walter Albertin, 1958)

Ferraro
(1979)

Joseph Giordano
(Lewis Hine, 1910)

Antonio Tiano
(Gordon Parks, 1943)

Benny Zucchini
(Jonas Dovydenas, 1977)

Anthony Parisi
(Gordon Parks, 1943)

Vincent Cannici
Angelo Brimo
(Lewis Hine, 1910)

Susini
(1855-1865)

Leopoldo Andreoli
(Lewis Hine, 1911)

Michael Spinella
(Marjory Collins, 1943)

Francesco Sanfilippo
(1939)

Angelo Ross
(Lewis Hine, 1911)

Philip Kurato, Jo Tabone
(Lewis Hine, 1911)

Daniel Anastazia
(Jack Delano, 1943)

Antonio Martina
(Lewis Hine, 1910)

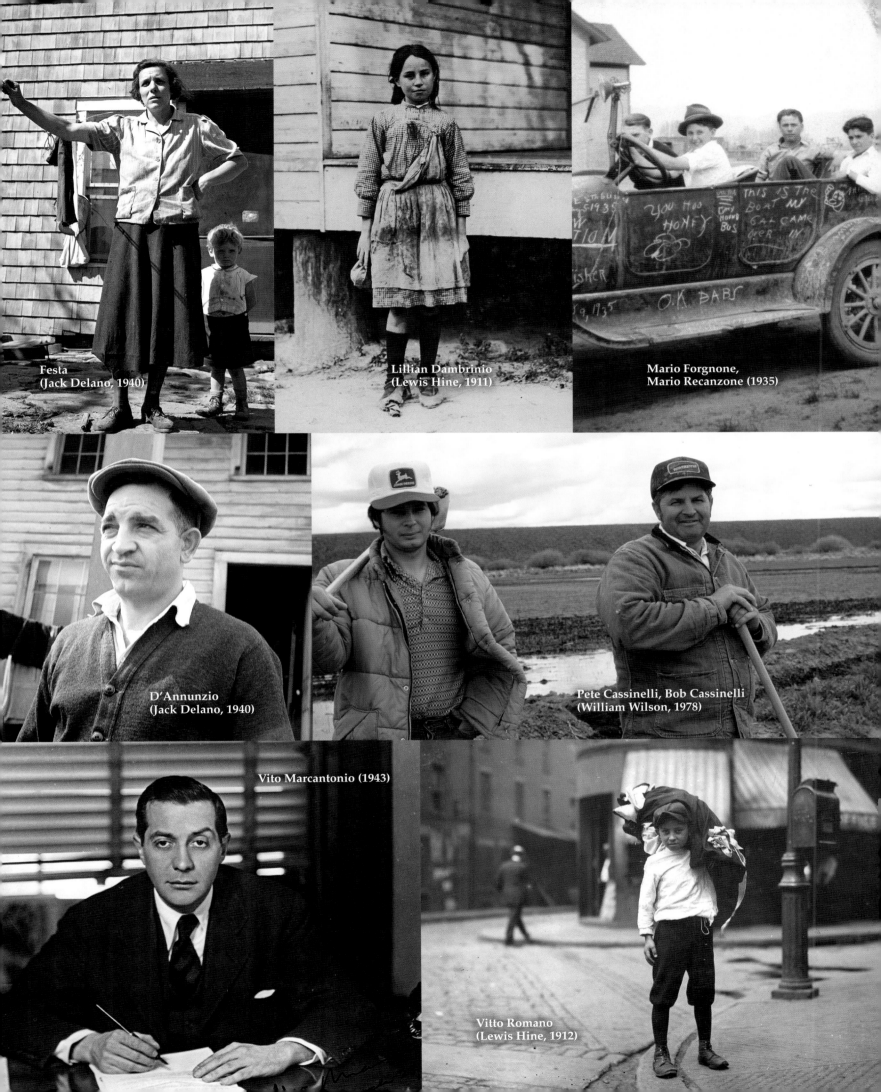

Festa
(Jack Delano, 1940)

Lillian Dambrinio
(Lewis Hine, 1911)

Mario Forgnone,
Mario Recanzone (1935)

D'Annunzio
(Jack Delano, 1940)

Pete Cassinelli, Bob Cassinelli
(William Wilson, 1978)

Vito Marcantonio (1943)

Vitto Romano
(Lewis Hine, 1912)

Selected Bibliography

Amfitheatrof, Erik. *The Children of Columbus: An Informal History of the Italians in the New World.* Boston: Little, Brown, 1973.

Baily, Samuel L. *Immigrants in the Lands of Promise: Italians in Buenos Aires ad New York City, 1870-1914.* Ithaca: Cornell University Press, 1999.

Barbati, Alberto. *Il passaporto: guida dell'emigrante e dell'emigrato* Naples: Presso l'autore, 1906.

Bernardy, Amy A. *America vissuta.* Turin: Fratelli Bocca Editori, 1911.

Bevilacqua, Piero, Andreina De Clementi, and Emilo Franzina, eds. *Storia dell' emigrazione italiana.* 2 vols. Rome: Donzelli, 2001-2002.

Brandenberg, Broughton. *Imported Americans: The Story of the Experiences of a Disguised American and His Wife Studying the Immigration Question.* New York: F.A. Stokes, 1904.

Carli, Gian Rinaldo. *Le lettere americane.* 3 vols. Cremona: L. Manini, 1781-83.

Catani, Patrizia and Roberto Zuccolini. *I fondi archivistici dei consolati in Chicago, Cleveland, Denver, New Orleans e S. Francisco conservati presso l'archivio storico diplomatico.* Rome: Ministero degli Affari Esteri, 1990.

Cecchi, Emilio. *America amara.* Florence: Sansoni, 1939.

Coan, Peter Morton. *Ellis Island Interviews: Immigrants Tell Their Stories in Their Own Words.* New York: Barnes & Noble, 1997.

Collo, Paolo and Gian Paolo Crovetto. *Nuovo Mondo. Gli Italiani 1492-1565.* Turin: Einaudi, 1991.

Corsini, Gianfranco. *America allo specchio.* Bari: Laterza, 1960.

Dall'Osso, Claudia. *Voglia d'America: il mito Americano in Italia tra Otto e Novecento.* Rome: Donzelli, 2007.

Daniels, Roger. *Coming to America: A History of Immigration and Ethnicity in American Life.* 2nd ed. New York: Harper, 2002.

Ets, Marie Hall. *Rosa: The Life of an Italian Immigrant.* 2nd ed. Madison, WI: University of Wisconsin Press, 1999.

Feraud, Lorenzo. *Da Biella a S.Francisco di California: ossia storia di tre valligiani andornini in America preceduta da una guida della valle superiore d'Andorno.* Turin: G.B. Paravia, 1882.

Ferrero, Guglielmo. *Fra i due mondi.* Milan: Treves, 1913.

Franzina, Emilio. *Gli Italiani al Nuovo Mondo: l'emigrazione Italiana in America, 1492-1942.* Milan: A Mondadori, 1995.

Gabaccia, Donna R. and Fraser M. Ottanelli, eds. *Italian Workers of the World: Labor Migration and the Formation of Multiethnic States.* Urbana-Chicago: University of Illinois Press, 2001.

Garlanda, Federico. *La terza Italia: lettere di uno Yankee.* Rome: Società editrice laziale, [1905?].

Giacosa, Giuseppe. *Impressioni d'America.* Milan: L.F. Cogliati, 1908.

"Gl'Italiani negli Stati Uniti d'America."*Giornale popolare di viaggi* no. 1-31 (July 30, 1871): 51-52.

"Gl'Italiani negli Stati Uniti d'America."*Giornale popolare di viaggi* no. 1-32 (August 6, 1871): 79.

Grassi, Giovanni. *Notizie varie sullo stato presente della repubblica degli Stati Uniti dell'America Settentionale, scritte al principio del 1818.* Rome: Presso L.P. Salvioni, 1818.

Handlin, Oscar. *The Uprooted: The Epic Story of the Great Migration that Made the American People.* 2nd ed. Boston: Little, Brown, 1979.

Higham, John. *Strangers in the Land: Patterns of American Nativism 1860-1923.* New Brunswick, NJ: Rutgers University Press, 2002 (©1955, ©1983).

Hoerder Dirk and Leslie Page Moch, eds. *European Migrants: Global and Local Perspectives.* Boston: Northeastern University Press, 1996.

Hoobler, Dorothy and Thomas Hoobler. *The Italian American Family Album.* New York: Oxford University Press, 1994.

Iannace, Carmine Biagio. *The Discovery of America: An Autobiography=La Scoperta dell'America: Un'autobiografia.* William Boelhower, trans. Bilingual ed. West Lafayette, IN: Bordighera, 2000.

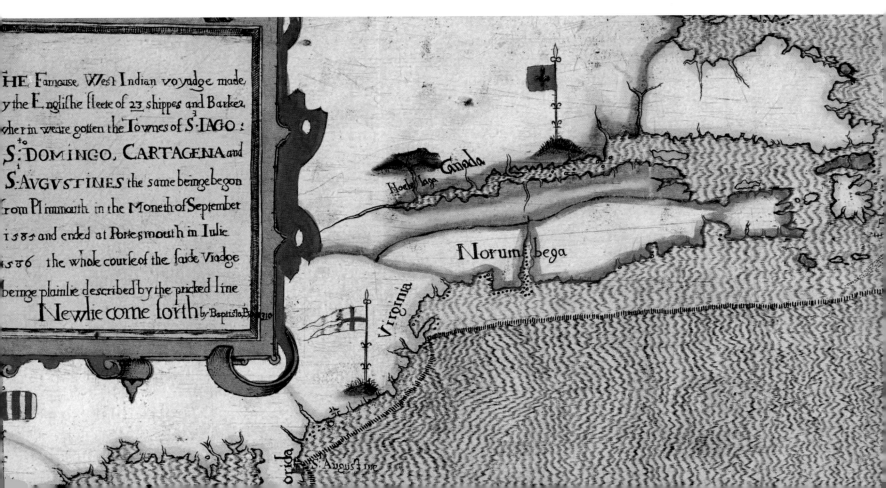

La Gumina, Salvatore J., ed. *Wop: A Documentary History of Anti-Italian Discrimination in the United States*. San Francisco: Straight Arrow Books, 1973.

Leone, Cataldo. *Italians in America: A Celebration*. Mockingbird Press; Portfolio Press, 2001.

Lucassen, Jan. *Migrant Labour in Europe 1600-1900: The Drift to the North Sea*. London: Croom Helm, 1987.

Mahn-Lot, Marianne. *La scoperta dell'America*. Milan: Mursia, 1971.

Mangione, Jerre and Ben Morreale. *La Storia: Five Centuries of the Italian American Experience*. New York: HarperCollins, 1992.

Mantegazza, Vico. *Agli Stati Uniti*. Milan: Fratelli Treves, 1910.

Marino, Cesare. *The Remarkable Carlo Gentile: Pioneer Italian Photographer of the American Frontier*. Nevada City: Carl Mautz, 1998.

Massara, Giuseppe. *Viaggiatori italiani in America (1860-1970)*. Rome: Edizioni di storia e letteratura, 1976.

Mayor des Planches, Edmondo. *Attraverso gli Stati Uniti. Per l'emigrazione italiana*. Turin: Unione tipografico—editrice torinese, 1913.

Molinari, Luca and Andrea Canepari, eds. *The Italian Legacy in Washington, DC: Architecture, Design, Art and Culture*. Milan: Skira, 2007.

Morrison, Joan and Charlotte Fox Zabusky. *American Mosaic: The Immigrant Experience in the Words of Those Who Lived It*. Pittsburgh: University of Pittsburgh Press, 1980.

Mosso, Angelo. *Vita Moderna degli Italiani*. Milan: Fratelli Treves, 1905.

Ojetti, Ugo. *L'America vittoriosa* Milan: Fratelli Treves, 1899.

Orsi, Robert A. *The Madonna of 115th Street: Faith and Community in Italian Harlem, 1880-1950*. New Haven: Yale University Press, 1985.

Pecorini, Alberto. *Gli americani nella vita moderna osservati da un italiano*. Milan: Fratelli Treves, 1909.

Piovene, Guido. *De America*. Milan: Garzanti, 1953.

Pivano, Fernanda. *L'altra America negli anni Sessanta*. Rome: Officina Edizioni, 1971-1972.

Pizzorusso, Giovanni and Matteo Sanfilippo. *Dagli indiani agli emigranti: l'attenzione della Chiesa romana al Nuovo Mondo, 1492-1908*. Viterbo: Sette città, 2005.

Rosoli, Gianfausto. "L'immaginario dell'America nell'emigrazione italiana di massa." *Bollettino di Demografia Storica* 12 (1990).

Rossi, Adolfo. *Un Italiano in America*. Milan: Fratelli Treves, 1894.

Sanfillippo, Matteo. *L'affermazione del Cattolicesimo Nel Nord America: Elite, emigranti e chiesa Cattolica negli Stati Uniti e in Canada, 1750-1920*. Viterbo: Sette città, 2003.

Sanna-Ser, Joseph. *Guida del minatore*. Pittsburgh: Economical Printing Company, 1914.

Scarpaci, Vincenza. *A Portrait of the Italians in America*. New York: Scribner, 1982.

Schiavo, Giovanni. *Four Centuries of Italian-American History*. 1st American ed. New York: Vigo Press, 1952.

_____. *Italian American History*. 2 vols. New York: Arno Press, 1975 (©1947-1949).

_____. *The Italian Contribution to the Catholic Church in America*. New York: Arno Press, 1975 (©1949).

_____. *The Italians in America before the Civil War*. New York: Arno Press, 1975 (©1934).

Schoener, Allon. *The Italian Americans*. New York: Macmillan, 1987.

Scott, Pamela. *Temple of Liberty: Building the Capitol for a New Nation*. New York: Oxford University Press, 1995.

Soldati, Mario. *America Primo Amore*. Florence: Bemporad, 1935.

Taylor, David A. and John Alexander Williams. *Old Ties, New Attachments: Italian-American Folklife in the West*. Washington, DC: Library of Congress, 1992.

Vangelista, Chiara, ed. *Fondazione Casa America, I primi italiani in America del Nord. Dizionario biografico dei liguri, piemontesi e altri. Storie e presenze italiane tra Settecento e Ottocento*. Reggio Emilia: Diabasis, 2009.

Vegas, Fernando. «Gli Stati Uniti dal 1890 al 1945,» in *Nuove questioni di storia contemporanea*. Milan: Marzorati, 1972 - II.

Venturini, Roberto. *Dopo nove giorni di cielo e acqua: storia, storie, e luoghi in mezzo secolo di emigrazione Sammarinese negli Stati Uniti*. San Marino: Edizione del Titano, 1999.

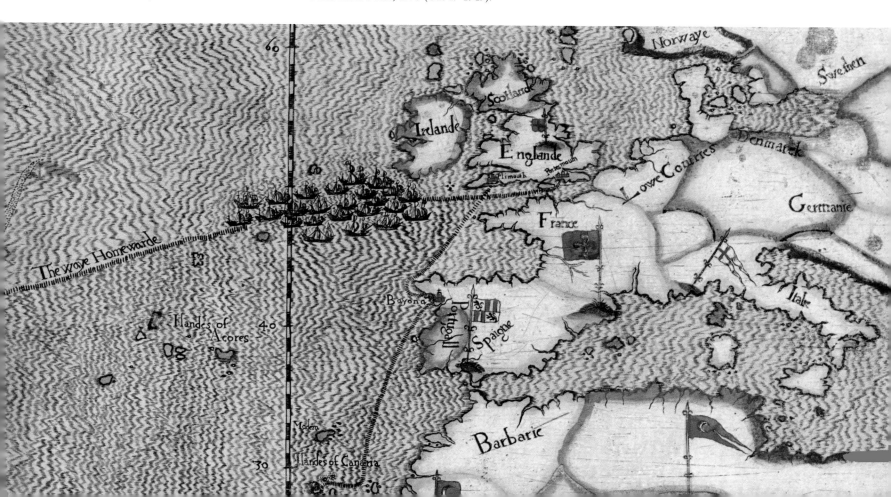

Acknowledgments

Making a book is a collaborative effort. We are grateful to Ralph Eubanks, former director of the Publishing Office, for bringing the Library of Congress on as a partner in developing *Explorers Emigrants Citizens* and for his support and encouragement. Special thanks go to Peter Devereaux of the Publishing Office, for his thoughtful and thorough editing. His untiring efforts made the timely production of this book possible. We also wish to thank Professors Antonio Canovi and Mario B. Mignone for sharing their expertise in the informative introductions to each chapter. We are grateful to Martin Scorsese for his heartfelt and expressive foreword, and to his assistants Lisa Frechette and Ashley Peter, for their skill at coordinating communications.

Peggy Wagner of the Publishing Office graciously filled in to complete the project, and Susan Reyburn and Athena Angelos contributed their invaluable knowledge of the collections. We also wish to thank the staff of Anniversary Books for their rapid response to every change in text and layout, especially Giulia Battaglia for her creative design work and Silvia Gibellini for her excellent writing. Library of Congress Publishing Office interns Mariana Robinson, Luke Wilson, and Gabrielle Winick did a commendable job of assisting with research. Caroline Bowman, Courtney Hall, and Sydney Sznajder aided in final production. The friendship and support of many were instrumental in bringing such a complex project from conception to production. We especially wish to thank Massimo Balboni, Lorenzo Bertucelli, Sebastiano Colombini, Marcello Ferrari, Laura Mastellaro, Laura Mazzi, Umberto Mucci, Antonio Panini, Claudio Silingardi, Stefano Soranna, Eugenio Tangerini, and Stefano Vaccari. Thanks to three generations of the Italian American Triggiani family for their love and interest in this book.

The Library is a large and sometimes overwhelming place to look for materials. We appreciate the help and advice of the knowledgeable staff of several reading rooms, including Todd Harvey of the American Folklife Center; Bryan Cornell, Karen Fishman, Dorinda Hartmann, and Josie Walters-Johnston of the Motion Picture, Broadcasting, and Recorded Sound Division; Helena Zinkham, Katherine Moore Arrington, Jeff Bridgers, Jonathan Eaker, Kristi Finefield, Jan Grenci, Marilyn Ibach, Martha Kennedy, Phil Michel, and Barbara Natanson of the Prints and Photographs Division; and Dan De Simone and Eric Frazier of the Rare Books Division. We would also like to thank Kia Campbell and Georgia Zola of Duplication Services for assistance with the reproduction of images, and Glen Krankowski and Domenico Sergi for their processing of frame enlargements.

Finally, we wish to thank our families—Silvia Salvatori, and Sara Battaglia, and Bob, Catherine, and Nick Osborne—for their enthusiasm and support; for sharing our passion for history; and for giving us the time and space to focus intensely on what was truly a labor of love for both of us.

Linda Barrett Osborne and Paolo Battaglia

Fans waiting for Frank Sinatra to arrive at the Paramount Theatre, New York, New York, 1945

Image Credits

INFORMATION ABOUT IMAGES

The images in this book are from the collections of the Library of Congress. Many are from the Library's Prints and Photographs Division and the following list provides the reproduction numbers of those images which can be viewed or downloaded from http://www.loc.gov/pictures . Items from other divisions are noted using the abbreviations listed below. Visit the Duplication Services Web Site at http://www.loc.gov/duplicationservices/ for further information. Please note that many of these images are not in the public domain and restrictions on their use may apply. All reasonable efforts have been made when necessary to secure usage permission from the copyright holders.

ABBREVIATIONS FOR CUSTODIAL DIVISIONS

GC	General Collections
G&M	Geography and Map Division
MSS	Manuscript Division
MUS	Music Division
RBSC	Rare Book and Special Collections
MBRS	Motion Picture, Broadcasting and Recorded Sound Division
SER	Serial and Government Publications Division
AFC	American Folklife Center

ABBREVIATIONS FOR POSITION ON THE PAGE

t: top; tr: top right ; tl: top left; b: bottom; br: bottom right; bl: bottom left; r: right; l: left; m: middle; mr: middle right; ml: middle left;

Front

2-3: LC-DIG-ds-03842; 4: LC-DIG-ds-03838; 5: LC-DIG-ggbain-13309; 9: Martin Scorsese Collection; 12-13: Courtesy of Barrett family; 14: Courtesy of Salvatori family; 15: LC-DIG-ppmsca-09890; 16: LC-DIG-nclc-04540; 17: LC-DIG-nclc-04549.

Chapter One: Explorers

18-19: RBSC, G3934.S2 1589 .B6; 30t: LC-USZC2-2743; 30r: LC-USZ62-39304; 31t: LC-USZ62-101688; 31b: LC-USZ62-118192; 32tl and 32 tr: RBSC; 32b: LC-USZC4-4806; 33t: RBSC; 33bl: RBSC; 33br: LC-USZ62-53657; 34-35: Martin Waldseemüller, G&M; 36b: G&M; 37t: LC-DIG-pga-00347; 37b: LC-USZ62-26683; 38tl: USZ62-30427; 38b: GC; 38-39t: LC-USZ62-119622; 39b: LC-DIG-ggbain-11303; 40 tl: LC-USZ62-3283; 40r: RBSC; 41t: RBSC; 41l: RBSC; 41b: RBSC; 42t: RBSC; 42b: LC-USZ62-54475; 43tl: HABS ARIZ,12-TUBA.V,1--10; 43tr: G&M; 43b: LC-USZC4-5667; 44t: LC-DIG-ds-03967; 44b: LC-USZC4-5613; 45tl: LC-USZC4-5675; 45tr: LC-USZC4-5615; 45mr: LC-USZC4-5674; 45bl: LC-USZC4-5676; 45br: LC-USZC4-5678; 46tl: RBSC; 46tr: RBSC; 46ml: RBSC; 46bl: RBSC; 46br: RBSC; 47t: LC-USZC2-1755; 47b: LC-USZ62-123425; 48t: LC-USZ62-99043; 48b: LC-USZ62-78112; 49t: LC-DIG-ppmsca-07837; 49b: MSS George Washington Papers; 50tl: MSS Filippo Mazzei Papers; 50b: MSS LC-MSS-27748-180; 51t: LC-USZ62-110171; 51b: LC-DIG-pga-02381; 52: LC-USZC4-4159; 53t: LC-DIG-csas-01112; 53bl: LC-DIG-cwpbh-02623; 53br: LC-DIG-cwpbh-02005; 54t: MUS The Moldenhauer Archives molden 1785t; 54b: LC-USZC2-2532; 55tl: MUS A-3755; 55tr: LC-DIG-cwpbh-01944; 55b: LC-DIG-cwpbh-03441; 56tl: LC-DIG-ds-03661; 56ml: Broadsides, leaflets, and pamphlets from America and Europe, RBSC; 56bl: MSS James Madison Papers; 56r: HABS MD,4-BALT,113--5; 57t: LC-DIG-cwpbh-05143; 57b: LC-USZC4-13414; 58t: LC-D4-33477; 58b: LC-USZ62-86271; 59t: LC-USZ62-94396; 59b: LC-DIG-ggbain-12995; 60t: LC-DIG-ds-03840; 60b: LC-DIG-ds-03839; 61t: LC-DIG-ds-03841; 62tl: LC-USZ62-119128; 62r: LC-DIG-ppmsca-20252; 63: LC-DIG-ppmsca-31563; 64t: LC-DIG-cwpb-03669; 64b: LC-DIG-cwpb-01691; 65t:

LC-USZ62-119789; 65b: MSS Abraham Lincoln Papers; 66t: GC; 66bl: RBSC; 66br: LC-USZC4-6811; 67t: LC-DIG-ppmsca-21433; 67bl: SER; 67br: LC-DIG-ppmsca-11694.

Chapter Two: Emigrants

68-69: LC-USZC4-2654; 90: LC-USZ62-26543; 90r: LC-USZC4-4635; 91l: AFC; 91b: LC-USZ62-44048; 92 t: GC; 92bl: GC; 92br: MBRS; 93t: LC-USZ62-93867; 93bl: GC; 95 br: LC-USZ62-87554; 94tl: LC-DIG-ds-03654; 94tm: LC-DIG-ds-03649; 94tm: LC-DIG-ds-03653; 94bl: LC-DIG-ds-03655; 94br: GC 95t: LC-USZ62-137829; 95b: LC-DIG-ds-03648; 96tl: LC-USZ62-86854; 96tr: LC-USZ62-80112; 96ml: LC-USZ62-93250; 96mr: LC-USZ62-116223; 96b: LC-USZC4-4656; 97t: GC; 97b: LC-DIG-ggbain-33266; 98: LC-USZ62-67910; 99t: LC-USZ62-32536; 99b: LC-USZ62-52584; 100: LC-USW3-015961-D; 101: GC; 102: LC-USZ62-25673; 103: LC-USZ62-114764; 104t: LC-D401-71269; 104b: LC-DIG-ds-03658; 105t: LC-DIG-ds-03659; 105b: LC-D4-19309; 106t: LC-USZ62-58927; 106b: LC-DIG-nclc-04191; 107t: LC-G406-T-0065; 107bl: LC-USZ62-19866; 107br: LC-USZC2-5299; 108tl: LC-DIG-nclc-04884; 108tr: LC-DIG-nclc-00761; 108bl: LC-DIG-nclc-00763; 108br: LC-DIG-nclc-00765; 109tl: LC-DIG-ds-03813; 109tr: LC-USZ62-24986; 109b: LC-USZ62-50720; 110t: LC-DIG-ppmsca-29037; 110b: AFC 1995/028: WIP-MC-B008-04; 111t: LC-USZ62-32308; 111b: LC-USW3-013552-D; 112t: The Century, Vol 58 August 1899; 112b: GC; 113t: LC-USZ62-50658; 113b: LC-B2- 2073-8; 114t: LC-DIG-ds-03657; 114bl: LC-USW3-014788-E; 114br: LC-USW3-013032-E; 115b: LC-USW3-013033-E; 116t: HABS CAL,43-SANCLA,5--6; 116b: LC-USZ62-103568; 117t: LC-DIG-ggbain-14196; 117b: LC-DIG-ggbain-14198; 118tl: LC-DIG-nclc-04538; 118tr: LC-DIG-nclc-04935; 118b: LC-USZC2-1017; 119t: LC-DIG-nclc-04605; 119b: LC-DIG-nclc-04801; 120t: LC-USZ62-93091; 120b: LC-DIG-ds-03125; 121t: GC; 121bl: LC-USW3-013557-D; 121br: LC-DIG-fsac-1a35007; 122t: GC; 122b: LC-USZ62-58461; 123: LC-DIG-ds-03835; 124t: LC-DIG-ggbain-03083; 124bl: SER; 124br: SER; 125 all: SER; 126t: LC-DIG-ggbain-02970; 126b: LC-DIG-ggbain-27184; 127t: LC-DIG-ds-03805; 127b: LC-DIG-ggbain-09831; 128-129t: PAN SUBJECT - Events no. 55 ; 128b: LC-DIG-ggbain-24723; 129b: LC-G605-CT-00416-1/2; 130-131t: PAN SUBJECT - Groups no. 48; 130b: LC-DIG-ggbain-30024; 131t: LC-DIG-ppmsca-26320; 131b: LC-DIG-ggbain-31654; 132t: LC-DIG-ggbain-34234; 132b: LC-DIG-ggbain-31576; 133t: LC-DIG-ggbain-23830; 133b: LC-DIG-ggbain-23775; 134t: LC-B2- 2999-10; 134b: LC-DIG-ggbain-24089; 135t: LC-USZ62-134894; 135b: LC-DIG-ppmsca-03351; 136l: LC-USZC4-13505; 136 r1: MBRS; 136 r2: MBRS; 136 r3-5: MBRS; 137tl: LC-DIG-ds-03834; 137bl: LC-DIG-ds-03836; 137r: LC-USZ62-19689; 138t: LC-DIG-ggbain-00317; 138bl: LC-USZ62-129826; 138br: LC-USZC4-5389; 139t: LC-USZ62-102883; 139b: LC-DIG-ggbain-09282; 140: Courtesy Paolo Battaglia; 141: MBRS; 142: LC-DIG-ppmsca-25972; 143t: LC-DIG-ppmsca-28430; 143b: LC-USZC4-5739; 144t: LC-DIG-ppmsca-26380; 144b: LC-DIG-ggbain-03246; 145 all: SER; 146t: SER; 146r: LC-DIG-ds-03815; 147b: MBRS; 147r: SER; 148t: LC-USW3-014767-D; 148b: GC; 149t: LC-DIG-ggbain-07761; 149b: LC-USZ62-134667; 150t: LC-USZ62-137644; 150bl: LC-USZ62-137641; 150br: LC-DIG-ggbain-03254; 151tl: LC-USZ62-124508; 151tr: HABS PA,51-PHILA,354--79; 151m: LC-USZ62-123222; 151b: LC-DIG-ds-03814; 152tl: LC-USZC4-5194; 152bl: MBRS; 152r: MBRS; 153: MBRS; 154tl: LC-DIG-nclc-00054; 154r: LC-DIG-nclc-00064; 155t: AFC; 155b: LC-DIG-ds-03809; 156t: LC-DIG-ds-03810; 156bl: LC-USF34-008557-D; 156br: LC-USF33-T01-001295-M2; 157t: LC-USF33-012451-M2; 157b: LC-DIG-nclc-00365; 158tl: G&M; 158tr: LC-USF34-070676-D; 158b: LC-DIG-ds-03651; 159tl: LC-USF33-T01-002022-M4; 159tr: LC-DIG-ds-00439; 159b: LC-DIG-hec-15244; 160t: LC-DIG-ds-03652; 160ml: LC-USZ62-16100; 160mr: LC-USZ62-93513; 160b: SER; 161: LC-D4-3604; 162t: LC-DIG-nclc-00069; 162bl: LC-DIG-nclc-00068; 162br: LC-DIG-nclc-00034; 163t: LC-DIG-nclc-00049; 163bl: LC-DIG-nclc-00070; 163br:

LC-DIG-nclc-00088; 164tl: LC-USF34-057688-D; 164tr: LC-USF34-057680-D; 164bl: afc96ran 47353; 164br: afc96ran 46354; 165t: LC-DIG-ds-03808; 165b: LC-USZ62-99880; 166: LC-DIG-nclc-01138; 167t: LC-DIG-nclc-01110; 167b: LC-DIG-ggbain-04370; 168t: LC-DIG-nclc-03244; 168: LC-USF33-T01-001361-M4; 169: LC-DIG-nclc-02364; 170t: CaLC-USZC4-4640; 170b: LC-DIG-ggbain-17802; 171t: GC; 171b: LC-DIG-nclc-00988; 172tl: LC-DIG-ppmsca-05641; 172tr: SER; 172b: LC-USZC4-5712; 173tl: LC-DIG-nclc-04313; 173tr: LC-DIG-nclc-04097; 173b: LC-DIG-nclc-04077; 174tl: LC-DIG-nclc-04138; 174tr: LC-DIG-nclc-04121; 174b: LC-DIG-nclc-04203; 175t: LC-DIG-nclc-04109; 175bl: LC-DIG-nclc-04144; 175br: LC-DIG-nclc-04276; 176t: SER; 176m: LC-DIG-nclc-04512; 176b: LC-DIG-nclc-02447; 177t: LC-DIG-nclc-02355; 177b: LC-DIG-nclc-03762; 178t: LC-DIG-ggbain-10149; 178m: LC-DIG-ggbain-15859; 178b: LC-DIG-ggbain-12864; 179t: LC-DIG-ggbain-12821; 179b: LC-DIG-nclc-04521; 180t: LC-USZ62-131861; 180b: LC-DIG-ggbain-07339; 181tl: LC-DIG-ggbain-18755; 181br: SER; 182t: LC-USZ62-42330; 182bl: LC-USZ62-136884; 182br: LC-USZ62-136885; 183 all: MSS; 184l: LC-DIG-ds-03622; 184r: LC-DIG-nclc-03217; 185lt: LC-USW3-015096-D; 185lb: GC; 185b: LC-DIG-ds-03975; 186t: LC-DIG-nclc-03643; 186bl: LC-DIG-ds-03811; 186br: LC-DIG-nclc-03197; 187t: LC-DIG-nclc-03308; 187b: LC-DIG-ds-03650; 188t: LC-USZC4-1584; 188b: LC-DIG-ppmsca-12163; 189l: LC-DIG-ppmsca-12164; 189tr: LC-DIG-ppmsca-12771; 189br: LC-DIG-ppmsca-12781; 190t: SER; 190bl: LC-USW3-006922-E; 190br: LC-USW3-006922-E; 191t: LC-DIG-ggbain-22947; 191b: LC-DIG-fsa-8d24520; 192t: LC-B2-3982; 192b: LC-DIG-nclc-05194; 193t: LC-DIG-nclc-04800; 193b: LC-DIG-nclc-04175; 194t: LC-DIG-ggbain-00237; 194b: LC-DIG-ggbain-08925; 195t: LC-USW3-024539-D; 195b: LC-DIG-ds-03667; 196t: LC-USZ62-139580; 196b: LC-USF34-081781-E; 197tl: LC-USW3-014922-D; 197tr: GC; 197b: LC-DIG-ds-03732.

Chapter Three: Citizens

198-199: LC-USW3-006904-E; 218l: LC-USW3-013566-D (detail); 218r: LC-DIG-ds-03664; 219: LC-USF33-012094-M4; 220tl: LC-DIG-ggbain-36396; 220tr: LC-DIG-ggbain-18953; 220bl: LC-USW3-013566-D; 220br: LC-DIG-hec-26646; 221t: LC-DIG-ds-03665; 221b: LC-USZC4-9653; 222t: LC-DIG-hlb-00036; 222bl: LC-DIG-hlb-00120; 222br: LC-DIG-hlb-01063; 223t: Mario Castelnuovo-Tedesco Papers, MUS; 223bl: MSS Rabi Papers; 223br: LC-USZ62-120917; 224l: USW3-014335-D; 224r: LC-DIG-ds-03828; 225: MSS Maurice Neufeld Papers; 226t: LC-DIG-ggbain-19241; 226bl: LC-USZC4-10145; 226br: GC ; 227tl: LC-DIG-ggbain-28070; 227tr: LC-USZC4-5845; 227b: LC-USZC4-9031; 228t: LC-DIG-hlb-00265; 228bl: LC-USW3-013036-E; 228br: LC-DIG-fsa-8d24240; 229: LC-USZC4-4265; 230t: LC-USW3-030569-E; 230b: LC-USW3-024557-D; 231t: LC-USW3-055815-C; 231bl: LC-DIG-ds-03822; 231br: LC-DIG-ds-03829; 232tl: LC-USW3-013072-D; 232tr: LC-DIG-ds-03669; 232b: GC; 233 all: MSS Maurice Neufeld Papers; 234t: LC-DIG-ppmsca-18815; 234bl: LC-USZ62-50137; 234br: LC-DIG-fsa-8d34223; 235t: LC-USW3-040006-E; 235bl: LC-USW3-040008-E; 235br: LC-USW3-039924-E; 236: LC-USZ62-135620; 237t: LC-USZ62-78697; 237bl: LC-DIG-ppmsca-19878; 237br: LC-USZ62-98628; 238t: LC-USW3-017675-E 238b: AFC, NV8-CF78-1; 239: LC-USW3-018527-D; 240: LC-DIG-ds-03816; 241: LC-USF33-T01-001277-M1; 242t: HABS GA,123-AUG,10--1; 242b: LC-DIG-ppmsca-28184; 243t: LC-DIG-stereo-1s02351; 243bl: LC-DIG-ggbain-35761; 243br: LC-DIG-ppss-00443; 244t: LC-USZC4-128044; 244b: LC-DIG-ds-03802; 245tl: LC-DIG-hlb-01164; 245tr: LC-DIG-ds-03819; 245b: LC-DIG-hec-28982; 246t: LC-USZ62-128901; 246bl: LC-DIG-hec-24126; 246br: LC-DIG-ds-03670; 247t: LC-DIG-ds-03823; 247b: LC-DIG-ppmsca-31201; 248t: LC-USE6-D-010891; 248b: LC-DIG-ds-03668; 249tl: LC-DIG-ppmsca-17207; 249r: MSS Sirica Papers; 249br: LC-DIG-ppss-00471; 250: Courtesy of Susan Reyburn; 251t: LC-USZ62-115333; 251b: HABS NJ,9-JERCI,16--46; 252t: LC-DIG-ggbain-34658; 252b: LC-DIG-ggbain-15573; 253t: LC-USZ62-98731; 253b: LC-DIG-hec-01677; 254tl: LC-USZ62-112832; 254tr: LC-DIG-ds-00104; 254b: LC-DIG-ds-03709; 255tl: Courtesy of Susan Reyburn; 255tr: Courtesy of Susan Reyburn; 255bl: GC; 255br: GC; 256t: GC; 256rt: LC-DIG-bbc-1309f; 256rb: LC-DIG-bbc-0837f; 257: LC-DIG-ppmsca-19535; 258t: LC-DIG-ppmsca-18794; 258b: SER; 259: LC-DIG-ppmsca-18828; 260t: MUS; 260b: LC-DIG-ppmscd-00184; 261t: LC-DIG-ggbain-11252; 261b: LC-USZC4-4798; 262t: LC-DIG-ds-03625; 262b: SER; 263tl: LC-DIG-ppmsca-19953; 263tr: LC-DIG-ppmsca-19956; 263b: LC-DIG-ppmsca-31946; 264tl: SER; 264tr: LC-DIG-ds-03824; 264b: LC-DIG-ds-03977; 265t: MBRS; 265bl: GC; 265br: LC-DIG-ds-03827; 266r: LC-USZC4-5154; 266l: LC-USZC4-5154; 267: LC-USZ62-94806; 268tl: LC-DIG-ds-03812; 268br: LC-USZ62-87999; 268bl: LC-DIG-ds-03660; 269tl: SER; 269b: LC-USZ62-87997; 270l: LC-DIG-ds-03820; 270tr: LC-DIG-ppmsca-08058; 270br: LC-DIG-ds-03825; 271t: LC-DIG-ppmsca-06460; 271bl: LC-DIG-ppmsca-32258, © 2013 Marvel; 271br: SER; 272 all: RBSC; Corso's BOMB courtesy of City Lights Books; 273 all: GC; 274 all: GC; 275l: LC-DIG-ds-04284; 275r: LC-USZ62-101625; 276: GC; 277t: LC-DIG-ppmsca-06778; 277bl: LC-DIG-ggbain-38803; ; 277br: LC-DIG-ppmsc-03692; 278l: LC-DIG-ds-03666; 278tr: LC-DIG-ds-03803; 278br: LC-USZ62-126194; 279t: LC-DIG-ppmsca-09565; 279bl: Courtesy of Paolo Battaglia; 279b: LC-DIG-ds-03830; 280t: LC-USZ62-102901; 280b: MUS; 281tl: LC-USZC4-8623; 281tr: LC-USZC4-13212; 281br: LC-USZ62-105918; 282t: LC-USZC4-5263; 282bl: MBRS; 282br: LC-DIG-ppmsca-19350; 283t: LC-USZC4-3932; 283bl: LC-DIG-ds-03966; 283br: LC-DIG-ds-03965; 284t: MUS LC-GLB23-0550 DLC; 284b: MUS LC-GLB23-0701 DLC; 285t: MBRS; 285bl: MUS LC-GLB23-0193 DLC; 285br: MUS LC-GLB23-0742 DLC; 286tl: MUS LC-GLB13-0716 DLC; 286tr: MUS LC-GLB04-1343 DLC; 286b: MBRS; 287tr: SER; 287tl: LC-DIG-ds-03701; 287b: LC-DIG-ds-03930; 288t: MUS LC-GLB13-0779 DLC; 288bl: LC-DIG-ppmsca-24371; 288br: LC-DIG-ds-03678; 289tl: MBRS; 289tr: LC-DIG-ds-03704; 289bl: LC-DIG-ds-03699; 289r: MBRS; 290 all: MBRS; 291r: LC-DIG-ds-03821; 291tL: MBRS; 291bl: Courtesy of Paolo Battaglia; 292: AFC, 1995/028: WIP-MC-C015-07; 293: AFC, 1995/028: WIP-TDC-C011-04; 294t: GC; 294b: LC-DIG-ds-03826; 295tl: AFC, 1995/028: WIP-TDC-C005-06; 295tr: AFC, 1995/028: WIP-TDC-C006-06; 295b: AFC, NV8-LG56-18; 296t: LC-USW3-022509-E; 296b: LC-USF34-042904-D; 297t: LC-DIG-ds-03702; 297bl: GC; 297br: AFC, 1995/028: WIP-TDC-C013-11; 298l: AFC, 1981/004_b54866_3; 298tr: AFC, NV8-CF80-10; 298br: AFC, 1989/022_IAW-KL-C115-4; 299t: AFC, 1995/028: WIP-DT-C003-01; 299bl: AFC, 1995/028: WIP-MC-B007-25; 299br: AFC, NV8-CF32-16; 300l: GC; 300tr: AFC, 1940/001_ph145; 300br: AFC, 1940/001_ph143; 301tl: AFC, 1981/004_b44028_4; 301tr: AFC, 1981/004_b43067_20a; 301bl: AFC, 1981/004_b54866_8; 301br: AFC, 1981/004_b43064_6a.

Faces and Names

304tl: LC-USZ62-109991; 304tm: LC-DIG-ds-03663; 304tr: USW3-030304-C; 304mr: LC-DIG-nclc-00769; 304bl: LC-DIG-nclc-00888; 304br: LC-DIG-ppmsca-12689; 305tl: AFC, NV9-WS44-2; 305tr: LC-DIG-nclc-04603; 305ml: LC-USW3-031294-E; 305mr: AFC, 1981/004_b44420_6; 305bl: LC-DIG-nclc-00781; 305bm: USW3-030309-C; 305br: LC-DIG-cwpbh-02944; 306tl: LC-DIG-nclc-02359; 306tr: USW3-030774-D; 306ml: AFC, 1940/001_ph141; 306mr: LC-DIG-nclc-01143; 306bl: LC-DIG-nclc-01119; 306bm: LC-DIG-fsac-1a34792; 306br: LC-DIG-nclc-00767; 307tl: USF34-41828-D; 307tm: LC-DIG-nclc-00903; 307tr: AFC, NV78-WW10-7; 307ml: LC-USF34-041511-E; 307mr: AFC, NV78-WW10-7; 307bl: USZ62-73262; 307br: LC-DIG-nclc-04241.

Back

308-309: RBSC, Baptista Boazio, Jay I. Kislak Collection; 310: LC-USZ62-125439; 319: LC-USZC4-14941; 320t: LC-DIG-pga-02392; 320b: LC-DIG-fsac-1a35006

Cover

Front cover: LC-USZ62-135620; **Back cover top:** LC-DIG-pga-02392; **back cover middle:** LC-DIG-nclc-01138; **back cover bottom:** LC-DIG-fsac-1a35006.

Index

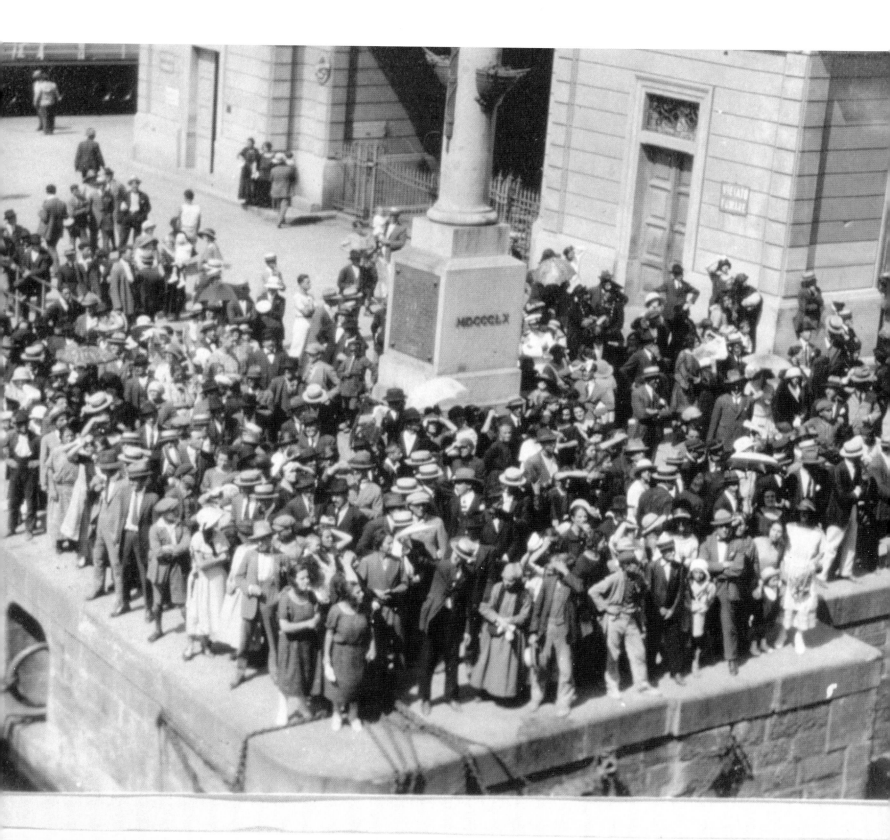

Sailing from Genoa. Hundreds of Italians
are waving bon voyage to relatives off for
the Land of Opportunity, the U.S.A.

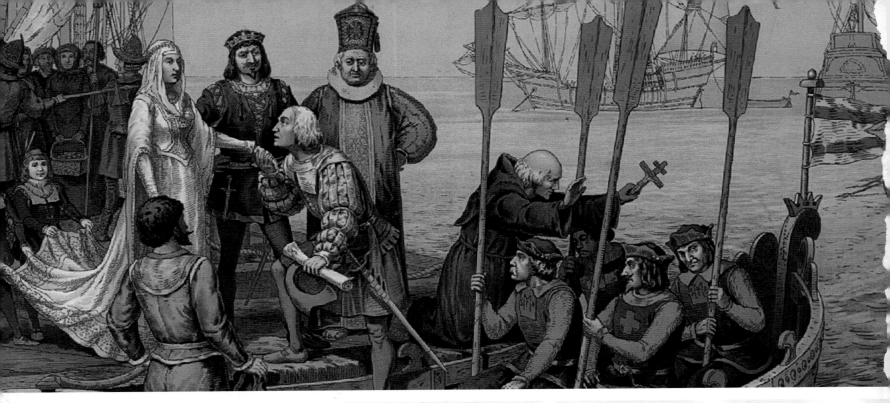

The authors selected 500 images related to the rich history of Italian Americans from the Library of Congress' holdings of photographs, maps, posters, letters, films, and sound recordings. Some of these, used to enhance the book's narration, have never been seen before, offering a fresh and original perspective on the Italian American experience from Columbus to today. They show the accomplishments of well-remembered individuals such as Fiorello LaGuardia, Vince Lombardi, and Martin Scorsese; but the book goes deeper to rediscover people like Giacomo Beltrani, who reached the sources of the Mississippi River in 1823, and Joe Petrosino, the first Italian American police officer to lose his life fighting organized crime.

We see how Italians lived through the work of many photographers, including Lewis Hine, who portrayed life in the slums of eastern cities, in fields, and in the mines of rural America; and the way Italians captured America in images like those of Carlo Gentile, who photographed southwestern Native Americans in the 1870s. And we also discover the contributions of artists like Athos Casarini, futurist painter and illustrator for *Harper's Weekly*.

Each chapter is introduced by essays by scholars Antonio Canovi and Mario B. Mignone

Linda Barrett Osborne, who wrote the text, is a fourth generation Italian American. A former senior writer and editor with the Library of Congress Publishing Office, she is the author of several books on American history. Her latest book is *Miles to Go for Freedom: Segregation and Civil Rights in the Jim Crow Years*.

Paolo Battaglia is an Italian author of illustrated history books such as *Un Italiano nella Cina dei Boxer* (2000), a photographic account of the Boxer rebellion in China; *Frammenti di Guerra* (2005), the photographic history of World War II in Northern Italy; and *New York In & Out* (2008) about a 1912 photographic journey to New York.

Antonio Canovi has written on Italian emigration to Northern Europe and to America in books such as *Altri modenesi* and *Pianure migranti* (2009).

Mario B. Mignone, SUNY Distinguished Service Professor, is the founder and Director of the Center for Italian Studies. He also co-founded the Association of Italian American Educators. Among his many publications are: *Columbus: Meeting of Cultures* (1993) and *Italy Today: Facing the Challenges of the New Millennium* (2008).